Dada/Dimensions

Studies in the Fine Arts:
The Avant-Garde, No. 48

Stephen C. Foster, Series Editor

Associate Professor of Art History
University of Iowa

Other Titles in This Series

Dada/Dimensions

Edited by
Stephen C. Foster
Associate Professor of Art History
University of Iowa
Iowa City, Iowa

U·M·I Research Press
Ann Arbor, Michigan

Produced and distributed by
UMI Research Press
an imprint of
University Microfilms Inc.
Ann Arbor, Michigan 48106

Library of Congress Cataloging in Publication Data

Main entry under title:

Dada/Dimensions

 (Studies in the fine arts. The avant-garde ; no. 48)
 Bibliography: p.
 Includes index.
 1. Dadaism—Addresses, essays, lectures. 2. Arts,
Modern—20th century—Addresses, essays, lectures.
I. Foster, Stephen C. II. Series: Studies in the fine
arts. Avant-garde ; no. 48.
NX600.D3D295 1985 700'.9'04 84-28089
ISBN 0-8357-1625-2 (alk. paper)

Contents

List of Figures

Foreword

The historiographic development or coming of age experienced by any field depends on both the introduction of new materials and the various perspectives taken on the data. In the past decade, Dada studies have grown tremendously in both respects. A number of exhibitions have brought to light new or rarely seen works; numerous and helpful anthologies have appeared; an important center for the study of the movement has been established at The University of Iowa and has done much to energize the field; the bibliography of the movement has been brought under control and scholarly resources consolidated.

In the course of all this, many Dada myths have been put to rest and the field brought squarely into line with other dimensions of scholarship pertaining to modernism and the avant-garde. The movement has been, to a significant degree, demystified and, at the same time, its connections to other movements and tendencies in the early twentieth century greatly clarified. Furthermore, there has been a tendency to stress Dada's variousness, in terms of both its individuals and the fundamentally different character of the movement as it occurred in its respective centers of activity: Zurich, Berlin, Cologne, Hannover, Paris, New York, and elsewhere.

Yet, for all this work, there remains a nagging feeling that something is being lost in the process; that having so analyzed the movement — in cases, almost out of existence — we must find ways of returning to some of the classic questions: What were Dada's major concerns? At what point did activity among the various individuals and centers become common property of the movement? How much of the myths represent the historical realities of the movement? What constitutes Dada's distinct identity? What individuals or centers of activity can, through further study, throw new light on these questions?

As the title of this book indicates, *Dada/Dimensions* attempts to look at all these questions and more as an indication of what are currently being pursued as important matters by scholars in the area. The organization of the book responds to the frustration encountered by those first achieving an orientation to the movement as well as to those already significantly engaged in the

subject. Thus, "themes" of concern form the basis of the book's structure. Many of these are relatively unprobed areas and promise to offer highly rewarding ways of recentering study of Dada.

Roy Allen's essay was chosen to launch the collection out of two considerations: first, that we should begin at the beginning and, second, that in offering a revisionist look at the inception of the movement, he challenges our perspectives on the balance of the movement as we historically see it occur in the other centers. The next two essays, by Allan Greenberg and Friedhelm Lach, present a general frame of reference for, and a very particular case of, the importance of the "event" and performance in the Dada movement, concerns that seem increasingly crucial for identifying and defining useful distinctions between Dada and other related movements of the same era, Jane Hancock and Harriett Watts, in like manner, represent widely conceived and highly specific accounts of the mystical sources for the work of Dada in general and of Hans (Jean) Arp in particular. Although addressing the same subject, they are mutually complementary essays and not in the least redundant. Indeed, taken together they offer highly useful perspectives on a subject other authors have scarcely touched on. Charlotte Stokes and Timothy Benson examine culture as content in visual works by Max Ernst and Raoul Hausmann and, in the process, underscore the nature and extent of Dada's awareness of the facts of culture, per se. Estera Milman questions and suggests alternatives to orthodox accounts of New York's involvement in Dada (or Dada's involvement in New York), while Ruth Bohan carefully considers the impact of one Dada, Marcel Duchamp, on the modernist work of American artist Joseph Stella. John Bowlt offers a rare opportunity to examine Dada in the context of post-revolutionary Russian experiments, while Stephen Foster profiles the career of one of the most sensational and engaging, but least published participants in the movement, Johannes Baader. The volume concludes, as befits any undertaking of a worthwhile subject, with some sobering methodological questions, posed here by Peter Guenther.

The book is not then merely a new collection of essays, but a cross section of questions scholars are asking about Dada at the present time. It attempts to serve the interested general public and students as well as the experienced scholar.

The vitality of any field depends to a great extent on the chemistry established among individuals working in the area. This book attempts both to prompt a reaction in its own right and to identify areas from which useful and further work in the field can proceed.

Stephen C. Foster

August 1984
Iowa City

Acknowledgments

In composing this volume, the editor has relied heavily on the help of a number of institutions, organizations, and individuals. The occasion for initiating the project was provided by The University of Iowa's School of Art and Art History, which hosted the annual meeting of the Mid-West Art History Society in the spring of 1983. Several papers included in this book were drawn from the sessions entitled "Dada and the Visual Arts." The organization of the effort, in large part, fell to the Fine Arts Archive of the Dada Archive and Research Center and to its coordinator, Estera Milman. Patricia Heddell graciously consented to act as design consultant for the book and is responsible for the handsome dust jacket. Gail Parson Zlatnik provided assistance in the initial preparation of the manuscript. The success of the venture was insured by the continuing support of the Fine Arts Archive by Wallace Tomasini (Director, School of Art and Art History, The University of Iowa) and The University of Iowa Foundation.

To all of the above, I am most grateful.

Acknowledgments

In composing this volume, the editor has relied heavily on the help of a number of institutions, organizations, and individuals. The occasion for initiating the project was provided by The University of Iowa's School of Art and Art History, which hosted the annual meeting of the Mid-West Art History Society in the spring of 1983. Several papers included in this book were drawn from the sessions entitled "Dada and the Visual Arts." The organization of the effort, in large part, fell to the Fine Arts Archive of the Dada Archive and Research Center and to its coordinator, Estera Milman. Patricia Heddell graciously consented to act as design consultant for the book and is responsible for the handsome dust jacket. Gail Parson Zlatnik provided assistance in the initial preparation of the manuscript. The success of the venture was insured by the continuing support of the Fine Arts Archive by Wallace Tomasini (Director, School of Art and Art History, The University of Iowa) and The University of Iowa Foundation.

To all of the above, I am most grateful.

1

Zurich Dada, 1916-1919:
The Proto-Phase of the Movement

Roy F. Allen

In his famous "Zurich Chronicle 1915-1919" (1920), Tristan Tzara records under July 1917: "Mysterious creation! Magical revolver! The DADA MOVE-MENT is launched."[1] There are four important pieces of information provided in that report: Zurich; July, 1917; Dada; the movement is launched. As has been the case with most such seemingly cut-and-dried data provided by Dada-ists, scholarship has had difficulty coming to terms with them. In the case of these four, the consensus of some six decades of studies by both Dadaists and Dada scholars has accepted the first, emended the second to 5 February 1916, thrashed over the definition of the third to small avail, and never challenged the fourth. In other words, the place and date of the beginning of Dada have been agreed upon, the nature of the phenomenon has not, but the question of whether it was then and there a movement has always been taken for granted. The latter issue is the one I want to deal with here and, as I will suggest, it places the other three in proper critical perspective.

An understanding of Dada in Zurich, as the initial phase of what was to become a global affair, obviously impinges upon an understanding of the phenomenon as a whole. An understanding of Dada is actually only a problem if we want the concept to signify more than certain stylistic or thematic features recurrent in the work of authors somehow identified with it. Of course, scholarship has always wanted it to signify more, and that is why scholars have insisted upon characterizing it as a whole with the term "movement." But the latter term has generally been bandied about quite casually in studies of much of the art and literature since the turn of the century when, at most, merely a degree of cooperative effort by members of an artistic group, whose work exhibits some similarities in styles and themes, has actually been noted. The question is, however, whether we are not implying much more when we use this term. A closer look at its standard definitions will show this to be the case.

We will have to base our definition of the term on dictionary glosses since standard handbooks to literature offer us surprisingly little help.[2] Such glosses apply to all contexts of usage but, in reference to literature or art, we can extrapolate four essential, interdependent features inevitably delineated by "movement." It involves (1) two or more artists who form a group by their own declaration of affiliation, (2) whose work exhibits related stylistic and thematic tendencies or trends, (3) who organize and engage in concerted artistic efforts for the mutual support of their work, and (4) who share a specific goal or objective as the central impetus of both their group and their own work.[3] This is, of course, only a skeletal outline. It could scarcely be applied in so simple and one-dimensional a form as a methodological yardstick, and I am certainly not going to attempt to do that in this chapter. Each of our definition's essential features insinuates a whole complex of ancillary features, which I will acknowledge as I examine the development of Dada in Zurich.

The beginnings of Dada in Zurich are well known. The precipitating event took place on 2 February 1916, when Hugo Ball released a press notice announcing the opening of a cabaret:

> Cabaret Voltaire. Under this name a group of young artists and writers has been formed whose aim is to create a center for artistic entertainment. The idea of the cabaret will be that guest artists will come and give musical performances and readings at the daily meetings. The young artists of Zurich, whatever their orientation, are invited to come along with suggestions and contributions of all kinds.[4]

The wording of this announcement was a decisive formulation, for it set the tone and character of everything that followed in Zurich until the end. Most importantly, it was more a guileless appeal to the unknown than a clear statement of position or intention.

First of all, the "group" that ostensibly sponsored the announcement was as yet largely nonexistent. It could have consisted at this time of, at most, three actual members, for the only known participants in the project before the cabaret's first performance were Hugo Ball, Emmy Hennings, and Marcel Slodki. Ball and Hennings qualified in the announcement as both "artists" and "writers"; both recited and wrote material for performances. In addition, Ball played the piano and Hennings sang. Slodki seems to have done little more than make the poster for the cabaret. Very shortly, however, on opening day, 5 February 1916, their ranks were sizeably increased. In response to Ball's invitation in the press, several artists wandered in as Ball and Hennings were making final preparations for their first show. They included Tristan Tzara, the brothers Marcel and Georges Janco, and Hans Arp. They were welcomed into the group, took part in that first evening's performance, and were henceforth regular participants and close associates of Ball. If we except Georges Janco, who quickly receded into the background, and add Richard Huelsenbeck, who

joined them a few days later on February 8, the regular, active membership of what came to be recognized as the core group of Zurich Dada was now complete.[5] And it was these artists who dominated and determined the future course of events.

What brought most of them together was largely adventitious and spontaneous. Ball's press notice specified no aim of the cabaret beyond that of "entertainment" and left its artistic direction totally open. Artists of any "orientation" whatsoever and ideas and creations of "all kinds" were welcome. The result was, not unexpectedly, a haphazardly eclectic gathering with no preconditioning in background for potential coherence. We need to consider the latent background of this group more closely, for it will help to explain later developments in Zurich Dada.

Ball, Hennings, Huelsenbeck, and Arp had a ready-made mutual affiliation: all were Germans with very strong roots in Expressionism, from which their subsequent work never fully separated them.[6] As is well known, all of them had participated in important projects identified in name and content with Expressionism before moving on to or, as in Arp's case, achieving notoriety in Switzerland.[7] These Germans thus brought with them to Dada a clear artistic bias that expressed itself in conspicuous ways during their Dada years. It expressed itself in a preoccupation with issues that had most recently been brought to the fore by Expressionism (e.g., opposition to the values, economics, politics, and the materialist-positivist-rationalist world view of the Wilhelminian middle class) and the search for a new language and a new reality that could register a fuller range of experiences of human character than the restricted Wilhelminian view allowed. It expressed itself in a preferential deference to Expressionist art and literature. Random reports on the program of the Cabaret Voltaire performances and the published programs of the Galerie Dada soirees indicate that presentations of Expressionist works dominated. Expressionist art prevailed in the exhibitions in the Cabaret Voltaire and the Galerie Dada. In addition, it was the contacts that Ball had made in Berlin with Herwarth Walden and *Der Sturm* prior to the war that later provided him, as director of the Galerie Dada, with the art that was shown at the two series of Sturm exhibitions.[8] Finally, the strong idealistic and optimistic thrust of Expressionism provided the foundation for the affirmative strain in the aesthetic and ideological iconoclasm of Ball's, Huelsenbeck's, Arp's, and Hennings's Dadaism.[9]

Tzara and Marcel Janco came to Dada from a very different cultural background. They were Romanians and lacked the total immersion of the others in Expressionism. They no doubt were acquainted with Expressionist and related tendencies (Cubism and Futurism) before coming to Zurich; but this acquaintance would have been superficial and largely secondhand, since Expressionism did not really establish roots in Romania until after the First

World War.[10] Their aesthetic and ideological dispositions were therefore not inclined strongly in the same direction as those of the others when they joined Dada. And, in the cultural and intellectual isolation of neutral Switzerland during the war, with its strong interregnum mentality, they would have found it more difficult than the others to discover an alternative, affirmative vision in the contemporary chaos. Not surprisingly, they found it easiest to identify with and exploit the oppositional tendency that Dada had inherited from previous revolutionary aesthetics. The logical result of such an orientation was not Janco's belated conversion to a "new confidence," which fed what he called the "second" or "positive speed" of Dada, but Tzara's notoriously inveterate nihilism or radical negativism. Janco's role was not the decisive one. As a painter and sculptor, he was not forced to take a verbally articulated theoretical stance, and he generally remained, in this sense, a low-profile and fairly reticent member of the group until after its demise.[11] Shortly after the group's formation, however, Tzara emerged, along with Ball, as a strong, vocal member with evident leadership and organizational abilities. His subsequent dissenting position in the group was therefore critical. This became most clear when it was bolstered by the addition to the circle of two new, similarly inclined artists: the Spaniard Francis Picabia, who passed through avant-garde circles in Paris, New York, Barcelona, and Lausanne before coming to Zurich, and the German Walter Serner, who had a superficial association with Expressionism in Germany and Expressionist expatriots in Zurich. Serner edited his own Expressionist-aligned journal in the same city before joining the Dadaists.[12]

The nature of the whole spectrum of participants in Zurich Dada's first public forum was not significantly different from that of the core group. Huelsenbeck described the founding of Dada in Zurich in a retrospective essay as the "spontaneous" feat of a group of "young people of the most heterogeneous nature."[13] The manner in which the particular mix of the cabaret's associates as a whole developed was totally fortuitous and spontaneous, but its heterogeneity was not; the latter seems, in fact, to have been intentional. In his autobiography, Huelsenbeck recorded that Ball and Hennings had *meant* the cabaret "to be a gathering place for all artistic trends, not just modern ones." He then clarified: "But we had in mind mainly living artists, not only those who took part in our cabaret, but others as well all over Europe."[14] The very possibility for such diversity was inherent in Ball's press notice call for artists "whatever their orientation." But it is also clear, from Ball's own record of his intentions at the time the cabaret was founded, that he was consciously and specifically aiming at diversity rather than agreement in his circle of associates. Just a few days before the opening, he wrote an especially revealing letter, in this sense, to his friend Käthe Brodnitz in which he discussed his plans to use his broad connections to attract the participation of the "most heterogeneous people"; he then added for stress: "Everyone shall be welcome — who has

talent.[15] After asking Brodnitz, who was then residing in Berlin, to send Huelsenbeck on to him in Zurich, Ball closed with a request that reinforced the priority of the quality of his performers' talents over any antecedent artistic commitments: "But just one request first: send us some interesting people so that we will be able to accomplish some great things."[16] Reports on the cabaret performances corroborate Ball's aim; performers represented, as Ball reported of an evening on 29 March 1916, "all the styles of the last twenty years."[17] They constituted a veritable *omnium-gatherum* of artists of all directions, nationalities, and affiliations represented in Zurich during the war: Poles, Dutch, Germans, Russians, French, Swiss, Romanians, Italians; Expressionists, Cubists, Futurists, Dadaists; dancers, singers, poets, musicians, painters. It is worth emphasizing that Ball was fully aware *at the time* of his supporters' other artistic ties and *in name.*[18] This fact applies equally to the performers and, as already indicated, to the works they performed. Ball is widely reported to have been a talented organizer. His presence in the group was sorely missed by the others after his first exodus (July 1916) probably more for this reason than for any other. To have converted such a motley gathering of artistic wills and interests, particularly one summoned together so casually, to genuine commitment to one single cause would have defied the skills of even the most determined strategist. One additional problem, as pointed out below, was that Ball lacked such determination.

From the very start, there was no inherent common ground in the Zurich group on which to lay the foundation of a cohesive effort. And there was nothing else, no clear cause or artistic concern, in Ball's initial announcement, or, as we will see, in the group's subsequent activities or pronouncements, to give them tangible guidance. Ball stated quite openly that the aim of his cabaret was to be "entertainment." The cabaret was therefore not to have an alleged ideological objective, as had been the case, for example, with the recitals he and Huelsenbeck had organized in Berlin in early 1915. It differed even more obviously from the Expressionist theater he had wanted to establish in Munich just before the war, which was to have been a "fusion of all regenerative ideas" and "capable of creating the new society."[19] There were at least two apparent factors that conditioned Ball's dramatically new position in Zurich.

First of all, he was coming to the new cabaret most directly from intensive work in the preceding months (ca. October 1915 to January 1916) in vaudeville, in Zurich and on the road in other parts of Switzerland.[20] Huelsenbeck suggested in his memoirs that a causal connection existed between vaudeville and the impetus to the founding of the Cabaret Voltaire: "The idea of starting a cabaret seemed logical since Emmy was a *diseuse* and Ball an excellent pianist."[21] Vaudeville is, of course, a medium of as pure entertainment as possible, and that is the way Ball had practiced it. It had constituted his main livelihood and way of life through a difficult period of soul-searching and

emotional crisis that had begun in disillusionment with the war and despair over the course of his career as an artist. It almost culminated in suicide.[22] His diary entries and letters just prior to the founding of the Cabaret Voltaire document that he had no clear artistic or intellectual direction in his life at this time. That his conception of the new venture was, indeed, closer to that of vaudeville than to that of a forum for a new artistic philosophy is reflected in his own characterization of it in a contemporary letter to Brodnitz (17 January 1916) as "an—'artists' bistro: in the Simplizissimus style, but more artistic and more deliberate."[23] This choice of words was no product of a momentary mood of flippancy. In other contemporary correspondence, "bistro" alternates freely with "cabaret" as a designation for the Cabaret Voltaire.[24] Huelsenbeck corroborates this conception in his description of it as a "miniature variety show."[25] The analogy to the style of Simplizissimus, a Munich bistro owned by Kathi Kobus and popular amongst the Schwabing avant-garde because of its off-beat style of entertainment, is important. Ball frequented the bistro before the war and therefore knew its style firsthand. Hennings was able to bring its heritage even more directly to the Cabaret Voltaire since she had been a regular and very popular performer there when Ball met her. The performances in Simplizissimus were often satirical, tinged politically with reference to contemporary affairs, but they were designed first and foremost to amuse their audiences, not to solicit support for an aesthetic or ideological program. Preference had been given to the frivolous verse of humorists such as Christian Morgenstern or Joachim Ringelnatz. The meeting place of Expressionists for the serious exchange of ideas had therefore been elsewhere, in the Schwabing Café Stephanie.[26] Significantly, Heinrich F.S. Bachmair's Expressionist circle in Munich, which had included Ball, Hennings, and Huelsenbeck, frequented Simplizissimus and the Café Stephanie. But when it set about to organize a literary cabaret with a clear ideological direction, it chose to hold it not in Simplizissimus but in the Café Glasl, like the Café Stephanie, an artists' center.[27]

The stress on entertainment at the Cabaret Voltaire was further enforced, *nolens volens,* by the owner of the bar, the Holländische Meierei at Spiegelgasse 1, where the cabaret had been installed. This man, a retired Dutch sailor by the name of Jan Ephraim, had a very simple, down-to-earth conception of his business. He insisted that the cabaret turn a profit, and when its audiences at one point began to thin out, he threatened to close it down if it did not offer "better entertainment" and "draw a larger crowd."[28] An entry for 1 March 1916 in Ball's diary probably reflects pressure of this sort from the owner:

> Our attempt to entertain the audience with artistic things forces us in an exciting and instructive way to be incessantly lively, new, and naive. It is a race with the expectations of the audience, and this race calls on all our forces of invention and debate.[29]

In addition, in his characterizations of their work throughout his diary and letters of this period, Ball consistently adheres to ingredients that would tend to inhibit ideological coherency or any other ulterior motives. For him Dada is "buffoonery," "a whim," "spontaneous foolishness," "a farce of nothingness."[30] Such words are not, as they are sometimes taken to be by students of Dada, opaque expressions of a new world vision. They are simple statements of fact. The Cabaret Voltaire was its performers', and especially Ball's and Hennings's, main source of subsistence and aimed primarily to amuse, not to convert or convince, its audiences. This fact is intimated nowhere more tangibly than in Ball's foreword to the group's first anthology, the *Cabaret Voltaire* (published 15 May 1916), in which he describes the founding of their cabaret.[31] His tone here is decidedly offhand and, in a few places, even borders on the sardonic; his style is discursive and factual. Ball seems to be purposely avoiding any intrusions of solemnity. This statement is, in greatest part, simply a straightforward, unpretentious chronicle of the basic organizational steps taken by Ball to get the cabaret started.

There is something else about this statement that should be stressed. It is something symptomatic of another conspicuous feature of Zurich Dada, particularly in its early stages; namely, its dearth of aesthetic or ideological program. *Cabaret Voltaire* was the first cooperative publication of the group. If it was, indeed, looking for a junction of ideas and aesthetics, then it needed at this critical stage the kind of position statement that is typical of other, similar group efforts. These were, most notably and recently in Dada's era, the many Expressionist journals, almanacs, and anthologies, including those worked on by Ball himself.[32] The placement and typography of Ball's foreword would suggest the format of such a statement, but there is actually precious little in it of substance, in that sense, beyond two very vague references in its opening and closing lines to an "independence" of mind that had drawn participants to the cabaret. This intellectual "independence," however, is implicitly little more than a thinly disguised euphemism for opposition to the war:

> When I founded the Cabaret Voltaire, I was sure that there must be a few young people in Switzerland who like me were interested not only in enjoying their independence but also in giving proof of it.... The Cabaret Voltaire ... has as its sole purpose to draw attention, across the barriers of war and nationalism, to the few independent spirits who live for other ideals.[33]

Had opposition to the war been made a consistent, inherent, and pervasive part of the aesthetics and ideology of Dada, it might have coalesced its followers behind a movement in Zurich. It did not, however, manage to play that role. Thus, its first group appearance in print was, as Ball himself characterized it, no more nor less than a "documentation" of the cabaret that had fostered it.[34]

In a letter to his friend August Hoffmann, written shortly after the book's appearance, Ball revealed the open-handed discrimination exercised in putting together its list of contributors. He reports that it includes the "most interesting" of "the whole colony of young painters and literati" then residing in Zurich.[35] The book's aesthetic eclecticism is alluded to in a diary entry made just two days later: "In [thirty-]two pages it is the first synthesis of the modern schools of art and literature. The founders of expressionism, futurism, and cubism have contributions in it."[36]

Even once a name for the group had been found — about the same time the cabaret anthology was being readied for publication[37] — the first manifestoes that surfaced shortly thereafter fell far short of providing a genuine program.[38] Dadaists themselves, of course, have suggested, sometimes quite categorically, that Dada had no program, even that by its very nature it was opposed to all programs.[39] This would explain, but only rhetorically, of course, why the corpus of such pronouncements from Zurich was so meager. Besides the random private thoughts recorded by Ball and Arp in their diaries (and not made public until 1927 and 1955, respectively), a mere four major, extant statements of program were sponsored and made public by the group between the founding of the Cabaret Voltaire on 5 February 1916 and the closing of the group's second great forum, the Galerie Dada, on 1 June 1917.[40] The four extant statements are: the manifesto by Ball traditionally called "The First Dada Manifesto" (14 July 1916), Tzara's "Monsieur Antipyrine's Manifesto" (14 July 1916), Huelsenbeck's "Declaration" (ca. second half of April 1916), and Ball's lecture on Kandinsky (7 April 1917).[41] The first three were read in the Cabaret Voltaire, and the last in the Galerie Dada. The Kandinsky lecture, although the most substantive of the four works, has very little to do with Dada overtly and in no way differs in its aesthetics from the many preceding or contemporary statements of this sort by Expressionists.[42]

The three manifestoes are among the most important documents of the Zurich phase, for they are the first recorded attempts by the group at self-conscious conceptualization of the aims and meaning of their work. It should be stressed that they were drafted in close proximity to one another and therefore reflect fairly well the thinking of the group's most vocal members at the same approximate stage in its development. The stage they had reached at this time is a crucial point, for they were just beginning to confront the public with a name for their efforts. Huelsenbeck announced the name's recent discovery in his "Declaration," and Ball's and Tzara's manifestoes were read at what was billed as the "First Dada Evening."[43] All three thus spoke in the name of Dada. Huelsenbeck was the most explicit in this sense, and he claimed to be speaking on behalf of the whole group:

> In the name of the Cabaret Voltaire and my friend Hugo Ball, the founder and director of this most learned institute, I have a declaration to make this evening which will upset

you. I hope that no bodily harm will come to you, but what we have to say to you now will knock you for a loop. We have decided to subsume our various activities under the name "Dada."

They all disagreed on the central issue, namely, the definition of the name they chose. Huelsenbeck, more to befuddle than to educate, declared that "Dada" means "nothing," is "nothingness": "Dada was found in a dictionary. It means nothing. It is significant nothingness, in which nothing means something." Ball, in a patronizing tone, played down the question of a definition and simply offered the kind of dictionary glosses alluded to by Huelsenbeck:

> Dada comes from the dictionary. It is terribly simple. In French it means "hobby horse." In German it means "good-by," "get off my back," "be seeing you sometime." In Romanian: "Yes, indeed, you are right, that's it. But of course, yes, definitely, right." And so forth.

Tzara, initiating in print the nihilism for which he was to become notorious, defined primarily what Dada is not and what it is against, not what Dada is or what it is for:

> Dada is our intensity: it erects inconsequential bayonets and the Sumatral head of German babies; Dada is life with neither bedroom slippers nor parallels; it is against and for unity and definitely against the future; we are wise enough to know that our brains are going to become flabby cushions, that our antidogmatism is as exclusive as a civil servant, and that we cry liberty but are not free; a severe necessity with neither discipline nor morals....

On the other hand, all agreed on three important ancillary features of Dada:

1) Dada is international in perspective and seeks to bridge differences:

Ball: [Dada] is an international word.... Dada is the world soul ... Dada is the world's best lily-milk soap.

Huelsenbeck: Noble and respected citizens of Zurich, students, tradesmen, workers, vagabonds, aimless people of all lands, unite.... We want to end the war with nothingness.

Tzara: Dada remains within the framework of European weaknesses, it's still shit, but from now on we want to shit in different colors so as to adorn the zoo of art with all the flags of all the consulates.

We are circus ringmasters and we can be found whistling amongst the winds of fairgrounds, in convents, prostitutions, theatres, realities, feelings, restaurants, ohoho, bang bang.

2) Dada is antagonistic toward established society in the modern avant-garde, Bohemian tradition of the *épater-le-bourgeois* posture:

Ball:

I don't want words that other people have invented. All the words are other people's inventions. I want my own stuff, my own rhythm, and vowels and consonants too, matching the rhythm and all my own. If this pulsation is seven yards long, I want words for it that are seven yards long. Mr. Schulz's words are only two and a half centimeters long.

... The word, the word, the word outside your domain, your stuffiness, this laughable impotence, your stupendous smugness, outside all the parrotry of your self-evident limitedness. The word, gentlemen, is a public concern of the first importance.

Huelsenbeck:

We have no intentions as we stand before you here; we don't even intend to entertain or amuse you. Although all of what we say and do is what it is, namely nothing, we nonetheless do not have to part as enemies. The moment you overcome your middle-class resistance and hoist the flag of Dada with us, we will be united and the best of friends.

Tzara:

... We spit on humanity....

DADA is neither madness, nor wisdom, nor irony, look at me, dear bourgeois....

... And if we reveal the crime so as to show that we are learned denunciators, it's to please you, dear audience, I assure you, and I adore you.

3) Dada is a new tendency in art that seeks to change conventional attitudes and practices in aesthetics, society, and morality:

Ball:

How can one get rid of everything that smacks of journalism, worms, everything nice and right, blinkered, moralistic, Europeanized, enervated? By saying dada.... A line of poetry is a chance to get rid of all the filth that clings to this accursed language, as if put there by stockbrokers' hands, hands worn smooth by coins. I want the word where it ends and begins. Dada is the heart of words.

Huelsenbeck:

We want to change the world with nothingness, we want to change poetry and painting with nothingness....

Tzara:

Art used to be a game of nuts in May, children would go gathering words that had a final ring, then they would exude, shout out the verse, and dress it up in doll's bootees, and the verse became a queen in order to die a little, and the queen became a sardine, and the children ran hither and yon, unseen.... Then came the great ambassadors of feeling, who yelled historically in chorus:

Psychology Psychology hee hee
Science Science Science
Long live France
We are not naive
We are successive
We are exclusive
We are not simpletons
and we are perfectly capable of an intelligent discussion.

But we, DADA, don't agree with them, for art isn't serious....

All this adds up to very little that is new, lucid, or substantive. The Dadaists subsequently became infamous for their obfuscations and, at least in Tzara's case, it was usually obscurantism for its own sake or for its scampish capacity for provoking audiences. Arp explained this tendency in Dada in a post-Zurich critique:

> The bourgeois regarded the Dadaist as a dissolute monster, a revolutionary villain, a barbarous Asiatic, plotting against his bells, his safe-deposits, his honors. The Dadaist thought up tricks to rob the bourgeois of his sleep. He sent false reports to the newspapers of hair-raising Dada duels, in which his favorite author, the "King of Bernina," was said to be involved. The Dadaist gave the bourgeois a sense of confusion and distant, yet mighty rumbling, so that his bells began to buzz, his safes frowned, and his honors broke out in spots.[44]

Janco was more caustic in his critical assessment of this provocative tendency and made clear its weaknesses and limitations:

> At the Cabaret Voltaire we began by shocking the bourgeois, demolishing his idea of art, attacking common sense, public opinion, education, institutions, museums, good taste, in short, the whole prevailing order.

> For writers, it was a godsend. They exposed themselves in their creations, their manifestoes, their poetry, and invectives and insults rained down on all sides. Courageously, they abused those who came to listen to them, and, to make themselves more interesting, they posed as nihilists declaring art already dead and Dada nothing but a joke. It was young and modern, delightful and novel! For those of us in the plastic arts it was less simple. We did not have their advantages and did not always take part in these negative and sometimes dangerous public demonstrations. Also, for us it was "literature." Ineffectaul babbling, irrational attacks. This repeated itself over and over again with no logic, became superficial, empty, like a circus.[45]

Pursued with excess and no substantive alternatives, such prankish negativism was, as Janco suggested, not capable of providing the foundation for a viable new direction in art.

As for newness of ideas in those three manifestoes, the same aesthetic and ethical stances had already been formulated — and generally in more precise and pointed terms — in the six years before Zurich Dada by Expressionists, Cubists, and Futurists. Even the one solid proposal in all three, namely, Ball's advocacy of a change in language, which was to involve cleansing it of stultifying conventions and reducing it to its essentials, is an echo of Expressionist and Futurist linguistic programs, especially that of the Sturm *Wortkunst* theory, which was developing about the same time. It is not surprising, then, that Herwarth Walden's circle was the Expressionist group to which Ball maintained closest ties in this period, not that of Franz Pfemfert, his former mentor in Berlin and the self-assured editor of the politically committed journal *Die Aktion*.[46] The only new element offered by the three manifestoes is, in reality, the word "Dada." But, as Ball himself sardonically hinted in his statement, a word is hardly sufficient foundation for a movement.[47]

The tone of the above remark, which pervades the first two paragraphs and the beginning of the third in Ball's manifesto, is explained in a diary entry he made about a month later (6 August 1916):

> My manifesto on the first *public* dada evening (in the Waag Hall) was a thinly disguised break with friends. They felt so too. Has the first manifesto of a newly founded cause ever been known to refute the cause itself to its supporters' face? And yet that is what happened. When things are finished, I cannot spend any more time with them. That is how I am; if I tried to be different, it would be of no use.[48]

Thus, at the *public* (Ball underscores that word himself) *debut* of Dada, the very leader and founder of the group chose, in his first and only position statement on the "cause," to take an antagonistic stand on it. This highlights what is probably the most decisive factor in Zurich Dada that militated against coalescing its adherents. Ball demonstrated on numerous occasions a tenacious reluctance to commit himself fully either to the group or to its aesthetics, which twice culminated in his abandoning Dada and, as though to make the break each time more conclusive and comprehensive, Zurich as well.[49] Both instances were precipitated by the same causes. Ball frequently complained, in letters and diary entries throughout his brief Dada phase, of being exhausted both physically and emotionally by the hectic and grinding pace of work in the Cabaret Voltaire and, later, in the Galerie Dada.[50] Both his departures from the group were explained by Ball himself as most directly related to nervous and physical exhaustion.[51] Equally important had been his consistent resistance, again in the context of the activities of both the cabaret and the gallery, to attempts by Tzara to "organize" Dada into a "school."[52] During the Cabaret Voltaire period, as Ball records in his diary (11 April 1916), he was supported in this position by Huelsenbeck. Both thought people had had enough of organizations. Ball added, stressing the frivolousness he always saw in Dada: "One should not turn a whim into an artistic school."[53] For Ball, it would seem that there was also a broad ideological question at stake in this issue. In November 1915, he had already criticized, in his diary, the "intellectualizing" and "rationalizing" of "art, philosophy, music, and religion" in his time.[54] He seemed to see this as an expression of the same intellectual orientation that had produced the contemporary war machine.[55] The depth of this conviction is revealed by its resurfacing in Ball's notorious letter of farewell to Tzara (15 September 1916) written after his abrupt exodus from the Cabaret Voltaire.[56] Ball here labels the attempt to pursue a specific artistic direction, to create a new ism, "the worst form of bourgeois mentality": "I have become even more mistrustful. I herewith declare that all forms of Expressionism, Dadaism, and other 'isms' are the worst manifestations of the bourgeois mentality. It's all bourgeoisie, all bourgeoisie."[57]

All along, Ball had been only little more than half-heartedly supportive of the direction pursued in the Cabaret Voltaire. The tenuousness of his commit-

ment comes through in records of his thoughts throughout the period of his involvement in the cabaret. In March and April 1916, concern over the fate of Hennings's child, who had been cared for by Hennings's mother and then left homeless on the mother's death, caused him to "neglect" the cabaret.[58] Less than two months later, on June 2, he wrote his friend August Hoffmann in Munich that he had lost interest in it and, as he admitted, at the very moment when it was meeting with success: "My aim [in the Cabaret Voltaire anthology] was to document the cabaret as an idea. I must, however, confess that it no longer interests me."[59] Just a day later, he reaffirmed this position in a letter to Käthe Brodnitz: "The cabaret has therefore prevailed as an idea, and if it comes to an end, the work in it was not in vain. But it will not come to an end; it will only, if possible, be continued on another basis."[60]

After his first exodus, his determination to go on to other things and in other directions seemed firm. His letter of 17 August 1916 from Vira to Hennings, who had stayed behind in Zurich for the time being, still left a door open for a return, although his tone in reference to Dada was scornful: "The Dadaists seem to be in an awkward position. Ah, to the devil with the whole business. I'm not interested in it anymore. Later maybe."[61] However, his break was expressed more decisively in a 6 October 1916 letter from Ascona to Brodnitz: "In short, I will not be involved in Dadaism nor in fantasy anymore, but will try to cure myself by means of descriptive methods."[62] The following day he described his change of position on Dada as the result of a new stage in his intellectual development: "I have also quickly learned to think differently about Dadaism, which I myself founded. And so I dropped the whole business."[63]

Ball was still determined not to return to the Dada group as late as November 28.[64] But then, only fifteen days later, as a letter to Tzara reveals, he was already making serious plans for a new cooperative venture with the group with the prospect of initiating a series of art exhibitions in the Galerie Dada.[65] In spite of the unexpected and unexplained change of mind that this letter reveals, it nonetheless makes clear that he was negotiating his return. Obviously urged upon him by Tzara and the other members of the Dada group still in Zurich, the basis of his return seemed to be respect for individual identities and directions within the context of the new cooperative effort:

> It does not seem very possible for us to work as a team. The times demand too loudly that we take a personal stand, and such a stand (it seems to me) excludes alliances. Mr. Corray will perhaps organize a series of such evenings, like those sponsored in Munich by Goltz. The individual would have a good opportunity to make clear his aims and convictions, and I think that would also be more interesting for us. Don't you think?[66]

Ball's conception of the new venture was, in fact, the one put in practice. The heterogeneity of artistic aims and directions of the cabaret continued in the

Galerie Dada, as already indicated. This fact would seem to explain Ball's description of the gallery in a contemporary diary entry (18 March 1917) as "a continuation of the cabaret idea of last year."[67] Before Ball rejoined the group, Huelsenbeck permanently returned to Berlin; he had decided on this move in the early fall of the previous year when he wrote Ball a letter, duly recorded by Ball in his diary, explaining that his plan was conditioned by the same problem that had bothered his friend:

> I decided weeks ago to return to Germany but cannot get away at the moment as I am suffering from a severe nervous stomach disease. It is terrible, a triple inferno, no sleep, always vomiting, perhaps the punishment for that Dada hubris that you think you have recognized. I too have always been greatly opposed to this art.[68]

Of course, Huelsenbeck's dissatisfaction obviously was more with the negativism of Dada in Zurich under Tzara than with the latter's attempts to organize it into a movement. He returned to Berlin in January 1917 and not only helped to establish a Dada group there that was rather tightly organized, but also developed a program that struck a clear balance between cricitism of the established order and affirmative alternatives.[69]

It is significant that no solid momentum toward developing a coherent program or establishing a continuing public tribune in print for Dada was realized in Zurich until after the departure of Ball and Huelsenbeck. Then, under Tzara's exclusive editorship, *Dada* was launched in July 1917. Its very first issue began to carry programmatic statements penned by Tzara. A dominant direction in the journal's position on Dada began to emerge with the third issue (December 1918), when Tzara's most important manifesto of the Zurich phase appeared, the "Dada Manifesto 1918."[70] The strong negativistic strain in this screed was reinforced in subsequent issues by Walter Serner's "Letzte Lockerung: Manifest" ("Final Dissolution: Manifesto"), Hans Richter's "Gegen Ohne Für Dada" ("Against Without For Dada"), and Francis Picabia's "Manifeste Cannibale Dada" ("Cannibal Dada Manifesto").[71] These last two manifestoes, along with another one of similar import by Tzara, were read at the Dada soiree organized by Tzara and executed on 9 April 1919 in the Kaufleuten Hall in Zurich.[72] Richter describes this evening as the climax and greatest success of Zurich Dada.[73] It was also one of the most ideologically cohesive Dada events in Zurich. With Tzara able to take over the now largely unchallenged leadership of the group and to guide it in his direction, one might have begun to speak of a Dada movement in Zurich. This seemed especially to be the case after Picabia joined the group in the fall of 1918 and Serner in the spring of 1919, both of them on Tzara's side of the ideological spectrum.[74] Thus, Tzara's declaration in his Zurich chronicle of the launching of the Dada "movement" in July 1917 — again, after the departure of his strongest opponents — seemed made with some justification. But Tzara's problems were not yet over.

The old divisions in the group between those in the "negative speed" and those in the "positive speed" were still latent. In addition, the times were putting ideological pressure on all to take a stand, as Ball had already put it in December 1916. They were being pressured to choose a constructive political position in the struggles between factions of the left and right for control of the new Germany. As has already been recorded in detail elsewhere, the final, permanent rupture and dissolution of Zurich Dada followed the separation of the group into two opposing camps in the second half of 1919. On the one side were ranged Tzara, Picabia, and Serner; on the other, Richter, Janco, and Arp. This division, along broad ideological lines, had always been implicit, but this time it was formalized by the second group's establishment of their own alliance as an expression of their rejection of the other group's nihilism and their sympathy with the political aims of revolutionary artists in the new, nascent governments of postwar Europe.[75] Thus, the removal of Tzara and Picabia to Paris in early 1920 was really only a postmortem gesture.[76]

What we have encountered in this brief survey of the activities of Zurich Dada can hardly be said to yield the features of a movement in the fullest sense of the term. The Zurich phase of Dada seems to have represented, at most, the first tentative steps toward laying the foundation for what followed in Berlin and Paris. It represented the initial gropings for a new approach to art and life, the incipient stage of the development of a new, coherent aesthetic and ideological program. It fares poorly, in this sense, in comparison with the depth and breadth of affiliations, both formal and informal, the extent of concertedness of efforts, the substantiveness and agreement in artistic and ideological programs of Expressionism and Futurism. Zurich Dada was clearly only a proto-phase of what we can recognize later, in particular in Berlin, as a genuine movement. Huelsenbeck, one of the eventual leaders of the Berlin phase, realized this when he confessed in a 1920 retrospective view of Dada that "the Dadaists of the Cabaret Voltaire actually had no idea what they wanted," that none of them then "suspected what Dada might really become" and that "the true meaning of Dadaism was recognized only later in Germany by the people who were zealously propagating it."[77]

The confusion of historians over these issues originated with Tzara, who, according to Fritz Glauser, had the ambition to "invent" a new direction in art and for whom Dada seemed to offer the desired vehicle for doing so.[78] Ball no doubt was alluding to this misguided ambition when he sneeringly characterized Dada in his "First Dada Manifesto" as "just a word, and the word a movement." Ball's next two lines put the finger on the snag in Tzara's plans: "Quite terribly simple. To make of it an artistic tendency must mean that one is anticipating complications."[79] Thus, Ball knew that the "complications," i.e., the differences within the group and in the implications of their work, would hinder the realization of any concerted efforts beyond a merely perfunctory or superficial kind of cooperation such as that in the Cabaret Voltaire or the

Galerie Dada. Tzara was, in essence, trying to launch a one-man movement without realizing that this is a contradiction in terms. More importantly, he was trying to establish one on the basis of negation as his program. But, as already suggested, that too is virtually a contradiction in terms: negation cannot be the basis of a program since its variations and targets are unlimited in number and all determined indirectly (negatively) by the opposing forces. It therefore lacks its own source of energy and, hence, independence to develop the goals or objectives requisite for a movement.

Finally, beyond all other factors that hindered the development of a movement in Zurich, Dada there simply lacked the time to develop. It took Expressionism more than a decade to gather forces and mature enough to produce a program. Expressionism had begun, in part, in underground movements at the turn of the century and gradually surfaced between about 1910 and the onset of the First World War, finally reaching full fruition only toward the end of that war. Zurich Dada began precipitously in the early spring of 1916 and was profoundly disrupted by Ball's departure in the summer that followed. Disrupted again in the same season of the following year, it continued only after a complete reorganization to mid-1919, when it was conclusively divided into two factions. Shortly thereafter it dissolved completely. The Ball phase can be measured in months, and Tzara's in little more. Zurich Dada seems from this perspective to have been, at best, no more than an experiment.

Notes for Chapter 1

1. Hans Richter, *Dada: Art and Anti-Art* (New York and Toronto: Oxford, 1965), p. 226.

2. Standard handbooks provide only very vague glosses, offering most often such equally opaque synonyms as "trend" or "development." See, e.g., Karl Beckson and Arthur Ganz, *A Reader's Guide to Literary Terms* (New York: Noonday, 1960), p. 129; J.A. Cuddon, *A Dictionary of Literary Terms* (New York: Doubleday, 1977), p. 397; C. Hugh Holman, *A Handbook to Literature* (Indianapolis: Bobbs-Merrill, 1980), p. 279; A.F. Scott, *Current Literary Terms* (New York: Macmillan, 1965), p. 187.

3. This definition is a revision of that in Roy F. Allen, *Literary Life in German Expressionism and the Berlin Circles* (Ann Arbor: UMI Research Press, 1983), p. 9.

4. Hugo Ball, *Flight Out of Time: A Dada Diary,* ed. John Elderfield, trans. Ann Raimes (New York: Viking, 1974), p. 50.

5. Others closely associated with the cabaret left no noticeable mark on its development. Besides numerous guest performers, they included especially Madame Le Roy (alias Madame Leconte), a chanteuse who appeared regularly in performances during the cabaret's early stage but played no recorded role in the group's other activities, and the artist Sophie Taeuber, Arp's girlfriend, who is reported to have had a very retiring association with the cabaret and made only one documented appearance in the later soirees of the Galerie Dada. For records of circle membership, see especially Peter Schifferli, ed., *Als Dada begann* (Zurich: Arche, 1957); Hans Arp, *On My Way: Poetry and Essays 1912-1947* (New York: Wittenborn, 1948), pp. 35-77; Hans Arp, *Unsern taglichen Traum ...* (Zurich: Arche, 1955); Hugo Ball, Annemarie Schutt-Hennings, ed., *Briefe 1911-1927* (Einsiedein: Benziger, 1957), pp.

51-83; Ball, *Flight,* pp. 50ff; *Cabaret Voltaire* (Zurich), 15 May 1916; *Dada* (Zurich and Paris), July 1917-September 1921; Richard Huelsenbeck, ed., *Dada Almanach* (Berlin: Erich Reiss, 1920), pp. 3-9; Richard Huelsenbeck, ed., *Dada: Eine literarische Dokumentation* (Reinbek: Rowohlt, 1964), pp. 5-23; Willy Verkauf, ed., *Dada: Monograph of a Movement* (New York: Wittenborn, [1957]), pp. 26-49; Lucy Lippard, ed., *Dadas on Art* (Englewood Cliffs, N.J.: Prentice-Hall, 1971), pp. 13-56; Richard Huelsenbeck, "Dada in Zürich," *Die Weltbühne* 23, 2 (1927): 172-74; Richard Huelsenbeck, "Dada, or the Meaning of Chaos," *Studio International* 183, 940 (January 1972): 26-29; Richard Huelsenbeck, "En avant Dada: A History of Dadaism (1920)," in Robert Motherwell, ed., *The Dada Painters and Poets: An Anthology* (New York: Wittenborn, 1951), pp. 23-47; Richard Huelsenbeck, *Memoirs of a Dada Drummer,* ed. Hans J. Kleinschmidt, trans. Joachim Neugroschel (New York: Viking, 1974), pp. 8-63; Richard Huelsenbeck, "Zürich 1916, Wie es wirklich war," *Die neue Bücherschau* 6, 12 (1928): 611-17; Miklavizh Prosenc, *Die Dadaisten in Zürich* (Bonn: H. Bouvier, 1967); Richter, *Dada,* pp. 11-80, 223-28; Richard W. Sheppard, "Ferdinand Hardekopf und Dada," *Jahrbuch der deutschen Schiller-Gesellschaft* 20 (1976): 132-61; Richard W. Sheppard, "Hugo Ball an Käthe Brodnitz: Bisher unveröffentlichte Briefe und Kurzmitteilungen aus den 'Dada'-Jahren," *Jahrbuch der deutschen Schiller-Gesellschaft* 16 (1972): 37-70; *Der Zeltweg* (Zurich), November 1919. The date of Huelsenbeck's arrival has been much disputed in Dada scholarship. Ball registers Huelsenbeck's presence in Zurich for the first time in his diary on 11 February 1916; this means Huelsenbeck would most likely have arrived anytime between that date and the previous diary entry of February 7, which makes no mention of him. See Ball, *Flight,* p. 51. One important report has generally been overlooked: Annemarie Schütt-Hennings dates Huelsenbeck's arrival as February 8 in the index to Ball's correspondents in her edition of his letters. See Ball, *Briefe,* p. 310. Since it can be assumed that she had access to Ball's unpublished papers, I accept this date as the most reliable.

6. See the conspicuously Expressionist formulations in Ball's Kandinsky lecture of 7 April 1917, which "realized a favorite old plan," namely, his Expressionist Theater concept of 1914; Arp's artistic theory, penned between 1914 and 1954 and published in 1955 in *Unsern täglichen;* Huelsenbeck's 1917 manifesto "Der neue Mensch." Ball's lecture is published in Ball, *Flight,* pp. 222-34; see also there, p. 104. Huelsenbeck's manifesto originally appeared in the Expressionist, later Dadaist, journal *Neue Jugend,* no. 1 (May 1917): 2-3; repr. in Huelsenbeck, *Dada: Eine literarische,* pp. 59-64. In addition, see Arp's aesthetic theory in Arp, *On My Way,* pp. 35-77, especially pp. 39-40, 45, 76-77; the earliest of these pieces dates from 1915. See also Allen, *Literary,* pp. 116-17, 211-50.

7. They were all contributors to *Die Aktion* and *Revolution;* Ball and Huelsenbeck were also involved in the editorial direction of the latter; and Ball and Hennings both contributed to, and were involved in the editorship of, *Die neue Kunst.* See Paul Raabe, *Die Zeitschriften und Sammlungen des literarischen Expressionismus: Repertorium der Zeitschriften, Jahrbücher, Anthologien, Sammelwerke, Schriftenreihen und Almanache 1910-1921* (Stuttgart: J.B. Metzlersche Verlagsbuchhandlung, 1964), pp. 33-37, 46-47, 50. Ball and Huelsenbeck also cooperated in arranging at least two recital evenings in Berlin before the war, one of which was dedicated in name to Expressionism. See Ball, *Flight,* pp. 15-17; Allen, *Literary,* pp. 217-19. Huelsenbeck's summary of their work in Munich in the period is unequivocal: "Ball and I had been extremely active in helping to spread expressionism in Germany...." See Huelsenbeck, "En avant," p. 24. I have already referred to Ball's plans for an Expressionist Theater in Munich before the war. See note 6 above and Ball's essays from the Munich period discussed by Richard Sheppard, "Sixteen Forgotten Items by Hugo Ball from the Pre-Dada Years," *German Life and Letters,* n.s., 29, 4 (1976): 362-69, especially the essay published in the Munich Expressionist journal *Phobus* (1, 3 [April 1914]:

68-74) entitled "Das Münchener Künstlertheater." On Ball and Expressionism, see also Rex W. Last, *German Dadaist Literature: Kurt Schwitters, Hugo Ball, Hans Arp* (New York: Twayne, 1973), pp. 68-88; Gerhardt Steinke, *The Life and Work of Hugo Ball: Founder of Dadaism* (The Hague: Mouton, 1967), pp. 56-120. Arp participated in the second Blaue Reiter exhibition in 1912 and in the "Erster Deutscher Herbstsalon" sponsored by Herwarth Walden and *Der Sturm*. He was also included in *The Blaue Reiter Almanac* and was a contributor to *Der Sturm*. See Peter Selz, *German Expressionist Painting* (Berkeley: Univ. of California, 1957), pp. 213-14; Wassily Kandinsky and Franz Marc, eds., *The Blaue Reiter Almanac,* new documentary ed., ed. Klaus Lankheit (New York: Viking, 1974), p. 193; Raabe, *Die Zeitschriften,* pp. 26, 28, 29.

8. See *Dada* 1, p. [24], German ed.

9. The affirmative note is especially clear, as many students of Dada have noted, in the espousal of primitivism as a vital alternative to the decadence and sterility of modern civilization. See Ball's experiments in a language that would be capable of reaching the subconscious, discussed in Last, *German Dadaist Literature,* pp. 88-101; Rudolf E. Kuenzli, "The Semiotics of Dada Poetry," in Stephen C. Foster and Rudolf E. Kuenzli, eds., *Dada Spectrum: The Dialectics of Revolt* (Madison: Coda Press; Iowa City: Univ. of Iowa, 1979), pp. 51-70. See also the idealization of the life of the lower strata of society in Ball's novel on life among the vaudevillians, *Flametti oder Vom Dandysmus der Armen* (1918), or his critique of positivism and hyper-rationalism and defense of fantasy in *Tenderenda der Phantast* (written 1914-1920, first published in 1967). Similar tendencies inform Arp's poetry from the Dada period, most notably "Kaspar" and Huelsenbeck's *Phantastische Gebete* (1916). See also Hans Arp, "Dadaland," in Lippard, *Dadas on Art,* pp. 23-34; Marcel Janco, "Dada at Two Speeds," in Lippard, *Dadas on Art,* pp. 36-38. Primitivistic elements appear sporadically in Tzara's work, most notably in his pseudo-Negro poems and some of his so-called "lampisteries," e.g., "Note on Negro Art" and "Note on Negro Poetry." But in his case, primitivism was not developed into a clear ideological alternative to the perspective he opposed nor was it integrated fully into his general aesthetic or ideological program. Tzara's pseudo-Negro verse begins to appear in *Dada* with the first issue. See there, pp. [16ff]. The lampisteries referred to are in Tristan Tzara, *Seven Dada Manifestoes and Lampisteries,* trans. Barbara Wright (London: John Calder, 1977), pp. 57-58, 69-70. See also Elmer Peterson, *Tristan Tzara: Dada and Surrational Theorist* (New Brunswick: Rutgers Univ., 1971), pp. 43ff.

10. See Al. Dima and Dan Grigorescu, "Rumanian Expressionism," in Ulrich Weisstein, ed., *Expressionism as an International Literary Phenomenon* (Paris and Budapest: Didier and Akadémiai Kiadó, 1973), pp. 269-86.

11. See Janco, "Dada at Two Speeds," pp. 35-38, where Janco dates his negativistic phase in Dada from ca. 1916-1917. The affirmative or positive phase emerged in 1917/18-1920, i.e., after the departure of Ball and Huelsenbeck. The importance of the latter event for the development of Dada as a movement will be discussed later. See also Verkauf, *Dada,* pp. 26-49.

12. Fritz Glauser describes Ball's leadership qualities in *Als Dada begann,* pp. 25-28. On Tzara, see Richter, *Dada,* pp. 18ff. On Picabia, see Lippard, *Dadas on Art,* p. 165; Verkauf, *Dada,* pp. 164-65. On Serner and Expressionism, see *Die Aktion* 1, repr. ed., ed. Paul Raabe (Darmstadt: Wissenschaftliche Buchgesellschaft, 1961), p. 99; Raabe, *Die Zeitschriften,* pp. 58-60.

13. Huelsenbeck, *Dada: Eine literarische,* p. 7.

14. Huelsenbeck, *Memoirs,* p. 19.

15. Sheppard, "Hugo Ball an Käthe Brodnitz," p. 50.

16. Ibid., p. 52.

17. Ball, *Flight,* p. 57.

18. Ibid., pp. 50ff; Ball, *Briefe,* pp. 51ff, 57; Sheppard, "Hugo Ball an Käthe Brodnitz," pp. 51ff.

19. Ball, *Flight,* pp. 8-9, 17; Huelsenbeck, *Dada: Eine literarische,* p. 13. See also notes 6 and 7 above.

20. Ball, *Flight,* pp. 29ff; Ball, *Briefe,* pp. 48ff; Sheppard, "Hugo Ball an Käthe Brodnitz," pp. 47ff.

21. Huelsenbeck, *Memoirs,* p. 4. See also there, p. 5.

22. See Ball, *Flight,* p. 29; Emmy Hennings, *Ruf und Echo: Mein Leben mit Hugo Ball* (Einsiedeln: Benziger, 1952), p. 67.

23. See Sheppard, "Hugo Ball an Käthe Brodnitz," p. 50; also Huelsenbeck, *Memoirs,* p. 5.

24. See, e.g., Sheppard, "Hugo Ball an Käthe Brodnitz," pp. 50, 55, 56; Ball, *Briefe,* pp. 53, 54, 55, 56, 57.

25. Huelsenbeck, "En avant," p. 23.

26. On Simplizissimus, see, e.g., Richard Seewald, *Der Mann von gegenüber: Spiegelbild eines Lebens* (Munich, 1963), pp. 147ff. On cafe life in Munich in this era, see Paul Raabe, ed., *Expressionismus: Aufzeichnungen und Erinnerungen der Zeitgenossen* (Olten and Freiburg im Breisgau: Walter, 1965), pp. 84-95, 105-6, 108; Franz Jung, *Der Weg nach unten* (Neuwied: Rowohlt, 1961), pp. 69-72.

27. See Raabe, *Expressionismus,* p. 108; Huelsenbeck, *Dada: Eine literarische,* p. 11.

28. Huelsenbeck, *Memoirs,* p. 17; Huelsenbeck, "Dada, or the Meaning," p. 27.

29. Ball, *Flight,* p. 54.

30. Ibid., pp. 56, 60, 61, 65; Ball, *Briefe,* pp. 51, 57.

31. See *Cabaret Voltaire,* p. 5; a translation of this foreword is in Richter, *Dada,* pp. 13-14.

32. See *Die neue Kunst, Die Aktion, Die Revolution,* in Raabe, *Die Zeitschriften,* pp. 34, 47, 50.

33. Richter, *Dada,* pp. 13-14. Tzara echoes this focus on "independence" in Zurich Dada in his "Dada Manifesto 1918." See Tzara, *Seven,* p. 5.

34. Ball, *Briefe,* pp. 54, 55, 57. See also, for a similar view, Huelsenbeck, "En avant," p. 27.

35. Ball, *Briefe,* p. 58.

36. Ball, *Flight,* p. 65.

37. Ibid., p. 63.

38. Ibid., pp. 60, 63; Ball, *Briefe,* pp. 52-53, 55, 57; Sheppard, "Hugo Ball an Käthe Brodnitz," p. 55.

39. Richter, *Dada,* p. 34; Huelsenbeck, "Dada in Zürich," p. 174; Tzara, *Seven,* pp. 5, 112.

40. Arp's theoretical position on Dada did not begin to appear in print until long after the Zürich phase was over. He claims, however, that the memoirs and thoughts recorded in the volume *Unsern täglichen* were written between 1914 and 1954. See also "Dadaland," first

published in 1938, in Arp, *On My Way,* pp. 39ff; also Hans Arp, "Notes from a Dada Diary," in *Transition* 21 (March 1932): 190-94; Hans Arp, "Abstract Art—Concrete Art," in Peggy Guggenheim, ed., *Art of This Century* (New York: Art of This Century, 1942), pp. 29-31. Marcel Janco also did not publish any pronouncements on Dada until after the Zurich phase. See Marcel Janco, "Creative Dada," in Verkauf, *Dada,* pp. 26-49. Of the other programmatic statements made from Dada forums in Zurich and referred to in the group's chronicles, we might perhaps have learned more about the Dadaists' own conception of their art in this phase from the lectures given in the Galerie Dada by Tzara and Janco and from Tzara's introduction to the gallery's second soiree (14 April 1917). But these works have unfortunately not yet surfaced in print. See Ball, *Flight,* pp. 101, 105, 110, 113.

41. Ball, *Flight,* pp. 219-34; Tzara, *Seven,* pp. 1-2; Huelsenbeck, *Dada: Eine literarische,* pp. 29-30. Huelsenbeck's work, which he himself dated "spring, 1916," can be more precisely placed, as the earliest possible date, in the second half of April of that year by a reference in it to having just recently decided upon labeling the group's efforts with the word "Dada." Huelsenbeck, *Dada: Eine literarische,* p. 29. Ball, *Flight,* p. 63, dates the adoption of the word sometime around 18 April 1916.

42. The lecture purports to be an interpretation of Kandinsky's aesthetics; but Ball's tone and language in it make his personal endorsement of Kandinsky's ideas quite evident. Ball begins by painting a critical picture of changes in the contemporary world and in human perspective, which have made necessary a new approach to artistic expression; he stresses features identified in numerous similar Expressionist statements: 1) the loss of God and unity in life as stabilizing principles; 2) the radical alteration in man's perspectives on reality by recent scientific discoveries, new technology, and the nature of life in the modern megalopolis; 3) the loss of individuality and the resultant disorienting anxiety fostered by anonymous existence in the modern era. See Ball, *Flight,* pp. 223-25. Ball's "interpretation" of the new art advocated by Kandinsky also echoes throughout Expressionist positions: 1) the new art turns inward in search of a new harmony; 2) it finds kindred spirits among primitive peoples; 3) it seeks to express the essential, spiritual reality; 4) it is nonrepresentational or abstract in style; 5) it is controlled only by the principle of "inner necessity," which is an expression of the new artists' total freedom. See Ball, *Flight,* pp. 225-28. For similar Expressionist programs, see the representative manifestoes of the movement's spokesmen reprinted in Paul Raabe, ed. *Expressionismus: Der Kampf um eine literarische Bewegung* (Munich: Deutscher Taschenbuch, 1965), especially those by Kurt Hiller, Kurt Pinthus, Kasimir Edschmid, and Alfred Döblin, pp. 25-34, 68-79, 90-108, 114-21. The lecture's close affinities to Expressionist ideas put in meaningful perspective Ball's characterization of it, in a diary entry made shortly after it was given and cited earlier in this chapter, as the realization of "a favorite old plan," i.e., from his Expressionist years. See Ball, *Flight,* p. 104.

43. See Richter, *Dada,* p. 224.

44. Arp, *On My Way,* pp. 48-49.

45. Lippard, *Dadas on Art,* p. 36.

46. As Ball's letters from his Dada phase suggest, his alienation from Pfemfert in this period was probably caused in part by political factors: Pfemfert was still very much committed to left-wing political solutions to Germany's general cultural crisis, while Ball was, of course, pursuing a radically different course by searching for answers in aesthetics and metaphysics. See especially Hugo Ball, *Zur Kritik der deutschen Intelligenz* (Bern, 1919); also Ball, *Flight,* pp. 27ff, 35ff, 38, 45ff, 53ff, 58ff, 68ff; Sheppard, "Hugo Ball an Käthe Brodnitz," pp. 38-39, 41, 44, 51, 55, 56, 57; Ball's Kandinsky lecture in Ball, *Flight,* pp. 223-34; Ball, *Briefe,* pp. 40ff, 63-64, 82.

47. Ball explains "Dada": "Just a word, and the word a movement. Very easy to understand. Quite terribly simple. To make of it an artistic tendency must mean that one is anticipating complications." See Ball, *Flight,* p. 220.

48. Ibid., p. 73.

49. Ball's first exodus was in July 1916, and the second in May 1917. See Ball, *Flight,* pp. 71, 117; Sheppard, "Hugo Ball an Käthe Brodnitz," p. 58, note 72; Ball, *Briefe,* pp. 60ff, 77ff.

50. Ball's physical and emotional frailty, which comes through very prominently and unequivocably in his letters and diary entries of this period, beginning with his conversion from the patriotic fervor of the beginning of the First World War until his death, makes Philip Mann's doubts about the sincerity of Ball's allegedly intense distress over the so-called "magical bishop" episode of 1916 seem to lack perspective and sensitivity. That episode should be interpreted before the background of such earlier reports by Ball as this one from his diary, dated 15 March 1916: "The cabaret needs a rest. With all the tension the daily performances are not just exhausting, they are crippling. In the middle of the crowds I start to tremble all over. Then I simply cannot take anything in, drop everything, and flee." See Ball, *Flight,* p. 57. Mann's reservations concerning Ball's report on the episode are raised in Philip Mann, "Hugo Ball and the 'Magic Bishop' Episode: A Reconsideration," *New German Studies* 4, 1 (Spring 1974): 43-52. For Ball's reaction to the episode and its background, see Ball, *Flight,* pp. 70-71; Ball, *Briefe,* pp. 34ff; Sheppard, "Hugo Ball an Käthe Brodnitz," pp. 56-57.

51. See Ball, *Flight,* pp. 71-72, 80, 82-83; Ball, *Briefe,* pp. 60, 61, 77, 78.

52. Ball, *Flight,* p. 60; Ball, *Briefe,* pp. 62-63.

53. Ball, *Flight,* p. 60.

54. Ibid., p. 43.

55. Ibid., p. 43.

56. Ball, *Briefe,* pp. 62-63.

57. Ibid.

58. Ibid., pp. 53-54; Sheppard, "Hugo Ball an Käthe Brodnitz," pp. 53-55.

59. Ball, *Briefe,* p. 57.

60. Sheppard, "Hugo Ball an Käthe Brodnitz," pp. 55-56.

61. Ball, *Briefe,* p. 61.

62. Sheppard, "Hugo Ball an Käthe Brodnitz," p. 58.

63. Ball, *Briefe,* p. 66.

64. Ibid., p. 69.

65. Ibid., p. 71.

66. Ibid., p. 71.

67. Ball, *Flight,* p. 100.

68, Ibid., pp. 82-83.

69. See Allen, *Literary,* pp. 229-50; Kleinschmidt, Hans J., "Berlin Dada," in *Dada Spectrum,* ed. Foster, pp. 145-74; Meyer Reinhart, et al., *Dada in Zürich und Berlin 1916-1920* (Kron-

berg/Taunus: Scriptor, 1973); Riha, Karl and Bergius, Hanne, *Dada Berlin: Texte, Manifeste, Aktionen* (Stuttgart: Reclam, 1977).

70. *Dada 3* (December 1918): [54-56]. A translation of this manifesto from French to English is in Tzara, *Seven*, pp. 3-13.

71. *Dada 4-5* (15 May 1919): 88-90, 98; *Dada 7* (March 1920): 113.

72. Tzara's manifesto for this evening is entitled "Unpretentious Proclamation." See Tzara, *Seven*, pp. 15-17.

73. Richter, *Dada*, pp. 77ff.

74. Ibid., pp. 226-27.

75. See Verkauf, *Dada;* John Elderfield, "Introduction," in Ball, *Flight*, p. xxxvi.

76. Richter, Arp, Janco, and Huelsenbeck are still represented in the sole issue of Tzara's and Serner's new journal *Der Zeltweg*, which appeared in the "Mouvement Dada" publishing company in November 1919; but all except Arp, who managed somehow to stay on good terms with Tzara, are conspicuously absent from the Paris numbers (February 1920—September 1921, nos. 6-8) of *Dada*. For Arp's continued adherence to Tzara after 1919, see his famous "Declaration" of 1921, in Lippard, *Dadas on Art*, p. 22. On *Der Zeltweg*, see Raabe, *Die Zeitschriften*, p. 113.

77. Huelsenbeck, "En avant," pp. 26, 27, 33. See also Huelsenbeck, "Zurich 1916," p. 614.

78. Schlifferli, *Als Dada begann*, p. 25.

79. Ball, *Flight*, p. 220.

2

The Dadaists and the Cabaret as Form and Forum

Allan C. Greenberg

The hectic and emotion-charged years before, during, and after World War I in Germany beckoned individuals of the political right, center, and left to become involved in political, social, and cultural affairs. Many artists and intellectuals answered the call for political and culturo-political action as well as wartime military participation. Their commitment and involvement led these people to question critically the course their society was taking, the relationship of their society and country to others, the attitudes of individuals within those societies, and their own particular actions. As much as anything else, artists and intellectuals seemed generally convinced that self-criticism, self-awareness, and a sense of humor were essential in coming to grips with the problems that contributed to the advent of war. In addition to the nature of their concerns, the artists and intellectuals sought appropriate media whereby to communicate their questions, analyses, and, to a lesser extent, solutions. If communications with the public had been problematic in a much calmer past, how much more difficult would it be in Germany during a period of change initiated by the forced wartime abdication of William II in November 1918? Moreover, if the construction of new governmental institutions and recovery from military defeat were not enough to be concerned with, what would it mean to also have been involved in understanding and changing the basic value and human substructure of society? A good number of these artists and intellectuals were claiming such a program to be absolutely vital to the construction of a new and effective political system and a society not bound to risk again the disasters of war. Among the critics of society and the proponents of a new future were the Dadaists, whose commitment was to a total transformation of Germany and Germans. Among the media that they identified as potentially effective for their purposes was the cabaret.

The artists and intellectuals who comprised the German, and primarily

Berlin, Dadaist movement were individuals who agreed that they were involved in a "cultural, human political [challenge to] the torpid and superficial [in society]" and who sought freedom for their own creativity and consideration for themselves (and others) as human beings.[1] Creativity for them meant the possibility not only of producing works of art that could be presented to the public without the risk of censorship, especially arbitrary censorship, but also of conducting their lives in the manner each deemed appropriate when this did not infringe upon the rights of any other person. The Dadaists insisted that if Germany and Germans were, in fact, to undergo significant change, then personal freedom should be and, in fact, had to be a right of each individual in society. Thus might the "torpid and superficial" lives led by people formed in molds cast by tradition and authoritarian leadership give way to a new, open, and self-critical approach to human development and growth. The Dadaists advocated a cultural transformation which they thought to be essential to make the political revolution initiated in 1918 become reality. A change in values, the primary concern at least of these artists and intellectuals, would have to occur to render their critique of society valid. In presenting their concerns to society, the Dadaists were involved in various traditional literary and visual media. In addition, they periodically held their own unique public performances from 1918 to 1921. More spectacular and iconoclastic than the better known and accepted presentational forms, these Dada events nevertheless failed to attract people eager to witness a critical and intellectual form of art. Trying to increase the size of their audience, the Dadaists became involved in two further and very widespread media of the 1920s, the literary-artistic periodical and the political-literary cabaret.

These two media, in addition to their occasional events, suited the Dadaists' efforts and had been flourishing in Germany during the first decades of the twentieth century. An enormous number of literary and artistic periodicals were published which, between them, represented every position on the political spectrum.[2] To these the Dadaists added a number of their own, most of which were extremely short-lived. Among them was one that by title was most expressive of the Dadaists' goal: *Everyman His Own Football.* Different Dadaists contributed to a number of other periodicals as well. At the very least, these publications drew the attention of Berlin officials who, upset by the content, confiscated and attempted to censor them. At the same time, the nature of periodicals is such that their impact remains a matter for conjecture. One can only analyze reviews of the periodicals and project leaders' responses. Moreover, as with all forms of art which result in products that may be considered over time, and thus which are not strictly ephemeral, there is room for critics, among other individuals, to skew an audience's perception of such creations. Given *Everyman His Own Football* and the Dadaist concern for individual development and self-determined growth, there certainly would be (and should have been) some skepticism about the impact one might have via such art. It is

not difficult to see that there might be a more significant role to be played by the other aforementioned medium, the cabaret, which was equally prominent during the early twentieth century.

The cabaret, an art form characterized by style or technique as well as by content, had some features especially appropriate for the Dadaist attitude and approach. As a type of theater, the cabaret was a public rather than private art form. The meaning of the cabaret was in the performance and in the accompanying or succeeding interaction of artists with the audience; it was hoped that all in attendance would contribute to the production as a whole. This certainly contrasts with the private and individual reaction to a painting, drawing, collage, or written work, which might subsequently be shared, but only after losing an oftentimes meaningful sense of immediacy. Its relatively intimate nature led the cabaret to be invitational to audience response, rather than to be forbidding as was the traditional theatrical performance. There also seemed to be a virtual requisite in the cabaret that the programs, depending on the views of the artists and the particular situation prevalent in society at the moment, be changed frequently. All these elements made this medium a potentially optimum vehicle for artists and intellectuals who had made a public political commitment. Individuality and spontaneity in action were primary considerations for the Dadaists, and such a stance was rooted necessarily in freedom and the ambiguity that accompanies freedom. Such was the Dadaist challenge to a society dominated by tradition and its related attributes of certainty and security. For the Dadaists, the cabaret seemed to be a particularly congenial medium.

Analyses of the cabaret as a platform for political, social, and cultural criticism have been written during the past twenty years,[3] although no thorough work has been done with regard to any one of the many cabarets that existed. The cabaret does not lend itself readily to scholarly, after-the-fact, analysis. Much was done in the cabaret that was impromptu; much was done that went unrecorded in any way. The style of presentation carried as much weight, in many instances, as the content. In a number of ways, the importance of the relationship between style and content — their essential integrity in the cabaret — was of great importance for many artists and may have attracted the Dadaists especially. Indeed, the Dadaists were more concerned with the process of effecting change than with the survival of their creations, artifacts, presentations, or representations. They certainly were more interested in process than in product. They wanted to affect their audiences and bring about change in people rather than leave something for scholars to analyze and muse over.[4] Dada exhibits, evenings, and presentations were intended to have a public impact. Provocation was a goal, and that goal was, in fact, to influence people in the audience to rethink their own positions on public issues.[5] Given the nature of the cabaret, understanding of it may only be arrived at through a willingness to speculate and draw reasonable conclusions that are rarely, if

ever, provable. (Sophisticated content analyses and the use of carefully devised questionnaires might enable one to develop a more thorough approach to understanding the impact of the cabaret, but the latter is impossible when one considers the cabaret of the past.) Only a conjectural analysis may make it possible to examine Dadaist impact via the cabaret. And while impact may be the more important interest ultimately, we may, nonetheless, reflect on presentations and apparent intent and hypothesize a relationship between the Dadaists in the cabaret and German society in the early 1920s.

While the cabaret in Germany has long been seen as a socio-political phenomenon, it has rarely been examined with regard to both form and content. To understand Dadaist involvement in the cabaret requires considering the cabaret as a political forum in the broadest sense, and not as a medium or art form in and for itself. This approach rests on certain assumptions. The primary assumption is that the Dadaist movement in Germany was of general socio-political significance, regardless of how little impact any specific Dadaist action might have had and regardless of how tongue-in-cheek one regards the Dadaists or how tongue-in-cheek they may have regarded themselves. Another basic assumption to be made is that everything and anything involving words and/or deeds may in some way be considered political in nature. Political issues are not merely the substance of politics in the party-political and/or electoral-political sense. Art also may be considered a political statement or act, regardless of the specific content. Both art and politics are aspects of life, a perspective that seems meaningful in discussing the Berlin Dadaists. In this light, a political discussion is one that focuses on the nature of society's governing norms and values (especially those comprising the political culture, or who determines those norms and values) and on how they are determined. Another assumption is that the Dadaists were concerned with communication, as are all intellectuals and artists who choose to make public statements. The Dadaists' interest in communication specifically involved interaction with the public through their soirees, individual and group acts, and public exhibitions. For example, at the National Assembly in Weimar in June 1918, Johannes Baader distributed the flyer "The Green Corpse on the White Horse Dada"; in November of the same year, he depicted Christ as a "sausage" in the Berlin Cathedral. To these various types of presentation, I add the Dadaists' participation in the Berlin cabaret Schall und Rauch from 1919 to 1921 and their contributions to the magazine of the same name.

The cabaret was a particular medium for expression and communication in which the aforementioned assumptions regarding the Dadaists became reality. Moreover, given that the Cabaret Voltaire in Zurich is usually regarded as the beginning location for the Dada movements in Europe, one might well argue that "... Dada ... started, in effect, as cabaret...."[6] Both form and content were important in the cabaret, and both form and content were important

to the Dadaists' events, actions, performances, and other types of activity. Both deeds and words were vital to the Dadaists, and the cabaret was a vehicle requiring more than words and theory alone.[7]

In one of the few studies that attempts to theorize about the cabaret, Manfred Berger, in his *Kabarett nach vorn*,[8] proposes a "cabaret-typology" from a Marxist perspective. He suggests that there have been essentially four types of cabaret, three of which were middle-class in nature. The middle-class cabarets might (1) identify with the dominant class, becoming essentially amusement theaters that offered cheap conversation and chauvinism to poison the minds of the audience; (2) focus on bourgeois humanism, critical of the ruling elite but not of the social structure of which the elite was a part and without which such an elite could not develop, thereby providing a vent for critical, albeit bourgeois democrats; (3) become a platform for left bourgeois cabaret performers, critical in attitude, who attack militarism and imperialism and claim an affinity with the working class and, although not Marxist, do seek change. And then there was the proletarian cabaret, the only truly politically significant cabaret, where art served as an effective means in the class struggle.[9] The socialist cabaret would serve as an effective weapon in the fight for true social progress.[10] In light of this particular characterization of cabarets, our concern is generally with the left bourgeois humanists, their cabaret performers, and their cabarets — perhaps most fairly a composite of the two. It is in this category, at least during its early years, that the Schall und Rauch may be placed. Given the nature of most cabarets, and in this sense Berlin's Schall und Rauch would be no exception, there is no specific ideology that one might identify. Performers came to participate in the cabaret as a particular medium and not because of its particular stance. The "master of ceremonies" often set the general tone but was seeking, at most, to establish continuity and some basic point of agreement, rather than an overriding ideological perspective. At the same time, the participants in the Schall und Rauch seemed to agree generally on "bourgeois humanist" and "left bourgeois" aims. (A thorough review of a number of the myriad of Berlin journals gives further evidence of this.) In a parallel way, there is no specific ideology that one can ascribe to the Dadaists as a group, except their agreement on the goal of change in the direction of freedom, spontaneity, and humanity.

Indeed, for the Dadaists, as well as for many other cabaret participants, the cabaret seemed an ideal forum. It appeared to be a potentially effective medium for the Dadaists' efforts to relate theory (or ideas) with practice. It provided a medium whereby the desire to communicate effectively could be realized. Active communication and influence might well go hand-in-hand. Given the nature of the cabaret, with its relatively small audience and the possibility for interaction between performer and audience, it seemed that there was a real hope that the concerned performers would be able to ascertain that communication did, in fact, occur. The Dadaists were joyfully satisfied when

people were agitated by their presentations,[11] a reaction that could be relatively easily assessed in the cabaret, where audience and artist were in direct contact and where the latter was always prepared to interact with the former. Thus, the cabaret provided a means for bridging the gap between artist and public, a major concern that had been identified and acknowledged by artists and intellectuals just prior to World War I, in Germany and elsewhere.[12]

It is in relation to these several concerns that the Dadaist might well be described as an artist-intellectual, an individual seeking to take up a leadership role. His art would be an instrument to define or influence the society, challenging the old order and offering or suggesting a new vision for the future. Such an individual may turn to a medium outside his own specialty in order to propagate his own views regarding society. Thus, a visual artist like George Grosz might participate in the cabaret, as did his Dadaist cohort, photographer John Heartfield. The artist-intellectual had the opportunity to address a wider and more varied audience than that to which he might ordinarily have been exposed had he relied exclusively upon his special medium. Furthermore, by means of the cabaret and live interaction with the audience, the artist-intellectual was immediately able to ascertain that what he was trying to communicate was more or less correctly perceived or interpreted. Perception was crucial: for these people all presentations had some direct or indirect meaning for society in general.

In the German cabaret, social and political issues effectively infused the content of literary parodies, short skits, and songs which comprised the primary presentational forms. Transcending specific social and political issues, artist-intellectuals attempted to attend to attitudes, values, basic beliefs, and the guidelines affecting decision making and public, as well as private, acts. A concern with values is, in fact, a concern with politics or with man as a political animal. And a concern with the relationship between ideas, values, and convictions on the one hand, and with reality or practice on the other, helps determine where change must occur if people and the society in which they live are to be transformed. In this sense, the Dadaists, in all they did, were involved with politics, or with a political approach to life, a decision-making, value-based "politics of life."[13] Accordingly, their goals included bridging the gaps between the artist-intellectual, who is specifically concerned with critical reflections on society, and the public, and between theory (ideals, values, beliefs) and practice (action, politics). They sought to influence change by educating people to inner freedom.[14]

As a forum for the artist-intellectual, the cabaret had some particularly strong features. Usually involving a small, sometimes intimate physical setting, the cabaret allows an immediacy in the relationship between performer and audience, including and often encouraging interaction between them. Changing performances in the cabaret, whether in emphasis or in total content, allows the maximum possibility for relating value concerns to a constantly changing

reality of events and issues of the day. At the same time, daily program changes need not necessarily occur. In some ways, the cabaret performer is akin to a political cartoonist in daily and weekly periodicals. The specific focus for the cartoonist may change, while the underlying value commitment and the context in which the specific work is placed remain more or less constant from one representation to the next. As a form, given the essential relationship between content and performance, the effective cabaret is also special as a medium. As an institution, the cabaret is ongoing and continues to exist, given adequate audiences and financial support. Meanwhile, the content changes, as does the manner in which the content is presented. As a result, and perhaps of special significance for the Dadaists, opposed as they were to the reification of concepts and standards, there is constant change in the cabaret and, as a result, there is the need for members of the audience constantly to change their perceptions. The artist-intellectual as cabaret performer raises challenges to existing views, stagnation, and stultification. He demands that the individuals in the audience review their concerns and attitudes. The emphasis here becomes change as well as permanence, with appropriate and responsible transformation and individual growth being the crucial, continuous human component. The Dadaist, as artist-intellectual, sought changes in people and not just in works of art; in particular, he sought changes in attitudes and in the resultant perceptions of events and developments in society.

The cabaret setting and its particular artist-audience relationship also seemed to minimize the effects of traditional audience preconditioning. Such preconditioning often occurs as a result of the reading of art and theater critics, who are often seen by readers as holding the keys to understanding works of art, whatever the form or content. With the audience confronted directly in the cabaret, as in all Dada events, the role of the critic as intermediary between artist and audience is virtually eliminated. The task of bridging the gap between artist and public is thereby simplified. Traditionally, that gap, one result of the views held by both artist and audience, especially the ideas of the artist as rebel and of the intellectual as a negative and destructive critic of society and its values, has been bridged by the critic, the "authorized" interpreter of the artist's work for the nonartist. Given this situation, the artist-intellectual has at least three options: he either accepts the situation, or he withdraws his work from the public realm, or he fights back against the critic. Kurt Schwitters, although only peripherally related to the Berlin Dadaists, was a representative of basic Dadaist concerns and an exemplar of the "proper" Dadaist approach to the critic. In waging a war against critics, Schwitters fought for the individual's right not to be imposed upon by another nonartist. He specifically condemned the influential Paul Westheim, editor of *Das Kunstblatt*,[15] and critics in general, in his "Artist's Right to Self-Assertion."[16] For the Dadaists to be effective, as for all cabaret performers and, in fact, all artists, lines of communication with their audiences had to be open. For change to be possible

in society, the blinders imposed on audiences, and people generally, by preconceptions had to be removed. The cabaret, among other media, was bound to become a vehicle for both the destruction of old conceptions and the presentation of new ideas.

These predominantly general remarks have established a context for a more specific consideration, within Dadaist limits, of the cabaret Schall und Rauch, one of the most prominent Berlin cabarets of the 1920s. Several Dadaists became involved, to varying degrees, in this cabaret and the associated periodical of the same name. Walter Mehring, in particular, was the key representative of the Dadaists in the Schall und Rauch, which became for him a major forum. *Schall und Rauch* was also supported at various times by contributions from George Grosz, Raoul Hausmann, and John Heartfield. As a cabaret, the Schall und Rauch was a middle-class institution, and the politics of the cabaret tended very definitely to be of the generalized form taken by the "politics of life." Its ultimate concern involved values and attitudes, rather than specific foci of a much more limited nature. This meant that there would be a broader potential audience base from which this cabaret could draw.

As a critical socio-political forum, cabarets like the Schall und Rauch highlighted satirical representations of current modes of life, especially those that might appropriately be termed bourgeois. Social mores, entertainment values (especially those embodied in the amusement theater and nudity cult of the day), economic attitudes, and political developments were depicted and derided through satire, parody, and mimicry.[17] At the same time, the two successive directors of Schall und Rauch asserted that a focus on daily events and cultural values was only one part of the cabaret's program; it was not to be too heavy. Rudolf Kurtz, the first director, suggested that there was to be a dash of intellect, but not so much that it would prove disturbing, especially to a predominantly middle-class audience.[18] What would be too much is something that could be decided only with reference to the kind of audience that was desired and expected. An analysis of the nature of the audience would depend on a great deal of speculation about the type of people attracted to the cabaret, Berger's typology notwithstanding. Other considerations would include the potential conflict between the need for a continuing audience and the critical nature of the performers/artist-intellectuals.

On the basis of the evidence considered, it does not seem that any performer, certainly not from among the Dadaists, toned down his work or compromised his values in order to become more palatable for the cabaret's audience. However, it seems that "strident" and "offensive" individuals were not generally involved in the "better" cabarets, namely (in this context), the bourgeois humanist and left bourgeois cabarets.[19] Walter Mehring, for one, was perhaps the least aggressive individual associated with the Dadaists and was the only one among them to be a regular cabaret participant. More critical and left-oriented cabaret observers shunned Mehring as the "house-poet of

'good society'."[20] Mehring rooted his satire in an essentially cosmopolitan and intellectual anarcho-communism, more or less in accord with that proposed by Peter Kropotkin. Mehring was one of the many artist-intellectuals who publicly condemned the war just past and greeted the revolution and the "new" bourgeois democratic values introduced as a result of that revolution.[21] Going beyond many of his non-Dadaist compatriots in the cabaret, Mehring was apparently convinced of the need for destructive criticism before there could be any truly positive developments in Germany, as he explained in one song: "The revolution was a dream!"[22] Although perhaps wishing to accept Expressionist author Leonhard Frank's assertion that *Man is Good,* and that the German people had finally recognized the folly of supporting war and its causes, Mehring, among others, was led in the postwar years to more pessimistic appraisals. He saw man revealing himself, even in peacetime, as a wretched beast, as he had been both during the war and when seen as contributing to the causes of war. Neither war nor "revolution" had brought about the kind of transformation that Mehring and the other Dadaists would like to have seen.

It is clear that for Mehring and the other Dadaists, as well as for kindred spirits among the cabaret performers and artist-intellectuals more generally, the characteristics of man had to be identified and accepted before they could be changed. Individual self-indulgence and disregard for others, stemming from a materially oriented individualism, heightened human tragedies in the postwar years: profiteering was the aim, and politics could be damned.[23] As Mehring put it: "Only an efficient rat-catcher / Is of value in this lousy world!"[24] The rats had to be pointed out before one could reeducate them. Effective individual concern was impossible, for the Germans lacked meaningful compassion and real intellect. Moreover, they seemed incapable of acting independently. Again, Mehring condemned those whose actions were rooted in a conformity inspired by ethics based upon slogans drawn from a heritage that was superficial and justified only by tradition and authority. "One thing above all else: Be united, united, united with regard to the metaphysical sense[of] *Wash with Luhns, Because everyone's doing it.* But don't let yourself be terrorized by any minority."[25] Moreover, no inner existence was necesary for the individual, so long as he had his "[sentimental, romantic] film and a [popular] Ullstein novel,"[26] for these were as intense as his upbringing and education would allow him to be. Would men, and especially Germans, trained in freedom, ready to obey when signalled to do so,[27] ever be able to distinguish themselves from beasts?[28]

Mehring condemned poets and intellectuals who nourished themselves "only on air.... You're everything except heroes — you who have wings instead of claws, and are useless in this world."[29] They might comment and criticize, but they could see no way in which those words might become reality in a material, institutional, or physical sense. Their reality was almost exclusively an intellectual or spiritual one, and they could not envision themselves in the

process of creating anything but an intangible and essentially ephemeral representation of reality. The lack of connection between theory and practice in the sense of concrete realizations, as well as continual theoretical pronunciamentos with no translation into deeds, had virtually allowed World War I to occur. The Socialist view that the bonds between members of the working class would take precedence over the call of chauvinism was a theoretical position that had no basis in reality. In a parallel vein, Raoul Hausmann wrote mockingly of the tragedy that occurred, as might be expected, when performers mixed intellect and muscle, and one dominated the other. Here, the unfortunate outcome resulted from the intellect exercising complete domination,[30] in contrast with a world wherein intellect and theory were separated from action and, in fact, to a considerable extent manipulated by it. In some situations, intellectual considerations might be the more important, but the complete suppression of either might well be expected to have disastrous consequences. All the explicit and implicit criticisms in the concern about a gap between theory and action, between the intellect and the physical nature of man, were justified. The criticisms were focused on a persistently authoritarian German society, wherein one of the strongest traditions was that of philosophical idealism and too strict a dichotomy of private morality, thought, and conscience, on the one hand, and public action on the other. Such criticisms were leveled at Germans and the wartime opponents of Germany who had criticized her form of government and sought to influence a change in her ways, but were not themselves exemplary models of putting ideals into practice. Woodrow Wilson was taken to task, along with the ways of the Weimar government in general, for continually compromising, a telling point made in Mehring's "Simply Classic," presented on the opening program of the Schall und Rauch as a parody of the *Oresteian Trilogy* being staged upstairs.[31]

Although the primary concern of the Dadaists was the value structure that would have to be altered to effect substantial change in Germany, there were specific criticisms of the current situation that were pointed and significant. Both Mehring and his cabaret colleague Klabund asserted that the revolution that had occurred was, at best, at an end;[32] at worst, it had been only a dream.[33] But what did such comments mean? For those making them, it implied a call either for a new revolution or for an effort devoted to making the so-called revolution a reality and realizing, in practice, the effective and functioning institutions about which people had spoken when the Republic was officially proclaimed. In 1918 and 1919, such comments were early acknowledgment of the weakness and even bankruptcy of the new German government. This might easily be recognized in retrospect, or understood as assertions made by a radical left. But do not allegations of this nature take on greater significance when made by individuals not committed to a specific party-political viewpoint? If effective, such criticism would point out the gap between postulated ideals and socio-political realities. Then would remain only the problem of shifting from

the sphere of the intellect to the sphere of politics and practical action.

The Weimar Republic is more lyrically criticized in Mehring's "Miss Irene, the amazing tatooed lady." In the course of portraying a strip show, he juxtaposed elements to challenge both the entertainment proclivities of the postwar years and the amusement cabarets and attitudes about the Republic. The focus of Miss Irene's song becomes "Germany: ... in the middle, in golden armor / The young republic, the sacred republic / In my sphere of innocence!" There follows a call for silence, and the band plays "Deutschland, Deutschland."[34] Is this the innocence of the prostitute or the prostituting of innocence? Certainly action by the Allies at Versailles had exacerbated matters for the proclaimed Republic, but this alone was not the root of Germany's problems. Neither Miss Irene nor the Republic was innocent. Whatever the reasons for such a judgment, it was part of an effort to express dissatisfaction and disappointment with the existing state of affairs. Similar suggestions appeared in Mehring's "Simply Classic," wherein the author noted the acceptance of aristocratic values by the newly arrived president of the Republic.

The Dadaist "philosopher" (Dadasoph) Raoul Hausmann summarized the criticisms of man and the Weimar Republic in an essay entitled "Kabarett zum Menschen." A cabaret number was envisioned in which man, as a concept, would be mechanically organized and represented by tiny pieces of paper with the word "soul" printed on them. Man's life was to be depicted as a senseless process of "profiteering, murder, adultery, birth, marriage, and death." The audience would clearly have to understand the uselessness of it all. Then the 10,000 pieces of paper with the word "soul" on them would be thrown out over the audience.

> Whoever still does not understand that man is really like this, and nothing more — an empty absurdity: well, I'm sorry for him! He receives none of the blessings of our age and culture ... liver sausage, smoked goose with champagne — nope, for his punishment he must immediately become President of Germany!"[35]

Was there any adequate way to move individuals out of the "thoroughly balanced psyche of bourgeois existence and into the center of humanity?"[36]

Short-lived as it was, from 1919 to 1924, the Schall und Rauch was a significant phenomenon of the hectic postwar years. For the participants it was much more than an economic venture. The cabaret developed, at least in part, out of an optimistic appraisal of Germany's potential. Despite comments deriding the so-called revolution, hope persisted for a time that something new and different would be made of Germany. All those who resisted joining the revolutionary left kept up their criticism through the defeat of the Communists. The question arises as to whether or not we are dealing with the satirical, political-literary cabaret. Involvement in socio-political concerns does not necessarily mean propagandizing activity. At the same time, lack of commitment to specific action supports a view of the artist-intellectual as an ivory tow-

er idealist who, because his own reality is in fact a secure one, is not attuned to socio-economic realities. In such a setting, the artist-intellectual will tend to maintain a primarily intellectual involvement, until he too has been confronted with economic problems and with socio-political restrictions that frustrate any hopes for change. In light of these suggestions, one could condemn the cabaret, along with every individual who took a public stand that did not positively support the Weimar Republic, as being responsible for the failure of democracy in Germany.[37] In any case, critical artists and intellectuals did not seem to affect more than a small minority of Germans in a positive way and are given far too much importance by intellectuals who assert the contrary. They certainly had some effect, as attested to by the continuing existence of the cabaret and support for various periodicals, but there is hardly sufficient basis for ascertaining its specific nature.

A study of the Dadaists, of the cabaret, and of reactions to them does point out some of the reasons for the failure of the Weimar Republic. Intellectuals concerned with contemporary problems dealt with those problems in a rarefied, although nonacademic atmosphere. Kurt Tucholsky, who as a satirist and critic was also active as a songwriter for Schall und Rauch and other cabarets, asserted that the cabaret was an ideal political forum, forcing members of the audience to come to grips with inadequacies in their views of reality and their attitudes towards social and political issues. The goal was for the individual to affect society, rather than to subordinate or accommodate himself to it. It is by virtue of this that the cabaret's public might take a stand: recognizing the failings of men should lead to action, not withdrawal.[38] But the chasm between the artist-intellectual and the public was not bridged by the German cabaret;[39] the traditional separation persisted, and the nature of cabaret reality tended to deny its own goals. Questions were raised and left unanswered, contemplated but never resolved — perhaps too serious to be translated into action with the accompanying risk of failure, a very un-Dadaist posture. Karl Wilcynski, in the December 1920 issue of the magazine *Schall und Rauch,* pointed to the elaborating, hesitating, and twisting that went on when some individuals sought to prevent their words from being metamorphosed into effective acts.

> Your hopes are fair,
> Saying nothing;
> Your deeds are pallid,
> Risking nothing.
> But your words are
> Full of thunder, lightning, and wind.
> If I grasp one little word gently,
> Beads of sweat form on your brow.
> You quickly retreat
> Daring nothing,

You elaborate, hesitate, and twist
Saying nothing,
Until the poor little word
Drops to the ground, dead.
Idiot![40]

In his appraisal of the French cabaret, German theater critic Alfred Kerr asserted that its function was to offer freedom for the human spirit.[41] Such a contention would certainly be applicable to many of the cabarets in Germany, particularly insofar as participation in the cabaret appealed to the Dadaists. Those individuals performing in and writing for the cabaret, those criticizing bourgeois values, adherence to authority, and traditionalism, tried to help create intellectual breathing space for themselves and others.[42] Put most simply, this seems to have been part of an effort to enable everyone and each generation to create his or its own reality. Here, as in so many ways in Germany, the spirit and intellect were critically free. But here, too, the chasm between the intellect and action, between theory and practical reality, precluded one of the vital necessities in the realization of revolution: the involvement of the total human being in the transformation of society.

In such a situation, it was left for the politicians to compromise the Republic away. Ideals were unrealized, men were not changed, and Weimar Germany was an experiment that failed before going much beyond an idea. In the cabaret, the spotlight focused upon some of the reasons for that grave failure of the post–World War I era. One major problem lay in the fact that cabarets such as Schall und Rauch and artist-intellectuals such as the Dadaists were ultimately hardly more significant than the cabaret's name, "Noise and Smoke."[43] The Dadaists' and the political cabarets' challenge to a familiar pattern of life, a challenge which brought fresh air and freedom, meant for most of their audience the fire behind the smoke and ultimate devastation, not the opportunity to build anew.

Notes for Chapter 2

1. Udo Rukser, "Dada. (Aufführung und Ausstellung im Salon Neumann, Kurfürstendamm)," *Freie Zeitung* (Berlin) 28, 8 May 1919, clipping in the Bauhaus Archive, Berlin.

2. For a discussion of this issue and relevant references, see Allan C. Greenberg, *Artists and Revolution: Dada and the Bauhaus, 1917-1925* (Ann Arbor, 1979), e.g., pp. 6-7, 12.

3. E.G., Helga Bemmann, ed. *Mitgelacht — dabeigewesen: Erinnerungen aus sechs Jahrzehnten Kabarett* (Berlin, 1967); Manfred Berger, *Kabarett nach vorn: Zu einigen Problemen der Kabarettbewegung* (Berlin, 1966); Jürgen Henningsen, *Theorie des Kabaretts* (Ratingen, 1967); Rudolf Hösch, *Kabarett von gestern nach zeitgenössischen Berichten, Kritiken und Erinnerungen,* Vol. 1, *1900-1933* (Berlin, 1967); Rainer Otto and Walter Rösler, *Kabarettgeschichte: Abriss des deutschsprachigen Kabaretts* (Berlin, 1977); George Zivier, Hellmut Kotschenreuther, and Volker Ludwig, *Kabarett mit K: Fünfzig Jahre grosse Kleinkunst* (Berlin, 1974).

4. Friedhelm Lach, "Schwitters Evening," presentation at the Tenth Annual Meeting of the Mid-West Art History Society, Univ. of Iowa, Iowa City, 1 April 1983.

5. E.g., Karl Riha, *Moritat-Song-Bänkelsang: Zur Geschichte der modernen Ballade* (Göttingen, 1965), p. 75.

6. "The Cabaret Tradition," *Times Literary Supplement,* 6 March 1969, p. 245.

7. See Greenberg, *Artists and Revolution,* e.g., pp. 26, 27-28, 79-80, passim.

8. See note 3 above.

9. Berger, *Kabarett nach vorn,* pp. 13-17.

10. Ibid., pp. 5-6.

11. E.g., Hans J. Kleinschmidt, "Berlin Dada," in Stephen C. Foster and Rudolf E. Kuenzli, eds., *Dada Spectrum: The Dialectics of Revolt* (Madison: Coda Press; Iowa City: Univ. of Iowa, 1979), p. 170.

12. See Greenberg, *Artists and Revolution,* e.g., p. 4.

13. See Kleinschmidt, "Berlin Dada," p. 170, and Greenberg, *Artists and Revolution,* ch. 7.

14. E.g., Werner Schumann, *Unsterbliches Kabarett* (Hannover, 1948), p. 96.

15. "Tran Nummer 16: Das Leben auf blindem Fusse," *Der Sturm* 11, xi-xii (December 1920): 152-53.

16. "Selbstbestimmungsrecht der Künstler," *Der Sturm* , 10 x (January 1920): 140-41.

17. E.g., Harald Drach, "Weihnachten! (Hab Sonne im Herzen!)," *Schall und Rauch* 1, iv (December 1920): 1-2; Walter Mehring, "Die Reklame bemachtigt sich des Lebens," *Schall und Rauch* 1, vi (February 1921): 12; Hellmuth Krüger, "Du riechst nach Spree...," *Schall und Rauch* 1, vi (February 1921): 14.

18. Rudolf Kurtz, "Captatio Benevolentiae," *Schall und Rauch* 1 (December 1919): 1; Hans von Wolzogen, "Die erste Seite," *Schall und Rauch* 1, i (September 1920): 1.

19. E.g., the case of Erich Weinert, in Bemmann, *Mitgelacht — dabeigewesen,* pp. 285-86.

20. Eugen Ortner, "Vorwort," in R.A. Sievers, *Runter mit dem Zylinder! Ein politisches Cabarett-Programm* (Leipzig, 1924), p. 5.

21. Hösch, *Kabaret von gestern,* p. 185.

22. "Es war ein Traum, " in, among others, Walter Mehring, *Das Ketzerbrevier: Ein Kabarett-programm* (Munich, 1921), pp. 86-87.

23. E.g., Klabund [Alfred Henschke], "Rag 1920," *Schall und Rauch* 1, i (September 1920): 11: "...Slender people, paunchy people, the director at rehearsals dance / And even the honest profiteer dances, when he's made a killing! / ... / Politics go to the devil, we dance the Two-Step or the Tango..."; Raoul Hausmann, *Die Schieberger* (drawing), *Schall und Rauch* 3 (February 1920): 9; Kurt Tucholsky, "Wenn der alte Motor wieder tackt...," in Helga Bemmann, ed., *Immer um die Litfassäule rum: Gedichte aus sechs Jahrzehnten Kabarett* (Berlin, 1968), pp. 110-11, performed in the Schall und Rauch cabaret by Paul Graetz, December 1919.

24. "Der Rattenfänger von Hameln," *Neues Ketzerbrevier* (Cologne-Berlin, 1962), p. 24.

25. "Wasche mit Luhns," *Schall und Rauch* 1, ii (October 1920): 12.

26. Hellmuth Krüger, "Berliner Liebe," *Schall und Rauch* 1, vi (February 1921): 4.

27. Walter Mehring, "Dressur," *Neues Ketzerbrevier*, pp. 17-19.

28. Friedrich Holländer, "In der Bar," refrain cited in Klaus Budzinski, *Die Muse mit der scharfen Zunge: Vom Cabaret zum Kabarett* (Munich, 1961), p. 105, performed in the Schall und Rauch, December 1919.

29. Walter Mehring, "Der Rattenfänger von Hameln," *Neues Ketzerbrevier*, p. 26.

30. Raoul Hausmann, "Percival und Klytemnästra," *Schall und Rauch* 4 (March 1920): 10-11.

31. Walter Mehring, *Schall und Rauch: Einfach klassisch! Eine Orestie mit glücklichem Ausgang* (Berlin, 1919).

32. Klabund, "Berliner Weihnacht 1918," in Budzinski, *Muse mit der scharfen Zunge*, p. 117.

33. Walter Mehring, "Es war ein Traum," *Das Ketzerbrevier*, pp. 86-87; also see Klabund, "Vater ist auch dabei," in his *Chansons: Steit- und Leidgedichte* (Vienna, 1930), p. 29, third verse.

34. *Schall und Rauch* 2 (January 1920): 8.

35. "Kabarett zum Menschen," *Schall und Rauch* 3 (February 1920): 1-2.

36. Walter Mehring, "Telepathomanie," *Schall und Rauch* 1, iv (December 1920): 19.

37. E.g., see Gordon A. Craig, "Engagement and Neutrality in Weimar Germany," in *Literature and Politics in the Twentieth Century, Journal of Contemporary History,* Vol. 5, ed. W. Laqueur and G.L. Mosse (New York and Evanston, 1967), pp. 49-63; a summary of such arguments and counterarguments appears in Harold L. Poor, *Kurt Tucholsky and the Ordeal of Germany, 1914-1935* (New York, 1968), pp. 81-86.

38. Wolfgang Müller and Konrad Hammer, eds., *Narren, Henker, Komödianten: Geschichte und Funktion des politischen Kabaretts* (Bonn, 1956), p. 61.

39. Johannes Günther, "Kabarett: Gedanken zu einem Gespräch mit Blandine Ebinger," *Eckart* 3, x-xi (July/August 1927): 329-30.

40. Karl Wilczynski, "Blond und blass," *Schall und Rauch* 1, iv (December 1920): 4.

41. Heinz Greul, *Bretter, die die Zeit bedeuten: Die Kulturgeschichte des Kabaretts* (Köln and Berlin, 1967), p. 121.

42. E.g., see Max Herrmann(-Neisse), "Berliner Kabarett," *Die neue Schaubühne* 4, iii (March 1922): 74.

43. Kurt Tucholsky, *Ausgewählte Briefe, 1913-1935,* in M. Gerold-Tucholsky and F.J. Raddatz, eds., *Gesammelte Werke,* Vol 4 (Reinbeck near Hamburg, 1962), letter of 7 November 1919 to Hans Erich Blaich, p. 74; also see Tucholsky, "Worte und Taten," a poem first published under the pseudonym Theobald Tiger in *Die Weltbühne,* 22 April 1920 in *Gesammelte Werke,* Vol. 1, pp. 635-36.

[This essay is a revised version of a paper entitled "The Dada Cabaret as a Political Forum," which was presented at the Tenth Annual Meeting of the Mid-West Art History Society, University of Iowa, Iowa City, 31 March 1983.]

Schwitters: Performance Notes

Friedhelm Lach

The rediscovery of Kurt Schwitters coincided with the discovery of the "event" character of art — with Pop, neo-Dada, happenings, and performance art. It is this event character of art that allows me to present Kurt Schwitters, who died in 1948, as the father of contemporary art currents and events and to celebrate him as the ingenious inventor who did in the 1920s what became, in the long run, the representative art of the twentieth century.

Even if this critical acclaim is often repeated in general terms by artists and critics alike, art historians and critics are right to smile and to feel uneasiness towards these Merz events. Schwitters' art events and artifacts are a flush of ideas; they are open art forms and outspokenly antisystematic. There are enormous difficulties in gaining a thorough analysis or understanding of his art. But even if one talks about the ambiguous image, one experiences the refreshment of his art as soon as contact is made with it. He is named the bourgeois Dadaist, the hidden provocateur, the abstract painter of naturalistic portraits, the concrete poet who wrote Schlagertexts, fairy tales, and travel reports, a performance artist of the living room, a preacher of consequence who liked fragmentation. You rightly name him a romantic classic of the avant-garde.

Nevertheless, one feels his magnetic attraction for the artists of our time — to musicians inspired by his "Urlautsonate," to art performers, theater groups, directors of museums, and teachers — all trying to transform Schwitters exhibitions and evenings into art events for the public. In a sense, it is proof of the event character of Merz art. Every sensible interpreter feels that the general idea of Merz is the constant happening of creativity. It is essential for this proclaimed creative practice to stimulate, awaken, and deautomatize the public and to incite its activity. To be Merz art is to be a catalytic agent. Therefore, the performance is written into the concept and character of all of Schwitters' articulations. In this sense, and with the help of my analysis of performance, I

will share a new, essential perspective for the understanding of Merz and, in general, of Dada.

Everyone will agree that the most obvious documentation of this concept can be cited from the manifesto for and explanations of the Merz stage (*Merzbühne*). Schwitters formulated: "[The *Merzbühne*] can't be written, or read or heard, it can only be experienced in the theater. Everything is perceived as a complex sensual happening, full of gestures, movements and sounds."[1] But the principle of creative events that leads to a whole new life practice is visible in all actions and creations of Schwitters — in his art, literature, theory, and critiques, even in his life. At the end of his life he wrote about it humourously:

> One needs a medium. The best is, one is his own medium. But don't be serious because seriousness belongs to a past time. This medium called you yourself will tell you to take absolutely the wrong material. That is very good because only the wrong material used in the wrong way will give you the right picture, when you look at it from the right angle, or the wrong angle.[2]

If we take the event character of art seriously and ask about the right and wrong angles of Schwitters research, we have to make a complete turnaround of our research techniques. The event is open-ended, a process in time and context. The structure is replaced by serial technique; attention is paid to the psyche, to behavior, to pretentions and intentions (which are touchy, or forbidden in so-called "scientific research"). In the following, I will use the analysis of a poem performance to demonstrate the value of this perspective for the interpretation of Schwitters' art, and I will further try to clarify the concept of Merz performance.

Interpretation of the Poem "Wall" ("Wand")

In 1922, Schwitters composed a poem with 37 repetitions of the word "wall," in singular and plural forms, with an introductory verse where he counted from one to five. To compose something with walls is different from composing something with brick or stone constructions. Brick is a basic building element, while a wall is an archetypal phenomenon, a functional appearance, a mythic object, and a very personal experience for everyone: for the prisoner, the climber, the architect, the ghetto inhabitant. Walls are built, in a certain sense, by everyone for the purpose of hiding and protecting, a result of ignorance and wisdom. But mainly, we detect walls when we stand in front of them, when they hinder us in our development. They then become signs of authority. We feel the pressure building inside to overrun them, to undo authority. The performer standing in front of his audience feels this wall as well, and he reacts against it. Schwitters' poem is significant because it is a model that shows how to build, how to break, and how to live with walls. He erects, in his poem, the

authority of walls and then he overcomes them; he puts the *power of creativity* against them. The poem has to be performed and acquires its meaning only by the performance. This becomes obvious in observing the performer's step by step preparation.

Schwitters makes clear to his public that the main element of construction is not the brick, a basic element, but the wall, a complexity which has, in various cultures, different meanings and connotations. A wall is a means of control for the organizer, of construction for the engineer, of imprisonment for the prisoner, of challenge for the climber, of business for the painter, of information for the informer, of work for the carpenter. At the beginning of the poem, every one of us may have a different understanding and picture of the wall. The performer has to take this into account and must overcome this complex multisignificance by gesturing or by declamation. He has to create his own stage, his own environment; he has to actualize this complexity, the wall, for himself and for the public; he must emotionalize and personalize the "experience" of the wall. Instead of a quick intellectual grasp of the word, he has to aim at a deeper existential understanding, at the archetypal, prenatal comprehension.

This begins with the first occurrence of the word, and it should be reinforced by further occurrences. By repeating the word 27 times in the singular and ten times in the plural, he establishes the serial technique employed in the poem. The repetitions should not be robotlike and mechanical (they do not serve the logical explanation). The series produces a process of variations — a process that makes the word more meaningful and that leads to and builds up to a different and deeper meaning. At the same time, one realizes the inner processes that lead to deeper understanding. The series, "wall wall wall wall," projects the images and experiences, "walls." The multitude of walls is verified by the plural "walls." The identification with the multitude of walls becomes a frightening perception. The inner world realizes the impact of such images and the effect of this emotionalization.

The technique of serial repetition offers a rhythmical stabilization, refers to the breathing rhythm, and establishes the ego as a balancing instance, to the exuberance of the emotionalizations. The affirmative naming of the wall as dialogue partner to the ego reestablishes the inner forces of creativity. The artistic recovery progresses with inventive and playful use of the sound. The poem produces, in this interpretation, a creative practice that is established at the end. The need for it is shown with the beginning of the poem, which includes a countdown from five to one. The wall series starts immediately thereafter. The pressure that is provoked by the counting is released at the end. Countdowns normally lead to explosions or important new events. This new process, heralded by the counting, is obviously the practice of creativity. In a time of severe restraints after the First World War, when everything was destroyed, the constructive energy of creativity was essential for new building.

In the performance of a work, the space in which it happens changes to a stage. The stage makes all actions and messages formalistic. For instance, a demonstration in the street projected to a stage becomes a play with stage character. The intimate admiration of the lover becomes a theater gag. All actions on the stage become plays of actions. The performance of the poem "Wand" creates, in this sense, a model that shows how to live with one's wall and how to overcome it with creativity. The performance as a catalytic event is integrated into all of Schwitters' creations, literary and visual. Everything he did was part of a life practice based on creativity and, as a result, everything he could touch became performance art material. The concept of Merz performance states that everything can become material for a performance. It is very important, then, to analyze the conceptualization of this performance.

The Concept of Merz Performance

In " 'Aus der Welt Merz,' a dialogue with interventions of the public," (1923) Schwitters describes an example of his performance art. Performing are artists (poets, painters, sculptors, musicians, actors), the public, and the stage. Each of these elements is described as "material" of the performance and produces by itself forces and tensions that all become destructive if they are not controlled by a leader — the so-called "Merzer," who takes all these forces and reactions into account and creates an art performance. He produces the stimulus that leads to feelings of provocation and tension, so that the public wants to change the situation (in this example, he puts the lights out; the public wants light and demands it back). The Merzer has a preconceived concept of the perceptions and reactions of the public. He knows the catalytic effects of darkness and of closed rooms; he knows the dramatic emotional developments from uneasiness to laughter, to unpleasantness, to anger, to shock (terrified state), to horror, to panic. Each situation has this possibility of a latent rise to chaos. Essential is the engagement, the reality and the totality of action.

What is important for the definition of Schwitters' performance art is the non-thought, the non-information in his analysis, which gives us a possibility to systematize his concept. Although stating continuously the availability of all materials (including human beings, emotions, nonsense, and banalities) and the intuitive and improvisational action and reaction of the performer vis-à-vis his public, one does not find any precise thought about control, discipline, and their means (that is, the limiting effects and political and social implications of this artistification). This is the more astonishing considering that he foresees and provokes the very active behavior of the public and hopes to change this public into a Dadaistic society.

The ideal public that Schwitters dreamt of was an unconditioned public, without any conception of what was to follow and without pretentions, preoccupations, prejudgments, codifications, norms, clichés, automatizations — a

public that did not know the great restraints of redundancy, of repetition, of predetermined expectations. This proclaimed openness and self-connectedness are integral to the performer and the public. Yet, how can one determine the non-thought of Schwitters and his control mechanisms in order to get a more systematized view of his performance concept?

Since ancient times, the control of time is pursued by three elements: (1) the control of rhythm, (2) the order of certain limited actions, and (3) the regulation of repetitive cycles. Control in ancient times started with purification (with washing hands or with exercises of faith). The Dadaistic cleaning of the human psyche is done by laughter, which is often provoked at the beginning of actions by unexpected happenings.

The discipline of the rhythm is established by the great technician of rhythm, the Merzer. He structures, manages, and modifies all visible, acoustical, and sensual happenings. It is not important for him what performance material is used; anything has equal value. Important is his rhythmic control. The Merzer can use the alphabet and determine, with the rhythmical use of consonants and vowels, the time sequences. Important for him is the uninterrupted control of time. In order to achieve the continuous use of his public's time, certain limitations are necessarily introduced. He, the controller, works with repetitive cycles and serial techniques, and he limits his responses and messages to a limited set of information and orders. The public's reaction, or a limited variety of reactions, is counted on as an evaluation of the event — by applause (positive reaction), by contra or boo calls (negative reaction), or by silence (tension reaction). These reactions, used for time control as well as psychological data, show how deautomatization by new ideas, or by their unusual combination, provoke contradiction and tension. Unpleasant reactions become, in this sense, highlights of art performances. Applause is not considered as a judgment of the performance but as part of the performance. Schwitters pretends that the Merzer can control everything, but he avoids mentioning forbidden reactions by the public in this performance concept (for instance, to converse with each other, to play musical chairs, to watch television, to sleep, to drink alcohol, to tell fairy tales, to pass gas). All activities that hinder control are non-thoughts.

There are other specifics not mentioned; for instance, the specificity of the rhythms. We find countdown rhythms — 4, 3, 2, 1 — that provoke attention at the beginning and establish control, or we find marching rhythms — 1-2, 1-2, 1-2, 1-2 — that especially help to control action, by proposing a rhythm program. The public will constantly be tested by the Merzer as to whether it is attentive and responsive to determine the nature of the control. Schwitters states that actions, behavior, and rhythms should be an integral part of the psyche.

As the action of a mother caring for her child can only proceed from her feelings for her child, so can the performer act only out of his feelings for his

audience. Each movement, each rhythm is controlled by his psyche. The time control is identical to a body control. The movements and gestures respond to the total behavior. The disciplined body and the artistic use of all articulating body parts are the operational context for the smallest reaction and gesture. The Merzer must inform his public of the right posture and behavior for achieving successful, meaningful, and energized gestures. This explains the combination, during Schwitters' Merz evenings, of performances, dances, and sport exercises. The disciplined body and mind are essential parts of these high-powered performances. In this rhythm control, one also finds a negative principle — the principle of non-laziness, non-contemplation. It is forbidden to have a negative approach to activity and creativity. What is wanted is the optimum of sensuality within the moment — the total use of forces, the intensification and the exploitation of the psyche, the elementarization and serialization of the life process. High speed is considered the highest effect (probably a Prussian heritage). It is easier to control time if it is segmented into tiny elements and if the speed is regulated. The identification with this control process is not possible by means of rationalization, but by emotionalization and spontaneous identification. Schwitters refused to use drill techniques, and all mechanical or technical time controls, but instead worked with psychological controls to evoke a natural and organic experience of rhythms.

The control of the Merzer is based on optical and mechanical laws. Schwitters describes his *Merzabende* as very spontaneous events composed of individuals with various backgrounds. In the beginning, he asks them to assemble before him or around him. Immediate eye contact is important. He does not talk to the mass, but to the individual. He differentiates between the individual responses and addresses each single participant, coercing him with words, gestures, and eye contact. His position in the center, from where he can best control and observe, is significant. The best place of control is there, where he oversees everything with one glance and to which place everyone's eyes are directed (Schwitters' compositional concepts in his pictures reflect these control stands as well as his performance arrangements).

Direct effect, closeness, and direct communication are essential for the total participation of the public. Schwitters' proclaimed aim for his art — complete liberation and personal inventive creativity — is based on these highly visible control concepts. It became necessary for Schwitters to propose and to create organizations that could promote the new creativity. With the help of his friends, he organized his *Merzabende* and wrote a manifesto and articles in which he proposed a *Merzbühne* (Merz stage) as a permanent institution for Merz performances. This whole artistic articulation and production, his work and life, were considered by him as catalytic agents and examples of the Merz world he promoted. The montages, collages, assemblages, texts, poems, and critiques were all self-imposed tests of his own potential as creator. The vigor and spontaneity of his creations were expressed in ever new explorations of

numerous disciplines. He expected to project his creative drive to his public. Creativity is power. It changes the world, not by political means, but by provocation, deautomatization, identification, obsessionalization, and invention. Creativity is perceived as such a power that it transforms the whole world.

Merz Creativity Projects the Merz World

Today we find the recipes, the scores, of Merz events by looking to the visual and poetic heritage of Schwitters. It represents a test of our own ability to invent and to become creative. Merz signals a challenge in a double sense — to become sensitive to the Merz approach and to constitute ourselves as an object of analysis. The art event provokes us to compare and mirror personal data with global and cosmic phenomena, and with collective, archetypal experiences of the mythic world. Merz is based on the experience of the totality and the connectedness of ourselves with this totality. Schwitters emphasizes the counterbalancing effects of art. Whenever the individual or society is unbalanced, for instance by too much emphasis on politics or consumption, the art event becomes treatment for the disease. Only the connection with total knowledge of world functions allows this therapeutical viewpoint.

The participants in a Merz performance were never forced into a participation that they were unable to perform. What was essential was their natural capacity for the action and gesture performance. The influence of the Merzer is not directed to distract, to push away, to mask, to give a role, to veil, to exclude individuality. On the contrary, he wants to produce, through his leadership, a life practice of truth, real experience, and rituals and operations of truth. The creative human being is the projected result of these interventions. Merz stresses the technique to produce creators of disciplines.

Notes for Chapter 3

1. Kurt Schwitters, *Das literarische Werk,* 5 vols., ed. Friedhelm Lach (Cologne, 1973), vol. 5, p. 42.

2. Ibid., p. 387.

4

Arp's Chance Collages

Jane Hancock

The two groups of collages that Jean Arp called *Collages Arranged According to the Laws of Chance* and *Torn Papers* form a small part of his total artistic production, yet they are important because they arose from his innovative concept of chance in art. He made the first group sometime during the Zurich Dada period, between 1916 and 1919. He took up the idea of chance again in 1930, creating *Papiers déchirés* by tearing, rearranging, and pasting his own earlier drawings and prints. In 1932, he also began to use uniform black paper for torn collage elements and, in the 1940s, he added the effects of stained and wrinkled papers — *Papiers froissés* — to his repertoire. He continued to make torn paper collages from time to time for the rest of his life. I will examine the special attractions that the "law of chance" had for Arp in the Dada period and in the early 1930s. The first part of this chapter will look at the two periods in terms of the historical circumstances of Arp's artistic career. In the second part, I will suggest some sources for his interest in chance.

Arp's chance collages stand near the beginning of the twentieth century's fascination with artistic process. Their stature was recently recognized in a monographic exhibition, with a substantial catalog, organized by the Musée National d'Art Moderne, Paris.[1] Until recently, the chance collages, together with the uses of chance by Tristan Tzara and Marcel Duchamp, tended to be considered as expressions of Dada nihilism. Yet, Arp's numerous statements about these works reveal their affirmative philosophical significance. Some scholars of German literature have provided thoughtful analyses of Arp's intent and achievements in using chance and nonsense in his poetry — notably Leonard Forster, Rudolf Kuenzli,[2] and Harriett Watts. In the introduction to her *Chance: A Perspective on Dada,* Harriett Watts set out some basic points that are also useful in examining the chance collages. She noted the necessarily limited role of chance operations in any work of art and recognized the Dadaists' use of chance as a weapon against logic. They welcomed chance

combinations of verbal or visual materials as part of their creative process, and they used these to place their art in a "state of indeterminacy" aimed at "thwarting all reasonable expectations."[3]

Hans Richter's famous anecdote about Arp dropping discarded scraps of paper, discovering them later, and pasting them down "in the pattern that chance had determined" is accepted in most of the nonspecialist literature on Dada as an adequate explanation for the *Collages Arranged According to the Laws of Chance*.[4] If Arp did make collages that way, they are not the same ones that we know today. The limits on his use of chance are apparent on examination of the works, as Alastair Grieve and William Rubin have pointed out.[5] In both the *Collages Arranged According to the Laws of Chance* and the *Torn Papers*, the homogeneity of collage elements, the care with which they are pasted, the absence of overlapping, and the harmonious balance of the compositions attest to Arp's deliberate aesthetic choices. These are chance works not in any extreme sense, but because Arp tipped his usual balance between accident and deliberation more than usual in the direction of accident, and because the works that resulted express visually the *idea* that some of their features are not deliberately determined. Being rather closely related to more controlled images, they jar our "reasonable expectations" and speak eloquently about a dialectic between accident and intention.

Arp also welcomed accidents and chance discoveries when making sculptures and reliefs — this is documented in his essays, the titles he gave, and reports of his working methods. But paper can be manipulated far more spontaneously than wood and plaster, and it was the medium he preferred for dealing with chance. In the torn edges and scattered compositions of his collages, Arp most clearly posed new questions about the respective roles of accident and control. In fact, the chance collages are so different from the main body of his work that it is tempting to regard them as antithetical to it. The swelling organic curves of his reliefs and sculptures convey the burgeoning forces of life, while the chance collages seem to admit destruction and chaos into the realm of art.[6] Awareness of Arp's philosophical background, however, permits us to establish a more accurate and profound relationship between his use of chance and the biomorphic style of his other works. Chance represented an important facet of the forces of nature which for Arp altogether superseded human logic.

The several known *Collages Arranged According to the Laws of Chance* are composed of roughly rectangular elements on blank background supports. Two collages have cleanly cut paper elements: *Elementary Construction "According to the Laws of Chance"* and *Squares Arranged According to the Laws of Chance* (figs. 4-1, 4-2). The collage in Basel is composed of gray and black quadrilaterals on a tan support. The *Squares* collage in New York is also on a tan background, but is coloristically more complex, with five black

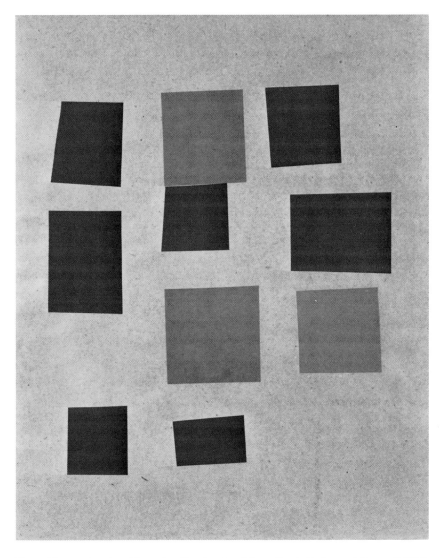

Figure 4-1. Jean Arp, *Elementary Construction "According to the Laws of Chance,"* 1916
 Collage, 40.4 x 32.2 cm.
 (*Kupferstichkabinett Basel*)

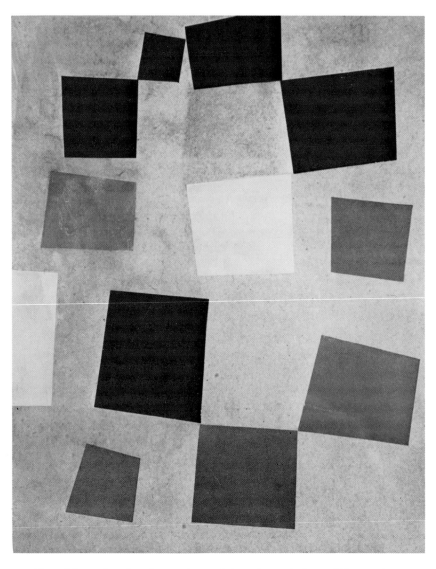

Figure 4-2. Jean Arp, *Squares Arranged According to the Laws of Chance*, 1917
Collage, 33.5 x 26 cm.
(*Museum of Modern Art, New York, gift of Philip Johnson*)

elements, two yellow, two green, and three gold. Arp used colored paper for the green shapes, but the other colors were painted on tan or buff paper before they were cut. Other chance collages have shapes with irregular torn outlines. One, with light-colored elements on a dark support, is in a private collection in France,[7] while another well-known example is a second collage in the Museum of Modern Art, also known by the title *Arrangement According to the Laws of Chance* (fig. 4-3). It is the largest of the group. The elements are of dark blue and cream-colored fibrous paper, and the support is gray.[8]

There is close continuity between these chance collages and other geometrical collages and paintings Arp made in the Dada period in response to the example of Sophie Taeuber's rigorously geometrical work. The other geometrical works may be divided into two types. One employs slightly asymmetrical, four-sided planes stacked above and beside each other, against a margin of blank background, as if to suggest precarious tectonic structures (fig. 4-4): the second type displays perfectly regular rectangular divisions of the entire surface plane, eliminating the figure-ground relationship.[9] The geometrical compositions with backgrounds are more closely related to the chance collages, with the main differences being that in the chance works, the elements are not contiguous, nor are they given more visual weight at the bottom of each image.

Far from having the effect of physical constructions, the chance compositions disregard weight and gravity. In each case, the elements tilt one way or the other, and their corners refuse to line up; they look as if they floated apart from a firm alignment. Those with torn elements give an especially strong feeling of irregularity and accident. Tearing up paper collage elements also gave Arp a means of rejecting his fine arts training and the emotional expressiveness permitted by virtuoso paint handling. Each collage implies, but does not quite adhere to, a horizontal and vertical grid. The deviation from a presumed grid subtly suggests a disintegration of order, and the impression of weightless drifting in space provokes thoughts of an infinite number of other possible formations. In the context of the Dada rebellion against bourgeois values, Arp seems ironically to say that works of art are worth no more or less than random arrangements. By extension, the collages question all ordering and regulating activities.

It is difficult to assemble precise evidence of the original circumstances, chronology, and intellectual climate surrounding the *Collages Arranged According to the Laws of Chance.* Most of our information about the Zurich phase of the Dada movement comes from memoirs written by the Dadaists many years later, with benefit of hindsight, a degree of nostalgia, and a tendency to mythologize. Although Arp, Richter, and Huelsenbeck eventually wrote about the great importance of chance in their Dada activities, none of Arp's chance collages was reproduced or mentioned in the Dada magazines or other early commentaries (such as Ball's diary, Huelsenbeck's *En avant Dada,* or Alexander Partens's article on Arp in the *Dada Almanach*). None of the

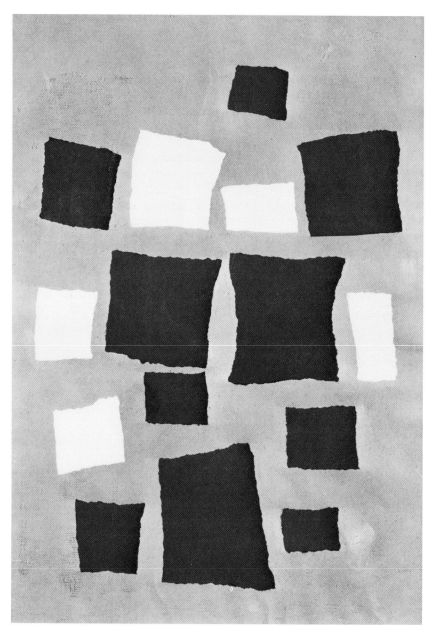

Figure 4-3. Jean Arp, *Arrangement According to the Laws of Chance*, 1916-1917
Collage, 48.5 x 34.7 cm.
(*Museum of Modern Art, New York, gift of Philip Johnson*)

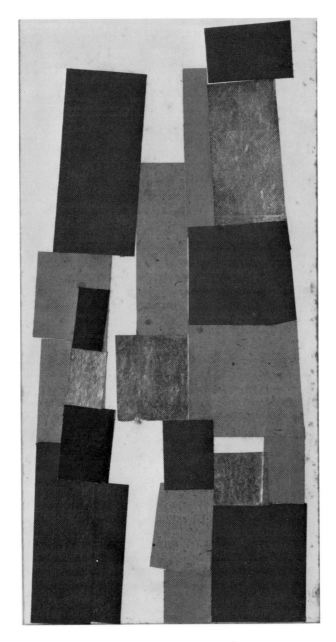

Figure 4-4. Jean Arp, *According to the Laws of Chance,* 1916
 Collage, 25 x 12.5 cm.
 (*Kupferstichkabinett Basel*)

collages can be identified in early exhibition catalogs, although they cannot be ruled out because Arp did not give his works individual titles at the time; he simply identified collages as *Papierbild* or *Tableau en papier.*

There is no verifiable account of how Arp made these collages. In 1932, the Surrealist Georges Hugnet offered an explanation that is more plausible than Richter's story about Arp dropping scraps of paper to the floor: "He also experimented with chance, putting on a piece of cardboard pieces of paper that he had cut out at random and then colored: he placed the scraps colored side down and then shook the cardboard; finally he would paste them to the cardboard just as they had fallen."[10] It is easy to imagine Arp using such a method as a starting point, but deliberately refining the chance arrangements before pasting the pieces down. Nevertheless, there is no record of Arp confirming either account of his method.

The Dada chance collages are traditionally dated 1916 or 1917, although the one in a private Paris collection was published by Hans Richter as dated 1920.[11] The period from late 1916 through late 1917 is indeed the most probable, because that was when Arp was most occupied with rectilinear shapes and compositions, and because by 1916 the Dadaists were already using chance effects in poetry. As Alastair Grieve has shown in his article "Arp in Zurich," his works in several geometrical and symmetrical manners can be assigned to 1916 through 1917 on the basis of exhibition records, reproductions and woodcuts in magazines and other publications, and commentaries on Arp's work by Ball, Tzara, and Huelsenbeck.[12] Further confirmation of Arp's concern with geometrical order is found in letters he sent to Hilla von Rebay between February 1916 and March 1917. In one undated letter, he declared that his new works were "essential examples of real life. And so all leads to architecture. The complicated personal will disappear." Members of Arp's circle frequently compared geometrical abstract art to architecture.[13] On 8 November 1916, Arp wrote to Rebay that "now, every day, I would gladly relinquish the joy of dividing up the world into orderly planes for your presence."[14]

Arp's interest in rectilinear composition apparently lingered into 1918 and perhaps 1919, the likely dates of a series of collaborative *Duo-Collages* executed with Sophie Taeuber.[15] It is not impossible that Arp continued to make chance collages but, by 1918, his primary style was biomorphic. Consequently, he was less likely to be involved in a subtle dialogue between chance and geometrical organization.

When Arp wrote retrospectively about his work with chance, he stressed the *Torn Papers* of the 1930s; only two passages deal specifically with the Dada collages. They confirm the visual observation that the *Collages Arranged According to the Laws of Chance* are counterparts of geometrical compositions inspired by Taeuber:

In Dec. 1915 I met Sophie Taeuber in Switzerland; she had already freed herself from traditional art. First we suppressed everything in our work that smacked of playfulness and good taste. We even felt the personality to be burdensome and useless, since it had developed in a world now petrified and lifeless.... Alone and together we embroidered, wove, painted, and pasted static, geometrical pictures. The results were rigorous and impersonal constructions of surfaces and colors. Any element of chance was eliminated. No spot, no rip, no fiber, no inaccuracy was to perturb the clarity of our work. For our paper pictures we even discarded scissors, which we had originally used but which all too readily betrayed the life of the hand. We used a paper cutter instead. In our joint work ... we humbly tried to approach the pure radiance of reality....

I continued to develop the collage, eliminating all volition and working automatically. I called this working "according to the law of chance." "The law of chance," which comprises all other laws and surpasses our understanding (like the primal cause from which all life arises), can be experienced only in a total surrender to the unconscious. I claimed that whoever follows this law will create pure life.[16]

The second paragraph above must be understood in terms of the nearly religious definition of chance that Arp held after World War II. As we have seen, the known *Collages Arranged According to the Laws of Chance* show no such elimination of volition and total surrender to the unconscious. Arp did not even use the word "chance" in his titles of the Dada period. And the notion that chance was a principle encompassing all other laws of life is one to which Arp became especially attached later in life.[17] The essential information about the Dada period in the statement above is that his work with chance grew out of the experience of strictly controlled composition. The other passage in question reiterates this point:

In 1915 Sophie Taeuber and I painted, embroidered, and did collages; all these works were drawn from the simplest forms and were probably the first examples of "concrete art." These works are Realities, pure and independent, with no meaning or cerebral intention. We rejected all mimesis and description, giving free rein to the Elementary and Spontaneous. Since the arrangement of planes and their proportions and colors seemed to hinge solely on chance, I declared that these works were arranged "according to the law of chance," as part of an inexplicable reason, of an inaccessible order.[18]

Here it appears that Arp's thinking about chance did not arise in an abrupt rejection of the controlled methods inspired by Taeuber, but as an awareness that chance and deliberate choice are actually closely related within artistic creativity.

Arp published no theoretical writings during Zurich Dada, and the essays, manifestoes, and commentaries by his associates give no direct information about the *Collages Arranged....* In fact, they made few references to chance at all. Tzara's most forthright statements about chance, including his famous instructions for making a poem by drawing words out of a bag, did not appear until late 1920, when he was already in Paris.[19] But, as Stefanie Poley has suggested in her monograph about Arp's sculpture, the Zurich group need not

have articulated a theory of chance while they used its effects.[20] Some of the time they dealt with the idea of chance under the rubric of "simultaneity." In *En avant Dada,* Huelsenbeck cited simultaneity as one of three fundamental principles of Dada, along with bruitism in poetry and new materials in art.[21] For the Dada poets, simultaneity was the combination of disparate sounds, words, phrases, and typefaces with disregard for logical discourse or representation. They worked with accidental effects — effects that were not logically determined — from 1916 on in "simultaneous poems" (unrelated lines read by several voices at the same time), poems with extraneous interpolations, sound poems, and poems filled with incongruous phrases and images. According to Richter, they also used free associations of words and phrases in conversation.[22]

The sources of Dada simultaneity were Cubist collage, the Simultaneous Disk paintings of Robert Delaunay, Apollinaire's *Calligrammes* and his inclusion of banal phrases in other poems, the simultaneous poetry of Henri-Martin Barzun, and the Futurists' compression of time and space in art and use of bruitism and free typography in poetry.[23] Tzara acknowledged his visual as well as literary sources in a "Note pour les bourgeois" appended to his simultaneous poem "L'Amiral cherche une maison à louer" in *Cabaret Voltaire* (July 1916). He especially credited Cubist art with stimulating "the wish to apply the same simultaneous principles to poetry."[24] In a 1922 letter, Tzara again mentioned visual art as a stimulus to the poetic techniques of combining disparate elements, which he developed around 1916:

> In 1916 I tried to destroy literary genres. I introduced into my poems elements [which would have been] judged unworthy of being there, like newspaper phrases, noises and sounds. These sounds (which had nothing in common with imitative sounds) were supposed to be the equivalent of the research of Picasso, Matisse, Derain, who used in their paintings different subject matters. Already in 1914 I had tried to take away from words their meaning, and to use them in order to give a new global sense to the verse by the tonality and the auditory contrast. These experiments ended with an abstract poem, "Toto-Vaca," composed of pure sounds invented by me and containing no allusion to reality.[25]

The train of thought that led Tzara from Cubist collage and fragmentation of the object to his abstract sound poem must have resembled the one that led Arp to the *Collages Arranged According to the Laws of Chance.* While Tzara was developing his simultaneous poetry in the first half of 1916, Arp was making a series of abstract collages, compositionally derived from Cubism and Futurism, incorporating found elements such as commercial labels, printed papers, and paper doilies.[26] Arp, Tzara, and their friends must have discussed these intrusions of the everyday visual world into art in terms of Tzara's *principes simultanés.* Also, around 1916, Arp's poetry turned from the serious, sometimes apocalyptic themes of the collection *der vogel selbdritt* to a verbal collage of mundane elements, using a method that openly embraced chance. His descrip-

tion of this poetry resembles Tzara's 1922 letter; both Dadaists rejected sentimentality and the idea of the masterpiece, and used found verbal elements from the base genre of advertising:

> Words, sayings, sentences which I selected from newspapers and especially from their advertisements were in 1917 the foundations of my poems. Often I shut my eyes and chose words and sentences in newspapers by underlining them with a pencil. I called these poems *Arpaden.* It was the beautiful Dada time when we hated and reviled the chiselling of work, the distracted look of the spiritual wrestlers, the titans, from the depth of our hearts. I twisted and turned easily, improvising words and sentences from words and sentences chosen from the newspapers.... We thought to penetrate through things to the essence of life, and so a sentence from a newspaper gripped us as much as one from a prince of poets.[27]

Thus, the Cubist collage aesthetic, which raised mass products of daily life to the level of art, encouraged Tzara and Arp to assign equal value to the newspaper ad and the poet laureate. The next step in their adventure was to raise the possibility of a corresponding equality between the activities of chance and artistic will.

Only one *Arpad* poem survived. The advertising phrases and other clichés are easy to recognize:

> WORLD WONDER send cards immediately here is a piece of pork all 12 pieces put together pasted down flat should give the distinct lateral form of an arched edge astonishingly cheap buys everything
>
> no 2 the robber effective safety apparatus useful and happy made of hardwood with explosion device
>
> no 2 the dwarfs are attached to their pegs they open the dovecotes and thunder claps
>
> the daughters of elysium and radium fasten the rheinwhirls into bouquets...[28]

Comparison between "Welt Wunder" and the *Collages Arranged...* shows obvious differences — one is a satirical conjunction of art and daily life, the other is purely abstract — but a similar underlying principle. Neither resulted from uncontrolled accidents or expresses extreme disorganization. Their success depends on using accident to depart from a familiar formula, but leaving enough of the pattern so that it is immediately spotted: the advertisement and the horizontal-vertical grid. The formula awakens a set of expectations in the observer, but chance interventions prevent them from being fulfilled. The effect of this "thwarting of expectations," for the Dadaists at least, was an exhilarating sensation of freedom, a realization that there are endless possibilities of structuring the world beyond what is usually deemed reasonable.

In the 1920s, Arp put aside the expression of chance in art. When he turned to it again with even greater intensity, he created collages without a clear

geometrical structure. A work like the *Cut Woodcut* collage of about 1939 is a much stronger expression of disorder than the previous chance collages (fig. 4-5). Pieces of an earlier print are cut up and disposed so as to destroy the meaning of its plantlike forms. A *Torn Drawing* from 1942 illustrates another method Arp used to negate previously established order (fig. 4-6). Scraps of an ink drawing from ca. 1919–1922 are rearranged so that many of their lines meet, as if to propose a new identity for an old work. Yet, at the same time, fragments of lines at the outside of the composition are disturbingly isolated.

Most of the *Torn Papers* collages were pasted more neatly and arranged less arbitrarily than the 1939 example. The torn elements of a given work are homogeneous, made from either fibrous black paper or a single print or drawing. The colors are limited to black on white. Instead of approximating squares, most of the collage elements make rough, irregular curves. The collages of black paper particularly show evidence of Arp's aesthetic judgment, both in shaping the elements and composing with them. The beauty of shapes such as those in the so-called *"First Torn Paper, 1932,"* and their similarity to forms in Arp's reliefs at the time attest to his deliberation (fig. 4-7). The composition of this and other *Torn Papers* is delicately balanced (fig. 4-8). However, the balance is fluid and dynamic; it has nothing to do with the grid of the *Collages Arranged...,* and it appears more nearly fortuitous. Arp included chance by tearing his papers before considering how to compose them, then arranging them improvisationally. Pierre Bruguière recounted Arp's own explanation of how he made *Torn Papers*:

> He covered the entire surface of the support with paste, and placed or distributed the pieces of paper upon it. With a light touch of his fingers he could slide them along on the sticky surface until they reached the precise spot where the piece of paper attained a fullness of meaning. Then he removed the excess paste by cleaning the collage. In some collages, looking at them close up, one sees the background is shiny from paste, on others one sees traces left by pieces of paper painted with gouache, as they were moved around.[29]

This description is consistent with Arp's method of composing his reliefs, as recorded by Marcel Jean.[30]

In contrast to Arp's vagueness about the *Collages Arranged...,* he left detailed commentaries about the origins of the *Torn Papers*. It is clear that this new way of working amounted to a breakthrough; as Stefanie Poley has indicated, it was only now, in 1930, that he fully came to grips with the intellectual and spiritual importance of using chance in art.[31] The *Torn Papers* began in an artistic crisis, but went on to assume metaphysical importance:

> The search for an unattainable perfection, the delusion that a work could be completely finished, became a torment. I cut the papers for my *collages* with extreme precision and smoothed them down with a special sandpaper. The slightest loose thread or fiber was intolerable to me. The iniest crack in a bit of paper often led me to destroy a whole *collage*. This frenzy ended in a tragedy when I was asked to exhibit some old *collages* I had done in

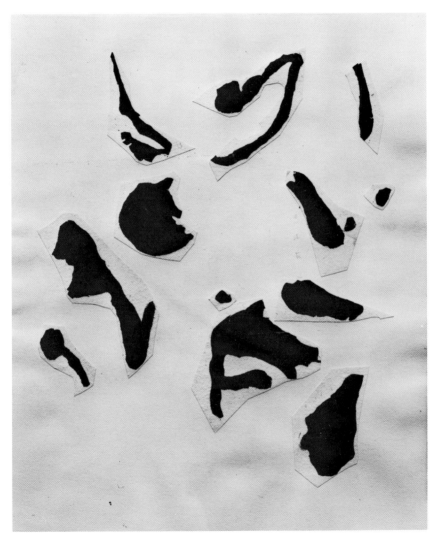

Figure 4-5. Jean Arp, *Cut Woodcut* (*Bois découpé*), ca. 1939
Collage, 24 x 19.9 cm.
(*Private collection, Switzerland*)

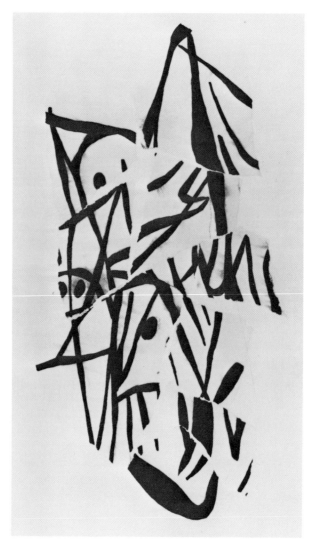

Figure 4-6. Jean Arp, *Torn Drawing,* 1942
 Collage, 27.3 x 15.5 cm.
 (*Foundation Arp: Clamart*)

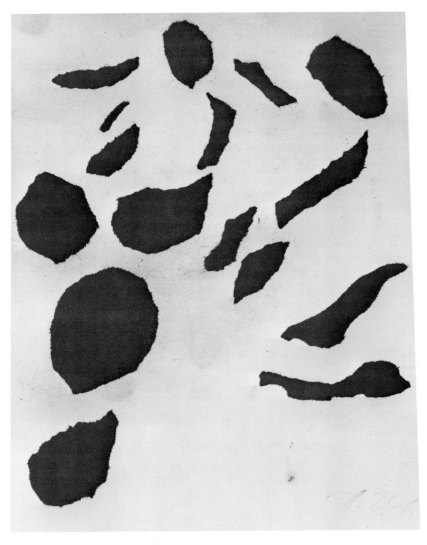

Figure 4-7. Jean Arp, *"First Torn Paper, 1932 "*, 1932
 Collage, 28 x 22 cm.
 (*Private collection, Switzerland*)

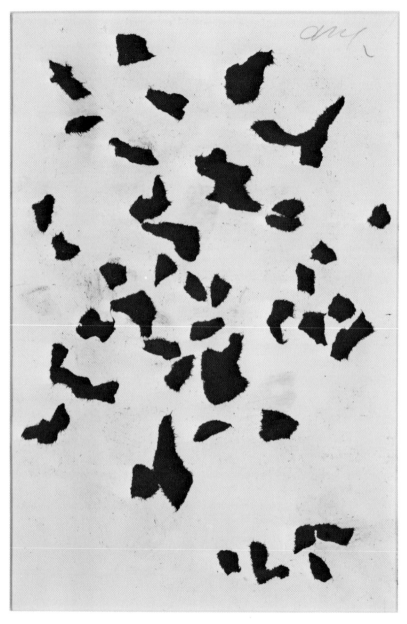

Figure 4-8. Jean Arp, *Torn Papers,* 1933
Collage, 27.1 x 19.7 cm.
(*Kupferstichkabinett Basel*)

collaboration with Sophie Taeuber. This accident taught me the true meaning of perfection and finish. The word perfection means not only the fullness of life but also its end, its completion, its finish, and the word "accident" implies not only chance, fortuitous combination, but also what happens to us, what befalls us. We brought down the *collages* from the attic where they had been exposed for years to heat, cold, and dampness. Some of the papers had come unstuck, they were covered with spots, mold, and cracks, and between paper and cardboard blisters had formed that looked more loathsome to me than the bloated bellies of drowned rats. When after many weeks of confusion I had calmed down a bit, I began to tear my papers instead of cutting them neatly with scissors. I tore up drawings and carelessly smeared paste over and under them. If the ink dissolved and ran, I was delighted. I stuck my *collages* together with a wad of newsprint instead of pressing them carefully with blotting paper, and if cracks developed, so much the better; as far as I was concerned, it made my work more authentic. I had accepted the transience, the dribbling away, the brevity, the impermanence, the fading, the withering, the spookishness of our existence. Not only had I accepted it, I had even welcomed transience into my work as it was coming into being. These torn pictures, these *papiers déchirés* brought me closer to a faith in things other than earthly.[32]

The occasion of this crisis and reappraisal must have been the Surrealist-dominated Exposition de Collages at the Galerie Goemans, Paris, March 1930. The catalog lists three collages by Arp, two untitled and one called *Papiers collés au hasard.* This is the first instance I have been able to find in which Arp published a title incorporating the word "chance." Louis Aragon's prefatory essay in the catalog, "La peinture au défi," mentions that Arp "attempted to paste papers according to chance."[33]

At the time of the collage exhibition, Arp was already withdrawing from the Surrealist group with which he had been closely associated in the 1920s. He kept contributing to their group exhibitions, but he publicly deplored their leaning toward illusionist art, their political preoccupations, and their personal quarrels.[34] He ignored Breton's condemnation of abstract art, joining the organizations Cercle et Carré and Abstraction-Création. As he drew away from Surrealism, Arp was reflecting on his experience of Dada in Zurich. This train of thought shows in his art, his poetry, and in the theoretical statements that he published around this time. Thus, the *Torn Papers* arose in a context of a general reappraisal and reaffirmation of original Dada principles and practice. For the first time since Zurich Dada, he tore collage elements by hand; when he chose preexisting drawings and prints as his raw material, they were Dada works in the biomorphic style he had used from 1917 to 1922. The reliefs and the sculptures that he began making in 1930 likewise reflect the abstract, biomorphic style he had developed in Zurich, in contrast to the recognizable everyday objects in his 1920s reliefs.

Arp's autobiographical poem "Strassburgkonfiguration," first published in 1932, singles out the Dada movement and its meaningful nonsense as one of four essential parts of his personal history.[35] Two other "configuration" poems that appeared in 1932 rework earlier material in a method similar to the collages of torn prints and drawings, as Aimée Bleikasten recently noted.[36] The

"wunderhornkonfiguration" is based on "verschlungene knaben blasen das wunderhorn," and the "kunigundulakonfiguration" on "die edelfrau pumpt," both poems from *der vogel selbdritt,* which he probably wrote just before the Dada movement.[37] Each "configuration" contains the source poem intact in one stanza and recombines its words in a series of variations in several other stanzas. The resulting new images appear to arise accidentally from an arbitrary system of reordering the words, yet many of them are intriguing and vivid: "the night has waxen feet and bags full of stars on soft fingers / ... the stars swim through the sky with bags full of boys / the burning flowers swim on soft fingers."[38] As in the *Torn Papers* collages, Arp destroyed the order and meaning of an old work and reconstituted its parts in constructions where chance played a large role. Beauty and meaning seemingly arise of their own accord in the new compositions — new life from old Dada works.

The statements and essays Arp published between 1929 and 1932 praise the original Dada spirit as the true source of art, in contrast to the limitations of constructivist styles and the blind alley of Surrealism. He emphasized three aspects of Dada most strongly, and these were the aspects he also revived in his art: abstraction, nature and natural processes as the correct model for art, and rejection of logic. For Arp these were not simply stylistic options, but were necessary on ethical and spiritual grounds: "dada is the basis of all art. dada is for the senseless which doesn't mean non-sense. dada is as senseless as nature. dada is for nature and against 'art.' dada is direct like nature and tries to assign each thing to its essential place."[39] Illusionism is "unnatural" because imitation is essentially falsehood, and because the products of nature, according to Arp, never imitate what they are not. Arp rejected logic, not just to distress the bourgeois, but also because he blamed over-reliance on reason for humanity's folly and evil. In place of reason he took nature as his ideal, holding that the ways of nature are illogical but meaningful and morally correct. Using chance to order works of art was a way to curb reason and allow "senseless" nature — the unguided flow of life — to play a role in his creations. According to his system of belief, the use of chance was both morally and artistically sound, since all manifestations of nature are inherently valid and beautiful.[40]

Despite Arp's growing alienation from Surrealism, he had to have been affected by the Surrealist approach to chance. Whereas in the Dada period Tzara offered simultaneous poetry as an opportunity for each listener to derive his own associations from accidental sound combinations,[41] the Surrealists concentrated on the mysterious connections between chance and the artist's own subconscious impulses. Breton explored this issue most eloquently in *Nadja* (1928) — a work Arp admired[42] — where Breton declined to separate the workings of chance from subconscious attractions in his unplanned encounters with the young woman. Arp joined in the Surrealist collaborative games of chance combinations of images or words, the "exquisite corpses,"[43] questions and answers, and other exercises which they regarded, according to Marcel

Jean, "as revelations of the group's 'mental-emotional state.' "[44] In the 1920s, Max Ernst, Joan Miró, and André Masson used a variety of chance techniques to stimulate their inner visions, to provide a basis for paintings. Arp did not claim his chance compositions as direct manifestations of his subconscious but, in retrospect, he did seem to imply a difference between the Dada interest in chance as provocative incongruity and the more sophisticated understanding that he came to around 1930. Now chance events revealed a greater reality, a principle beyond normal comprehension: "The word 'accident' implies not only chance, fortuitous combination, but also what happens to us, what befalls us.... These torn pictures, these *papiers déchirés* brought me closer to a faith in things other than earthly."[45]

Arp's ideas about chance in art eventually assumed a central place in his philosophy of creativity. By 1950, he regarded chance as an all-encompassing principle of life, "a law that has now become a supreme law,"[46] which "comprises all other laws and surpasses our understanding (like the primal cause from which all life arises)."[47] In his late article "Die Musen und der Zufall," he declared chance occurrences to be a form of providential guidance. Such occurrences emerged from the artist's subconscious in a state of waking dream, he explained, but they originated from a source outside the artist, which he treated as quasi-divine. The more attentively the artist responded to chance, the more naturally and successfully he could create:

> Moving poems, sculptures, paintings, songs that were sent from the Muses apparently accidentally, "on approval" and with no obligation to buy, fell to the dreamers as beautiful chance.... He who can still experience life in our times as a dream still has the good fortune to encounter the Muses. "Chance" in the art of our time is nothing accidental, but a gift of the Muses. This spiritual gift falls only to dreamers.[48]

As these statements imply, Arp incorporated an element of chance in most of his works, a fact known from his essays and accounts of his methods.[49] Yet, he exerted a great degree of conscious control and aesthetic judgment over the final results in his reliefs and sculptures, a fact most evident in their suave contours and unblemished finish. Arp explained elsewhere that accidents alone could not produce art; art required the imprint of human aspirations.[50] The *Torn Papers*, with their comparative freedom from control, were Arp's exception to this rule:

> When I make *papiers déchirés,* I feel happy. What diverts me once again from these procedures is the fact that there is no longer a person forming within me. I gain peace and calm but lose as a creator. Thus I am forced to become a "shoemaker" again, for in a state of relaxation I am no longer capable of forming.[51]

The act of making a *Torn Papers* gave Arp temporary relaxation from the tensions of artistic control. Such a release was all the more necessary to counter-

balance a strong perfectionist streak in Arp. This reveals itself in the immaculate surfaces of his works and in the longing for clarity and order found throughout his essays.[52] In a 1958 interview, Arp even insisted that he disliked disorder and that for him disorder had nothing to do with Dada or chance.[53]

It is very likely that even as early as the Dada period, the *Collages Arranged According to the Laws of Chance* served as an emotional outlet for the frustration built up by his drive for perfection. Around 1916 to 1918, he was using chance and automatic techniques freely in poetry, but he was going through a period of severe perfectionism in his art: "The human being is a very complex bouquet. At the very time that I was defending anonymous and impersonal art, my poetry was venturing into the most personal eruptions. In the dada period most of my poems were very different from the problems that I was investigating in plastic art."[54] Having adopted Sophie Taeuber's method of austere geometrical composition, his drive to suppress all irregularities and personal expression and to achieve complete clarity became a frustrating obsession. "During the Dada period I was morbidly obsessed with the idea of an incommunicable absolute."[55] This statement was not the exaggeration of an old man looking back on his youth. A 1918 article by his friend L.H. Neitzel, who had been active in the Dada Gallery the year before, confirms Arp's recollection:

> Since the war Hans Arp has withdrawn from the agitation of Expressionist forms. He strenuously rejected any memory image that tried to penetrate from the outer world into his images. So a great calm came into his work, which became even more austere in spatial composition, and so as not to disturb the intellectual construction through accidental agitations of the hand, he had his compositions carried out by others in the calm cross-stitch technique with wool, silk, or pearl cotton that at their most beautiful were to have the effect of mosaics in severe architecture. Only the most essential is given by him, only value relationships of color and form, that like magic charms contain the power to make everything that has become embedded in them through long experience rise up again.[56]

In a later memoir, Neitzel reiterated Arp's fanatical avoidance of the marks of his own hand and consequent preference for having others execute his designs.[57]

Arp's quest for perfect, undisturbed images was far more than a visual exercise. He considered his impersonal geometrical constructions as embodiments of ethical values, a counterexample to the world's egotism and brutality. In one of his letters to Hilla von Rebay, written in March 1917, he declared : "I think that the most valuable thing about people is their works. I believe that my works are very good too. I believe that people could benefit a lot from them, that they could draw a lot of strength from this remoteness from things and human beings."[58] The war and Arp's position as a draft resister and a bicultural Alsatian must have fueled this drive for an expression of selflessness and calm in art.[59] His inner turmoil comes out in his love letters to Rebay,

a fellow Alsatian who was in Germany. Several times he expressed pro-German sentiments to her, but he also expressed his horror of combat. He reported troublesome frictions with his fellow artists and poets, and his nerves must have been on edge as his love affair with Rebay faltered and his attachment to Sophie Taeuber grew.[60] Arp coped with the stress and ugliness of life by creating images of calm regularity, but he could not maintain this detachment for long.

Given the spiritual importance Arp attached to his geometrical works, the *Collages Arranged According to the Laws of Chance* must have been a weighty, difficult choice for him. The account that Pierre Cathelin received from him suggests that Arp reached a point of crisis in his drive for "an absolute":

> Arp found these pursuits leading him toward aridity; geometrism drove him up against a wall. This striving for the absolute, he confessed to me one day recently at Meudon, suddenly appeared to him to lead to the brink of madness, to end in the impossible masterpiece and total nothingness. Only a man like Malevitch would go to the length of a square monochrome. While Sophie was working it out of her system by introducing a musical rhythm ... Arp was throwing himself into chance arrangements.[61]

The chance collages were an unprecedented solution to emotional and artistic tensions. They must be attributed in part to the rigid requirements Arp set for his art. He had ruled out known artistic styles. Expressionism was unacceptable because it vainly and arrogantly drew attention to the artist's passions. Cubism and Futurism were tied to the representation of material things and thus were false, illusory. Even the diagonal compositions of his slightly earlier collages expressed too much inner turbulence.[62] The chance collages met Arp's needs. They evaded the frustration of perfectionism and excluded techniques that might reveal his fine arts training. They referred to the serenity and universality of horizontal and vertical alignments, yet each chance arrangement was different and unpredictable. They gave vent to his energy, expansiveness, and agitation, qualities communicated by the deviations from the grid and by the endless variations each composition suggests. Yet they preserved Arp's humility, because he did not exercise complete control over the collages, and because they make no direct references to his emotions.

The *Torn Papers* collages of the early 1930s also began as a release from perfectionism. In the passage from "Looking" quoted above and elsewhere, Arp recounted the perfectionism with which he worked just before 1930 and his anguish on discovering that his art inevitably disintegrated.[63] The reaction he described, tearing and pasting collages and using chance, was a direct rejection of highly determined and finished work. "What arrogance is concealed in perfection. Why strive for accuracy and purity if they can never be attained?"[64] As he explained, he came to terms with the decay of art by

anticipating it with relatively careless execution and visual effects of disorder. After the initial crisis he continued making *Torn Papers*, as we have seen, as an intermittent relaxation from the pressure of his creative drive.

Some of Arp's comments about the *Torn Papers* indicate they also had to do with another form of release: the dissolution of artistic order was a metaphor of death. At this time, he was deeply troubled by a conflict between his feeling of the impermanence and relativity of life, and the will to achieve something absolute and final in art. The *Torn Papers* were a kind of resolution of this conflict. "The work decomposes and dies. Now, the death of a painting no longer devastated me. I had come to terms with its ephemeralness and its death, and included them in the painting."[65] Behind the artistic dilemma was Arp's distress and mourning of his mother's death. Joséphine Arp had died in Strasbourg on 9 May 1929.[66] We know Arp was deeply affected by her death, because he explicitly connected it with his poem "Das Tages Gerippe" ("The Skeleton of the Days"), one of the "configuration" type in which chance word combinations were used. It was first published in 1932, although parts of it appeared in 1930.[67] The poem is a grief-stricken meditation about transience, contrasting images of fruitful nature with barrenness and death. It tells about a tragic loss, about the eternal cycle of flowering and decay in nature, and about the inability of the poet to regain his former happiness. The acceptance of mortality also meant that Arp acknowledged the limits of his own artistic and poetic powers, represented by eyes, leaves, words, mouth, and voice:

> much higher than the clouds of the eyes
> the hearts and blessed fruits sway
> before the leaf opens its eye
> the fire has already bathed
> the wings carry the sky
> the words leave the mouth like smoke
>
> the eyes are crowns of earth
> the voice only reaches from one leaf to another[68]

The hearts and blessed fruits are beyond reach, the fire is extinguished, his eyes and voice earth-bound and weak. "Das Tages Gerippe" and the *Torn Papers* collages were both based on Arp's emotional struggle to accept death as a normal part of life and, therefore, necessarily as part of art. Tearing and disorganizing a drawing or print was a metaphor of death. But new collages resulted from the destruction so that, in the end, they affirm the value of artistic creation.

Arp's chance collages furthered the Dada attack on reason and allowed him to release tension and grief, but they also surpassed those essentially destructive purposes. His use of chance was founded on belief in its potential for creating meaningful structures and orders in the world. There is ample reason

to think this conviction was already present during Zurich Dada. Arp's fervent commitment to making meaningful statements through art, the popularity of mystical philosophies in the Zurich group, and his own early attachment to a mystical strain in German Romanticism all support this argument. " 'Chance,' which guides our hands when we tear up paper, and the figures that result from this, reveal mysteries, deeper events of life."[69] Statements like this grew out of his longstanding conviction that life's essence is beyond the grasp of reason but may be perceived intuitively in chance phenomena.

Neitzel's 1918 article, cited above, regarding Arp's strenuous efforts to create an impersonal art of ideas, is only one of the contemporary testimonials to the utter seriousness of his artistic intentions during the Dada period. Others are found in Ball's diary, in essays about Arp by Tzara, Huelsenbeck, and Alexander Partens, in Arp's 1915 Tanner exhibition catalog introduction (from which Tzara quoted in a 1917 note about Reverdy's poetry), and in his letters to Hilla von Rebay.[70] A letter from Rebay to Rudolf Bauer gives a further indication of this seriousness and esteem for art: "His works and these woodcuts too ... are most fascinating to me and will continue to be so, because I understand what he meant to say with them and it is something too beautiful.... He loves art, he loves works of art.... He loves them like a fool."[71] The primary written sources on Arp in the Dada period, and on the beauty and clarity of the *Collages Arranged According to the Laws of Chance,* contain no hint that Arp was capable of a destructive stance toward art.

The Dadaists' familiarity with a spectrum of mystical thought is known from their publications, their performance programs, Ball's diary, and Otto Flake's novel *Nein und Ja* (1920). Their reading included medieval German mystics, Jakob Boehme, the Greek pre-Socratic philosophers, and Taoist literature. An excellent account of this predilection is found in Richard Sheppard's "Dada and Mysticism: Influences and Affinities."[72] As Sheppard ably explains, mysticism appealed to those among the Dadaists who sought a "secret patterning" within the flux of nature, and for whom the absurdity of the universe was only apparent. Sheppard cautions that Arp, Huelsenbeck, and even Ball in the first years of Dada were not authentic religious believers, but they discovered affinities between the mystic writings and their own fundamentally secular conviction that life had inner significance to be apprehended by nonrational investigation.

According to Flake's novel, Arp was especially attached to Lao Tzu, traditionally considered the founder of Taoism and author of the *Tao Te Ching* (*Book of the Way*). This philosophy is quite relevant to Arp's idea of art made according to chance. The *Tao Te Ching* teaches that one must not strive against the natural course of events, or the "way," but must act in harmony with it. Then order and success will result without apparent effort. "Do that which consists in taking no action, and order will prevail."[73]

> Should lords and princes be able to hold fast to it
> The myriad creatures will submit of their own accord,
> Heaven and earth will unite and sweet dew will fall,
> And the people will be equitable, though no one so decrees.[74]

The "way" is real, but it cannot be understood; it is "nameless." Its paradoxical, nonrational quality is sometimes expressed by means of paired contraries:

> As a thing the way is
> Shadowy, indistinct.
> Indistinct and shadowy,
> Yet within it is an image;
> Shadowy and indistinct,
> Yet within it is a substance.
> Dim and dark,
> Yet within it is an essence.
> This essence is quite genuine
> And within it is something that can be tested.[75]

Arp must have found reassurance in these precepts. Applied to his own situation, they would have told him that submitting artistic decisions to chance was not abdicating responsibility or accepting chaos. Instead, using chance was a way to align himself and his art with the inherently correct flow and pattern of nature — even if that pattern escaped definition.

The *I Ching* (*Book of Changes*) is a work of Chinese philosophy and oracular wisdom that preceded and contributed to Taoism. Herbert Read implied that familiarity with this work may have affected Arp's outlook on chance; and he also pointed out the fundamental similarity between Arp's outlook and the ancient Chinese conviction that meaning and guidance are to be found in the study of configurations determined by chance.[76] Arp could easily have known the *I Ching* in Richard Wilhelm's definitie German translation and commentary after its first publication in 1924.[77] There are further points of comparison between the principles of the *I Ching*, as presented by Wilhelm, and Arp's philosophy that tend to support Read's suggestion. Whether Arp knew the *I Ching* earlier (in the Zurich Dada period), how well he knew it, whether he consulted it in earnest, and its many possible ramifications for his art and poetry — these are questions that I hope will receive more extended analysis in the future.[78]

The writings in the *I Ching* are consulted by means of visual configurations known as hexagrams. These are images comprising six horizontal lines, each line either continuous or interrupted (——— or — —). Each of the 64 possible arrangements of the two kinds of lines is a hexagram with a name and meanings. The user performs a series of chance operations involving the counting off of yarrow sticks or the throw of coins to draw a hexagram. The result of each operation is assigned a numerical value, which in turn determines

whether each line, from bottom to top, is to be broken or continuous, and whether each line has a changing or stable nature. The user then consults the parts of the book that interpret the meanings of that particular hexagram, its individual lines, and related hexagrams. The wisdom of the book is said to provide the user with understanding of the present situation, of the direction in which it is tending to change, and guidance for wise and proper actions.

Arp might well have been encouraged in his creation of *Torn Papers* collages by this Chinese system, which assigned profound meanings to images that are, in themselves, abstract and determined by chance. Certainly, when he began to write about the collages later on, it was in terms very much like Wilhelm's comments about chance and the *I Ching:*

> As divine beings do not give direct expression to their knowledge, a means had to be found by which they could make themselves intelligible. Suprahuman intelligence has from the beginning made use of three mediums of expression — men, animals, and plants, in each of which life pulsates in a different rhythm. Chance came to be utilized as a fourth medium; the very absence of an immediate meaning in chance permitted a deeper meaning to come to expression in it.[79]

Arp similarly saw that the *Torn Papers* provided an opportunity for the expression of profound issues from a source beyond the individual, in a way not possible when the artist creates willfully:

> We should show gratitude and amazement in welcoming the light and the darkness sent to us by "chance." "Chance," which guides our hands when we tear up paper, and the figures that result from this, reveal mysteries, deeper events of life.[80]

In "Die Musen und der Zufall," he addressed the idea of chance in quite oracular terms: chance occurrences are messages sent to earthly beings by superior, perhaps divine ones. The artist or poet wise enough to receive these messages receives a happy and beautiful destiny or, sometimes, an ominous lesson.[81] Wilhelm said the absence of meaning permits deeper meaning; and Arp: "The chance occurrences that the Muses direct to artists are like the enlightenments that are imparted to saints, especially when they come out of the infinite or out of 'Nothingness.' "[82]

If chance is the vehicle of the *I Ching*'s communications, change is the heart of its content. Each hexagram represents a state of change; names such as "yielding," "inciting movement," "resting," "light-giving," and "penetrating" are applied to the eight trigrams that make up the 64 hexagrams. Lines of a hexagram that are assigned special numbers are considered to be changing lines; that is, a broken line has the ability to turn into a straight one and vice versa. Thus, these special lines have the power to change their hexagram into another, whose meanings the user must also study to learn the changes that the future is bringing. The *I Ching* teaches that all things are constantly in a state of

change. Nature moves in cycles, propelled by the alternation of polar opposites — yin and yang — which are also the dark and light principles, earth and heaven, the divided and the continuous lines, the receptive and creative forces. In the case of the birth and death of generations, however, change is successive, nonrepeating. The universality of change does not render life meaningless, however, because change unfolds against the background of an unchanging conceptual principle, the Tao, the force along which the changes move.[83]

The centrality of change for Arp, in the early 1930s, adds weight to the hypothesis that he knew and drew upon the *I Ching*. Cyclic changes of the natural world are a very important theme in his art in the 1930s. The gentle, rounded irregularity and asymmetry of his sculpture and relief forms perfectly convey movements of growth, rearrangement, or contraction, whether of organic life or of the starry constellations, eroded stones, or fugitive clouds. The collages of torn drawings and prints, as we have seen, express a wonderfully condensed cycle of existence, death, rearrangement, and new life. Arp explicitly connected organic life cycles with the genesis and life of works of art in 1931 when he used his most famous metaphor for the first time: "Art is a fruit that grows in man like a fruit on a plant or a child in its mother's womb."[84]

If Arp was, in fact, inspired by the *I Ching*'s emphasis on change, then the Chinese image of change as alternation of darkness and light would have reinforced his preference for black and white in his works on paper. Against this, however, one must consider that Arp's use of black ink on white supports extended back to his earliest known drawings and prints and, also, that the metaphysical polarity of light and dark is entrenched in Western systems of thought. Another line of inquiry would be a comparison of the structure of Arp's "configuration" poems to the construction of hexagrams. Chance seems to determine Arp's arrangement of a sharply limited number of words into sentences, just as chance assembles straight or divided lines into hexagram images. The poems move through a succession of images derived from rearrangements of the same words, in a way suggestive of the special changing lines that transform hexagrams into completely different ones — new images with new sets of meanings. Not only the formal structure, but also the thematic content of one "configuration" relates to the *I Ching*: "Das Tages Geripppe" juxtaposes the anguishing, irreversible loss of Arp's mother against the unending cycles of death and rebirth in nature, in a way reminiscent of Wilhelm's explanation of cyclic versus successive change.[85]

Arp never published confirmation that the *I Ching,* Taoism, or other aspects of Asian thought influenced his art. However, he did connect his collages to an author who specifically mentioned chance: the German Romantic Novalis. In Arp's article "Die Musen und der Zufall," he quoted Novalis in connection with the *Torn Papers*:

While the torn-up smaller and larger bits of paper dropped down onto a support coated with glue, the paper picture began to live, like a fairy tale, and I took joy in the mysterious duet of nature and muse. Concerning the style and content of such accidental fairy tale songs, Novalis declared the essential in his Fragments 2067 and 1755: "The fairy tale is so to speak the canon of poetry. All that is poetic must be like a fairy tale. The poet worships chance." And: "All chance is marvelous, contact with a higher essence, a problem, a datum of the active religious sense."[86]

Shortly after this article appeared, Leonard Forster sketched a similar relationship between Arp's use of chance in Dada poetry, his love of Novalis, and his religious inclination. Forster noted that in the Dada period, Arp was reading Novalis, who professed "all that we call chance comes from God." Forster distinguished between the positive approach to chance by Arp and Ball and what he characterized as the nihilistic approach of Duchamp and Tzara: "Indeed one can only rely in this way on the laws of chance if one is a deeply religious person, or on the other hand a complete and tragic atheist."[87] No doubt, Forster used the expression "religious person" broadly; Arp became devout in a traditional sense only after Sophie Taeuber's death in 1943.

It was an overstatement to divide the Dadaists into the deeply religious and complete atheists; Sheppard's distinction between the mystically inclined and those who saw absurdity in the flux of nature is more precise.[88] But Forster does call attention to Novalis's mystical belief that chance occurrences, like all facets of nature, express the divine presence in the world. Arp read the German Romantics well before the Dada period. According to several sources, he read Brentano, Arnim, Jean Paul, and especially Novalis as an adolescent. When an interviewer asked Arp, in 1956, whether philosophy influenced his art, he named Novalis as one of the authors who had "been with me throughout the years."[89]

Like other mystics, Novalis believed that the secrets of existence could be penetrated by a small number of enlightened thinkers. Where Taoism considers a follower of the "way" to be a great sage or statesman, for Novalis it was the artistic soul, and above all the poet, who could attain true understanding. He expressed this in an extended allegory of life, the fairy tale told by the character Klingsohr in *Heinrich von Ofterdingen*. The villain of the story is a scribe who represents analytical thinking. His evil is finally thwarted and a Golden Age of harmony established by the concerted efforts of Ginnestan (Imagination), Eros, and Fable, the components of poetic and intuitive understanding.[90] In *Die Lehrlinge zu Saïs,* Novalis examined how the poet attains insight. The apprentices were to use intuition to read a secret and divine code that is inscribed in all facets of nature. The opening of the book lays out the vast range of nature susceptible to exploration:

Men follow manifold paths. Whoever traces them and compares them will see wonderful figures arise; figures that seem to belong to that great secret writing that one perceives

everywhere, upon wings, egg shells, in clouds, in snow, crystals and the structure of stones, on water when it freezes, on the inside and the outside of mountains, of plants, of animals, of human beings, in the constellations of the sky, on pieces of pitch or glass when touched or rubbed, in iron filings grouped about a magnet, and in the strange conjunctures of chance. In them one divines the key to this marvelous writing....[91]

Thus, Novalis included the "conjunctures of chance" among all the normal structures and patterns of nature; all contain the secrets of life's meaning. Arp adopted this position and justified his chance collages by it: "I declared that these works were arranged 'according to the law of chance,' as in the order of nature, chance being for me simply a part of an inexplicable reason, of an inaccessible order."[92]

Arp did not mention Novalis as a source until late in life, but the Dadaists were already conversant with Novalis's theory of the "secret writing" in nature. Tzara paraphrased part of the passage quoted above from *Die Lehrlinge zu Saïs,* without acknowledgment, in his "Note 14 sur la poésie," dated 1917 and published in *Dada 4-5,* 1919. Possibly, Arp brought the passage to the attention of Tzara, who was more at home with French than German. Tzara did not mention chance in "Note 14," but he did express a view about hidden order in poetry that was similar to Arp's comment about chance as "inaccessible order": "there is a rhythm which is neither seen nor heard: rays of an internal grouping leading toward a constellation of order.... the poet will be demanding of his work, in order to find true necessity; from this asceticism order will blossom, essential and pure."[93] Elsewhere in 1917, Tzara commented on Arp's art in terms of hidden structure in nature:

Every natural thing keeps its clarity of organization, hidden, pulled by relationships which are grouped together like the family of lunar lights, the hub of a wheel that might revolve ad infinitum, the sphere, it ties its liberty, its final, absolute existence, to innumerable and constructive laws.[94]

Novalis's idea about a divine order, encoded even in accidental effects of nature, would have been relevant to Arp again in 1930. Saddened by his mother's death, he may well have found solace in such theories. Certainly, in later years, he shared the Romantic outlook that cosmic order lay even in the apparent chaos of death: "By tearing up a piece of paper or a drawing one permits the entry of the very essence of life and death."[95] If some of the *Torn Papers* were beautiful or expressive, if "these torn-up papers, these scraps, included some that pointed a finger into the air, zen papers, papers beyond time and space,"[96] that was evidence that behind the confusion and despair of life was a meaning to all things.

With the *Torn Papers* collages, Arp revived the central Dada idea of chance, but he also modified it. Where the central theme of the *Collages Arranged Accord-*

ing to the Laws of Chance was departure from an expected order, the *Torn Papers* recreate, in microcosm, nature's cycles of disintegration and creation. He now saw the inexplicable flow of events as endless cycles within the inevitable course of nature. When Arp reevaluated the importance of Dada in the early 1930s, he stressed the Dada belief that nature is "senseless," that is, illogical, innately moral, and to be apprehended only by nonrational means: "dada wanted to destroy the rationalist swindle for man and incorporate him again humbly in nature. dada wanted to change the perceptible world of man today into a pious senseless world without reason.... dada is a moral revolution.... dada is as senseless as nature and life."[97] The "senselessness" of nature made a bridge between the organic forms of his sculptures and reliefs and the chance arrangements of the *Torn Papers*. Chance collages represented another aspect of the same mysterious order of nature that Arp celebrated in the rest of his work.

Notes for Chapter 4

1. Musée National d'Art Moderne, *Hans/Jean Arp: le temps des papiers déchirés* (Paris, 1983).

2. Leonard Forster, *Poetry of Significant Nonsense* (Cambridge: Cambridge Univ., 1962). Rudolf Kuenzli, "Hans Arp's Poetics: The Sense of Dada 'Nonsense,' " in Richard Sheppard, ed., *New Studies in Dada. Essays and Documents* (Hutton, Driffield, England: Hutton, 1981), pp. 46-59.

3. Harriett Watts, *Chance: A Perspective on Dada* (Ann Arbor: UMI Research Press, 1980), p. 3. The reader is referred to this work for excellent discussions of the sources of Dada chance in Cubist and Futurist art and of parallels to Dada chance in Jung's psychological theories and twentieth-century atomic physics.

4. Hans Richter, *Dada: Art and Anti-Art* (London: Thames and Hudson, 1965), p. 51. A similar story is given by Richard Huelsenbeck, "Arp and the Dada Movement," in Janes Thrall Soby, *Arp* (New York: Museum of Modern Art, 1958), p. 18; and by Marcel Jean, *The History of Surrealist Painting,* trans. Simon Watson Taylor (New York: Grove, 1959), p. 193.

5. William Rubin, *Dada and Surrealist Art* (New York: Abrams, 1969), p. 82; Alastair Grieve, "Arp in Zurich," in Stephen C. Foster and Rudolf E. Kuenzli, eds., *Dada Spectrum: The Dialectics of Revolt* (Iowa City: Univ. of Iowa, 1979), pp. 192-94.

6. See especially Rudolf Arnheim, *Entropy and Art. An Essay on Disorder and Order* (Berkeley: Univ. of California, 1971).

7. Reproduced, undated, Musée National d'Art Moderne, cat. no. 4, p. 9.

8. A fifth collage resembles the Dada chance group, but there is uncertainty about its date. It has the same vertical orientation, torn shapes approximating rectangles, and suggestion of a grid pattern as the others. It was published as *Papiers déchirés,* 1936, in *Plastique* 4 (1939): 17; but it appears (opposite side up) dated 1916 in Gabrielle Buffet-Picabia, *Jean Arp* (Paris: PUF, 1952), n.p.

9. E.g., Sophie Taeuber-Arp and Arp, *Duo-Collage,* 1918, in Herbert Read, *Arp* (New York: Abrams, 1968), fig. 22, p. 35.

10. Georges Hugnet, "The Dada Spirit in Painting" in Robert Motherwell, ed., *The Dada Painters and Poets: An Anthology* (New York: Wittenborn, 1951, repr. 1981), p. 134.

11. Richter, *Dada*, fig. 12. Arp's Dada art is dated largely according to his later recollections and those of his family, which in some cases seem inconsistent with evidence from dated publications and exhibitions. No documentary evidence has come to light to support or disprove the traditional dates of the Dada chance collages.

12. Grieve, "Arp," pp. 175-207. Huelsenbeck's article was published in edited form as "Die Arbeiten von Hans Arp," dated 1916, *Dada 3* (December 1918), n.p. The original manuscript appears in Sheppard, pp. 99-102. Huelsenbeck associates Arp's abstraction, use of collage materials, and geometrical forms with a new inner simplicity and spirituality.

13. E.g., Hugo Ball, *Flight Out of Time,* ed. John Elderfield, trans. Ann Raimes (New York: Viking, 1974), pp. 93-94.

14. The Hilla von Rebay Foundation Archive at The Solomon R. Guggenheim Museum, trans. Wilfred Kling: "Darum auch liebe ich die neuen Arbeiten weil sie ... wesentliche Beispiele des rechten Lebens geben. Und so wird alles zur Architektur führen. Das complizierte personliche wird sich verlieren." "Ich würde jetzt jeden Tag die Freude, die Welt in geordnete Flächen aufzuteilen, so herzlich gerne hingeben für Deine Gegenwart."
 I wish to acknowledge Vivian Barnett, Curator, and Lewis Kachur for their assistance, and the Rebay Foundation Trustees for permission to quote these and other excerpts. I am also grateful to Joan M. Lukach for help with Rebay materials.

15. See Grieve, pp. 188-92 for dating of the *Duo-Collages.*

16. "And So the Circle Closed," 1948, *Arp on Arp,* trans. Joachim Neugroschel (New York: Viking, 1972), pp. 245-46. Hereafter cited as *AA.* For the original French versions of my numerous citations from *AA,* the reader is referred to Jean Arp, *Jours effeuillés: poèmes, essais, souvenirs, 1920-1939* (Paris: Gallimard, 1966).

17. "FORMS," 1950, *AA*, p. 274.

18. "Dadaland," 1948, *AA*, p. 232.

19. Tzara, "Manifesto on Feeble Love and Bitter Love," in Motherwell, pp. 86-97. Read at Galerie Povolozky, Paris, 12 September 1920; published in *La Vie des Lettres* 4, 1921. Elmer Peterson, *Tristan Tzara: Dada and Surrational Theorist* (New Brunswick, N.J.: Rutgers Univ., 1971), p. 34. Several other, fleeting, references to chance were made by members of the Zurich group. Tzara: "Experience is also a product of chance and individual faculties." "Dada Manifesto 1918," in Motherwell, p. 79. Huelsenbeck: "A Dadaist is the man of chance with the good eye and rabbit punch." *En avant Dada,* 1920, in Motherwell, p. 29. Richter: "Versuchen wir über jede Umkehrung hinweg einen Sprung in die Form, komponieren wir aus gut verdaulichem Salat Eisenbahnfahrkarten und dem allermomentansten Reflex eine Melodie mit dem gelegentlichen Takt aller Zufälle der Seelenkreuzungen." "Gegen Ohn Für Dada," *Dada 4-5* (May 1919): n.p.

20. Stefanie Poley, *Hans Arp: Die Formensprache im plastischen Werk* (Stuttgart: Gerd Hatje, 1978), p. 116.

21. Huelsenbeck, *En avant Dada,* in Motherwell, pp. 35-37.

22. Richter, *Dada*, p. 52.

23. See especially Watts for Cubist and Futurist sources.

24. Tzara, "Note pour les bourgeois," *Cabaret Voltaire* (1916): 6: "Les essays [sic] sur la transmutation des objets et des couleurs des premiers peintres cubistes (1907) Picasso, Braque, Duchamp-Villon, Delaunay, suscitaient l'envie d'appliquer en poésie les mêmes principes simultans."

25. Trzara letter to Jacques Doucet, 30 October 1922, trans. and ed. Mary Ann Caws, *Tristan Tzara: Approximate Man and Other Writings* (Detroit: Wayne State Univ., 1973), p. 34. See also Tzara, "Le papier collé ou le proverbe en peinture," *Cahiers d'Art* 6, pp. 61-64, for the importance he accorded Cubist collage in the development of modernism.

26. See, e.g., Musée Nationale d'Art Moderne, *Papier collé*, 1915, and *Collage "Crayon,"* 1915, fig. 1.

27. "Wegweiser," trans. in Read, p. 142.

28. Hans Arp, *Gesammelte Gedichte I* (Wiesbaden: Limes, 1963), p. 47:
"WELTWUNDER sendet sofort karte hier ist ein teil vom schwein alle 12 teile zusammengesetzt flach aufgeklebt sollen die deutliche seitliche form eines ausschneidebogens ergeben staunend billig alles kauft
nr 2 der räuber effektvoller sicherheitsapparat nützlich und lustig aus hartholz mit knallvorrichtung
nr 2 die zwerge werden von ihren pflöcken gebunden sie öffnen die taubenschläge und donnerschläge
die töchter aus elysium und radium binden die rheinstrudel zu sträussen...."

29. Pierre Beuguière, "Importance des Papiers Déchirés," Musée National d'Art Moderne, p. 13: "Il encollait toute la surface du support, il y posait ou disposait les morceaux de papier. Par un léger attouchement de ses doigts, il pouvait les faire glisser sur la surface gluante jusqu'à la place exacte où le morceau de papier prenait une plénitude de sens. Puis il enlevait les excédents de colle en nettoyant le collage. Sur certains collages, en les examinant de près, on voit le fond lustré par la colle, sur d'autres les traces que ces morceaux de papier peint à la gouache, dans leurs déplacements, y ont laissées."

30. Marcel Jean, Introduction, *AA*, p. xxv-xxvi.

31. Poley, p. 116.

32. "Looking," in Soby, pp. 15-16.

33. Louis Aragon, "La peinture du défi," in Marcel Jean, *Autobiographie du Surréalisme* (Paris: Seuil, 1978), p. 224: "Arp, qui sous le titre Fatagaga, avait fait des collages en collaboration avec Max Ernst ... chercha à coller des papiers au hasard, puis se servit de papier découpé." The *Fatagaga* collages dated from the early 1920s and the collages with cut papers from the Zurich Dada period, so it appears Aragon was referring to Arp's chance collages from the Dada period, rather than to his new works. At this time also, Arp began referring to reliefs as "according to chance." In a letter to Carola Giedion-Welcker, 20 October 1930, he wrote: "das verflachte eierrelief wie sie es nennen trägt den gleichen titel wie die unendlichkeitstafel nahmlich — körper nach dem gesetz des zufalls geordnet." And 24 January 1931: bitte schicken sie mir bald eine photographie des reliefes objets placés d'après la loi du hasard." Carola Giedion-Welcker, *Schriften 1926-1971* (Cologne: DuMont Schauberg, 1973), pp. 499, 501.

34. "dear monsieur brzekowski," [ca. 1929], *AA*, p. 35; Arp, "Notes from a Diary," trans. Eugene Jolas, *Transition* 21 (March 1932): 94.

35. Arp, *Gesammelte Gedichte I*, pp. 204-5. The other autobiographical points are that he was born in Strasbourg, had written five books of poetry, and made sculpture.

36. Aimée Bleikasten, "Jean Hans Arp: Poèmes des années 1930-1945," Musée National d'Art Moderne, p. 18.

37. Arp, *Gesammelte Gedichte I:* "wunderhornkonfiguration," pp. 190-93; "verschlungene knaben," p. 37; "kunigundulakonfiguration," pp. 194-95; "die edelfrau," p. 33.

38. Arp, "wunderkornkonfiguration," *Gesammelte Gedichte I,* p. 33: "die nacht hat füsse aus wachs und säcke voll sterne an weichen fingern / ... die sterne schwimmen mit säcken voll knaben durch den himmel / die brennenden blumen schwimmen an weichen fingern."

39. "dear monsieur brzekowski," *AA,* p. 35. For the emphasis on Dada values, see also "Notes from a Diary," and Arp, "A Propos de la'art abstrait," *Cahiers d'Art* 6 (1931): 357-58.

40. "Interview with George L.K. Morris," 1956, *AA,* p. 349. Arp's belief in the inevitable beauty of natural phenomena came out when he discussed abstract expressionism: "All manifestations of this art are beautiful as matter is beautiful." Pierre Schneider, "Arp Speaks for the Law of Chance," *Art News* 57 (November 1958): 50: "Jetsam is beautiful, but it is nature. The same holds for *l'art informel.*"

41. Tzara, "Note pour les bourgeois," p. 7: "Je voulais réaliser un poème basé sur d'autre principes. Qui consistent dans la possibilité que je donne à chaque écoutant de lier les associations convenables. Il retient les éléments caractéristiques pour sa personalité, les entremêle, les fragmente etc, restant tout-de-même dans la direction que l'auteur a canalisé."

42. Schneider, p. 51.

43. Musée National d'Art Moderne, *Cadavre exquis,* 1937, and *Cadavre exquis,* n.d., figs. 39, 40.

44. Jean, *History of Surrealism,* p. 167.

45. "Looking," in Soby, pp. 15-16. He also claimed the "Law of Chance" was experienced in total surrender to the unconscious. See note 16.

46. "FORMS," 1950, *AA,* p. 274.

47. "And So the Circle Closed," 1948, *AA,* p. 246.

48. Arp, "Die Musen und der Zufall," *Du* 20 (October 1960): 15: "Aus dem scheinbar zufällig und ohne Kaufzwang 'zur Ansicht Geschickten' wurden ergreifende Gedichte, Plastiken, Malereien, Lieder, die von den Musen geschickt, als schöner Zufall den Träumern zufielen. ... Wer das Leben in unserer Zeit noch als Traum erleben kann, hat immer noch das Gluck, den Musen zu begegnen. Der 'Zufall' in der Kunst unserer Zeit ist nichts Zufälliges, sondern ein Geschenk der Musen. Nur den Träumern fällt dieses geistige Geschenk zu."

49. Jean, Introduction, *AA,* pp. xxv-xxvi; Arp's essays, e.g., "The Germ of a New Plastic Work," 1948, *AA,* p. 243; "With Lowered Eyelids," 1955, *AA,* p. 341.

50. Schneider, p. 50: "An object becomes human only if man exerts all his faculties on it. That is my objection to *objets trouvés.* Jetsam is beautiful, but it is nature. The same holds for *l'art informel.* It is very beautiful, but man ought to assert himself more. That kind of painting could have been done by birds."

51. "Conversation at Meudon," 1955, *AA,* p. 339.

52. E.g.,: Arp, "Notes from a Diary," p. 191: "in art too man loves a void.... every living transformation of art is as objectionable to him as the eternal transformation of life. straight lines and pure colors particularly excite his fury. man does not want to look at the origin of things, the purity of the world emphasizes too much his own degeneration."

"...Oasis of Purity....," 1946, *AA*, p. 165: "in the dreadful chaos of our era i catch sight of only a few rare oases of purity. man has succumbed to the frenzy of intelligence.... his in- humanity has led him into a sordid labyrinth and he is unable to find a way out.... i catch sight of only a few rare oases of purity in the dreadful chaos of our era. i catch sight of only a few rare men in this chaos. artists like van doesburg, eggeling, mondrian, sophie taeuber, and vordemberghe-gildewart...."

53. Schneider, p. 50.

54. "Interview with George L.K. Morris," 1956, *AA*, p. 350.

55. "Conversation at Meudon," 1955, *AA*, p. 339.

56. L.H. Neitzel, "Schweizer Kunst: Ausblick und Überblick," *Das Kunstblatt* 7 (July 1918): 204: "Hans Arp hat sich seit dem Kriege aus der Erregtheit expressionistischer Formen zur- ückgezogen. Er schloss sich streng gegen jedes Erinnerungsbild ab, das von der Aussenwelt in sein Gestalten dringen wollte. So kam eine grosse Ruhe in sein Werk, das immer strenger in der Raumgestaltung wurde und um den geistigen Bau nicht durch zufällige Erregtheiten der Hand zu stören, liess er in der ruhigen Kreuzstichtechnik von andern mit Wolle, Seide oder Perlgarn seine Gestaltungen ausführen, die am schönsten als Mosaiken in strenger Architektur wirken würden. Nur das Wesentlichste wird von ihm gegeben, nur Wertver- hältnisse von Farbe und Form, die wie magische Formeln die Kraft enthalten, alles erstehen zu lassen, was aus langen Erlebnisreihen in sie eingeschlossen war."

57. L.H. Neitzel, "Hans Arp–Sophie Taeuber-Arp. Erinnerungen eines Freundes," *Das Kunst- werk* 9, 2 (1955-1956): 39-41.

58. Arp to Rebay [March 1917], trans. Wilfred Kling, Rebay Archive: "Ich glaube dass die Arbeiten meistens das wertvollste der Menschen sind. Ich glaube auch dass meine Arbeiten sehr gut sind. Ich glaube dass sie den Menschen viel nützen könnten und dass sie viel Kraft an diesen Entfernungen zu Dingen und Menschen sämmeln."

59. Huelsenbeck (who became a psychiatrist) believed that Arp, who was kind and peaceful, habitually sublimated aggressive and anxious feelings in his work, and that during the Dada period, Arp's resistance to the war was completely directed into his art and philoso- phy. Richard Huelsenbeck, "Hans Arp," *Kunstwerk* 20, 1-2 (1966): 84-86.

60. Arp correspondence, Rebay Archive. The picture of Arp that Rebay gave in a 1918 letter to Rudolf Bauer (dated December 5; in Rebay Archive) is far more serious than the stereotype of the joking, irreverent Dadaist: "Wenn man an seine Einsiedlerwohnung, an sein unber- echenbares rührendes Wesen denkt und die reine Atmosphäre um ihn, kann man ihn nur lieben.... Ein Mensch, der sich so quält und so tief und eigenartig ist, so lebensunfähig und voller Leiden ... wie Hans Arp gibt es in meinem Bekanntenkreis sonst nicht, und die Berü- hung mit ihm tut wohl und macht gut...."

61. Pierre Cathelin, *Jean Arp,* trans. Enid York (New York: Grove, 1959), p. 49.

62. See note 56 above. Also Ball, p. 53: "Arp speaks out against the bombast of the gods of painting (the expressionists)...."

63. See also Arp's similar accounts in "And So the Circle Closed," 1948, *AA*, p. 246; "Die Musen und der Zufall," p. 16.

64. "And So the Circle Closed," *AA*, p. 246.

65. Ibid. I believe that Arp's taking up sculpture in the round, with its associations of perma- nence, was also connected with his desire to create something lasting. It is notable that al-

though Arp sculpted primarily in plaster, his poems and essays refer to his sculptures as stones.

66. The correct date was given me by Ruth Tillard-Arp, letter of 9 May 1979.

67. Bleikasten, p. 18, and note 15.

68. Arp, "Das Tages Geripper," *Gesammelte Gedichte I,* p. 232:
 viel höher als die wolken der augen
 schweben die herzen und seligen früchte
 bevor das blatt sein auge öffnet
 hat das feuer schon gebadet
 die flügel tragen den himmel
 die worte ziehen aus dem munde wie rauch

 .

 die augen sind kränze aus erde
 die stimmen reichen nur von einem blatt zum anderen blatt

69. "With Lowered Eyelids," 1955, *AA*, p. 341.

70. Ball, *Flight,* pp. 53, 60; Tzara, "Note 2 sur l'Art. H. Arp," *Dada 2* (1917): n.p.; "H. Arp Exposition am Kunsthaus," *Dada 4-5* (1919); "Inzwischen-Malerei," *Der Zeltweg* (1919): n.p.; Huelsenbeck, "Die Arbeiten von Hans Arp;" Alexander Partens, "Dada-Kunst," *Dada Almanach* (Berlin: Erich Reiss, 1920), pp. 84-90; Art, introduction, *Moderne Wandteppiche, Stickereien, Malereien, Zeichnungen* (Zurich: Galerie Tanner, 1915); quoted in full in original German in Herbert Henkels, "The Beginning of Dadaism: Art and the van Rees in Zurich 1915," *Nederlands Kunsthistorish Jahrboek* 23 (1972): 387. Arp letters to Rebay, 1916-1917, Rebay Archive.

71. Letter from Rebay to Bauer, 5 December 1918, trans. Wilfred Kling, Rebay Archive: "Seine Arbeiten und auch diese Holzschnitte ... haben für mich den grössten Reiz und werden es behalten, denn ich verstehe was er damit wollte und das ist sehr etwas Schönes ... er liebt die Kunst, er liebt die Werke der Kunst ... wie ein Narr liebt er das...."

72. In Foster and Kuenzli, pp. 91-113. Evidence of Dadaists' awareness of Taoism is also adduced by Ko Won, *Buddhist Elements in Dada: A Comparison of Tristan Tzara, Takahashi Shinkichi, and their Fellow Poets* (New York: New York Univ., 1977), pp. 84-86.

73. Lao Tzu, *Tao Te Ching,* trans. D.C. Lau (Harmondsworth: Penguin, 1963), p. 59.

74. Ibid., p. 91.

75. Ibid., p. 78.

76. Read, pp. 111-13.

77. Richard Wilhelm, *I Ging, Das Buch der Wandlungen* (Jena: E. Diederichs, 1924). My comments are based on the standard English translation by Cary F. Baynes and Richard Wilhelm, *The I Ching or Book of Changes* (New York: Bollingen, 1950).

78. I am grateful to Harriett Watts, who directed my attention to the *I Ching,* and look forward to her detailed discussion of the *I Ching*'s influence on Arp in a book-length study of his poetry that she is currently preparing.

79. Wilhelm, pp. 262-63.

80. "With Lowered Eyelids," 1955, *AA*, p. 341.

81. Arp, "Die Musen und der Zufall," p. 15: "Die Musen wurden ihnen zu einem frohen, schönen Schicksal, manchmal auch zu einer unheilvollen Lehre, zu einem unheilvollen Zufallen."

82. Ibid., p. 16: "Die Zufälle, die dem Künstler durch die Musen zufallen, sind den Erleuchtenungen ähnlich, die den Heiligen zuteil werden, besonders wenn sie aus dem Unendlichen oder dem 'Nichts' kommen."

83. Wilhelm, pp. 280-83.

84. Arp, "A propos de l'art abstrait," p. 358.

85. Wilhelm, pp. 280-83.

86. Arp, "Die Musen und der Zufall," p. 16: "Während die zerrissenen kleineren und grösseren Papierchen auf einen mit Kleister bestrichenen Grund niedersanken, fing das Papierbild einem Märchen gleich, zu leben an, und ich freute mich an dem rätselhaften Duett von Natur und Muse. Über die Weise und den Inhalt solcher zugefallener Märchenlieder hat Wesentliches Novalis in seinen Fragmenten 2067 und 1755 ausgesagt: 'Das Märchen ist gleichsam der Kanon der Piesie. Alles Poetische muss märchenhaft sein. Der Dichter betet den Zufall an.' Und: 'Aller Zufall ist wunderbar, Berührung eines höchsten Wesens, ein Problem, Datum des tätig religiösen Sinns.' "

87. Forster, pp. 31-32.

88. Regarding the connection between Arp's use of chance and his fundamentally religious inclination, see also Hans Richter, "Hans Arp," *Begegnungen von Dada bis heute* (Cologne: DuMont Schauberg, 1973), p. 201.

89. "Interview with George L.K. Morris," 1955, *AA*, p. 350. Also Jean Arp and Marguerite Arp, "Konzept einer Ansprache in Köln 1961," *Wallraf-Richartz Jahrbuch* 33 (1971): 286; Carola Giedion-Welcker, *Jean Arp* (Stuttgart: Gerd Hatje, 1957), p. v; Reinhard Döhl, *Das literarische Werk Hans Arp* (Stuttgart: J.B. Metzler, 1967), p. 93.

90. Novalis, "Klingsohr's Fairy Tale," in *Hymns to the Night and other Selected Writings,* trans. and ed. Charles E. Passage (Indianapolis: Bobbs-Merrill, 1960), pp. 17-44.

91. Novalis, *Die Lehrlinge zu Saïs* (Stuttgart: Reclam, 1975), p. 3: "Mannigfache Wege gehen die Menschen. Wer sie vorfolgt und vergleicht, wird wunderlich Figuren entstehen sehn; Figuren, die zu jener grossen Chiffernschrift zu gehören scheinen, die man überall, auf Flügeln, Eierschalen, in Wolken, im Schnee, in Kristallen und in Steinbildungen, auf gefrierenden Wassern, im Innern und Aussern der Gebirge, der Pflanzen, der Tiere, der Menschen, in den Lichtern des Himmels, auf berührten und gestrichenen Scheiben von Pech und Glas, in den Feilspänen um den Magnet her und sonderbaren Konjunkturen des Zufalls erblickt. In ihnen ahndet man den Schlüssel dieser Wunderschrift...." Trans. partly Roger Cardinal, *German Romantics in Context* (London: Studio Vista, 1975), p. 34.

92. "Dadaland," 1948, *AA*, p. 232.

93. Tzara, "Note 14 sur la poésie," (dated 1917 in text): "... il y a un rhythme qu'on ne voit et qu'on n'entend pas: rayons d'un groupement intérieur vers une constellation de l'ordre.... le poète sera sévère envers son oeuvre, pour trouver la vraie nécessité; de cet ascétisme fleurira, essentiel et pur, l'ordre."

94. Tzara, "Note 2 sur l'art. H. Arp": "Toute chose naturelle garde sa clarté d'organisation, cachée, tirée par des relations qui se groupent comme la famille des lumières lunaires, centre de roue qui tournerait à l'infini, en sphère, elle noue sa liberté, son existence dernière, absolue, à ces lois innombrables, constructives."

95. "The Collection *Die Wolkenpumpe....,*" 1955, *AA*, p. 342.

96. "Collages," 1955, *AA*, p. 329. Marguerite Arp-Hagenback steadfastly maintains that Arp did not become familiar with Zen until late in his life.

97. Arp, "Notes from a Diary," pp. 191-92.

5

Periods and Commas: Hans Arp's Seminal Punctuation

Harriett Watts

Punkte und Kommas: Gegenstände nach den Gesetzen des Zufalls geordnet is a relief of 1943, completed thirteen years after Hans Arp first began composing reliefs and poems as "constellations." It consists of elements familiar to anyone acquainted with his work (fig. 5-1). The periods of the constellation are scattered ovals, designated elsewhere as navels, eggs, eyes, or simply elements. The comma shape also appears under other names: leaves, tears, drops, buds, and also as elements. The compositional procedure is familiar as well, a constellation of forms suggested by *das Gesetz des Zufalls,* or Arp's law of the accident. The work reproduced here is one of Arp's most successfully realized constellations, elegantly simplified and conveying a profound sense of organic balance. Yet this balance is achieved without creating the impression of any finalized order in the distribution of elements: recombination could begin at any moment. This instant of aesthetically chosen balance within a system in constant motion is recorded by the artist as an emblem for man's contemplation.

Arp's demonstrations of *das Gesetz des Zufalls* are to be understood as expressions of organic order, of the human artist creating as nature creates. In this organic context, it is surprising to find elements of a constellation designated as periods and commas, punctuation signs lifted out of the printed flow of language. This relief, however, is not the only instance of a punctuation constellation. In 1954, Arp entitled a work *Interpunctuation.* The elements are the same as those of 1943. The relief *Bewegte Konstellation,* or *Constellation mouvemente,* of 1955 is an example of the elements — periods and commas — constellated in a new medium, bronze, the permanence of which is challenged by the movement in the title (fig. 5-2). This last title recalls Arp's discovery, in 1917, of the *bewegte Ovale* as a formal principle.[1] Arp identified these fluid

Figure 5-1. Hans (Jean) Arp, *Punkte und Kommas: Gegenstände nach den Gesetzen des Zufalls geordnet* Wood relief, 110 x 140 x 3.7 cm. *(Kunstmuseum Basel, Depositum Emanuel Hoffmann-Stiftung)*

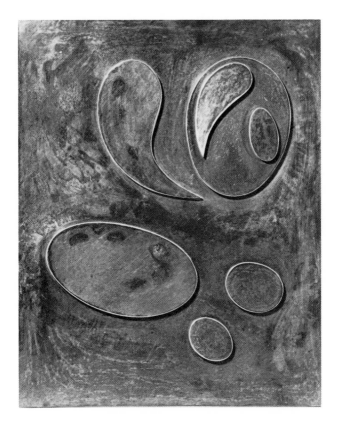

Figure 5-2. Hans (Jean) Arp, *Bewegte Konstellation,* 1955
 Bronze, 33 x 44 cm.
 Location unknown. (*Photo: Etienne Bertrand Weill*)

ovals as the *Sinnbild* (emblem) of organic growth and change. By 1930, *bewegte Konstellationen* had established themselves as a further emblem of natural transformation. This principle of art, as a human expression of organic transformation, accompanies Arp from his Dada years throughout his lifetime. It determines the dynamic energies of his later forms and compositional techniques as well as those of his Dada drawings and reliefs.

The emblematic significance that Arp read into the *bewegte Ovale* leads one to ask if his periods and commas might not also signify something more than punctuation within a sentence. Further inquiry into what this significance could be leads one back to two philosophical structures that made a profound impression on Arp's imagination as early as Zurich Dada, if not earlier. One is the structure proposed by Jakob Boehme in his dualist interpretation of Renaissance micro/macrocosmic models, and the second embodies the dynamic interaction of yin and yang in Taoist thought. Boehme's microcosmic *aufgethaner Punkt,* as well as the diagram he formulated for a macrocosmic "Wunderkugel der Ewigkeit," were familiar to Arp during the Dada years of structural experimentation, as was the Taoist *T'ai-chi-tu* (great map of poles).

The fluid ovals offer an initial clue to the organic potential of periods in Arp's constellations. The word for "period" in French and in German has two meanings. *Pointe* in French is both period and point, as is *Punkt* in German. This multivalence enables the *pointe* or *Punkt* to function not only as a sign terminating a sentence, but also as a point from which a new line may be generated. Arp, who often eliminated periods from sentences in his poems, positions them, instead, above the initial stanza and beneath the final stanza of poems as well as between stanzas. According to Marguerite Hagenbach, he was adamant that publishers observe his "extra-stanzaic" punctuation.

In these instances, it is obvious that the isolated period is not to be understood as terminal punctuation.[2] Instead, it is activated as point, a point that compacts into itself all that was developed in the previous stanza and that signals the presence of renewable verbal energies for development into the next verse. From the point grows a verbal line, then a verbal block, in short, the poem itself.

With his period/point, Arp reactivates a Renaissance emblem of center point and circle, the micro/macrocosmic structure in which the microcosmic point contains all the potential actualized in the macrocosmic whole. Arp was intimately acquainted with Renaissance, Pythagorean, and medieval geometrical mysticism. The image of the center projecting the circle was all but an intuitive element of his formal vocabulary, but he modifies the image by rendering the center in terms of its implicit duality. The center is bifocated to engender an elliptical curve, or oval, and the bifocal point develops in the sense of Jakob Boehme's *aufgetahner Punkt* (exfoliating point).

Boehme's structural influence on Arp began very early, years before Arp's documented interest in this seventeenth-century German mystic philosopher

during the Dada period. According to Arp's younger brother, François, Hans was already reading Boehme intensively as a boy. One of François' first recollections of his brother was that Hans read him passages from Boehme rather than giving him candy: "Er hat mir Boehme gelesen statt mir Zuckerwurfel zu geben."[3] Boehme, Paracelsus, and Renaissance *Naturmagie* were subjects of discussion among the Dadaists, at least between Ball and Arp. Arp read selections from Boehme's *Aurora* at the Cabaret Voltaire 12 May and 19 May 1917,[14] having just returned from a trip to Ascona. Ball notes Arp's departure for Ascona on April 8,[5] and this spring visit could well have been the occasion on which Arp finally made his formal breakthrough to the *bewegte Ovale,* emblems of organic growth and change. If the formal discovery had not occurred before the Boehme Soirée in May, then it is certain to have taken place on Arp's return to Ascona for the summer. In any case, Jakob Boehme and the tradition of mystical alchemy in the late Renaissance and early Baroque periods made important contributions to Arp's definition of the formal energies inherent to his fluid ovals and the generative period/point.

Arp's hermetic Renaissance and Baroque sources reveal themselves unmistakably in the alchemical micro/macrocosmic imagery of "je suis un point,"[6] from the 1941 collection *Poèmes and prénoms.* The initial figure of this poem is that of the circle squared, a geometrical representation of the alchemical unification of opposites, in this case, male and female (fig. 5-3).

In a poem charged with the imagery of alchemical sublimation and crystallization, the visionary dream begins with a point which dilates to such an extent that it embraces eternity within the four corners of terrestrial space:

> je suis un point
> et rêve d'un point
> l'éternité à quatre coins

The point replicates itself in dream fission, then begins to exfoliate as contraries interact:

> je lance ma lance dans l'oeil du coeur
> mes pieds balancent l'air

Contraries engender one another in the dream projection: heights produce depths, and sublimation is accompanied by crystallization of organic life:

> je lèche le haut et le bas
> l'âme du coeur s'envole
> et plant un animal
> l'animal engraisse
> et rit
> et taille l'air en éventail

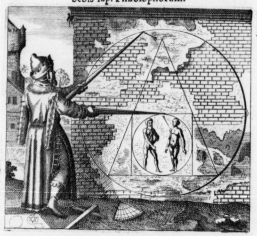

EMBLEMA XXI. *De fecretis Naturæ.* 61

Fac ex mare & fœmina circulum, inde quadran-
gulum, hinc triangulum, fac circulum & ha-
bebis lap. Philofophorum.

EPIGRAMMA XXI.

*F*oemina masque unus fiant tibi circulus, ex quo
 Surgat, habens æquum forma quadrata latus.
Hinc Trigonum ducas, omni qui parte rotundam
 In sphæram redeat: Tum Lapis ortus erit.
Si res tanta tuæ non mox venit obvia menti,
 Dogma Geometræ si capis, omne scies,

H 3 PLA-

Figure 5-3. Michael Maier, "Squaring of the Circle:
Reuniting the Two Sexes," emblem XXI
from *Scrutinium chymicum,* 1787. Frankfurt.
(*By permission of the Houghton Library,
Harvard University*)

The point is spun into a rotating wheel, the result of interaction between the opposing forces of centrifugal and centripetal motion. The wheel of contraries spins through a series of images:

> je tourne comme tous les roux
> je tourne ma clef
> comme ça
> je ferme la porte
> je ferme la rond

The hermetic curve is closed, and further processes of differentiation and reunification now commence within the vessel of the heart, the closed circle:

> enfin l'eau jaillit entre toi et moi
> et porte le nous
> par ci
> par là
> comme ci
> comme ça

The initial "je" of the point is divided into a "toi" and a "moi," but a new synthesis is reached in "le nous." A new set of contraries now engenders itself, contraries reduced to the most simple clichés of direction and manner, "par ci / par là / comme ci / comme ça." A resonance at the core of Arp's bipolar structures is struck, and a bell sings within the vessel of the poet's mouth, resounding throughout the chamber of the head:

> une cloche chante dans ma bouche
> comme ci
> comme ça
> c'est l'heure de la minute
> c'est l'heure de l'air

Time itself is simultaneously crystallized into the point of a minute and sublimated into an endless expanse of the air, diffused from an initial crystal moment to the "four corners of the world."

Arp consciously isolated and developed the bipolar point in his poetry as early as 1922, in the collection later published in 1930 as *weisst du schwarzt du* (*if you white, you black*). In the initial poem of the collection, Arp reconciles a square to the circle and condenses the unified geometrical contraries to a point, which then exfoliates again in a clockwise progression of contraries:

> sie gehen ein quadrat
> einen kreis
> einen punkt
> und drehen sich auf dem punkt

> pünktlich halb um
> und wieder halb um
> und gehen weiter
> und wollen nicht ausratten
> auf der rattenmatte
> auf der zwölftesten platte
> und kürzen das kurze
> und verlängern das lange
> und verdünnen das dünne
> und verdicken das dicke
> und bleiben sich vis-à-vis[7]

Each half rotation around the point is met by the complementary and opposite 180-degree rotation. The point itself is transformed into a clock after Arp introduces it as an adverb, "pünktlich" (punctually). The contraries generate one another with clocklike regularity. Thinness is thinned, whereupon thickness is thickened. The rotation of the hand around the clock from 6:00 to 12:00 is balanced by a mirror image of rotation in the opposite direction, in which all the elements remain "vis-à-vis." The "sie gehen" of the first line in the poem is plural, announcing the principle of fission. The "sie" are split, vis-à-vis, as they progress in opposite directions through the series of contraries. This split into plurality maintains the principle of bilateral symmetry as the two agents follow identical but opposite 180-degree trajectories, engendering contraries while remaining face-to-face mirror images of one another.

There is a proximity of structural tensions engendered by Arp's bipolar *bewegte Ovale* to the tensions of bilateral symmetry in the Dada woodcuts; for example, those illustrating Richard Huelsenbeck's *Phantastische Gebete*. The formal principle which immediately preceded that of the fluid ovals[8] is reestablished in mirror image oppositions that Arp sets up throughout the collection *weisst du schwarzt du*. The majority of these poems evolve through a progression of contraries, a process signaled by the title of the collection. The point at which each contrary is generated by its opposite is literally a "turning point" in time, space, or direction. For example, the second poem begins as follows:

> ist dies diesseits
> ist jenes jenseits
>
> das vorderteil geht vorne hinaus
> das hinterteil geht hinten hinaus
> und die mitte bleibt stehen[9]

Each element of the poem both replicates itself and engenders its opposite, which then likewise replicates itself. "Dies" replicates itself into "diesseits," then generates its opposite, "jenes" and "jenseits." "Vorderteil" replicates into "vorne," then generates "hinterteil" and "hinten." The point stays in

place to promise the renewal of all potential inherent to the species or realm, regardless of the individual direction in which life forms have developed the day before. Although the point may rest dormant through the night, it will germinate anew the next morning.

Arp transforms the point into the double image of pearl and dewdrop in the poem "Pousses" of 1953.[10] The generative point signals a plethora of growth, which is announced in the title, "Sprouts."

> Pousses
>
> La lumière jette des perles dans un jardin
> les belles pousses élancées.
> Jeux perlés
> Vive les perles!

Manifesting themselves simultaneously as light and as water, the pearls are reflections of the morning sun in the dewdrops, the interaction of the sun's "fire" and the element "water." No sooner do they enter the sentence than sprouts appear. The germinating interplay of pearls, points, light, and sprouts begins, and the cry "vive les perles" launches new life into its next phase of growth, differentiation and the development of stems:

> Colonnes vivantes, sveltes.
> Cadence des tiges.

The cadence sounds as the stems merge with shadows and the sprouts awaken out of dormant sleep into the blue skies of day:

> L'ombre et la tige se confondent
> C'est alors qu'ils quittent le rêve
> et poussent dans le bleu tels des épées.

Each dewdrop/pearl/point/sprout is a microcosmic expression of infinite potential for universal growth, growth that must initiate in each discrete instance of germination. Life in the garden is one of infinite instants and instant infinities, the extreme of contraries and contradiction compacted into each germinative point.

> C'est une vie d'infinis instants.
> De chaque pousse surgit une main
> et à chaque main surgissent cinq pousses.

Man and plant become one expression of growth, as each sprout ramifies into a hand and every hand produces, in turn, five-finger sprouts. Stems, stars, and bones become one in a cosmic weave, in a veil of plant stars:

Leurs bouches s'ouvrent parmi les souvenirs des
souffles
envelopées dans un voile d'étoiles végétales.
Les cavitées articulaires écument et sirotent.

Breath is introduced, and articulation begins. The articulation will be that of
the pre-Adamic tongue, in which the act of naming is one with that of creating.
The web of differentiating life is sublimated into the diffuse perfume of man
before the fall, and the stems and veins separate and structure a body of flesh.

Dentelles de veines.
Parfum d'Adam.
Des tiges furieuses se dispersent
pareilles à des éclairs dans un fond immense de chair.

Man is still one with nature, and human torso and tree are fused in an image of
growth. Trunks produce limbs, and the finest of filaments ramify into capillary
systems.

Des membres supérieurs s'élèvent et s'éloignent du tronc.
Des masses de filaments tenus, déliés,
enfin des consónnes fines,
sortent de leurs graines de lune embaumée.

From the cadence of stems, growth culminates in actual powers of speech.
These are the last seeds to germinate — the word (*logos*) which man himself
may pronounce in order to generate life. The living filigree of stalks, stems,
veins, trunks, bones, and flesh is assembled into a final image of the tortoise-
shell fan poised not far from the play of pearls, the initial points, which ger-
minated into the organic cosmos of the poem.

Des éventails d'écaille d'une belle venue
se balance non loin d'un jeu de perles.

The primal *aufgetahne Punkte* of the poem "Pousses" is not to be under-
stood as one single starting point from which all life develops. Rather, the
aufgetahner Punkt repeats itself in each individual instance of growth. Every
moment of germination is an "instant infinity," life itself the cadence of such
instants. The development of the poem is discontinuous, one constellation after
another of discrete points. The play of pearls in the first and final image is
effervescent; dewdrops alight in the sun before they evaporate. There is no
suggestion that the pearls are strung together in a continuous chain. Instead,
they are strewn at random like seed, glittering from the tips of freshly germi-
nated sprouts, sparkling in momentary configurations, each point a potential
expression of the infinite. Finalized form is introduced to the poem only in the

last line, with the image of a fan constructed from tortoise shell, hardened tissue that is no longer living. This configuration of inert matter is counterbalanced, however, by the resumption of the play of pearls, the reactivation of seminal points of light and water.

Jakob Boehme also combines the image of the pearl with that of the germinating sprout. The pearl is a variation on the bipolar generative microcosm in *Von der Menschwerdung Christi* (vol. II, ch. 8).[11] A trembling "Perlenzweig" is born at the moment of shock, the confrontation of opposites. The "Schrack" occurs as the "Angstquall" of death and the "stille sanfte Quall" of divine love come into contact and interact as the two eyes of the divinity. The pearl branch itself embodies the *conjunctoria oppositorum* as it grows into "das grosse Leben," which is born out of "dem Angst" and "dem Bösen."

> So dann seine Angst die Freiheit kostet, dass sie eine solche stille sanfte Quall ist, so erschricket die Angstquall und im Schrecken zerbricht der feindige herbe Tod, denn es ist ein Schrack grosser Freuden und eine Anzündung des Leben Gottes. Und also wird der Perlenzweig geboren, der stehet nun in zitternde Freude, aber in grosser Gefahr, denn der Tod und die Angstquall ist seine Wurzel und ist damit umgeben, als ein schöner grüner Zweig der aus einem stinkenden Miste auswachset, aus der Stankquall, und bekommt eine andere Essenz, Geruch, Wesen und Quaal, als seine Mutter hat, aus welcher er geboren ward: wie dann auch die Quaal in der Natur solche Eigenschaft hat, dass aus dem Bösen als aus der Angst, das grosse Leben erboren wird.

The new "Essenz, Geruch, Wesen und Quaal" diffused by the "Perlenzweig" could be characterized, in Boehme's terms, as the perfume of a restored Adam.

There is no definitive evidence that Arp took his "Perle/Pousse" directly from Boehme, but both poets develop the image with precisely the same dynamics involved and with the same final goal. Arp's germinative process culminates, as does Boehme's, in "das grosse Leben" and in "eine andere ... Geruch." The "parfum d'Adam" accompanies the lines with which the poem began: "Des tiges furieuses se dispersent/pareilles à des éclairs dans un fond immense de chair." Boehme often describes his moment of "Schrack" and the "Anzündung des Lebens" as a lightning flash. Arp's lightning flashes ("éclairs") likewise play in the cosmic depths of materialized flesh, "des éclairs dans un fond immense de chair."

The definitive characteristic in all Boehme's depictions of the microcosmic point is its bipolarity. The seminal point, or seed, cannot be activated without a built-in provision for the interaction of contraries, of the "ja" and "nein," black and white, "Angstquall" and "sanfte quall," "schöner grüne Zweig" and "stinkender Mist." A diagram illustrating Boehme's *Vierzig Fragen der Seelen* graphically demonstrates the bipolar opposition through which both the microcosm and the macrocosm can materialize (fig. 5-4). The diagram is entitled "Wunderauge der Gottheit," or, alternately, "Philosophische Kugel

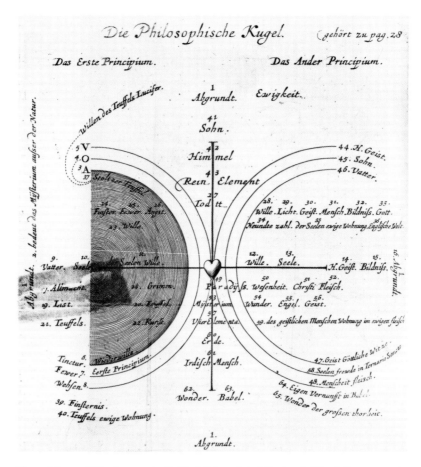

Figure 5-4. "Wunderauge der Gottheit," from Jakob Boehme's *Vierzig Fragen von der Seelen: Verstand, Essenz, Wesen und Eigenschaft,* 1648, Amsterdam. (*By permission of the Houghton Library, Harvard University*)

der Ewigkeit.'' Macrocosmic in dimension, it is equally valid for any microcosmic pearl or germinating seed. The divine eye is split into two eyes, which propel one another back-to-back while rotating in opposite directions. One arc issues from the corrosive fire eye of the divinity; the other issues from the sustaining eye of divine love, which radiates warmth and illumination. No materialization, macrocosmic or microcosmic, can take place without the inter-action of the opposing arcs. Boehme's concept of the materialized cosmos, of ''göttliche Leiblichkeit'' as divine corporality achieved through the interaction of contraries, is echoed in Arp's use of the term *concrétion* for the work of art.

In the 1951 collection *Auch das ist nur eine Wolke,* Arp expands the two-dimensional period/point into three-dimensional spheres, which are activated in his prose poem ''Bälle:''[12]

> Bunte Bälle bedecken mich von Scheitel bis zur Sohle. Sie haften, wie von einem Magnet angezogen, an mir.

The balls await fulfillment in the imagination of the poet, who must find a way for them to express their activated three-dimensional, geometric potential:

> Ich spüre ihr verfehltes, jammervolles Dasein. Sie möchten wie in einer abendlichen Gal-avorstellung im Zirkus, von kreideweissen, giftigem Licht umstrahlt, ein extravagentes Spiel aus blitzendem Treiben, prunkenden Schwüngen, stolzem Aufsprühen entfalten. Sie möchten kreisen, steigen, wirbeln. Sie möchten schweben.

The poet launches the points into geometrical acrobatics, tracing circles, curves, parabolas, and spirals. Following this imaginary gala presentation, the balls are suddenly ''aufgethan,'' sprung open into waves of light and sound:

> Ein starker Applaus aus einem in der Nähe gelegenen Gebaüde lässt die bunte Bälle, die an mir haften, in summende Punkte zerspringen. Das Zimmer blinzelt unsicher um mich. Die summenden Punkte schwarmen aus und durchdringen die Stühle, die Tische, die Bücher, die auf den Tischen liegen und in denen ich fleissig lesen wollte. Die Stühle, die Tische, die Bücher summen. Das ganze Zimmer summt.

The hum vibrates throughout the room as the points propagate themselves into every element in the environment. The room, the table, the books, the chairs — all are humming. Each microcosmic point participates in the macrocosm of the vibrating chamber. The previous geometrical dream of circles, arcs, and spirals finds expression in a resonance, waves propagated through space, which encompasses the room and each individual point in it.

In the previously discussed 1942 collection, *Poèmes sans prénoms,* Arp similarly transforms the geometrical figures of a circular sun and the helixes of a waxing and waning moon into resonant vibrations, the expression of an oscillation between polar opposites:

> les vrombissements des hélices de la lune
> chassent le soleil de miel
> je ferme les yeux et j'ouvre les fenêtres
> je ouvre la bouche et ferme la porte
> la moisson métallique carillonne dans ma tête[13]

A series of oppositions is established: sun and moon, opening and closing. These opposites are accompanied by double pairing of eyes and windows, and mouth and door. The head itself becomes the resonating chamber of the *aufgetaner Punkte,* a metallic harvest of vibration. Arp frequently converts the head into a bell, with the tongue as bell clapper. With in elliptical head, alternation between the two generative foci, the two eyes, is converted into sources of light waves. The tongue, or clapper, initiates the vibrations struck up at both ends of its arc as it swings from pole to pole within the head.

During the highly innovative and productive period in Grasse when *Poèmes sans prénoms* was written, Arp made his most intensive metaphorical use of what would seem to be the least lyrical aspect of writing: grammatical classifications and punctuation. This reduction in elements is even more radical than the sober language and strict bilateral and polar pairings of *weisst du schwarzt du.* In these experiments, Arp infuses his punctuation with heightened ambiguity, with energies for the generation of new forms, and with potential for recombinations within the general framework of the poem or the relief.

In the concluding stanza of the *Poèmes sans prénoms,*[14] Arp recapitulates alchemical motifs that have surfaced repeatedly throughout the collection. The rosy-red culmination of the alchemical process follows a successful realization of the *conjunctia oppositorum* (mating of opposites) of male and female, of sun and moon:

> une rivière accourt et chante et danse et boit
> son petit doigt
> et laisse les portes et les fenêtres du bonheur
> et du malheur ouvertes.
> les nuages entrent et attaquent à brûle-pourpoint
> les virgules
> et parent les traits d'union rouges entre les hommes
> et les femmes.

In the first image of the stanza, a hermetic circle is closed: a river rushes to meet its beginning, sings, dances, and drinks its little finger. A personification implicit in the common expression "mouth of the river" (which also exists in German and French) is taken literally with the actual presence of the river's little finger, which suggests the river's smallest tributary and its original source. A river drinking its own beginning is a liquid variation on the figure of the oroborus, the serpent swallowing its own tail. The river's hermetic closure completes a figure that can accommodate the polarities of the poem. Arp again

evokes the resonance chamber of the head, where eyes and mouth became windows and door. The head is now hermetically sealed as the serpentine river/ oroborus, and the windows and doors can be left open to admit both "bonheur" and "malheur." The clouds enter as vapor, a chemical sign of the process of sublimation in the hermetic vessel of the head. There they attack at "brûle-pourpoint" (point blank) or, literally in French, at the elevated temperature necessary to initiate the chemical transformation within the vessel. The attack is launched against the precipitates of the distillatory process: here, periods and commas. Arp's alchemical crystallite, punctuation signs, echo the grammatical title of the collection, *Poèmes sans prénoms.* It also leads to a surprising new embodiment of the *mercurius fils,* the offspring of a successfully realized *conjunctia oppositorum.* The creation of the *mercurius fils* is signaled by the appearance of the color red. In Arp's alchemical marriage of opposites, a red hyphen appears, the "traits d'union rouges entre les hommes et les femmes." The attacking clouds prepare the way for the "traits d'union" in this stanza, whereby the sense of the punctuation mark is expanded by having been taken as a literal realization of an alchemical union between male and female. The hyphen (*traite d'union* in French) has a similar literal capacity for bonding in German, where it is the *Bindestrich.* On occasion, Arp also takes this word at its face value, making it more than a hyphen.

The philosopher's stone, in all serious alchemical accounts, is not so likely to be found in gold as it is in the most commonplace, the most universally distributed of objects. For this reason, it is very difficult to recognize. By implication, Arp, in the *Poèmes sans prénoms,* would seek out the philosopher's stone in those most commonplace and seemingly lifeless objects in the verbal landscape: punctuation marks. These signs, taken literally rather than for granted, can be recognized as embodying the *conjunctia oppositorum.*

In English, there is no possibility for the wordplay with the hyphen that exists in both German and French. A hyphen binds words together, but only as a punctuation command. As noted before, in French and in German, Arp has further possibilities for playing with the double meaning of *Punkt* and *pointe* as either period or point. Once aware of the double significance with which he invests both the period and the hyphen in the *Poèmes sans prénoms,* one begins to notice a further punctuation mark that appears verbally and as a visual sign in Arp's work. This punctuation sign is the comma. Commas are specified, along with periods, in several poems and in the reliefs cited. In the 1955 relief *Bewegte Konstellation,* the elements of punctuation interpenetrate. On the left side of the constellation, the two elements announce themselves in isolation, oval and comma; on the right, the two are united within the framework of a further oval. The *Bewegte Konstellation* is in motion due to an implied fertilization. The sperm like comma and the female egg nucleus meet within the vessel of the ovum prior to the division of the fertilized egg into the zygote.

In the company of periods, commas had already appeared, in 1939, in the collection *Muscheln und Schirme,* where they display generative powers of their own.[15]

> der blitz schiesst für
> die schlange die flügel
> vom mond das
> komma strickt für den
> punkt eier
> voll schritte der
> schwanz zählt für
> die zunge die sterne
> in den mähnen

Within the image "the comma knits eggs for the period" are all the implications of the *bewegte Konstellation.* The period/point suggests the ovum; the comma with a tail, which follows the production of the eggs, suggests the sperm cell. The eggs are full of steps, or developmental stages, in this *bewegte Konstellation,* and between the tongue and the tail waves a mane of celestial configurations with all its star points to be counted.

In the next stanza of the poem, quartets of commas and periods are paired as complements, the two quartets carrying clouds of different colors:

> vier punkte tragen eine rosenrote
> wolke vier
> kommas tragen eine
> meergrüne wolke

The complementary opposition of the two quartets in the stanza is intensified by the color associations of "rosenrote" and "meergrüne," fire (or the sun) opposed to water and the sea. Commas carry the same cloud load as periods, and one is led to ask if they are not carrying a metaphysical charge as well.

In later constellations, commas become almost equivalent to navels. The comma is modified toward the shape of a drop in which the head is slightly more rounded and the tail foreshortened. Arp often accords these drop/commas titles that imply the germination of plants. The first designated appearance of commas in the relief of 1943 is followed, in one alternate title, by the question, "Wird eine Blume daraus?" ("Will it turn into a flower?") Indeed, commas are associated more and more with vegetation, and navels with animal growth, in the later works. In the white on white relief of 1959, two commas are placed within an oval field, their tails touching. The relief is called *Bourgeon de larmes* (*Bud of Tears*) (fig. 5-5), and the containing oval of the two commas would suggest both egg and eye. The drop of the tear becomes one with the germinative bud of the plant.

Arp's Alsatian acquaintance, Otto Flake, mentioned Arp's fascination in

Figure 5-5. Hans (Jean) Arp, *Bourgeon de larmes,* 1959
 Relief, 40 x 40 cm.
 Location unknown.
 (*Photo: Robert David*)

Zurich with the writings of Jakob Boehme and Lao Tse.[16] Flake knew Arp at the time, and one may assume that Flake's remark in his *roman à clef* depicting Zurich Dada personalities was doubtless based on his recollections of Arp at the time. Carola Giedion-Welcker, likewise a lifelong friend from the first years in Zurich, makes a similar reference to Arp's interest in Boehme and Lao Tse.[17]

One obvious reason for Arp to have been reading both Boehme and Lao Tse, at the same time, was his interest in philosophical models that depict cosmic development in terms of interacting polarities. Lao Tse, rather than having to invent his own model, works from a construct already established in Taoist tradition. The *T'ai-chi-tu* (great map of poles) is the Taoist symbol for the interaction of contraries, the cosmic principles of yin and yang (fig. 5-6). The yang is male and represents fire, dryness, light, and the creative principle active in nature. Yin is female and represents moisture, darkness, and the earth's receptivity. The universe is generated through the interaction of these two opposing principles. The *T'ai-chi-tu* is contained in a circle, but the circle is set into motion by being split into the contraries of black and white.

Both Boehme and Lao Tse require systems with two foci. Boehme places incredible strain on the confines of his *Philosophische Kugel,* rendered two-dimensionally as a circle that must contain the back-to-back propelling forces of the two opposing divine eyes. The *T'ai-chi-tu* offers a model in which the two foci, divided by an S-shaped curve, are more organically inegrated into the confines of a circle. Here, two halves of an implicit interior circle are likewise split. Rather than confronting one another back-to-back, however, they are linked in a curved continuum, a line that separates as it unites, transforming the frame of the circle from a figure of static equilibrium to an expression of polar opposition and suggested rotation.

In his essay "Analysis of a Symbol of Interaction," Rudolf Arnheim focuses on the *T'ai-chi-tu*, examining the relation of both parts to one another and of the parts to the whole.

> By inscribing in a circle two smaller circles of half the diameter of the first, one obtains an internal S-curve made up of the two half-circles. This shape has certain disadvantages. Circular curves are hard and inflexible, which interferes with the dynamics of the patterns that use them. Also, being of constant curvature, they form no apex as, for instance, a parabola would. These possible drawbacks, however, are compensated by the fact that the circular internal shapes reflect the circularity of the total pattern and thereby contribute to the intimate relationship of the whole and parts, essential to the symbolical meaning of the figure.[18]

Arnheim suggests a Japanese name for these two half-circles created by the S-line, a teardrop shape called "matagama." He elaborates on the matagamas' positioning within the whole of the circle, on their autonomy, and on their potential for interaction. The matagamas maintain their autonomy by being simply shaped and strongly unified. Each of them profits from the isolating

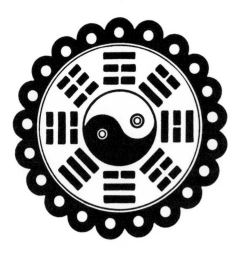

Figure 5-6. *T'ai-chi-tu* (great map of poles),
the Taoist symbol for the
interaction of contraries.

power of a semicircular head. He characterizes the matagama as a variation on the more simple symmetry of the teardrop shape. Throughout Arnheim's analysis, one could substitute a stylized Western comma for the Japanese matagama, and the principles of interaction and autonomy would still hold. Transposed to a Taoist context, two commas, each with a focus in its circular head, could fit tail-to-head within a circle, thereby constituting a bipolar point, or period. Once one has recognized a structural similarity between the separate halves of the *T'ai-chi-tu* and the comma, it is difficult to imagine that Arp would not have had this affinity in mind when he introduced commas to poems and visual constellations along with periods and hyphens. All are charged with metaphysical significance beyond their powers as punctuation.

The autonomous matagamas of the *T'ai-chi-tu* interact, first with one another, then with the circle as a whole. These interactions, all occurring simultaneously, can be registered by an observer only if his physical perception oscillates between the different possible configuration patterns in which the parts and the whole may be ordered. As Arnheim explains, perceptual oscillation is a necessity if the human perceiver is to absorb the figure in its entirety.

> Equal strength of whole and parts creates ambiguity, and ambiguity produces oscillation. The mind cannot hold two different structural organizations of the same pattern at the same time — it can only sub-ordinate the one to the other. Consequently, the mind provides for the necessary hierarchy by alternately giving dominance to either structure. At one moment the whole prevails, at the next, the parts. Such oscillation makes it possible to present identity without losing duality.[19]

Identity presented without loss of duality is characteristic of Arp's formal vocabulary — independent images which contain, within themselves, a multitude of often contradictory images. Ideally, the range of interior images would encompass the polar extremes of latent image possibilities. Perception is then forced to oscillate between polar extremes in order to integrate the figure of the whole, which is simultaneously expressing itself through opposite parts.

Arnheim emphasizes the intertwined aspect of head-to-tail positioning of the two matagamas within the circle:

> This intertwining of two obliquely placed figures is perhaps the most stable organization the T'ai-chi-tu yields and is, at the same time, a particularly dramatic picture of the two generating powers in interaction. The over-all result is a protean spectacle. The solidity of a convex object constantly changes into the emptiness of shapeless ground and vice-versa. No more impressive perceptual support could be given to the preaching of the Taoists against the short-sighted notion that objects, acts or events are isolated, self-contained entities in empty space. The T'ai-chi-tu demonstrates that each fact posits its opposite and complement, and that what looks like mere surroundings from one point of view appears as the central positive fact from another.[20]

This interplay of concave and convex, of "empty" space and solid object, is a dynamic tension on which Arp's sculpture is based. Such interplay is a natural extension, into three-dimensional space, of complementary tensions that Arp creates between two-dimensional forms and the "empty" plane on which they appear. This interplay of "empty" space and elements of constellation is equally important to the reliefs, a structural feature that is commented upon frequently by Carola Giedeon-Welcker and other Arp critics. It also characterizes the interchangeability between figure and ground in the Dada "Earthly Forms" and pre-Dada drawings. Arp actually intended to name a sculpture after the Taoist interplay of space and materialized object. The sculpture, *Lengam,* was originally entitled *Yin-Yang,* but Arp was delighted with a mistaken pronunciation of the title and opted for the oblique, rather than the direct, reference to Taoist dynamics.[21] This indirect route was, in fact, the one he invariably took when translating into works of art the dynamic energies of those philosophical systems that interested him. Arnheim comments further on the perceptual oscillation required by the *T'ai-chi-tu* and by Bohr's principle of complementarity:

> Whether both components of the T'ai-chi-tu really can assume figure-character at the same time and be seen together in one unified precept is debatable. But in addition, or instead, of such peaceful co-existence there surely occurs the oscillation of views that cannot be held together because they exclude each other. In such alternation, the figure-role constantly passes from one matagama to the other, while the partner vanishes to become ground. These two views are also complementary, but in the modern sense of the term introduced by the physicist Niels Bohr. When perceptual inversion occurs, a new view presents itself, which is not experienced as a change of conditions in the world of outer objects but as a changed aspect of the same objective state of affairs. The two conditions contradict each other only as views (perceptual statements) but are experienced as one complex state of the objective situation and therefore as existing together rather than occurring consecutively.[22]

Considerable perceptual tensions are generated by any model in which contradictory categories must be integrated into one concept, in which precise location of elements is impossible because they are, in effect, simultaneously everywhere. The strain is not unlike the tensions embodied in Jakob Boehme's "Wunderauge der Ewigkeit," or in the more immediate perceptual effect of the *T'ai-chi-tu.* Anyone constructing a system to be activated by polarities, whether artist, philosopher, or scientist, would be instinctively attracted to Niels Bohr's principle of complementarity. Likewise, Boehme's "Wunderauge," with its interacting "ja" and "nein," and the *T'ai-chi-tu,* with its perceptually evoked interaction of yin and yang, could attract the empirical scientist trying to construct paradigms in which opposites may be accommodated. Marguerite Hagenbach maintains that Arp was particularly interested in Bohr's principles of complementarity, which Arp cited in an essay of 1952.[23] The perceptual oscillation demanded by Bohr's atomic model and by the *T'ai-chi-tu* is a

Figure 5-7. Hans (Jean) Arp, untitled cover of *Transition*,
ed. Eugene Jolas, 1932, Paris.
(*Foundation Arp: Clamart*)

phenomenon that Arp activates in his deployment of commas, periods, fluid ovals, indeed, in all his elemental forms. In his introduction to the 1981 catalog of Arp's reliefs, Michel Seuphor characterizes the oscillation between "attraction" and "opposition" that Arp establishes within the single figure.

> L'art est de réunir association et opposition dans la même objet, dans la même image, voire dans la même profil plastique qui, ondulant à ravir, se trouvera tout à coup brisé, puis raidi dans la droite absolue.[24]

No visual work by Arp oscillates more intensively between figure and ground, between the polarities of black and white, and between two oval foci than a print which he produced for the cover of the 1932 issue of *Transition* (fig. 5-7). Two torso-like shapes with oval navels are placed head-to-foot, the left figure black and the right one white, in a way that indicates an oscillation of perception from one figure to the next, an oscillation in which they are alternatively perceived as torso and background. The two torsos, positioned head-to-foot, and their two foci reinforce the perceptual oscillation. Furthermore, in Arp's print, the two navel foci can be perceived within two different configurations. On the left, one sees either a white oval with a black center or a black oval framed by a white background. The process is reversed on the right. Whatever oval one perceives, a figure is doubled by its opposite. Each oval focus generates its own torso, and the black figure to the far right, functioning as more than just a frame that defines the white torso, suggests one half of a third torso. By implication, a third navel would result in the completion of a new black torso, which has already begun to materialize. A navel would mark the actual birth into the world of this incipient human form. Important for Arp's theme of continuous generation is that one perceive the development on the right as potential form, a torso in progress, rather than a visual "fait accompli."

In this work, the commas, or yin and yang of the *T'ai-chi-tu*, are humanized, transformed into a black and white opposition of torsos, presumably male and female. The ontological reading of the configuration, however, has not changed: the work of creation remains in never-ending progress. The period/points of micro/macrocosmic structures have been humanized as well. They have become navels, the sign of human birth and the generative point around which each fully developed torso has materialized. No reading of the constellation reliefs would be complete without reference to Arp's human realizations, the *concrétions humaines,* of his periods and commas.

Notes for Chapter 5

1. Hans Arp, *Unsern täglichen Traum* (Zurich: Arch, 1955), p. 12. Jane Hancock has given a detailed account of this discovery as Arp's fundamental breakthrough to an individual style

in her dissertation "Form and Content in the Early Work of Hans Arp, 1903-1930" (Harvard, 1980), ch. 4.

2. Wassily Kandinsky, with whom Arp was in contact from 1912 on, also converted the period into a point in the essay "A Little Article on Big Questions." Here Kandinsky discussed the possibility of lifting the period out of its accustomed context and printing it alone on the page. In isolation, the period becomes a point with a new range of potential expression in the visual realm. My appreciation to Jane Hancock for calling my attention to this article.

3. Interview with François Arp in Paris, September 1981.

4. Hugo Ball, *Flucht aus der Zeit* (Lucerne: Stocker, n.d.), pp. 159-61.

5. Ibid., p. 148.

6. Jean Arp, *Jours effeuillés* (Paris: Gallimard, 1966), p. 171:
 I am a point
 and dream of a point
 eternity with four corners
 I lance my lance into the eye of the heart
 my feet balance the air
 I lick the high and the low
 the soul of the heart takes flight
 and plants an animal
 the animal swells up
 and laughs
 and fans out across the air
 I turn the wheels of reds
 I turn my key
 like that
 I close the door
 I close the circle
 finally the water wells up between you and me
 and carries the us
 this way
 that way
 like this
 like that
 a bell sings within my mouth
 like this
 like that
 it is the hour of the minute
 it is the hour of the air

7. Hans Arp, *Gesammelte Gedichte I* (Wiesbaden: Limes, 1963), p. 126:
 they walk a square
 a circle
 a point
 and rotate on the point
 punctually halfway round
 and continue
 and do not want to rat out
 on the rat-round mat
 at the twelfth-most flat
 and shorten the short

and lengthen the long
and thin out the thin
and fatten the fat
and always remain face-to-face

8. Arp, *Unsern täglichen Traum,* p. 12.

9. Arp, *Gesammelte Gedichte I,* p. 127:
 is this the here-and-now
 is that the here-and-after

 the frontside goes out forwards
 the backside goes out backwards
 and the center stays in place

10. Arp, *Jours effeuillés,* p. 395:
 Sprouts

 The light strews pearls throughout a garden
 beautiful sprouts started on their way
 play of pearls
 Long live the pearls!
 Living columns, svelte,
 Cadence of the stalks.
 Shadow and stalk seem to merge
 and now they leave the dream
 and grow up in blue blades of the foils.
 A life of infinite instants.
 From every sprout springs forth a hand
 and five sprouts, from every hand.
 Memories of signs cause their mouths to open
 enveloped in veils of vegetative stars.
 The articulating cavities begin to foam and whistle.
 Lace of veins
 Adamic perfume.
 The furious stalks disperse themselves
 like stars in an immense depth of flesh.
 The superior members raise themselves and extend beyond the trunk
 Masses of filaments, taut, delirious,
 At last the fine consonants
 emerge from their grains of embalmed moon.
 The tortoise-shell fan of a lovely surrounding
 is poised not far from the play of pearls.

This poem was designated by Arp to accompany a monograph on the sculpture of François Stahly, a younger friend of Arp whose work embodies a sense of organic growth similar to that expressed by Arp himself. Stahly told me that he and Arp had discussed Novalis and numerous earlier mystics in their conversations in Meudon. Stahly noted that Arp was particularly interested in Christian writers who made extensive use of hermetic sources in formulating their thought. Interview, Meudon-Bellevue, August 1983.

11. Jakob Boehme, *Sämmtliche Schriften,* ed. Peuckert (Stuttgart: Frommann, 1957), vol. 4, p. 172: "So when his angst tastes of freedom, realizing that it is such a quiet and gentle source, at that moment the angst source recoils and in this shock, the bitter inimical death is shattered, because the shock is one of greatest joy and the ignition of divine love. And thus

the pearl-branch is born, it stands now in trembling joy, but also in great danger, for death and the source of angst are its root and its surroundings, just as a lovely green branch grows up out of stinking manure and receives another essence, smell, being and source than that of its mother from which it is born: the source of nature is characterized in the same way, that out of evil, out of angst, glorious life is born."

12. Arp, *Gesammelte Gedichte I,* p. 114: "Colorful balls cover me from head to foot. As if drawn by a magnet, they cling to me. I can sense their failed, pitiful existence. They long for something like an evening gala circus performance where, spotlighted in chalk-white caustic light, they could unveil their extravagant play of sparkling drives, splendorous arcs, noble leaps and springs. They long to circle, climb, whirl. They long to soar. / Loud applause from a nearby building allows the bright balls, which are still clinging to me, to explode into humming points. Uncertain, the room sparkles around me. The humming points swarm out and penetrate the chairs, the tables, the books that are lying on the table and in which I intended to read diligently. The entire room is humming."

13. Arp, *Jours effeuillés,* p. 175.
throbbings of the helixes of the moon
chase the sun of honey
I close my eyes and open the windows
I open my mouth and close the door
the metallic harvest carillons in my head

a river rushes and sings and dances and drinks its little finger
and leaves open the windows of happiness and sadness
the clouds enter and attack the commas at point blank
and make ready the red hyphens between the men and the women

14. Ibid.

15. Arp, *Gesammelte Gedichte I,* p. 246.:
the lightening bolt shoots
the wings from the moon for
the snake the
comma knits eggs
for the period
full of steps the
tail counts for
the tongue the stars
in the manes

four periods carry a rosy-red
cloud four
commas carry a
sea-green cloud

16. Otto Flake, *Nein und Ja* (Berlin: Schmiede, 1923), p. 79.

17. Carola Giedion-Welcker, *Hans Arp* (Stuttgart: Hatje, 1957), p. xiv.

18. Rudolph Arnheim, *Towards a Psychology of Art* (Berkeley: Univ. of California, 1972), p. 233.

19. Ibid., pp. 236-37.

20. Ibid., p. 239.

21. Conversation with Greta Stroh, director of the Foundation Arp, Meudon, July 1982.

22. Arnheim, p. 240.

23. Conversation with Marguerite Hagenbach-Arp, August 1982.

24. Michael Seuphor, Introduction to *Hans Arp: The Reliefs* (Stuttgart: Hatje, n.d.), p. xxxi: "The art is to unite association and opposition within one and the same object, within the same image, even within one plastic outline, undulating to the point of ecstasy, which suddenly finds itself broken, then drawn into the absolute perpendicular."

[Research for this article was made possible in part by support from the Alexander von Humboldt Stiftung.]

6

Dadamax: Ernst in the Context of Cologne Dada

Charlotte Stokes

For Max Ernst, or Dadamax as he termed himself, Dada was a liberating force that permitted him to work out his own solutions to artistic problems. Although Ernst was as disillusioned with conventional society as any of his Dada contemporaries, his work is not anti-art. His rebellion takes the form of art that is subversive, that takes swipes at artistic conventions from the inside. While Ernst clearly intended to shock with unconventional themes and methods, even his earliest Dada works have an artistic order that may be derived from his pre–World War I experience: his study of psychology and of art history at the University at Bonn, or his connections to the Munich Expressionists and, through them, to avant-garde French painting. In any event, the Dada rebellion liberated Ernst. At the same time that he was enthusiastically participating in such Dada activities as the outrageous Dada in Early Spring Exhibition in Cologne (1920), he was also developing methods of working, themes, and philosophies that remained with him for the rest of his career.

When Max Ernst was, as he said, "resuscitated [on] the 11th of November 1918"[1] by being set free after his four years of active duty in the German army, he did not go back to the Expressionism he had known before the war. During those years his friend, the Rhineland artist August Macke, had introduced Ernst to the group of artists in Munich associated with the *Blaue Reiter Almanac* (1912). Around the *Blaue Reiter Almanac* revolved the most international of the German Expressionist artists. Vasili Kandinsky, who along with Franz Marc was at the center of the group, brought with him the culture of Russia. The group also looked to Paris and all its revolutionary art movements and even to the contemporary scientific discoveries of Einstein and Planck. The *Blaue Reiter Almanac* itself contained, along with reproductions of contemporary art, illustrations of primitive art, children's art, European folk art, and

early German prints. Philosophically, it sought to link all the arts with life experience itself.[2] Macke had also introduced Ernst to Robert Delaunay and Guillaume Apollinaire in 1913. These links are important because Cologne Dada takes its distinct character from the relationships of the artists — especially of Hans Arp and Ernst — who were connected to and influenced by pre-World War I French avant-garde art and German Expressionism as well as by wartime Dada.

The war changed the art world that had seen Ernst's decision to become an artist; Macke, who had been his mentor and link to the Munich Expressionists, was dead, along with many others. And Dada, spawned and flourishing in Zurich, was beginning to supplant Expressionism in vigor and innovation. In a Dada exhibition in Zurich Ernst had already shown *Battle of Fish,* an Expressionistic work he painted while on leave in 1917. After his discharge Ernst established himself in Cologne instead of in his family home at Brühl or in Bonn, to complete his formal education or to continue his informal artistic apprenticeship of his college days. In Cologne Ernst took to postwar Dada immediately.[3]

One of Ernst's guides was the "senior" Dada, Hans Arp, whom he had met first in 1914. Arp also had been associated with the group around the *Blaue Reiter Almanac* before the war; during the war he was one of the founding members of the Dada group in Zurich. But Arp used Dada in a quite different way from his more boisterous Zurich contemporaries. For them Dada art, or anti-art, was only one of a number of ways of attacking the values of the society around them. Richard Huelsenbeck would later say that Arp had a "classical, pure approach to art"[4] that kept him away from the "publicity" of Dada while accepting the support of its members. Arp saw Dada as a route to freedom, leading to pure plastic expression of his own feelings. Arp's body of work has a consistency belying his association with various movements; conceptually and formally, "Expressionistic" etchings such as his *Crucifixion* of 1914 seem only a step from "Dada" works such as his *Automatic Drawing* of 1918. Beginning his formal training by entering an art academy at eighteen (1904), Arp pursued the goals of an artist from the beginning of his adult life.

In contrast, Ernst came to art comparatively late. He had planned a university degree with an emphasis in abnormal psychology. He, of course, had gone to a *Gymnasium* for the rigorous classical secondary education that would prepare him to enter the elite world of the German university system. Although he remained committed to psychology, he gravitated to courses in art history. In his life outside the University he began to play a role in the art world, writing criticism for local papers, showing a few works in exhibitions, and finally deciding to become an artist in 1912.

He, like Arp, saw Dada art as an important means of self-expression rather than as an adjunct of political and other activities. As Dadaists, both Arp and Ernst at first avoided traditional materials such as bronze and oil

paint. Ernst, in particular, would see in the exploration of nontraditional techniques a means of realizing artistic inspiration. This would be a characteristic of his work for the rest of his career. He developed collage and frottage (rubbing), two of his great technical innovations, in his Dada pieces and continued to explore them in various forms in his Surrealist works. His continuous search for new techniques prevented him from refining his art to great heights of technical virtuosity but — and more important to him — this very limitation would prevent him from developing "manner." He retained the Dada qualities of instability and spontaneity; he was the explorer, rarely the settler, into any technique.

Because Ernst and Arp saw in Dada a means of liberated personal expression they worked together well even though their individual styles differed. Unlike Arp, Ernst would come to "abstract" means only rarely. His background of strict intellectual training, especially in psychology and art history, marked him as an artist who looked to manipulation of subject as a means of expression rather than to the formal concerns that interested the artistically trained Arp. The manic nature of Dada gave Ernst the freedom to explore these subjects in freewheeling, often shocking, ways.

The collages called *Fatagaga,* an acronym for *fabrication des tableaux garantis gazométriques* (fabrication of pictures guaranteed gasometric), were collaborations by members of the Cologne Dada group but Ernst's hand seems to be dominant in the choice of secondhand images — engravings and photographs from popular books, magazines, and catalogs — and the evocative nature of the subjects themselves. In the collage *Here Everything is Still Floating* Arp's contribution seems to have been the title although this is not clearly the case in all the *Fatagaga.*[5] The cut-and-pasted *Fatagaga* collages are certainly related to Arp's *Squares Arranged According to the Laws of Chance* (1916-1917) but, in the case of the *Fatagaga,* each artist gave up control to the other, rather than to chance.

Many of Arp's and Ernst's works are related in their use of natural forms but Arp developed forms in his wood reliefs that are biomorphic and abstract — forms suggestive of life without representing any of its specific forms. Ernst continued to use recognizable biological forms in such works as *Sitzender Buddha (demandez votre médecin)* (fig. 6-1), based on a schematic diagram of the brain. On this diagram the artist painted out or enhanced certain parts and collaged elements onto the surface.[6] In contrast to Arp, Ernst kept ties to the subject by actually showing that subject and subverting our perceptions of it with painted or collaged modifications. One of their more telling "collaborations" is the cover of *Die Schammade*[7] (fig. 6-2), a magazine edited by Ernst in 1920. On this cover the "Dadameter," a parody of the rational methods of measurement used in biological science that reflected the concerns of Dadamax, is juxtaposed to the free biomorphic and abstract woodcut by Arp.

Die Schammade was the last in a series of Cologne Dada periodicals that

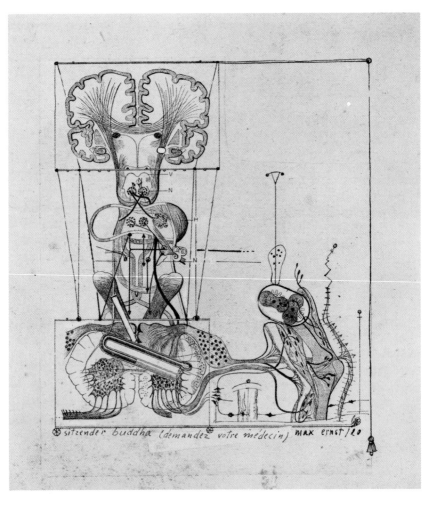

Figure 6-1. Max Ernst, *Sitzender Buddha* (*demandez votre médecin*), 1920
 Drawing, paint, and collage, 20.3 x 19.5 cm.
 (*Collection: Mrs. Barnett Malbin, New York*)

Figure 6-2. Hans (Jean) Arp and Max Ernst, *Dadameter,* cover, *Die Schammade,*
ed. Johannes Baargeld and Max Ernst, 1920, Cologne.
(*Private collection, New York; photo: Estera Milman*)

were started by the third member of Cologne Dada, Alfred Grünewald. He was known also as Baargeld, which translates as "easy money," and was the son of a wealthy Cologne businessman who financed Dada activities in hope of keeping his son out of Communist activities. Although Baargeld contributed to the artistic aspect of Dada, including the *Fatagaga*, he was equally concerned with political questions. He was the guiding spirit of the first Cologne Dada publication after the war. It was called *Der Ventilator* because it was to bring in fresh air through the use of mockery and more direct attacks on wartime social and political systems. The periodical reached a wide circulation before the occupying British troops stopped its publication. Later *Bulletin D,* a joint effort of Baargeld and Ernst, served as the catalog of the first Dada exhibition in Cologne in 1919. *Die Schammade,* guided by Ernst's interests, moved further away from political concerns; it was devoted very much to poetry and the visual arts, containing contributions from members of Cologne Dada and the international Dada movement.

Certainly we can find models for the group activities of the Cologne Dada group (Zentrale W/3 West Stupidia) among artist's groups such as the Expressionists. But many of the Dada events were like children's pranks. Indeed the character of youthful rebellion in both Expressionism and Dada comes from some of the same cultural forces that produced the German youth movement the Wandervogel (migratory bird), which reached its peak before World War I and during the same period that saw the development of German Expressionism and the adolescence of many Dadaists, including Ernst.

The Wandervogel was composed largely of middle-class boys in their teens. Formed into small groups, they were led not by an adult but by an older boy in their group. Escaping the rigid rules of home and school, the boys set off on wandering trips through the countryside, often sleeping out of doors. They wore rough camping clothes which some of them topped off with a hat decked with feathers. Their clothes marked them. The Dada groups with their dandy clothes and rebellious monocles[8] demonstrated the same type of social rebellion — for which dress is an important symbolic gesture — against older values. Although the members of the Wandervogel were not political in a direct sense, they were committed to revival of folkways — songs, poems, and crafts — that they considered true to German life.[9]

Similar elements but with more concern for aesthetic values are to be found in the *Blaue Reiter Almanac* with its folk art and early German woodcuts. Like the members of the Wandervogel, the Expressionists wanted to get back to truer means of expression. The young Expressionists believed that academic art and the social and political structure that supported it were corrupt and divorced from real experience. They also believed that youth would lead the return of society toward worthwhile goals. One aspect of the Wandervogel that also fit the requirements of the Dadaists was the concept of

purposeful nondirection: set a task loosely, play it out with kindred spirits, and take the result as is.

Where the Wandervogel, the different Expressionist groups, and the Dadaists parted company was in their views of modern life. The members of the youth movement wanted to get back to nature and to their own roots in the Romantic and Germanic sense. Expressionists such as Macke saw a hopeful future in the modern industrial city: the woman at the shop window was the new Venus; the man reading the newspaper was the new intellectual. This optimistic vision is in contrast to a city environment of pain and loneliness that the (specifically) Berlin Expressionists saw. After the war Berlin Dada would continue the tradition of the Berlin Expressionists and be the most political and the most radical of the Dada groups. Arp and Ernst in Cologne would retain an interest in cultural rather than political matters that exemplified the Expressionists associated with the *Blaue Reiter Almanac* in Munich. Whatever their locale or traditions all the German Dadaists held equally pessimistic opinions of modern life — no doubt intensified by the occupation and harsh living conditions after the war.

The Dadaists response to the horrors of war was a profound disillusionment with the patriotism, religion, modern education, and technology that brought about and justified the war. Whatever their approach the Dadaists' first works were protests — Ernst said expressions of rage[10] — at the death, maiming, and lost youth that were the products of the war. Unlike the cries of most of the Expressionists the Dada artists not only shouted but also carried weapons to attack. Their most deadly weapon was humor. Whether it be black sarcasm or dizzy nonsense, humor was the agent provocateur of the Dada.

Within this postwar context, which included social and artistic influences from before and during the war, Ernst developed as a mature artist. Between 1919 when Cologne Dada was formed by Ernst and Baargeld and 1922 when Ernst left Germany for Paris never to live in his native country again Ernst touched on all the major themes (e.g., psychology, fashion, art history, natural science) that would occupy him for the rest of his career. Certain types of works are associated with his Dada years but the basic concepts associated with these early endeavors are no more Dada than those used later. Indeed, many of them are explored again later. The early works are simply the first. Dada is the catalyst. If one sees Surrealism as a more systematic approach than Dada to self-expression through nontraditional means then Dadamax was always a Surrealist. If one looks at the techniques he explored but never developed and at the mind fully aware of the absurdities of conventions and thinks of this as Dada, Ernst never stopped being Dadamax.

An Ernstian touch is present even in his early Expressionistic paintings such as his 1913 *Hat in Hand, Hat on Head*. In a parklike setting a man tips his hat to the self-consciously provocative woman but another hat, larger and

very phallic, still rests on his head. A sense of irony pervades the picture, an irony completely absent in the idyllic paintings of city parts by his friend Macke. In 1913 Ernst had read Freud's *The Interpretation of Dreams*[11] and though the play of hats was probably suggested by this book[12] Ernst's painting is not a transcription of *angst*, the feeling transmitted in paintings by contemporary Expressionists like Ernst Ludwig Kirchner and Erich Heckel. Using the painting style open to him at the time Ernst, the future Dadamax, showed the hypocrisies in social graces that disguised but could not hide not-so-socially acceptable sexual instincts.

The sexual implications of fashion continued as an important theme in Ernst's work. *The Hat Makes the Man* from 1920 (fig. 6-3) is a Dada example of the use of this theme. Ernst takes the interest in contemporary fashion and bright color from Macke but with a difference. The fragmented shapes and the straight lines associated with Cubism and the color prisms associated with the Delaunays are given sexual and ironic possibilities when Ernst modified with collage and paint a page from a hat catalog. A rough translation of the French and German in the lower right: "Seed-covered stacked-up man, seedless water former (precious former) well-fitting nervous system also !TIGHTLY-FITTED NERVES! (the hat makes the man, style is the tailor)."[13] Even in translation — without puns — the long title plays against the phallic men who are literally made of hats. Ernst sees in modern man a repressed sexuality that pops through his clothes no matter what. And hats — be they the conventional hats worn by conventional men or even the affected headgear worn by his Dada contemporaries — concealed the natural and unique hair that sprang from the heads of individuals of free intellect and personality.

In response to seeing reproductions of de Chirico's paintings in 1919 Ernst made a series of lithographs called *Fait Modes: Pereat Ars* (*Let there be fashion: Down with Art*). The latter half of the title, a Latin phrase, comes dangerously close to a cross-language pun, "*Parade* arse." Ernst's allusions to fashion are comments on the mechanical aspects of society — especially in the manikin lifted from de Chirico — in which modern man, mechanical man, and fashion's dummy are all one. The grotesque props of fashion have sexual meaning. These witty visual and verbal puns are truly anti-Expressionist comic strips of Freud's interpretations of fashion's totems and society's taboos.[14] De Chirico helped set Ernst along the path of creating the more complex images because he provided Ernst, along with the dressmaker's dummy, the most useful of all Surrealist pictorial conceptions: an elastic, nonrational — but no less believable — space which became a stage on which the subconscious could come to strut its own fashions.

The use of images drawn from fashion makes Ernst's paintings and collages topical thereby undermining the standards of academic art that dictated a so-called universality of subject. Although such rebellions against

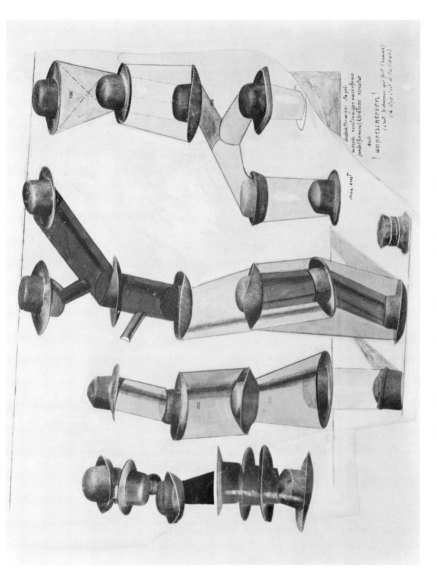

Figure 6-3. Max Ernst, *The Hat Makes the Man*, 1920
Collage, pencil, ink, and watercolor, 35 x 45 cm.
(*Museum of Modern Art, New York, purchase*)

standards were part of Ernst's Dada use of fashion it was his study of psychology, and of Freud in particular, that taught Ernst to look for meaning below the surface of clothes, and more important, of behavior. Ernst's Dada years saw his growing sophistication in the use of psychology in the making of art both as a means of arriving at subjects and as a means of changing ideas into objects. Contrary to the usual interpretation of Dada as a chaotic approach Ernst's Dada works make very direct and systematic references to Freud's methods and theories. Later, his use of Freud becomes less insistent and more smoothly blended with his own ideas.

During the Dada years Ernst developed ways of conjuring up highly personal images, ways that mirrored Freudian thought. When Freud analyzed a dream he described a series of images brought together to suit a certain dream situation. Many of these images came from half-forgotten or half-noticed details of the day before or from long-forgotten childhood experiences. These items taken together have a true personal meaning because they were chosen by the uncensored subconscious of the dreamer. Some of these images may not be from direct experience but from pictures or photographs the person has seen. This, of course, is the process that Ernst adapted long before the advent of Surrealism for the selection and manipulation of subjects for collages and then paintings. When Ernst described the waking hallucination of a rainy 1919 day on the Rhine during which he saw, in the pages of a catalog, evocative images that needed only a little tinkering with brush or scissors to bring them into line with his inner visions,[15] he was referring directly to Freud's methods of analysis of dreams. Ernst wrote on a 1920 collage called *Bedroom*: "This is Max Ernst's bedroom it's worth your while to spend a night here." He invites us to share his most valuable dreams.[16]

Ernst was not speaking lightly when he said that paste had little to do with collage;[17] rather, it was the principle of startling and telling juxtaposition. From the beginning of Ernst's Dada works and even his prewar Expressionistic paintings Freud — that is, the systematic use of psychological theory as a guide to self-examination so dear to the Surrealists — played a role not only in the subjects Ernst chose but also in the method by which he put them together.

Even at this early date Ernst was looking for a new system on which to base his art. He found psychology to replace the old values he was vigorously protesting. Thus he sought to imbue his art with new values not to destroy or discredit the old ways, which ultimately would lead to destruction of artistic activity. Many of his Dada contemporaries, such as Tristan Tzara, were willing to suggest such a possibility and to live with the ironies inherent in the argument.

But why collage? Why not paint these juxtapositions the way de Chirico had done? The answer lies again in Freud's ideas although Freud did not sanction it. Traditional methods for painting detailed, recognizable images take time and conscious effort; by the time the painting is done the spontaneous

vision may become stale — one of the criticisms later leveled at Dali's work. A way to keep the spontaneity and the recognizability was to seize previously created images that were encountered by chance and perceived immediately as meaningful. These images could be cut out and pasted to others or as in the first of Ernst's collages some part of the images could be painted over. Ernst usually left some recognizable aspect of the original subjects to intensify the irony and cause the collages to subvert the subjects in their original state.

Further, he often limited chance by choosing from only one sort of image, e.g., nineteenth-century engravings thereby causing the collage to have a formal and surface consistency. These precreated images had a deceptive blandness and a reference to modern imagery and printing methods that the spontaneous but traditionally painted Expressionist work lacked.

In these collages Dadamax often ribbed elements of contemporary life: fashion (discussed above), bourgeois pastimes,[18] education, and natural science — especially natural science. *Sitzender Buddha (demandez votre médecin)* (fig. 6-1) is among the first of a long line of collages and paintings in which Dadamax turned scientific subjects on their ears. The diagram of the brain — which is still recognizable as such in the collage — suggested a seated figure, and so it became; the brain revealed in diagrammatic clarity has become the focus of an ironic new religion. Pointing at the pompous little figure are phallic or penetrating elements that Ernst has added to the original illustration. One wonders about the malady that brings this squatting buddha/brain to ask advice of his doctor.

Further, the collage's irreverent title takes pokes at religion and science and is a further destabilization of the intended rational meaning of the original, serious illustration. But more noteworthy in this title and in many others (e.g., *The Hat Makes the Man* and *Fait Modes: Pereat Ars*) is that Ernst plays back and forth from one language to another. These are the mad games of the student who has just learned the possibilities of language after overserious, disciplined study of modern and especially classical languages in school. The smell of the schoolroom lingers not only in Dadamax's elaborate word plays but also in the Dada images themselves. Most of the raw material for his first revolutionary collages in 1919 and 1920 came from a teacher's handbook.[19] The book of collages and poetry *Répétitions* (planned by Ernst and Paul Eluard in Cologne in 1921 and published in 1922) is, according to Renée Riese Hubert, a parody, at least in part, of the conventional school experience.[20]

Although nontraditional in subject and technique, these collages are art. They are works that disturb or humiliate traditional conceptions of art. Another humiliation is *Objet dad'art,* a tall and tippy assembled piece of stuff, associated by its title with the precious little objects kept on polished bourgeois tables. To help make his point Ernst reproduced it in *Die Schammade* and a

photograph of it was included in the collage *Design for a Manifesto* (1921). This little object is at once phallic, unstable, and birdlike.

More common representations of this erect personage are found in Ernst's elegantly linear two-dimensional works that seem to represent — like newly demobilized soldiers — damaged, unbalanced, and outmoded war machines. Like many of the works that come later their formal style is not a function of the artist's hand — as we usually think of style — but rather of the techniques he has chosen to use. On the title page of *Die Schammade* (fig. 6-4), the illustration was made by taking more or less random prints from printers type and blocks. The resulting shapes were then enhanced and connected into a single image with pen and ink. The converse of this method is to be found in the 1919/1920 *From minimax dadamax self constructed little machine, for fearless dusting of female suckers at the beginning of the change of life, and for similar fearless acts.*[21] To make this image Ernst modified with ink and paint the pencil rubbings (rather than prints) he took from similar printers' type and blocks. Later he would use the same technique, now called frottage, to make the highly sophisticated series of images in *Histoire naturelle* (1925). For this series he replaced the printers' letters and rectilinear shapes with natural textures exploiting more fully the expressive possibilities of the technique. But still the germ of frottage was planted during the Dada experience.

Another humiliation of the technical aspect of art for art's sake was the use of the photograph. In making such collages as *The Swan is Very Peaceful* of 1920 (fig. 6-5) Ernst not only used photographs and halftone prints to make the collages but also photographed the result. Further, he thought of the photograph, not the original collage, as the finished work. The photographs of the collages have the unified surface of any photograph. The differences in color and texture of the various elements have been effaced in the photographic process. Photography itself is subverted; we have a photograph, a "true" record of a scene that has never existed nor could exist. For the rest of his career he would continue to step around the classical skills and the mystique of the painter in order to make revolutionary and vital works.

Some of Ernst's most witty collages are jokes on religion as it has been traditionally visualized in art, and on the history of art itself. These collages not only tease the pompous proponents of the grand traditions of religious art but alter in fundamental ways our perceptions of art. Such collages distance us from emotional and religious content of religious art thus making art historical, aesthetic, and other judgments of its worth easier to make. A good example is the collage inscribed: *It is already the twenty-second time that (for the first time) Lohengrin has left his fiancé, it is there that the earth has spread its crust on four violins, we will never see each other again, we will never fight against the angels, the Swan is very peaceful, he vows hard to catch Leda.*[22] While the inscription takes a poke at the art of music, especially German music, the image combines the angels from a painting of the Virgin and Child by the

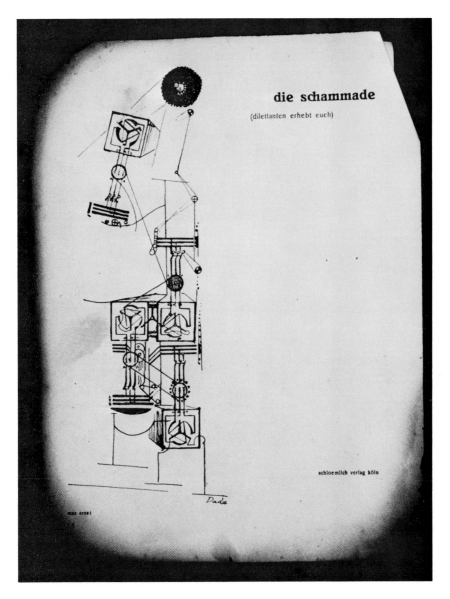

Figure 6-4. Max Ernst, *Dada*, title page, *Die Schammade,*
ed. Johannes Baargeld and Max Ernst, 1920, Cologne.
(*Private collection, New York; photo: Estera Milman*)

Figure 6-5. Max Ernst, *The Swan is Very Peaceful*, 1920
Collage, pasted photo-engravings, 8 x 11.9 cm.
(*Anonymous collection; reproduced courtesy of Galerie Rudolf Zwirner,
Cologne; photo: Museum of Modern Art, New York*)

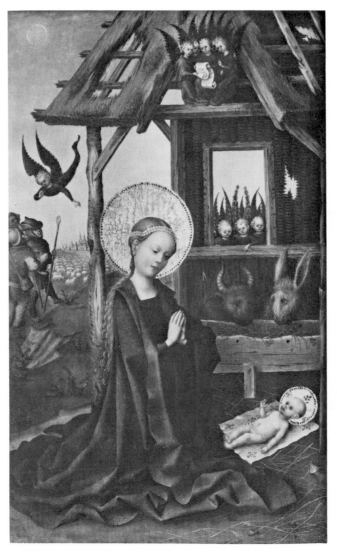

Figure 6-6. Stephan Lochner, *Virgin Adoring the Christ Child,* 1440s
Oil on panel, 35 x 21.3 cm.
(*Alte Pinakothek, Munich*)

early Renaissance artist Stephan Lochner (fig. 6-6) of Cologne with the airplane, the most modern instrument of war and commerce. The only way the angels can now fly is like the rest of us — in a modern machine. Given the unhappy state of affairs in the Rhineland in 1920 this image contains considerable irony — art historical and otherwise.

Ernst does not represent the angels directly but rather shows a neatly framed painting — art within art — of lovely cherubs from another more devout era. They do not come out of a lovingly rendered hand copy nor a fine original photograph nor an expensive reproduction; rather, the source for the image is an inexpensive halftone print — the Ben Day dots are quite visible — like those found in common little books on famous artists. The choice of a cheap reproduction is no doubt a function of Ernst's meager circumstances at the time. But more importantly, the choice of such a popular reproduction of a traditional painting is the right comment on the popular heritage. Further, although this collage may be seen as a slap at such traditions it found and honored an unfaded power and significance — albeit ironic power and significance — in these sweetly strange handmaidens from the history of German art.

Later, Ernst took the themes of birds and various framed "asides" and turned them into personal and very complex metaphors for himself, especially in the paintings and collages that include Loplop, Superior of Birds. In many of his other collages, notably the "Court of the Dragon" chapter of his collage novel *Une Semaine de Bonté,* Ernst interjected framed pictures to introduce themes that complement or haunt the main action. In *The Swan is Very Peaceful* however, the "frame" is from the original and serves as a window through which the angels look in on the Virgin and Child. Transplanted onto Ernst's collage the angels regard from their new vantage point on the grounded airplane, the equally grounded and indifferent Wagnerian swan.

By late 1921 Dada group activities were winding down in Cologne and Ernst was looking more and more to the avant-garde in Paris. While continuing to make collages during this period he developed from the collage technique a method of painting that offered him greater flexibility. He copied into his paintings, in an enlarged form, "found" images of the sort he had used, and was continuing to use, directly in collages. He could still make evocative combinations of images but by varying the size, making subtle changes, and using color more freely, he gained formal control and could make works of a more imposing scale than was possible by working directly in collage. (Most of his early collages derived from engraved images are about 6 x 9 inches or less.) But because he could retain the spontaneity in the way he chose the images he could continue to enjoy the creative benefits of the collage method. The long multilanguage statements that appeared on his collages disappeared from these larger works.

These paintings, or picture/poems, are complex and powerfully evocative images that have a feeling later called Surrealist. *The Elephant of the Celebes*

(1921) is a good example of this development. It speaks of an interest in primitive art (bridging Expressionism and Surrealism) as a picture of a West African grain storage bin served as the pictorial model for the body of the elephant. The headless torso is a comment on the lovely but lifeless female nudes of academic art. The more or less Cubist construction on the back of the elephant refers to the avant-garde art of his own time and the male and female personages speak to the Surrealist concern with definitions of maleness and femaleness that will occupy Ernst, in one form or another, through such works as the 1948 *Capricorn*. The spirit of Dada's youthful rebellion against the dictates of father, priest, and teacher is most clearly exemplified by the painting's title. It comes from the disreputable couplets chanted by naughty German schoolboys: "The elephant from Celebes / has sticky, yellow bottom grease. / The elephant from Sumatra / always fucks his grandmama. / The elephant from India / can never find the hole ha-ha."[23]

Perhaps it is in the early collages that the Dada spirit of Ernst's work is most clearly demonstrated. *The Deadly Female Airplane* of 1920 (fig. 6-7) is the protest of Dadamax, the ex-artilleryman, against the machines of war and the dislocations of modern society. He made female sexuality a metaphor for military destruction when he gave the term *femme fatale* visual form as a machine of war. Like Big Bertha or the even more deadly and much later Enola Gay, she seeks the destruction of men. One of the wounded is being carried away in the lower right. Yet she too is wounded. Dehumanized fragments of her body are interchangeable with machine parts.[24] The same aggressive war protest and sexual innuendo are integral parts of Ernst's contemporary poem "Lisbeth" from *Die Schammade*.[25] The last three lines read: "protuberances and shrapnel in my neighbor's eye / visit my exhibition / lisping Lisbeth."

But to say that the theme of deadly sexuality in *The Deadly Female Airplane* is merely a revival or a continuation of late nineteenth-century fascination with the *femme fatale* is off the mark. Rather, Ernst associates and subverts the fear of death in war with the fears of sex Freud described. For Ernst Dada itself was a bomb[26] and the sexual allusion in *The Deadly Female Airplane* is a missile tossed into the lap of polite society and at the patriotic rally filled with rhetoric on a hero's death.

Trailing back from the bent nose of this deadly airplane are arms carefully held in the conventional positions of arms on female nudes in paintings. In *The Deadly Female Airplane* Ernst makes impudent allusions to art historical conventions as well as to Freudian theory. We are placed back at the art "exhibition," booby-trapped by subversive ideas in which Dada, the bomb, exploded. Ernst protests society's conventions but always in the context of art; this is at the base of Ernst's work whether it be called Dada art or Surrealist art but never anti-art.

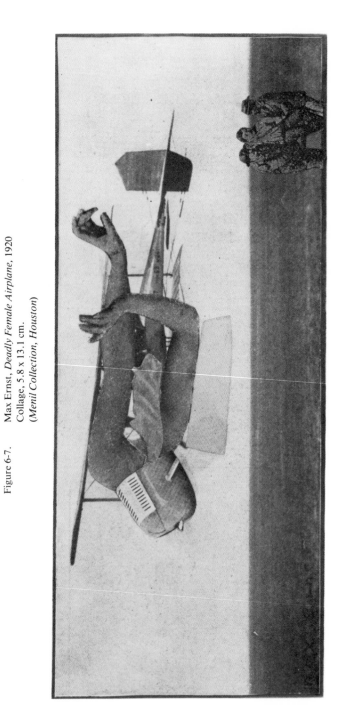

Figure 6-7. Max Ernst, *Deadly Female Airplane*, 1920
Collage, 5.8 x 13.1 cm.
(Menil Collection, Houston)

Notes for Chapter 6

1. Max Ernst, "Some data on the youth of M.E. as told by himself," *View*, Special Max Ernst Issue (April 1942), p. 30.

2. Paul Vogt, "The Blaue Reiter," in *Expressionism: A German Intuition 1905-1920* (New York: Solomon R. Guggenheim Museum, 1980; San Francisco: Museum of Modern Art, 1980), p. 192-99.

3. For a detailed account and more general discussion of this period in Ernst's life, see John Russell, *Max Ernst: Life and Work* (New York: Abrams, n.d.), pp. 39-67.

4. Richard Huelsenbeck, "Arp and the Dada Movement," in James Thrall Soby, ed., *Arp* (Garden City, N.Y.: Museum of Modern Art and Doubleday, 1958), p. 19.

5. Werner Spies makes a plausible case for excluding Arp from the actual fabrication of the collages in Werner Spies, *Max Ernst — Collagen: Inventar und Widerspruch* (Cologne: Verlag M. duMont Schauberg, 1974), p. 65.

6. Dirk Teuber, in a personal letter to me dated 31 January 1982, confirmed my supposition that this collage was based on a page from the *Kölner Lehrmittel-Anstalt* (p. 476) by Hugo Inderau published in 1914 in Cologne. Mr. Teuber first published this Cologne teacher's manual as a major source of Ernst's early collages in his essay "Max Ernst's Lehrmittel (Der Kölner Lehrmittelkatalog)," in Wulf Herzogenrath, ed., *Max Ernst in Köln: Die rheinische Kunstszene bis 1922* (Cologne: Rheinland-Verlag GmbH, 1980), pp. 206-40.

7. This title, according to Hans Richter, is a "portmanteau word made up from *Schalmei* (*shawm*), sweet and earnest tones, *Scharade* (charade), a guessing game played in earnest, and *Schamane* (witch-doctor), a dangerous, earnest necromancer." Hans Richter, *Dada: Art and Anti-Art* (New York: Abrams, 1965), p. 160. Spies says that the name was from Shiller's *"Schamade schlagen,"* a drum or trumpet call for retreat and thus *"Schammade"* was chosen to fit the post–World War I era in Germany. Werner Spies, "Dada Köln," in *Von Dadamax zum Grüngürtel: Köln in den 20er Jahren* (Cologne: Kölnischer Kunstverein, 1975), p. 32. Ursula Dustmann suggests that the title is an unappetizing combination of *Sham* (shame) and *Made* (maggot or mite) that also has meaning in the postwar Dada context. Ursula Dustmann, "Die Kölen Zeitschriften und Verlage für aktuelle Kunst und Literature," in Herzogenrath, *Max Ernst in Köln*, p. 118.

8. William S. Rubin, *Dada and Surrealist Art* (New York: Abrams, n.d.), p. 12.

9. Walter Z. Laqueur, *Young Germany: A History of the German Youth Movement* (London: Routledge & Kegan, 1962), pp. 3-55.

10. Lothar Fischer, *Max Ernst in Selbstzeugnissen und Bilddokumenten* (Hamburg: Rowohlt, 1969), p. 35.

11. At Bonn University, before the war, Ernst had studied the currently accepted theories of psychology and had clinical experience in a nearby mental hospital. Also, when his friend Karl Otten returned from his study in Vienna with Sigmund Freud, he introduced Ernst to *The Interpretation of Dreams* and *Wit and its Relation to the Unconscious* in 1913.

12. Freud said hats — especially hats on the head — are common phallic symbols. He also pointed out that the German phrase *unter die Haube kommen* (to come under the cap) is used idiomatically to mean "finding a husband." Sigmund Freud, *The Interpretation of Dreams,* trans. James Strachey (New York: Avon, 1965), pp. 395-96.

13. "bedecktsamiger stapelmensch nacktsamiger wasserformer ('edelformer') kleidsame nerva-
 tur auch !umpressnerven! (c'est le chapeau qui fait l'homme) (le style c'est le tailleur)". See
 Lucy R. Lippard's interesting though brief discussion of some of the cross-language puns
 in this inscription in Lucy R. Lippard, "Max Ernst: Passed and Pressing Tensions," *Art
 Journal* 33 (Fall 1973): 14.

14. Freud saw clothing of various types as symbols or indirect indicators of sexual concerns in
 dreams, jokes, and in common figures of speech. See Freud, *Dreams,* pp. 219, 391, 395-
 96, to name only a few references.

15. Max Ernst, "Au-delà de la peinture," *Cahiers d'Art* 6-7, dedicated to Max Ernst (1937;
 repr. in Max Ernst, *Ecritures* [Paris: le point de jour, 1970]), pp. 258-59.

16. Spies describes item by item the Freudian symbolism of this collage. Werner Spies, *Max
 Ernst: Loplop: the Artist in the Third Person,* trans. John W. Gabriel (New York: Brazil-
 ler, 1983), p. 99.

17. While describing the principle of juxtaposition used in making collages, Ernst stated: "Si ce
 sont les plumes qui font le plumage, ce n'est pas la colle qui fait le collage." Ernst, "Au-
 delà de la peinture" in *Ecritures,* p. 256.

18. Marion Wolf sees Ernst's 1920 collage *The Little Tear Gland That Says Tic Tac* as an evo-
 cation of the landscape around such well-known Rhenish spas as Ems, Munster, and Nau-
 heim. Marion Wolf, "Tic-Tac: the Early Imagery of Max Ernst," *Arts Magazine* 49
 (February 1975): 68-69.

19. See note 6 above.

20. Renée Riese Hubert, "Ernst and Eluard, a Model of Surrealist Collaboration," *Kentucky
 Romance Quarterly* 21, 1 (1974): 114-15.

21. *von minimax dadamax selbst konstruiertes maschinchen für furchtlose bestäubung weib-
 licher saugnäpfe zu beginn der wechseljahre u. dergl. furchtlose verrichtungen.*

22. "C'est déjà la vingt-deuxième fois que Lohengrin a abandonné sa fiancée (pour la première
 fois) c'est là que la terre a tendu son écorce sur quatre violons nous ne nous reverrons jamais
 nous ne combattrons jamais contre les anges le cygne est bien paisible il fait force de rames
 pour arriver chez Léda."

23. For a complete discussion of this painting, see Ronald Penrose, *Max Ernst's Celebes* (Lon-
 don: Univ. of Newcastle upon Tyne, 1973).

24. Ernst's collage *Anatomy of a Young Bride* (1912) and his lost painting *La Belle Jardinière*
 (1923) are other examples from his early work in which women are seen as mechanical ob-
 jects. Relevant to the themes in *The Deadly Female Airplane,* Aaron Scharf pointed out that
 the body structure of *La Belle Jardinière* is taken from a photograph of an airplane. Aaron
 Scharf, "Max Ernst, Etienne-Jules Marey and the Poetry of Scientific Illustration," in Van
 Deren Coke, ed., *One Hundred Years of Photographic History: Essays in Honor of Beau-
 mont Newhall* (Albuquerque: Univ. of New Mexico, 1975), pp. 120, 123-24.

25. Max Ernst, "Lisbeth," *Die Schammade,* 1920, n.p.: "Schossente, Kalikokokotte, Krick-
 hündchen durchrieseln das Telefonzellengewebe / am frühfag mit helio-anthro-trop / kok-
 likokohorten, erkorener chor der guten Familien / pomeranzenwangen der blühenden
 kneiferzangen / protuberanzen und schrapnells im auge des nächsten, / besuchen Sie miene
 ausstellung / lispelt lisbeth."

26. Fischer, p. 35.

The Functional and the Conventional in the Dada Philosophy of Raoul Hausmann

Timothy O. Benson

The Dadaist, as presented in Raoul Hausmann's 1920 collage self-portrait entitled *Der Kunstkritiker* (*The Art Critic*) (fig. 7-1), strikes a pose of ironic critical disdain, but not without a marked potential for aggression. As an artist, poet, satirist, and as the resident theoretician, or "Dadasoph," proclaimed for the movement as it culminated in the *Dada Almanach* of 1920,[1] Hausmann mounted his attack on the traditions of Western culture in its broadest sense. "I announce the Dada World!" he declared in his 1919 pamphlet that he called "against the Weimar way of life;" "I deride science and culture, these miserable assurances of a society condemned to death."[2]

But if Dadaism was simply an embodiment of chaos and angry nihilism, how are we to regard Hausmann in the early 1920s, when he wrote texts extolling fashion and praising conventions?[3] Was the Dadasoph merely "bluffing" when he put forth the following appeal in his 1922 essay, "Lob des Konventionellen" ("In Praise of the Conventional")? "Hey, Hello Mr. Neighbor, wake up, let's be joyous, let's just live in the present. Our houses are hideous, you say? Exactly, they are conventional, but I don't wish for more."[4] Bluffing or not, such a statement is consistent with efforts that the Berlin Dadaists undertook below the antagonistic surface of their rhetoric to redefine culture generally and to specify an appropriate individual response.

An apparent shift in attitude from rejection to acceptance was far from unusual among Dadaists. Marcel Janco, of the Zurich circle, recalled "two speeds" in Dada, which he called "negative" and "positive."[5] His notion of having to demolish a culture in which he had lost confidence in order to create a *tabula rasa* recalls Hausmann's characterization, expounded in his journal, *Der Dada 3* (1920) of the "Dada bluff" as "practical self-decontamination."[6]

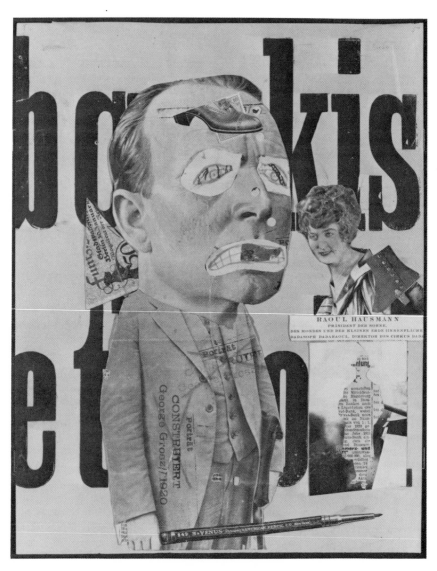

Figure 7-1. Raoul Hausmann, *Der Kunstkritiker,* 1920
 Collage, 31.5 x 25.5 cm.
 (*The Tate Gallery, London*)

Many in the Berlin group, while hoping for a utopian New World and New Man, were so absorbed in their ambiguous existence in the present that historical phases appeared to them to be indistinct. As early as 1915, a publicity announcement, in which three of the major thinkers of the Berlin movement proposed their ill-fated journal, *Erde*, shows this tendency:

ERDE

1915

A JOURNAL

published by

Baader

Friedländer

Hausmann

THE MYTHOS OF THE OLD EARTH PLAYS
ACROSS THIS LIVING PRESENT INTO THE
POETRY OF THE NEW EARTH FORESEEN,
PROMISED AND PREPARED BY IT.[7]

In an article of 1921 called "The New Art," Hausmann insisted that no viable position was yet available to those "in the condition of suspension between two worlds." This left only the "satire, grotesque, caricature, clown and puppet" to "come forth."[8] This irony, as presented in Hausmann's satires and sketches, George Grosz' drawings, and Johannes Baader's collages and public actions, sets apart the Berlin group from the other Dada centers.[9]

But beneath its irony, Hausmann's contribution was an essentially functionalistic interpretation of conditions in the present, which he held to be valid for society and for consciousness itself. Hausmann's functionalism, which became most apparent in the Neue Sachlichkeit period of the early 1920s, can be regarded as a purification of the views held by several maverick writers of the early Expressionist milieu in Berlin. Salomo Friedländer, Franz Jung, Otto Gross, and Carl Einstein maintained that the essential meaning of reality was to be perceived in the contradictions of the immediate context in which it occurred, without recourse to comforting external absolutes or to a unified inner self. Indeed, the self was an integral part of that reality. Such an attitude was not necessarily a fundamental denial of more universal meaning, but simply an insistence that essential meaning — and whatever order might be associated with it — could be perceived only situationally. This view of nature became a dominant model for culture among those of the Berlin circle who could share the social involvement, but not the basic assumptions, of the

growing political activism. During the summer of 1918, just after his tentative involvement in Dada at the first group soiree on April 12, Hausmann was placing such vast hopes on "experience" (in the vitalistic sense associated with *Erleben*) within the immediate situation of the "community" (*Gemeinschaft*) that he could hold it to be capable of replacing all beliefs, including the religions he was then trying to synthesize with the zeal of an eccentric: Taoism, Buddhism, and Christianity.[10]

As will be seen, Dadaism for Hausmann became part of the strategy of supplanting all belief systems and a move toward a community consisting of "relationships without boundaries."[11] This was not to deny the possibility of a cosmic order or the revelatory transformation (*Wandlung*) sought by many Expressionist writers.[12] Rather, as Hausmann saw it, his central task as an artist was to establish the terms in which the "enchanted process" of perception, experience, and enactment could take place.[13] Given the consistency of this objective throughout Hausmann's career, the diversity and progress of his artistic activities can be regarded as the changing tactics of a basically heuristic enterprise. The "satire, grotesque, caricature, clown and puppet" were the starting points agreed upon by the Berlin Dadaists. But for Hausmann, "it is the profound sense of these forms of expression [which] ... permits us to divine and feel another life."[14]

While his role as a critic and essayist permitted him to articulate and prescribe, it was his multiple roles as a poet, visual artist, and performer that permitted him to grapple with specifying the terms through which he believed the essential perception of reality could take place. And it is precisely in this search that Hausmann recognized the centrality of the "convention." All of Hausmann's activities involved identifying and manipulating conventions of every sort (linguistic, visual, auditory) in an effort to reveal how they are generated and how they function. At the same time, the concept "convention" seemed to deny the notion of "originality," so abhorred by Hausmann, in his rejection of the privileging of the artist's persona as put forth in postwar Expressionism.

The disgust with the contemporary avant-garde among the Berlin Dadaists grew out of a severe crisis in social meaning that occurred as the term "Expressionism" became increasingly bound to political issues. The impasse was evident in October 1917, when Hausmann appeared at a literary soiree held by the Expressionistische Arbeitsgemeinschaft in Dresden. When Hausmann received a proposed founding statement for the group in August, he was clearly dismayed, crossing out most of every line of the proposal, until he finally gave up and crossed out an entire page, while scribbling "Unsinn!" and "Ein etwas ungotlicher Bund!" ("A somewhat ungodly alliance!") across others.[15] What annoyed Hausmann was the awkward imbalance shown in the statement between politics and the concern — at the time, common currency in all Bohemian intellectual circles — with *Geist* (Spirit) and the transformation of

man. Thus, at the end of September, when he wrote Hannah Höch to announce that he would go to Dresden to speak at the Expressionist Soiree at Conrad Felixmüller's studio, his attitude toward Expressionism was clearly one of ambivalence.

The meeting was dominated by a mood that publicist Heinar Schilling characterized as a desire "to paint, write, and cry protest" or else "share the blame."[16] Expectations among intellectuals for social change had been running high since the Russian February Revolution of 1917, and now the schismatic lines were being clearly drawn between the *geistige* (intellectual or spiritual) fighters who disdained the means of the opponents (*Ungeistigen*), and those who wished first to "end the disgrace with the weapons of the opponents."[17] Ironically, Hausmann, who would declare the need for what he called the "agitationalist political deed"[18] and proclaim Dada as "the full absence of what is called Geist," appeared on this occasion to be a leading spokesman for the avid *geistige* fighters.[19]

However unsuitable the occasion in Dresden, Hausmann managed to get across not only the inclusive outlook and the emphasis on enactment that would characterize Dada, but also, perhaps, the most central of his philosophical tenets. Consider Heinar Schilling's account:

> Raoul Hausmann placed religiosity next to deed, conceived them as one, therewith the religious, the bound existence suspended every other expression of life. A conflict will arise. Today where we stand in all awe, the ultimate reassurance cannot only be a spiritual concern, it must wade through the terror itself, it must come out of contact with matter.[20]

This claim would find an astonishingly clear echo four years later in Hausmann's Presentist manifesto. In this extolling of the "innumerable possibilities" of the present, he demanded "a synthesis of Spirit and Matter — instead of the eternal grumbling analyses and trifles of the German Soul!!"[21] Indeed, this refrain was consistently secularized in the speculations of the Dadasoph, despite his shifts from Expressionism to anti-Dada, from Stirnerian Individual-Anarchism to Anarcho-Communism, from an eccentric Christianity through Dada as "the only practical religion" to the pseudo-science of opto-phonetics in the early 1920s.[22]

By 1917, Hausmann had made commitments that would place him at odds with many of the Expressionist norms. About a month before his 1917 appearance in Dresden, Hausmann was deeply absorbed in his manuscript entitled "Christus" ("Christ").[23] In it, he sought an alternative to the Expressionist apocalyptic vision familiar, for example, in Jacob van Hoddis's poem, "Weltende" (1910), the war poetry of Georg Trakl and Alfred Lichtenstein, and such visual works as Ludwig Meidner's fractured *Burning City* (1913) (fig. 7-2) and Otto Dix's futuristically exploding *War* (1914).[24] "The idea of the end of the world is deterministic," Hausmann concluded; "Christ was indeterministic!"[25] The divine, the "permeation of the world with spirit," in Hausmann's

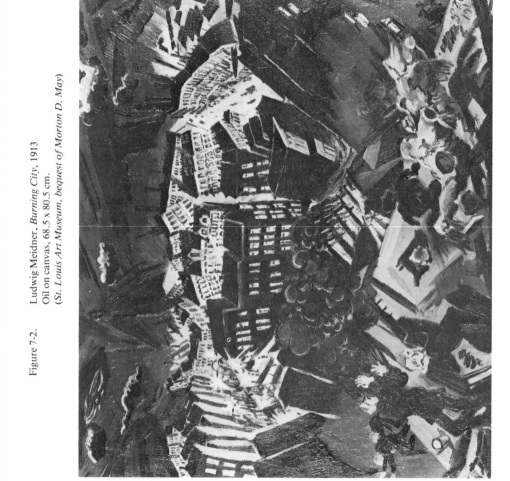

Figure 7-2. Ludwig Meidner, *Burning City*, 1913
Oil on canvas, 68.5 x 80.5 cm.
(*St. Louis Art Museum, bequest of Morton D. May*)

speculations, was present in man "as compulsion, power and chance."[26] The New Man as Christ was a haven of indeterminacy — something he insisted was lost on a Christianity that "never comprehended Christ."[27] Indeed, an alternative "religion" was being offered at just about this time by Hausmann and the architect-poet-artist Johannes Baader in their mock Jesus Christ Club (Christus GmbH), an organization for pacifists who, upon changing their names to Christ, were to claim conscientious objector status. The intentions may have been identical with those that produced a poster at the climactic Dada Messe (Dada Fair) of 1920, which read "Dada ist kein Bluff" ("Dada is no bluff").[28]

In contrast to the Expressionist "meliorism," which so riled Huelsenbeck against the poets Kasimir Edschmid and Kurt Hiller in his *En avant Dada* (1920), Hausmann and his colleagues posited a *Gegen-Speil* (counterplay of contradictory forces) *within* man.[29] Huelsenbeck's New Man carried "pandemonium within himself ... for and against which one can do nothing."[30] To Hiller's "Man is Good," Hausmann preferred the Russian theorist Demitri Merzhkowski's view of good and evil as inextricable.[31] For Hausmann, "God" was present "in man as humility and violence, good and evil, indeterminate determinism."[32] Baader, whose discourse on monism, *Fourteen Letters of Christ,* appeared in 1914, also produced his *Eight World Theses* (1918), in which he held each man to be a "unit of consciousness" whose conduct, with that of all other bodies, "occurs to sustain heavenly pastimes as a game."[33] No longer could man be conceived of as the inward-turning *Inselexistenz* (island existence) of Ludwig Rubiner, given a visual equivalent in the tortured and isolated figures in the foreground of Ludwig Meidner's *Burning City* of 1913 (fig. 7-2). How different are what have been called Hausmann's "anti-portraits," arbitrary arrays of contradictions from the external world (figs. 7-3, 7-6).[34]

Huelsenbeck brought the "magic word" Dada from Zurich in early 1917 but had little success in his repeated efforts to convert the members of the Berlin Neue Jugend group.[35] However, soon after the Russian October Revolution, when he was inspired to distance this word "Dada" from what he called the intellectual "theorems of Cubism" and "elements of Futurism," toward a position from which "politics" was "only a step away," Berlin Dada was soon underway.[36] Hausmann's primary task, as a Dadaist, became one of clarifying what he had insisted was the "fiction" of outward appearances:

> From the sphere of the most inner, highest reality flows everything "produced" into the reality of the "world" as a fiction. The working out in the world-humanity; Time-World generally, obeys the voice of the Spirit, of the true reality — the "sense," "meaning," "value" flows out and flows back, is recognized through the play of the "senseless" organ "chance," the immovable source of direction, eternal Creator-Person, Spirit-God.[37]

In forwarding man's awesome "contact with matter," all aspects of this "fiction" — in which he included "thought systems," "governmental forms," and

the "capitalist economy" — would become raw material, accepted into art as functioning components.[38]

"New Material in Painting," a determined effort to encounter matter — to permit "Dada art" to exist as "the plane for the appearance of conflicts" — dominated Hausmann's Dada proclamation, "Synthetic Cinema of Painting," presented at the first official Dada evening in April 1918. "In Dada you will recognize your real state of mind," he insisted, "miraculous constellations in real material, glass, wire, tissue, corresponding organically to your own equally brittle bulging fragility."[39] Conceived as one of what he called his "marvelous contradictory organisms," Hausmann's sculptural *Mechanical Head* (fig. 7-3) or, as he sometimes called it, "The Spirit of Our Times," was intended to fix "the spirit of everyone in their rudimentary state."[40]

Yet already, in the New Material manifesto, Hausmann's main emphasis was not as much on the objects themselves as on how they functioned. Just as the ruler and watch affixed to the *Mechanical Head* cannot provide us with anything more than approximations of the true reality, Dada art would offer what Hausmann called "an impetus toward the perception of all relations."[41]

Automatism had been a dominant aim for the works that Hausmann created within the Expressionist woodcut aesthetic through the early teens and into 1918. In his Dada period, Hausmann sought to cultivate this automatism in the context of the new materials that he proposed as more appropriate to the task at hand. The association of "all relations" was being integrated with automatic procedures.

This relational aspect of materials was emphasized in Hausmann's 1918 book, *Materials of Painting, Sculpture, and Architecture.* Illustrated by four abstract woodcuts, and accompanied by an exquisite collage cover, the text itself is an early example of semiautomatic writing, as this passage shows: "Painting dynamism of colors of form thought in the surface they are to be made as pure as possible a formulation organic in analogy of the observed moments neither intuitive nor descriptive."[42] Hausmann's invention of phonetic poetry, in the late spring of 1918, was a similar combination, analogous to an indeterminate "state of mind." In one case, the letters were actually chosen by chance and the mood of the printer (fig. 7-4).[43] Denied their specific theoretical or semiotic functions, these letters became part of a new concretion in which their traditional signification was melted away entirely.

Around the time of this invention, Hausmann wrote to his companion, the artist Hannah Höch, admonishing her for not understanding his "letting go" of Expressionism. "The Expressionist," he instructed her, "would want a poem, as the forest is cut into lumber." "The Dadaist," he continued, "does not translate something which today has a purely machine character, like typography, or its dynamic form ... into another material."[44] A central problem had become the direct "transformation into art" of the vitalistic, dynamic forces of the Expressionist and Futurist heritage, which Hausmann saw, at this point, as functioning in an essentially mechanistic fashion.

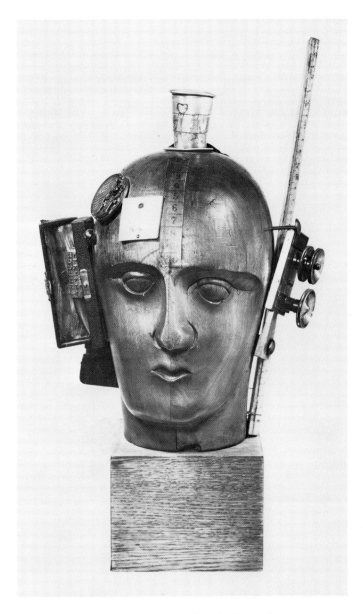

Figure 7-3. Raoul Hausmann, *Tête mécanique: L'esprit
de notre temps*, 1920
Assemblage, 32.5 cm high.
(*Musée National d'Art Moderne, CNACGP, Paris;
Cliché Musée National d'Art Moderne, Paris*)

Figure 7-4. Raoul Hausmann, *Phonetic Poster-Poem*, 1918
32.8 x 47.8 cm.
(*Musée National d'Art Moderne, CNACGP, Paris; Cliché des Musées Nationaux, Paris*)

In his collage of 1920 entitled *Elasticum* (fig. 7-5), Hausmann absorbed the artifacts of the modern world directly. Gears, letters, and faces, presented in this unaltered form, would have been unacceptable to many of the Expressionists, who often depicted what their apologist, Hermann Bahr, called "the soul's struggle with the machine."[45] By contrast, Dadaism, in its climactic manifestation at the Dada Fair held in Berlin during the summer of 1920, left the impression on receptive art critic Adolf Behne that "Man is a machine, civilization is in shreds."[46]

A rejection of Expressionism, with its *Kathedralenstil* and claims on an "inner soul," is also implicit in Hausmann's query in *Der Dada 3:* "Why have spirit in a world which runs on mechanically?"[47] His conjoining of a mechanically functioning world with a mechanical consciousness, or "soul-motor" (*Seelenmotor*), is closely allied with the view of satirist and essayist Salomo Friedländer, who is the subject of Hausmann's "anti-portrait" (fig. 7-6). Hausmann's close association with Friedländer, who was also known appropriately under the pseudonym "Mynona," the retrograde of anonym, began through the agency of Hans Richter in 1915.[48] Early in their friendship, the two spent an entire night walking the streets of Berlin discussing the possibility of a Spiritual Man (*geistiger Mensch*).[49]

In the book that codified his views, *Schöpferische Indifferenz* (*Creative Indifference*), Friedländer held that both man's consciousness and the world can be described as phenomena generated automatically and mechanically, as polarizations of a subjective and creative "Individuum" that exists only above consciousness.[50] Willful acts then are purely, in Friedländer's words, "automatic, like mechanisms"; "the world is machinery, men are but small wheels in this machinery."[51] In his collage *Tatlin at Home* (fig. 7-7), Hausmann attempted to arrive at a composition through an automatic procedure that would, as he later said, permit the means to "define the limits" of his "intention."[52]

Höch later reflected that, in inventing photocollage in late June of 1918, she and Hausmann intended the results to appear as if "entirely composed by a machine."[53] Similarly, Hausmann's hypothetical mechanical environment, proposed for the stage in his essay "Kabarett zum Menschen," was a two-story iron cage full of machinery intended to "show you in three minutes how the mechanism of the soul functions ... that man is really an empty-running *Unsinn,* nothing more."[54] Accordingly, Hausmann's painting of a poet-acquaintance, metaphorically at work, was given the wry title *Kutschenbauch dichtet* (*makes poetry*) (fig. 7-9) just as Hausmann's own *Seelenmotor* (soul-motor) ground out a dozen or so *Seelen-Automobil* letter poems, in late April 1918 (fig. 7-8).[55]

Whether the mechanical world disfunctions and reverts back to organic nature, as in Höch's painting called *Mechanical Garden* (1920), or natural and physical laws function through machines, as in Hausmann's matter-of-fact and

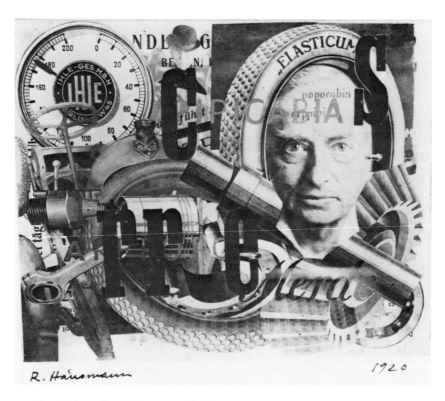

Figure 7-5. Raoul Hausmann, *Elasticum,* 1920
 Collage, 7 x 8.5 cm.
 Location unknown.
 (*Hausmann's photograph from the original; Prévot collection, Limoges*)

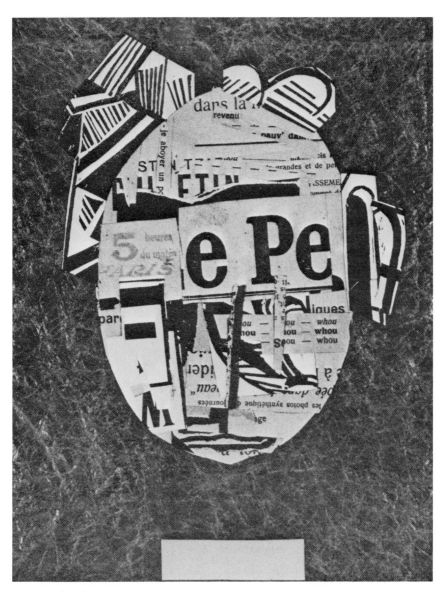

Figure 7-6. Raoul Hausmann, *Mynona-Friedländer,* 1919
Collage, 25.5 x 21.2 cm.
(*Mme. Vordemberge-Gildewart, Stuttgart*)

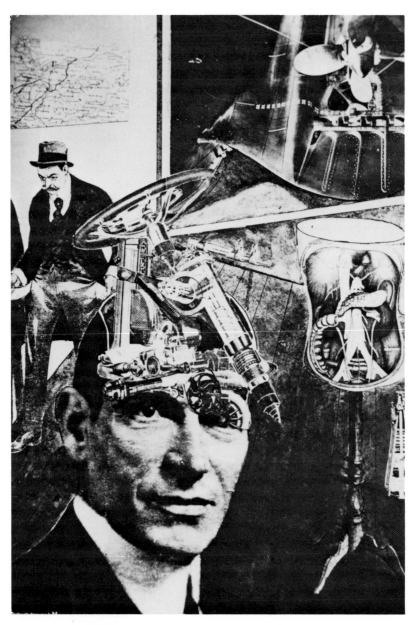

Figure 7-7. Raoul Hausmann, *Tatlin at Home,* 1920
Collage, 41 x 28 cm.
(*Hausmann's photograph from the original; Prévot Collection, Limoges*)

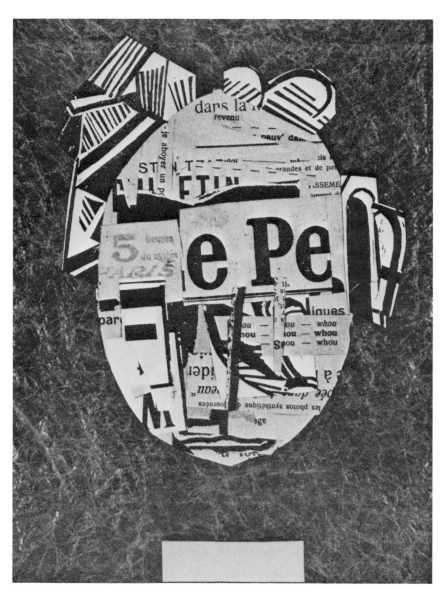

Figure 7-6. Raoul Hausmann, *Mynona-Friedländer,* 1919
 Collage, 25.5 x 21.2 cm.
 (*Mme. Vordemberge-Gildewart, Stuttgart*)

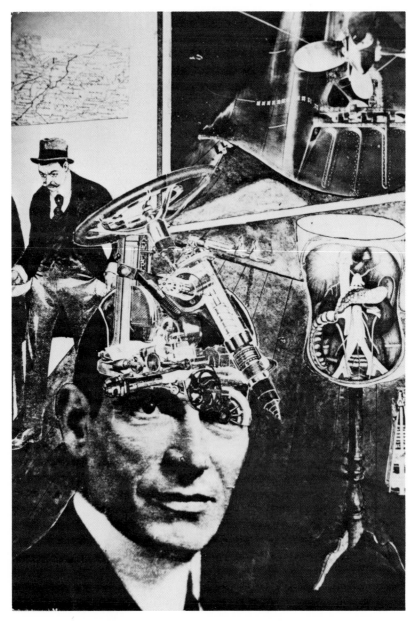

Figure 7-7. Raoul Hausmann, *Tatlin at Home,* 1920
Collage, 41 x 28 cm.
(*Hausmann's photograph from the original; Prévot Collection, Limoges*)

SEELEN-AUTOMOBIL.

Solao Solaan Alamt
lanee leneao amamb
ambi ambée enebemp
enepao kalopoo senou
seneakpooo sanakoumt
saddabt kadou koorou
korrokoum oumkpaai
lapidadkai adathoum
adaneop ealop noamth.

RAOUL HAUSMANN.

Figure 7-8. Raoul Hausmann, *Seelen-Automobil,* phonetic poem,
Der Dada 3, ed. Raoul Hausmann, John Heartfield,
George Grosz, 1920, Berlin.
(*Private collection, New York; photo: Estera Milman*)

mechanical renderings of 1919-1920, such "models" of the world prescribe the artist's strategy for creating and behaving.[56] If the artist creates mechanically, in a culture of arbitrarily generated sounds and visual signs having meaning only in their functions, then Hausmann's optophonetic drawing *D2818* (fig. 7-10) was a kind of schematic diagram for creating that culture.

Furthermore, the unprecedented manner in which the term "Dada" was promoted suggests a consensus based on a recognition that it could reveal, map, and label the components of the surrounding culture. Hausmann's "What is DADA?", which appeared in his journal, *Der Dada 2,* is an example of what he called the "tactical application" of Dada to "uncover" and drive "to absurdity" the "spiritual and social mechanism" of the "Christian-bourgeois world" (fig. 7-11).[57] By overtly seeming to announce and deny the meaning of the term, the whole process by which meaning occurs is implicated: "What is dada? An Art? A Philosophy? A Politics? A Fire Insurance? Or: State Religion? is dada really Energy? or is it Nothing at all, i.e., everything?" By contrast, Hausmann's Dresden colleagues, on the title page of the premier number of their journal, *Menschen,* sought to contain and clarify the term "Expressionism" discursively and polemically. *Menschen* was to rescue a corresponding "feeling for life" from the social mechanisms of "cliquedom and radicalism," which had led it to be "barred."[58]

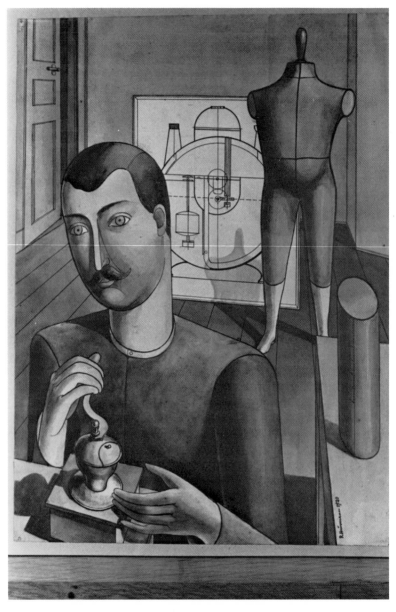

Figure 7-9. Raoul Hausmann, *Kutschenbauch dichtet,* 1920
 Watercolor, 42.5 x 35 cm.
 (*Musée d'Art et d'Industrie, Saint-Etienne*)

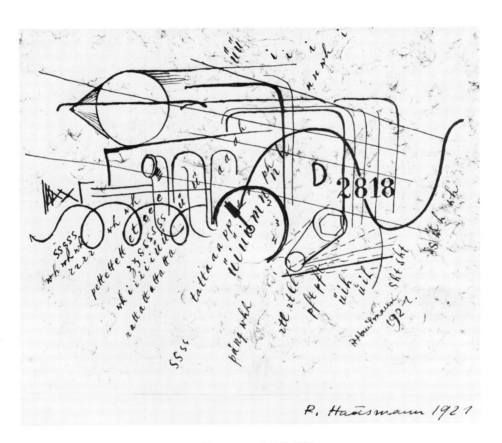

Figure 7-10. Raoul Hausmann, *D2818,* 1921
Pen and ink on photographic paper, 9.7 x 12.3 cm.
(*Prévot collection, Limoges*)

Figure 7-11. Raoul Hausmann, "Was ist Dada?" *Der Dada 2,*
ed. Raoul Hausmann, 1919, Berlin.
(*Private collection, New York; photo: Estera Milman*)

The Dadaist mapping of culture implied an ironic value-neutrality for all positions, including those of conventional protest. "Your positions are all the same to us," Hausmann scoffed in his "Der deutsche Spiesser ärgert sich" ("The German Bourgeois Takes Offense"), written in the midst of the Dada furor of 1919.[59] Although scarcely exempted from his condemnations, the offended German Bürger was advised to "sew up" his "torn trap," having concerned himself "for nothing": "We endure, scream, blaspheme, [and] laugh [out] the irony: Dada! Because we are ANTIDADAISTS!"[60] Hausmann's point was that he was, after all, protecting the Bourgeoisie from the "romantic mendacity" and "war profiteering" (*Kriegsgeschäft*) of Expressionism. Indeed, on 12 April 1918, when he appeared for the first time with Richard Huelsenbeck and George Grosz, Hausmann had begun his attack on such Expressionist underpinnings as "inner necessity"; he called them a "reversal of impulses" deemed fit only for "quitters."[61]

Hausmann and the Dadaists were certainly not alone in their polemic against self-proclaimed "radical" artists who hid their "poeticized energies" behind a "discussion of Art, Culture, and Geist."[62] As Iwan Goll — himself a prominent participant in Expressionism — succinctly stated it, "Expressionism died on that carcass of revolution, whose maternal *Pythia* it wanted to be."[63] By 1920, the critic G.F. Hartlaub viewed the situation as a general crisis,[64] and even Wilhelm Worringer, who helped to bring the term Expressionism into its German usage in 1911, showed some sympathy with what he called the Dadaists' recognition of the "tragic situation."[65]

By diagramming and mapping this crisis situation, Hausmann and his Dadaist colleagues were able to enact their chosen roles within artistic, as opposed to more routinely political, stratagems. Like Huelsenbeck's "Meisterdada" and Grosz' "Propagandada," Hausmann's guises as Dada-Director of Culture or, more ironically (as presented on his visiting card, seen affixed to *The Art Critic,* fig. 7-1), as the "President of the Sun, Moon, and Little Earth," could endow or deny currency to cultural values. As the "Kunstkritiker" (art critic), he sought to make "transparent" what he considered the Expressionist "swindle," while hoping to avoid the pitfalls of previous modernisms.[66] This ambition was expressed in the New Material manifesto: "Here and for the first time, there are neither retreats nor anguished obstinacies; we are far from the symbolic, far from totemism."[67]

As the Dadasoph, Hausmann was able to put forth his general theory, which he hoped would make these specific artistic aims a reality. His 1922 essay, "Lob des Konventionellen" ("In Praise of the Conventional"), is an inventory of conventions that he chose to accept or reject. Furthermore, he refined and purified the conventional as a philosophical and artistic concept. Hausmann accomplished this task by dissociating his concept of convention from that of tradition, allowing conventions, instead, to operate purely in their practical functions. These functions included informing man about the nature

and laws of reality and, consequently, offered the artist and social activist what Hausmann viewed as the potential for transcending these laws. In short, Hausmann had evolved a functionalist view of culture as something which, once "decontaminated," could be transformed according to principles he later defined as "the higher unity of universal functionality."[68]

The prime target of Hausmann's attack in his praise of the conventional remains what he called the "Expressionist chamberpot."

> I am so conventional that I am ruined for the Gothic. I am ruined for everything interesting because I consult its practical sense first. I am against the Werkbund, against Caligari, against the Golem, and against all attempts to make practical life interesting, to polish it spiritually: I am too conventional for any kind of old or new Expressionism.[69]

Hausmann pleaded to be spared not from art, but from the ambitions of the "Artistes" who wanted to be "interesting" and "unconventional."[70] Not only was "artistic fantasy," "sabotage to life," but it was "romantic, retrospective and ridiculous against the fantasy of the technician, the constructor of machines, against the scientific experimenter and even against the watchmaker, laborer or locomotive engineer."[71]

In an article published in the Constructivist journal, *G*, Hausmann stated that "what can be given is fixed in human formulae, approximations to the relativity of the creative flux of the Universe, but never this flux itself."[72] If "approximations" to "a higher reality" are what the new Conventional Man sought "in the creative condition which we call art,"[73] then his task was to ignore "philosophical extravagances and alleged spiritual romantic" and, instead, to "formulate the new conventions of the simple, obvious life," to do "everything entirely simply as an end in itself, without deviations" — as portrayed in Hausmann's watercolor sketch of 1920 (fig. 7-12).[74]

Furthermore, however approximate they may be, colors, images, numbers, and letters are, as conventions, the stuff of man's beliefs; his broader value system, what Hausmann called his "sociological structure," is the nearest thing he has to a reality on which to act.[75] Hausmann and the other Dadaists attacked cultural values in their broadest sense precisely to clarify the "approximate" and unfixed character they believed even the most rigid of these systems had in reality. Tristan Tzara declared in his 1918 manifesto: "I am against systems, the most acceptable system is on principle to have none."[76] Similarly, Hausmann clarified in 1921 that "the Dadaist hates stupidity and loves nonsense."[77] Stupidity consisted in retreating into the cultural sanctuaries of certain knowledge, while nonsense was demonstrated as follows:

> Whether God or Tao, Identity and number, individual and Ding an sich — for Dada these are not yet exactly posed questions because for Dada all of this is known to exist at once and with equal certainty not to exist.[78]

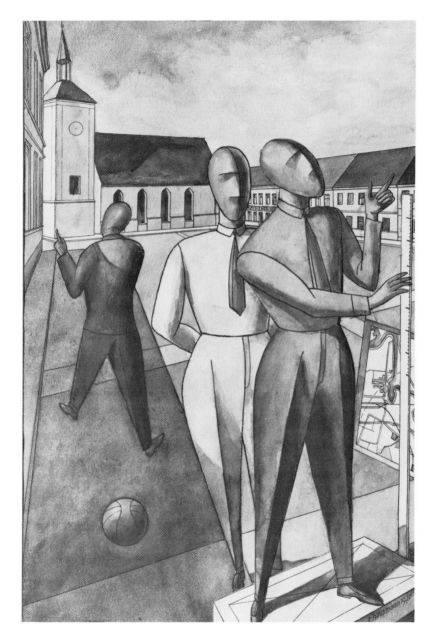

Figure 7-12. Raoul Hausmann, *Les Ingénieurs,* 1920
Watercolor, 36 x 24.5 cm.
(Collection: Arturo Schwarz, Milan)

For that matter, the Dadaists' own values were seen as equally questionable. Thus, Huelsenbeck ended his 1918 "Dadaist Manifesto" with the clause: "To be against this manifesto is to be a Dadaist!"[79]

Like Giorgio de Chirico, whose *pittura metafisica* he much admired, Hausmann viewed the world as "simply an enigma": "Dada was flagrant everywhere," Hausmann insisted, "and no one could have invented it. A christening is no invention."[80] During an extended visit to Dresden in 1920, Hausmann portrayed his friend Conrad Felixmüller, imprisoned in an unsettling and enigmatic space, perceiving the world through a mask of symbols (fig. 7-13).[81] This uncanny de Chiricoesque space also dominates *Tatlin at Home* (fig. 7-7) and *Kutschenbauch dichtet* (fig. 7-9). Spatial unity is even more illusive in *Elasticum* (fig. 7-5), where the viewer perceives only discontinuity through the layers of symbols.

The anti-Dada or, more accurately, Presentist phase of Hausmann's career began when the social fabric of Berlin Dada disintegrated soon after the climactic Dada Fair of 1920. Hausmann now gave his attention to the "functional principles of time, which, as kinetic energy, forms space and matter."[82] In making the dynamic process the subject of his speculations, Hausmann adhered to functionality as a principle, while staking a claim on the potential for overcoming the finality usually associated with conventions. In the instability of this dynamic world of change, he saw the hope of transcending it.

A clear change in tactics accompanied Hausmann's shift in focus. He now conspired with Kurt Schwitters, who on being denied membership in the Club Dada by Huelsenbeck in 1918, had applied the term "Merz" to his diverse creative activities. The two artists promoted their first "grotesque-evenings" in Prague during November 1921, with scrupulous avoidance of the term "Dada." The crowd, remembering the "Dada scandal" of February 1920, was so disappointed to be treated to a "presentist world propaganda evening" of anti-Dada and Merz that, according to a contemporary account, they attempted to take over the podium and furnish their own entertainment.[83] There was no audience for the recitation of Schwitters' *Anna Blume,* the repetition of a single sentence two hundred times, or Hausmann's eccentric dances, let alone the straightforward, if "long-winded" Presentist declaration, with its extolling of a consciousness "entirely transformed" by modern technology.[84]

In his anti-Dada performances, Hausmann sought to "enact" his new Conventional Man as an inhabitant of the absolute present. Like a musical top (*Brummkreisel*), the Presentist was impelled to spin around his "vortex" by external forces, constantly struggling to maintain his balance while attempting "the impossible" of "making of himself a transcendent-immanent perpetual motion."[85]

A fixed image, such as the collage *Dada Cino* (fig. 7-14) (which Hausmann dedicated to Schwitters), could allude to the dynamic factor of time, despite its

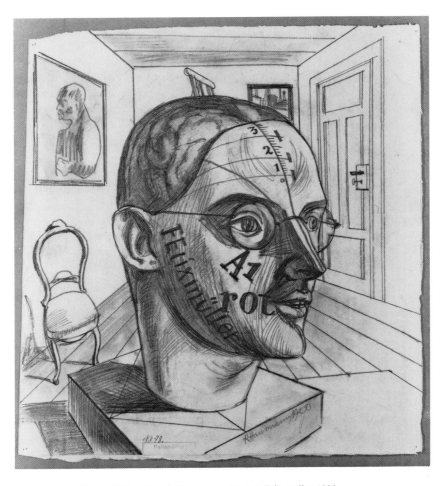

Figure 7-13. Raoul Hausmann, *Porträt Felixmüller,* 1920
Drawing, 36.5 x 34.5 cm.
*(Nationalgalerie, Staatliche Museen Preussischen
Kulturbesitz, Berlin (West); photo: Jörg P. Anders)*

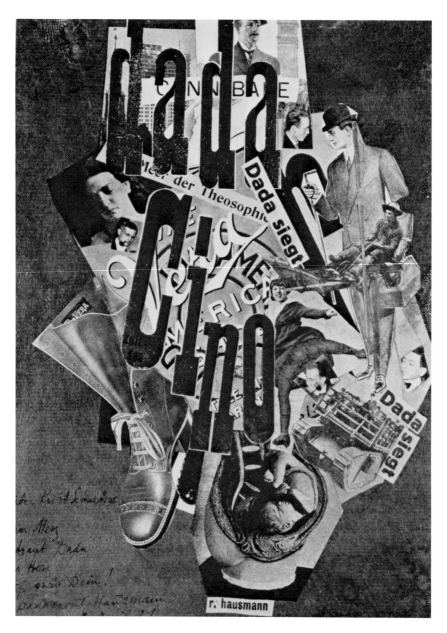

Figure 7-14. Raoul Hausmann, *Dada Cino,* 1920
Collage, 31.7 x 22.5 cm.
(*M. Philippe-Guy E. Woog, Geneva*)

literal absence, only by becoming static-dynamic, through what Hausmann referred to in his notebooks as "decentralization" and "dissolution."[86] "Our art is already today film! At once event, sculpture, and image!" Hausmann declared in his Presentist manifesto where he defined the new cinematic consciousness of his transformed man.[87] As "static film" and "static poetry," Hausmann's works were intended as an instantaneous present with its relationships partially formed but subject to change.[88] As such, they are explorations not only of "the conventions of the psychology of cinema," but also of articulation itself.[89]

Kurt Schwitters, in his Merz manifesto of 1921, regarded his art as primordial, inexplicable, and without purpose. "I know only how I make it," Schwitters claimed; "I know only my medium of which I partake....The medium is as unimportant as I myself. Essential is only the forming."[90] And herein lies precisely the affinity between the iconoclastic Dadasoph and the apolitical Merz-Künstler — an affinity certainly lost on the unruly audience of their first anti-Dada/Merz soiree. As Hausmann defined it in his Presentist manifesto: "Beauty, that is something which originates during the process of production."[91]

Like Schwitters, who advocated the "equal rights of all materials,"[92] Hausmann was drawn to the raw material of culture and insisted that "all the conventional things are splendid."[93] As he portrayed himself in his collage *The Art Critic* (fig. 7-1), Hausmann's Dadaist role was to "decontaminate" culture and to rid it of its destructive traditions, with the objective of making the beauty of its operations — its process of production — more visible.

These utopian intentions dominated the investigations of consciousness and perception in the Presentist phase of his work. Only through clarifying the mechanisms of culture and consciousness could the indeterminate, and what Hausmann called the "supra-causal" realm beyond the "cosmic inferiority" of "lever mechanics," be attained in the unconscious.[94] If "every form is a frozen instantaneous image of an event," and if "there is no three-dimensionality of space, time and movement except in our imagination of Spirit and Form," then the ultimate contact with "universal functionality" could occur only in the imagination as the center of the cultivation of a new sensibility, an "organic" "time-space sense."[95] The Dadasoph concluded his Presentist manifesto with a passage that leaves little doubt regarding the potential he believed resided there:

> The individual, considered as an atom, has only one task: to find his law through every sort and form of work on his hardened "I," against this "I" — in this new world of the present we must bring to realization the voluntary abandonment of all forces inherent in the atom!!![96]

Notes for Chapter 7

1. Caption under photograph of Hausmann in Richard Huelsenbeck, ed. *Dada Almanach* (Berlin: Erich Reiss Verlag, 1920; repr., New York: Something Else Press, 1966), p. 145: "Raoul Hausmann der alf Dadasoph die erkenntniskritische Voraussetzungen des Dadaismus erfolgreich untersuchte." The notion of a self-portrait is itself the subject of Hausmann's critique. The faces and modish silhouette below Hausmann's name (fig. 7-1) are as anonymous as the portrait of Tatlin (fig. 7-7).

2. Raoul Hausmann, "Pamphlet gegen die Weimarische Lebensauffasung," *Der Einzige* 14 (20 April 1919): 163-64: "Ich verkünde die dadaistische Welt! Ich verlache Wissenschaft und Kultur, diese elenden Sicherungen einer zum Tode verurteilten Gesellschaft." This text, and virtually all of Hausmann's published works from the Dada period, are reprinted in Raoul Hausmann, *Texte bis 1933*, ed. Michael Erlhoff, 2 vols. (Munich: Text + Kritik, 1982), vol. 1, pp. 39-42. This text and a selection of others are also reprinted in Raoul Hausmann, *Am Anfang war Dada*, ed. Karl Riha and Günter Kämpf, 2nd ed. (Giessen: Anabas-Verlag, 1980), pp. 74-77. Unless otherwise indicated, all translations are mine.

3. Raoul Hausmann, "Mode," *G* 3 (Berlin: June 1924): 50-52; and Raoul Hausmann, "Lob des Konventionellen," *Die Pille* 3, 1-2 (1922): 4-7.

4. Hausmann, "Lob des Konventionellen," p. 4: "He, Halloh, Herr Nachbar, wachen Sie auf, seien wir lustig, leben wir doch mal in der Gegenwart! Unsere Häuser sind scheusslich, sagen Sie? Gewiss, sie sind konventionell, aber mehr wünsche ich nicht."

5. Marcel Janco, "Dada at Two Speeds," in Lucy R. Lippard, ed., *Dadas on Art* (Englewood Cliffs, N.J.: Prentice-Hall, 1971), pp. 36-38.

6. Raoul Hausmann, "Dada in Europa," *Der Dada 3* (1920): n.p.: "DADA, das ist der Bluff. ... Der Bluff ist kein ethisches Prinzip, sondern praktische Selbstentgiftung." This view is echoed in 1921: "Dada ist praktische Selbstentgiftung, ein westeuropäischer Zustand, anti-östlich, anti-orientalisch, unmagisch." Raoul Hausmann, "Dada ist mehr als Dada," *De Stijl* 4, 3 (March 1921): col. 47, reprinted with revisions in Hausmann, *Am Anfang*, pp. 84-89.

7. Announcement for "*Erde* 1915 Eine Zeitschrift," Nachlass Hannah Höch, Berlinische Galerie, Berlin: "DER MYTHOS DER ALTEN ERDE SPIELT IN DIESER LEBENDIGEN GEGENWART HINUBER IN DAS VOM IHM VORAUSGESEHENE, VERHEISSENE UND VORBEREITETE GEDICHT DER NEUEN ERDE."
 I am grateful to Dr. Eberhard Roters, director of the Berlinische Galerie, for making the Hannah Höch estate available to me.

8. Raoul Hausmann, "Die Neue Kunst: Betrachtungen (für Arbeiter)," *Die Aktion* 11, 19-20 (14 May 1921): col. 284: "In dem Zustand des Schwebens zwischen zwei Welten, wenn wir mit der alten gebrochen haben, und die neue noch nicht formen können, tritt die Satire, die Groteske, die Karikatur, der Clown und die Puppe auf."

9. Hausmann's satires were collected and republished in Raoul Hausmann, *Hurra! Hurra! Hurra! - 12 Satiren* (Berlin: Malik-Verlag, 1920; repr., Giessen: Anabas, 1970). For a discussion of irony in German Dada, see Hanne Berguis, "Der Da-Dandy — das 'Narrenspiel aus dem Nichts,' " in *Tendenzen der Zwanziger Jahre,* 15. Europäische Kunstausstellung (ex. cat., Berlin: Dietrich Reimer Verlag, 1977), pp. 3, 12-13, 29.

10. Letter from Hausmann to Hannah Höch dated 18 June 1918, Nachlass Höch, Berlinische Galerie, Berlin: "Das *Erleben* der Gemeinschaft als Bindung in Beziehungen muss an Stelle des *Glaubens,* der Religion treten — aus welchen Grunden aus dem Taoismus, dem Budd-

hismus, dem Christentum eine Lüge wurde" (Hausmann's emphasis). Also see Raoul Haus-
mann, "Menschen Leben Erleben," 1917, *Die Freie Strasse* 9 (November 1918): 2. Richard
Sheppard summarizes the meaning of the "almost untranslatable concept of 'Erleben' " as
follows: "For Jung, Gross and Hausmann, 'Erleben' is a complex idea, referring both to
the activity of the liberating life-force and to the liberated existence of the person and or
'Gemeinschaft' in whom that force flows freely." Richard Sheppard, "Dada and Politics,"
in Richard Sheppard, ed., *Dada: Studies of a Movement* (Buckinghamshire: Alpha Aca-
demic, 1979), p. 54.

11. Letter from Hausmann to Hannah Höch dated 18 June 1918, Nachlass Höch, Berlinische
Galerie, Berlin: "Gemeinschaft, erfordert seine Selbstauflosung ohne Grenze — die Un-
wahrheit der Grenzen soll ja überwunden werden!"

12. For a discussion of this theme in the works of Leonard Frank, Fritz von Unruh, Ernst
Toller, and others, see Walter H. Sokel, *The Writer in Extremis* (Stanford: Stanford Univ.,
1959), pp. 164-91.

13. Hausmann, "Die Neue Kunst," col. 281: "Sehen ist ein zauberhafter Vorgang und die Um-
formung dieses Vorgangs in der Kunst ist Beschwörung, Bannung, Zauberei."

14. Ibid., col. 284: "und es ist der tiefe Sinn dieser Ausdrucksformen ... uns ein anderes Leben
erraten und fühlen zu lassen."

15. "Der Bund," unsigned typescript dated 22 August 1917, Nachlass Höch, Berlinische Galer-
ie, Berlin. The text, with its title revised in Hausmann's hand as "Expressionistische Arbeits-
Gemeinschaft," is probably by one of Conrad Felixmüller's close associates.

16. Heiner Schilling, "Bericht über die Verlagsjahre 1917-1918," *Menschen* 2, 10 (21 Septem-
ber 1919): 7: "Protest wird gemalt, gemeisselt, geschrieben, geschrieen. Wir müssen ihn tun
oder unserer Mitschuld erliegen."

17. Ibid.: "Empörung schafft geistige Kämpfer, die die Mittel der Ungeistigen verschmähen
und den Protest nur als seelische Angelegenheit ausgesprochen haben wollen. Empörung
schafft anderen den Willen, mit den Waffen der Gegner der Schande ein Ende zu setzen, das
Geistige wird erst bestehen, wenn die Schuld getilgt ist."

18. Raoul Hausmann, "Menschen Leben Erleben," p. 2: "Die innere Umgestaltung des Men-
schen ... Freimachung des Erlebens aller fordert die agitatorische politische Tat."

19. Hausmann, "Dada in Europa," "DADA is die völlig Abwesenheit dessen, was man Geist
nennt." Hausmann does not argue against Geist but against its misuse as "neues Mittel zur
Stabilisierung der Bourgeoisie." For this argument, see "Der Geistige Proletarier," *Men-
schen,* no. 23 (February 1919): 3.

20. Schilling, "Bericht," p. 7: "Raoul Hausmann stellt Religiöses neben Tat, fasst, sie in eins,
damit die Religion, das gebundene Sein jede andere Lebensäusserung aufhebe. Ein Wider-
spruch wird wach. Letzte Beruhigung kann heute, wo wir in allen Schauern stehen, nicht nur
seelische Angelegenheit sein, sie muss die Schrecken selbst durchwaten, muss aus der Berüh-
rung mit der Materie kommen."

21. Raoul Hausmann, "PREsentismus gegen den Puffkeismus der teutschen Seele," *De Stijl*
4, 9 (September 1921): col. 138: "Wir wollen in dieser mitteleuropäischen Flachheit endlich
den Aspekt einer Welt, die real ist, eine Synthese des Geistes und der Materie — anstatt der
ewigen, nörglerischen Analysen und Bagatellen der deutschen Seele!!"

22. Hausmann, "Dada in Europa:" "Sie einsehen, dass DADA, geboren aus der Unerklär-
barkeit eines glücklichen Augenblicks, die einzig praktische Religion unserer Zeit darstellt."

23. Note, dated 3 September 1917, which lacks an addressee but was probably to Hannah Höch, Nachlass Höch, Berlinische Galerie, Berlin: "Ich brauche dringend die Manuskripte 'Christus' — Ich besitze den Original text nicht mehr."

24. Hoddis's "Weltende" became well known when it first appeared in *Demokraten* 2 (11 January 1911), col. 43. A convenient reprint and translation of this poem, among the most famous in Expressionism, is found in Eberhard Roters, "Big-City Expressionism: Berlin and German Expressionism" in *Expressionism: A German Intuition, 1905-1920* (ex. cat., New York: Solomon R. Guggenheim Museum, 1980), p. 240. Ludwig Meidner's *Burning City* (fig. 7-2, 1913), a double-faced painting, is in the Morton D. May Collection, St. Louis. The verso of Meidner's work and Otto Dix's *War* (*Arms*) (1914), in the Kunstmuseum, Düsseldorf, are illustrated in Paul Vogt, *Expressionism: German Painting 1905-1920* (New York: Abrams, 1980), pp. 121, 118.

25. Hausmann, "Christus," undated typescript: "Die Idee vom Ende der Welt ist deterministisch, Christus war Indeterminist!" This passage appears in a manuscript fragment dated 12 March 1917. The rest of "Christus" appears in a manuscript dated 24 June 1917. Nachlass Höch, Berlinische Galerie, Berlin.

26. Raoul Hausmann, "Notiz," *Die Aktion* 7, 31-32 (11 August 1917): col. 421: "Die Balance der Geistssphäre ... erkannt muss werden den ihr ungeheuerer Gegensatz, ihr Zusammenhang als Durchdringung der Welt mit Geist." Raoul Hausmann, "Der Mensch ergreift Besitz von sich," *Die Aktion* 7, 14-15 (7 April 1917): col. 198: "Noch ist Gott in der lebendig als Zwang, Macht und Zufall."

27. Hausmann, "Christus:" "Christus war Indeterminist! ... Das Christentum hat Christus nie begriffen!"

28. Adolf Behne, "Dada," *Die Freiheit,* Abend-Ausgabe (Berlin), 9 July 1920. I am indebted to Richard Shappard for this reference.

29. Richard Huelsenbeck, *En avant Dada: Eine Geschichte des Dadaismus* (Hanover: Paul Steegemann Verlag, 1920). For an English translation, see Richard Huelsenbeck, "En avant Dada: A History of Dadaism," trans. Ralph Manheim, in Robert Motherwell and Jack D. Flam, eds., *The Dada Painters and Poets: An Anthology,* 2nd ed. (Boston: G.K. Hall, 1981), p. 40.

30. Huelsenbeck, "Der neue Mensch," *Neue Jugend* 2, 1 (23 May 1917): 1-3. This passage is from the partial translation in Hans. J. Kleinschmidt, "The New Man — Armed with the Weapons of Doubt and Defiance: Introduction," in Richard Huelsenbeck, *Memoirs of a Dada Drummer,* ed., Hans. J. Kleinschmidt, trans. Joachim Neugroschel (New York: Viking, 1974), p. xxxi.

31. Letter from Hausmann to Höch dated 28 September 1917, Nachlass Höch, Berlinische Galerie, Berlin: "Merezhkowski ist der erste, der das Böse bewusst, auch im Göttlichen sicht."

32. Text beginning "Die Friedrich Adler-Niederlassung" dated 21 August 1917, Nachlass Höch, Berlinische Galerie, Berlin: "Gott im Menschen als Demut und Gewalt, Gut und Böse, indeterminierter Determinismus."

33. Johannes Baader, *Vierzehn Briefe Christi* (Berlin: Verlag de Tagebücher, 1914); fasc. repr. ed., Karl Riha, ed., *Johannes Baader Oberdada: Vierzehn Briefe Christi,* PA-RA-BU Series (Frankfurt: Patio Verlag, 1979); Johannes Baader, *Die achte Weltsätze,* published privately in 1919, appeared earlier in *BZ am Mittag* (30 July 1918), and as part of "Der Sinn der Weltrevolution," *Die Freie Strasse,* no. 10 (December 1918): 3. For an English translation, see *The Eight World Theses of Master Johannes Baader,* trans. Lerke Foster (Iowa City: Center Press, Fire Arts Dada Archive, 1980). Baader's two texts are closely related.

34. Raoul Hausmann, *Je ne suis pas un photographe,* ed. Michel Giroud (Paris: Chêne, 1975), p. 24.

35. These efforts are conveyed in Richard Huelsenbeck's correspondence with Tristan Tzara in the Fonds Doucet, Bibliothèque Littéraire Jacques Doucet, Paris. This correspondence is published in Richard Sheppard, ed., *Zürich–Dadaco–Dadaglobe* (Fife, Scotland: Hutton Press, 1982), pp. 10-11. But, as Wieland Herzfelde reports, they were fruitless: "Was die 'Neue Jugend' anging, so haben die Mitarbeiter beider Ausgaben [weekly and monthly series], ausgenommen Huelsenbeck, in den Jahren 1916/17 einander und sich selbst nicht als Dadaisten bezeichnet." Wieland Herzfelde, "Aus der Jugendzeit des Malik Verlags: Zum Neuedruck der Zeitschrift, *Neue Jugend,"* in *Neue Jugend: Monatschrift und Wochenausgabe* (repr. ed., Berlin: Rütten & Loening, 1967), p. 15.

36. Richard Huelsenbeck, "Erste Dadarede in Deutschland," in Huelsenbeck, *Dada Almanach,* p. 108: "Es ist nur ein Schritt bis zur Politik. ... Der Dadaismus ist etwas, was die Elemente des Futurismus oder der kubistischen Theoreme in sich überwunden hat." Christopher Middleton makes the suggestion that the Berlin Dadaists had "adopted Communism as a convenient weapon against Expressionism" by the time of the first Dada manifestation. J.C. Middleton, "Dada versus Expressionism, or the Red King's Dream," *German Life and Letters* 15, 1 (October 1961): 45. Huelsenbeck's proclamation in favor of Dada occurred at the Vortragsabend held at I.B. Neumann's Gallery on 22 January 1918.

37. Hausmann, "Notiz," col. 421: "Aus der Sphäre der innersten, höchsten Realität fliesst alles 'Wirken' in die Realität der 'Welt' als einer Fiktion. Die Auswirkung in der Welt-Menschlichkeit; Zeit-Welt überhaupt gehorcht der Stimme des Geistes, der wahren Realität, die 'Sinn', 'Bedeutung,' 'Wert' ausstrahlt und zurückstrahlt, erkennen lasst durch das Spiel 'sinnloser' Organe 'Zufall,' die unerschütterte Richtquelle, ewige Schöpfer-Person, Geist-Gott."

38. Ibid.: "Der Organismus: Mensch, auf dieser Erde, die tausendfach verflochten, sich durchkreuzenden Genankensysteme (Regierungsformen, Kapitalwirtschaft, burgerliche Gesellschaft als ebensoviele Machtwillen)."

39. Raoul Hausmann, *Synthetische Cino der Malerei* (Berlin, 1918), repr. in Hausmann, *Am Anfang,* pp. 28-29: "In Dada werden Sie Ihren wirklichen Zustand erkennen: wunderbare Konstellationen in wirklichem Material, Draht, Glas, Pappe, Stoff, organisch entsprechend Ihrer eigenen geradezu vollendeten Brüchigkeit, Ausgebeultheit." For an English translation by Mimi Wheeler, see Lippard, *Dadas on Art,* p. 50.

40. Raoul Hausmann, "L'esprit de notre temps 1919," dated 14 September 1967, in Hausmann, *Je ne suis pas un photographe,* p. 30: "Je voulais dévoiler l'esprit de notre temps, l'esprit de chacun dans son état rudimentaire."

41. Hausmann, *Synthetische Cino der Malerei,* trans. in Lippard, *Dadas on Art,* p. 60.

42. *Material der Malerei Plastik Architektur* (Berlin, 1918, edition of 23), text reprinted in Richard Sheppard, "Neuen kurze Beitrage aus den Dada-Jahren von Raoul Hausmann," *Sprach im technischen Zeitalter* 58 (April-June 1976): 163: "Malerei Dynamismus der Farben der Form gedacht in der Fläche man wird sie so rein machen als möglich eine Gestaltung organische in Analogie der gesehenen Momente weder nachahmend noch beschreibend." For the collage cover (not editioned), see Malmö Konsthall, *Raoul Hausmann* (ex. cat., Malmö: Malmö Konsthall, 1980), p. 43.

43. Hausmann, "Zur Geschichte des Lautgedichts," in Hausmann, *Am Anfang,* p. 43

44. Letter from Raoul Hausmann to Hannah Höch dated 5 June 1918, Nachlass Höch, Berlinische Galerie, Berlin: "Noch eins: meine neuen Kunstbestrebungen betrachtest Du nicht

als Loslösung vom Expressionismus. So wird z. B. der expressionistische Künstler ein Gedicht, wie der Wald in Holz schneiden wollen. Der Dadaist kann das garnicht wollen: er wird nicht etwas, was heute rein maschinellen Charakter hat, wie Typographie, oder ihre dynamische Form ... in ein andres Material übersetzen.''

45. Hermann Bahr, *Expressionismus* (Munich: 1916), cited in John Willett, *Expressionism* (New York: McGraw Hill, 1970), p. 100.

46. Behne, "Dada:" "Es ist so: Der Mensch ist eine Maschine, die Kultur sind Fetzen."

47. Hausmann, "Dada in Europa:" "Wozu Geist haben in einer Welt, die mechanisch weiterläuft?" For Hausmann's attack on the Expressionist *Kathedralstil,* see "Objektive Betrachtung der Rolle des Dadaismus," *Der Kunsttopf* 4 (October 1920): 64.

48. Letter from Hausmann to Doris Hahn dated 30 September 1964: "Ich lernte Mynona 1915 durch Hans Richter kennen." Hausmann dates the friendship "Anfang 1915" in a letter to Hahn of 15 November 1966. Friedländer is first mentioned by Hausmann in his correspondence with Höch in a letter of 6 June 1915. These letters are in the Nachlass Höch, Berlinische Galerie, Berlin.

49. Letter from Hausmann to Höch, dated 31 August 1915, in Götz Adriani, ed., *Hannah Höch: Fotomontagen, Gemälde, Aquarelle* (Cologne: Dumont, 1980), pp. 9-10.

50. S[alomo] Friedländer, *Schöpferische Indifferenz* (Munich: George Müller, 1918), pp. xix-xxiii. For an earlier version of these views, of particular importance to Hausmann, see Salomo Friedländer, "Präsentismus: Rede des Erdkaisers an die Menschen," *Der Sturm* 3, 144-45 (January 1913): 1-2.

51. Friedländer, *Schöpferische,* p. xxi: "Auch alle vereinzelten Willkür-Akte sind automatische, wie Mechanismen. ... Welt, das ist eine Maschinerie. Menschen, es sind nur Räderchen in dieser Maschinerie."

52. Raoul Hausmann, "Tatlin at Home Prende Forme," 3 September 1967, in Hausmann, *Je ne suis pas un photographe,* p. 52: "Mais il ne suffit pas d'en avoir l'intention, if faut trouver et assembler les moyens qui imposent leurs limites."

53. Edouard Roditi, "Interview with Hannah Höch," *Arts* 34, 3 (December 1959): 26. For a discussion of the Berlin Dadaists' exploration of the concent of mechanical production, see Hanne Bergius, "Dada Machinel," in *Kunst und Technik in den 20er Jahren: Neue Sachlichkeit und Gegenständlicher Konstruktivismus* (ex. cat., Munich: Städtische Galerie im Lenbachhaus, 1980), pp. 124-37. In fact, the earliest extant photocollages by Hausmann and Höch were made in 1919 when the machine was beginning to emerge in Berlin Dada.

54. Raoul Hausmann, "Kabarett zum Menschen," *Schall und Rauch* 3 (February 1920): 1-2: "Wir werden Ihnen innerhalb von drei Minuten zeigen, wie der Mechanismus der Seele funktioniert. ... dass der Mensch wirklich so ist, nichts weiter, ein leerlaufender Unsinn."

55. Hausmann, *Am Anfang,* p. 31.

56. Hannah Höch's *Mechanischer Garten* is in the H. Marc Moyens Collection Alexandria, Virginia, and is illustrated in Adriani, *Höch,* p. 59.

57. Hausmann, "Objektive Betrachtung der Rolle des Dadaismus," p. 66: "Der Dadaismus ist eine Ubergangsform, die sich taktisch gegen die christlich-bürgerliche Welt wendet und die Lächerlichkeit und Sinnlosigkeit ihres geistigen und sozialen Mechanismus schonungslos aufdeckt."

58. *Menschen* 1, 1 (1918): 1: "Von der Fixierung unseres Lebensgefuhls, das man heute mit dem Worte EXPRESSIONISMUS bezeichnet, bis zur letzten Konsequenz, der Tat, enthält diese

Folge vorwiegend Beiträge, denen Cliquentum und Radikalismus bisher dem Weg versperrten.''

59. Raoul Hausmann, "Der deutsche Spiesser ärgert sich," *Der Dada 2* (December 1919): n.p.: "Begreifen Sie doch, dass Ihre Positionen uns völlig gleichgültig sind."

60. Ibid.: "Wir dudeln, quietschen, fluchen, lachen die Ironie: Dada! Denn wir sind — ANTI-DADAISTEN! ... Sparen Sie sich Ihre zerschundenen Knochen und nähen Sie Ihre zerrissene Fresse, Sie haben alles umsonst getan!"

61. Hausmann, *Synthetisches Cino der Malerei,* trans. in Lippard, *Dadas on Art,* p. 60.

62. Hausmann, "Objektive Betrachtung der Rolle des Dadaismus," pp. 63-64.

63. Iwan Goll, "Der Expressionismus stirbt," *Zenit 1* (Zagreb, 1921): 8-9: "Wollte man kritisch sein, so wäre allerdings nachweisbar, dass der Expressionismus an jenem Revolutionsaas krepiert, dessen mütterliche Pythia er sein wollte." Quoted in Roy F. Allen, *Literary Life in German Expressionism and the Berlin Circles* (Göppingen: Verlag Alfred Kümmerle, 1974), p. 112.

64. H.G. Hartlaub, "Deutscher Expressionismus," *Frankfurter Zeitung* (15 July 1920), accordint to Fritz Schmalenbach in "The Term *Neue Sachlichkeit,*" *Art Bulletin* 22, 3 (September 1940): 163.

65. In one of the first uses of the term, Worringer related "synthesists and expressionists in France" to primitive art. Wilhelm Worringer, "Zur Entwicklungsgeschichte der modernen Malerei," *Der Sturm* 2, 75 (August 1911): 597. Worringer's later remarks were made in a lecture given on 19 October 1920 to the Deutsch Goethegesellschaft in Munich and published as *Künstlerische Zeitfragen* (Munich: Hugo Bruckmann Verlag, 1921), see pp. 14, 23. Worringer's disenchantment was apparent in his "Kritische Gedanken zur neuen Kunst," *Genius,* 1919, pp. 221-36, a lecture given in March at the Kölnischen Kunstverein in which he identified the "Problematik des Expressionismus" (pp. 230ff).

66. Hausmann, "Objektive Betrachtung der Rolle des Dadaismus," p. 64.

67. Hausmann, *Synthetisches Cino der Malerei,* trans. in Lippard, *Dadas on Art,* p. 61.

68. Raoul Hausmann, "Ausblick," *G 3* (June 1924): 4: "Ein neues einheitliches grosses Weltbild muss daher allen Dualismus beseitigen ... Das Wesen des Seins oder viel mehr des Werdens ... ist in sich gegenläufig, die Gegensätze der Kräfte und Erscheinung hervorrufend und ihre Entsprechungen äussern sich für uns in der höheren Einheit der universalen Funktionalität."

69. Hausmann, "Lob des Konventionellen," p. 5: "Ich bin so konventionnel, dass ich für die Gotik verdorben bin. Für alles Interessante bin ich verdorben, denn ich frage zuerst nach seinem praktischen Sinn. Ich bin gegen den Werkbund, gegen Caligari, gegen den Golem und gegen alle Versuche, das praktische Leben interessant zu machen, es geistig auszupolieren: ich bin für jederlei alten oder neuen Expressionismus zu konventionell." Hausmann continues: "Wenn ich mir das Leben interessant oder dunkel machen will, muss ich dies selbst besorgen, aber ich benutze niemals einen expressionistischen Nachttopf."

70. Ibid., p. 6.

71. Ibid.: "Die künstlerische Phantasie ist Sabotage am Leben, sie ist romantisch, retrospektiv und dumm gegen die Phantasie des Technikers, des Konstrukteurs von Maschinen, gegen den naturwissenschaftlichen Experimentator und selbst gegen die Fähigkeit eines Urmachers, Schweizers oder Lokomotivführers."

72. Hausmann, "Ausblick," p. 6: "Was gegeben werden kann, sind, stets in menschlichen Formeln, Angleichungen an die Bezüglichkeiten des schöpferischen Fluidums des Universums, aber nie dies Fluidum selbst."

73. Hausmann, "Die Neue Kunst," col. 285: "ein Gleichnis dieser höheren Wirklichkeit suchen und finden in dem schöpferischen Zustand, den wir Kunst nennen."

74. Hausmann, "Lob des Konventionellen," pp. 6-7: "Die Künstler hätten die Aufgabe zu erfüllen ... die neue Konventionalität des einfachen selbstverständlichen Lebens zu formulieren, nicht philosophische Vertiegenheiten und angebliche seelische Romantik! ... Konventionnel ist ein Mensch, der jede Sache um des in ihr liegenden Selbstzwecks ganz einfach macht, ohne Abschweifungen."

75. Raoul Hausmann, "Photomontage," A bis Z 16 (May 1931): 61-62, trans. in Lippard, Dadas on Art, p. 65.

76. Tristan Tzara, "Dada Manifesto 1918," trans. Ralph Manheim, in Motherwell, The Dada Painters and Poets, p. 79.

77. Hausmann, "Dada ist mehr als Dada," in Hausmann, Am Anfang, p. 84: "Der Dadaist hasst die Dummheit und liebt den Unsinn."

78. Ibid., p. 85: "Ob Gott oder Tao, Identität und Zahl, Individuum und Ding an sich — für Dada sind dies noch nicht einmal exakt gestellte Fragen, denn Dada ist alles dies zugleich und als ebenso sicher nicht existent bewusst."

79. Richard Huelsenbeck, "Dadaistische Manifest," in Huelsenbeck, Dada Almanach, p. 41, repr. in Hausmann, Am Anfang, p. 25: "Gegen dies Manifest sein, heisst Dadaist sein!"

80. Hausmann, "Dada ist mehr als Dada," in Hausmann, Am Anfang, pp. 84, 88: "Das Unerklärliche daran ist nun dies, dass der Dadaismus allgemein flagrant war und dass ihn neimand erfinden konnte. Eine Namengebung ist keine Erfindung ... Dem Dadaisten ist das Leben schlechtweg eine Unerklärbarkeit."

81. J. Heusinger von Waldegg, "Wie sie einander sahen — die Dresdener Sezession Gruppe 1919 in Bildnissen ihrer Mitglieder," in Dresdener Sezession 1919-1925 (ex. cat., Milan and Munich: Galleria del Levante, 1977), n.p.

82. Raoul Hausmann and V[iking] Eggeling, "Zweite Präsentistische Deklaration — Gerichtet an die internationalen Konstructivisten," MA 8, 5-6 (1923): n.p.: "Funktionalitätsprinzip der Zeit, die als kinetische Energie Raum und Materie bildet."

83. Review by "aeo," "Dadaistenunfug in Der Urania," in Bohemia, 8 November 1921. I am indebted to Richard Sheppard for providing me with this review and the related newspaper announcements below.

84. Hausmann, "PREsentismus gegen den Puffkeismus der Teutschen Seele," in Hausmann, Am Anfang, p. 131. For Hausmann's account of this event, see Raoul Hausmann, Courrier Dada (Paris: Le Terrain Vague, 1958), pp. 111-12, and Hausmann, Am Anfang, pp. 64-66. Hausmann is concerned here mostly with phonetic poetry and the important exposure of Schwitters to "fmsbwtözäu" as well as this event being the premier of "MERZ plus Anti-DADA." The Presentist declaration is mentioned in newspaper announcements in Bohemia of 4 and 6 November 1921.

85. Raoul Hausmann, "Sieg Triumph Tabak mit Bohnen," Zenit 8 (October 1921): 10-11, repr. in Hausmann, Am Anfang, p. 140 (in the latter, Hausmann added the subtitle "Manifest des Unmöglichen": "Der Mensch versucht vergeblich aus sich ein transcendent-immanentes Perpetuum mobile zu machen."

86. Hausmann, "Der Vermenschlichungswille ...," in Sheppard, "Neuen kurze Beitrage aus den Dada-Jahren von Raoul Hausmann," p. 166: "die neue Kunst ist Decentralisation, die Aufteilung des Mittelpunktes, eine Auflösung."

87. Hausmann, "PREsentismus," in Hausmann, *Am Anfang,* p. 131: "Unsere Kunst, das ist schon heute der Film! Zugleich Vorgang, Plastik, und Bild!"

88. Hausmann, "Photomontage," in Lippard, *Dadas on Art,* p. 64.

89. Hausmann, "Lob des Konventionellen," p. 5: "uns nötig ist ... die Konvention der Kinopsychologie."

90. Kurt Schwitters, "Merz," *Der Ararat* 2, 1 (January 1921): 3-9, trans. Ralph Manheim, in Motherwell, *The Dada Painters and Poets,* p. 59.

91. Hausmann, "PREsentismus," in Hausmann, *Am Anfang,* p. 130: "Schönheit, das ist eine Sache, die Während des Produktionsprozesses entsteht!"

92. Kurt Schwitters, "An alle Bühnen der Welt," in *Anna Blume: Dichtungen* (Hanover, 1919), pp. 31-37, repr. in *Text + Kritik: Zeitschrift für Literatur,* no. 35-36, special Schwitters number (October 1972): "Ich fordere die prinzipielle Gleichberichtigung aller Materialien."

93. Hausmann, "Lob des Konventionellen," p. 6: "herrlich sind alle die konventionellen Dinge!"

94. Hausmann's discussion of "lever mechanics" can be found, e.g., in "Sieg Triumph Tabak mit Bohnen," February 1921, *Zenit* 1, 9 (November 1921): 10-11, repr. in Hausmann, *Am Anfang,* pp. 141-43, and in a manuscript entitled "Neue Wahrheiten sind Meistens sehr alt," 14 January 1922, published in Hausmann, *Texte bis 1933,* vol. 2, pp. 60-62. See Hausmann's "Ausblick" and "Zweite Präsentistische Deklaration" for his arguments for a new sensibility beyond "mechanical consciousness."

95. Hausmann, "Ausblick," pp. 5, 6: "Wenn auch jede Form ein erstarrtes Momentbild eines Geschehens ist ... es gibt keine Dreidemensionalität von Raum, Zeit und Bewegung als allein in unserer Vorstellung von Geist und Form." Hausmann discusses his "time-space sense" in "Ausblick" and "Zweite Präsentistische Deklaration."

96. Hausmann, "PREsentismus," in *Am Anfang,* p. 134: "Das Individuum als Atom betrachtet, hat nur die eine Aufgabe: sein Gesetz zu finden durch jede Art und Form der Arbeit an seinem verhärteten Ich, gegen dieses Ich — in dieser neuen gegenwärtigen Welt müssen wir die freiwillige Hergabe aller der dem Atom innewohnenden Krafte zur Verwirklichung bringen!!!"

8

Dada New York:
An Historiographic Analysis

Estera Milman

When Tristan Tzara published his "Zurich Chronicle 1915-1919" (1920), he provided scholars of the twentieth-century avant-garde with a number of revealing observations. Of particular value is his closing paragraph:

> Up to October 15, 8,590 articles on Dadaism have appeared in the newspapers and magazines of: Barcelona, St. Gall, New York, Rapperswill, Berlin, Warsaw, Mannheim, Prague, Rorschach, Vienna, Bordeaux, Hamburg, Bologna, Nuremberg, Chaux-de-fonds Colmar, Jassy, Bari, Copenhagen, Bucharest, Geneva, Boston, Frankfurt, Budapest, Madrid, Zurich, Lyon, Basle, Christiania, Berne, Naples, Cologne, Seville, Munich, Rome, Horgen, Paris, Effretikon, London, Innsbruck, Amsterdam, Santa-Cruz, Leipzig, Lausanne, Chemnitz, Rotterdam, Brussels, Dresden, Santiago, Stockholm, Hanover, Florence, Venice, Washington, etc. etc.[1]

Although there may be some question as to the historical accuracy of Tzara's compilation, there is little doubt that he was intent upon the making of history.

Dada was born in Zurich, sometime in March or April 1916.[2] Tzara writes, "A word was born no one knows how Dada - dada we took an oath of friendship on the new transmutation that signifies nothing."[3] Whether or not Tzara can be credited as the individual who chose this particular nonsense word remains a moot point. That he was primarily responsible for the international propagation of this "new transmutation" is far more important.[4] Tzara employed all available means by which an avant-garde could ensure its interaction with culture. The very emptiness of the word "Dada," not only semantically, but also in its inability to represent a set of aesthetic principles, presented him with an unprecedented opportunity to concentrate upon the mechanics of the avant-garde. In the spring of 1916, when Tzara first became the prophet of the word, Dada signified nothing[5] and, as a result, it could encompass everything.

From Dada's birth until its eventual demise, Tzara remained its most active propagandist[6] and, as such, felt free to incorporate concurrent developments into the movement. By 1921, Tzara defined Dada as being neither a school nor a dogma, but rather "a constellation of individuals and of free facets." While supplying his mock authorization for Marcel Duchamp and Man Ray's periodical *New York Dada*, not only did he explain that Dada belonged to everyone, but he also insisted that the spirit of Dada had existed long before its present form was identified in Zurich.[7]

Scattered throughout Tzara's chronicle of Zurich Dada are statements that mark various points of convergence between Dada and affinitive, although generally disconnected, developments that had been initiated in America. An entry for December 1918 welcomes Francis Picabia, "the anti-painter just arrived from New York"; February 1919 lists *391* under "Dada Movement Editions" and also mentions Marcel Duchamp and *The Blind Man,* both of which were subsequently included in the Dada canon. Dada had identified an ahistorical and universal state of mind, and the ranks of the European movement were visibly increased as a result. Indigenous aspects of New York modernism, on the other hand, concurrently established an even more complex relationship to the movement. Tzara's entry for May 1919 announces that *TNT* is the "latest magic," although, in this case, Man Ray and Adolf Wolff, the magazine's American editors, have been visibly excluded from Tzara's chronicle.[8]

Despite his newly won, albeit moderately short-lived, position as catalyst for the resurrection of the avant-garde in postwar Paris, Tzara was probably not yet aware, in the early 1920s, of the full power inherent in the myth of Dada and its capability of providing a primary paradigm for the twentieth-century avant-garde in general. In retrospect, it has become evident that the ascendancy of this particular paradigm was based not only on the seductiveness of the word "Dada," but also to a large extent on the inclusive nature of the "Dada spirit." One aspect of Dada's affinity with a universal state of mind can be illustrated through an investigation of the process by which the pre-Dada activities of artists, and of anti-artists like Marcel Duchamp and Francis Picabia, were retroactively introduced into the history of the movement. Richard Huelsenbeck provides us with evidence of yet another example of Dada's propensity to be inclusive.

Although the movement was born in Zurich, it was in Berlin that Dada unquestionably became most overtly politicized. As a member of the Berlin Dada group (having rejected his earlier Zurich affiliations), Huelsenbeck, in *En avant Dada* (1920), distinguishes between the true Dadaist, one who makes literature "with a gun in hand,"[9] and the members of Zurich's Galerie Dada who he insists, established a "manicure salon of the fine arts."[10] And yet, for Huelsenbeck, anyone — except perhaps Tzara, Johannes Baader, and Kurt Schwitters[11] — can be a Dadaist:

The bartender in the Manhattan bar, who pours our Curacao with one hand and gathers up his gonorrhea with the other, is a Dadaist. The gentleman in the raincoat, who is about to start his seventh trip around the world, is a Dadaist. The Dadaist should be a man who had fully understood that one is entitled to have ideas only if one can transform them into life — the completely active type, who lives only through action, because it holds the possibility of his achieving knowledge.[12]

The avant-garde can be defined as a collective attempt to respond, from within an art context, to the cultural and social imperatives of a particular period of time. While the politicization of the arts is not the sole means by which such interaction is ensured,[13] participants in Berlin Dada undeniably maintained what can be described as a set of classical and easily identifiable avant-garde postures. Huelsenbeck, Höch, Baader, Hausmann, Grosz, and Heartfield participated in a particularly radical aspect of historical Dada. The Manhattan bartender and the world traveler, on the other hand, serve to exemplify what Katherine Dreier, president of the Société Anonyme, Inc., identified as "natural Dadaism."[14]

We can only begin to understand historical Dada from within the context of each of its centers. Furthermore, we are generally aware that, rather than stagnate once established in a particular location, Dada continued to evolve in response to each specific context. In the course of this evolution, Dada continued to appropriate and was reciprocally appropriated. The following historiographic analysis will attempt to distinguish between (1) historical "New York Dada," which during its short lifespan functioned within a context that differed greatly from those to which its European counterparts responded; (2) the "Dada spirit" in America, an ahistorical concept that served to identify artists and poets who displayed conceptual and stylistic affinities with Dada and to incorporate their past and present activities into the history of the movement;[15] and (3) "natural American Dadaism," a term that in the early 1920s referred not to American modernism, but rather to aspects of American popular culture that were held in high esteem by the Dadaists.

Tzara's inclusion of aspects of early twentieth-century American modernism in his history of Zurich Dada, alongside his insistence on the prevalence of an ahistorical Dada spirit, provided the basis for subsequent convictions that Dada was born in Zurich and New York simultaneously. However, an investigation of the disparate contexts within which European Dada and American modernism respectively flourished, and an awareness of their often contradictory goals, present evidence in direct conflict with such a supposition. Of particular relevance are their divergent responses to the very term "modernism."

In *En avant Dada* (1920), Huelsenbeck, from a Berlin perspective, recounts his early experience at the Cabaret Voltaire, where "Dada was to be a rallying point for abstract energies and a lasting sling-shot for the great international artistic movements."[16] He later adds: "The Dadaists of the Cabaret Vol-

taire actually had no idea what they wanted — the wisps of 'modern art' that at some time or other had clung to the minds of these individuals were gathered together and called 'Dada.' "[17]

Anyone who peruses the early programs performed at the Cabaret Voltaire will agree that its members appropriated various aspects of European modernism, juxtaposed one against the other, and presented them to the Zurich public.[18] Although the Cabaret Voltaire may initially have served as a connective for pre–World War I "modernist" tendencies, Zurich Dada evolved into something far more complex. Georges Hugnet, in "The Dada Spirit in Painting" (1932-1934), summarizes:

> At Zurich in 1916, Hugo Ball opened a literary cabaret called "Cabaret Voltaire"; here Dada came into being amidst such confusion that it had a hard time distinguishing itself from Art, its hereditary enemy, and proceeded to evolve on the plane of cubism and futurism. But Dada profited from the confusion; it also profited from the ferment going on in Zurich, a haven for deserters, anarchists and revolutionaries. Those who had taken refuge in Zurich were not themselves fully conscious of what was going on within them, and of the force that in some of them was acquiring substance and becoming explosive. Everything was rotting, everything was reduced to appearances, and the appearances had become sordid. A smell of latrines was seeping beneath the doors.[19]

Huelsenbeck contributed to some of Zurich Dada's earliest events. By the end of 1916, however, he left Zurich for Germany.[20] The political and economic realities of Berlin presented Dada with a context far different from the confusions of neutral Switzerland. For Huelsenbeck, looking back from Berlin, "an art for art's sake mood lay over the Galerie Dada."[21] Hugnet, in 1932-1934, provides yet another perspective:

> In Berlin there were the same confusions and contradictions as in Zurich. To increase its numbers, Dada took in — though briefly, it must be admitted — names both startling and discordant. In both cities there was a curious mixture of true and false Dadaists, if we may use these terms to distinguish between the moral consciousness of one group and the modernist theories of the other; and the false Dadaists made use of the others.[22]

Hugnet is particularly insistent when he maintains that "the disdain in which Dada held all forms of modernism was indispensible to its own vitality."[23] Huelsenbeck attacks Zurich's early modernist tendencies in his attempt to discredit Tzara's Dadaism, even at the expense of historically negating the importance of his own affiliations with Zurich.[24] When he describes the publication *Cabaret Voltaire* as a "catch-all for the most diverse directions in art," he is defining what, for him, was a "traditional view" that interfered with the formulation of "a conception of art as a moral and social phenomenon."[25]

The insistence upon a conception of art as a moral and social phenomenon remains an elemental feature by which we continue to identify an avant-garde. Although the term was originally coined, in 1825, as a utopian concept during a

period of European history that maintained a belief in progress and perfectibility,[26] the avant-garde had, by the second decade of the twentieth century, long since demonstrated its ability to respond to negativistic world views. Cultural criticism had become yet another primary characteristic of the twentieth-century avant-garde.

In the early twentieth century, during recurring periods of optimism, modernism often coincided quite naturally with avant-gardism. During the "heroic years" directly preceding the First World War, modernism came to be identified with the prevailing sense of imminent change and with a universal readiness for great events.[27] By the time the tragedy of the Great War became apparent, the heroic years had ended. Although not universally rejected, modernism came to connote, for some, an ineffectual search for the new and, as such, was generally repudiated by Dada. This rejection of modernism by most European Dadaists is central to this investigation of Dada in New York.

On 1 April 1921, the Société Anonyme, Inc., New York, sponsored the symposium "What is Dadaism." Marsden Hartley, Claire Dana Mumford, and Dr. Phyllis Ackerman were the participants.[28] Hartley presented a paper that was to explain Dada to an American art audience. April 1921 also marked the publication of the only "official" American Dada periodical. On the second page of *New York Dada,* while listing New York contributors to his never realized *Dadaglobe,* Tristan Tzara included Hartley's name alongside those of W.C. Arensberg, Gabrielle Buffet, Marcel Duchamp, Adon Lacroix, Baroness v. Loringhoven, Man Ray, Joseph Stella, E. Varèse, A. Stieglitz, and C. Kahler.[29] That same year, Hartley published *Adventures in the Arts,* which included an afterword entitled "The Importance of Being 'Dada.' " He opens the essay with the following statement:

> We are indebted to Tristan Tzara and his followers for the newest and perhaps the most important doctrinary insistence as applied to art which has appeared in a long time. Dadaism is the latest phase of modernism in painting as well as in literature, and carries with it all the passion for freedom of expression which Marinetti sponsored so loudly in his futurist manifestoes.[30]

Hartley's afterword is complex and offers a number of definitions of Dada that clearly illustrate his broad familiarity with aspects of the movement. Identifying himself as a Dadaist, he criticizes all individuals who worship art as an "orchidaceous rarity" and states: "War has taught us that idolatry is a past virtue and can have no further place with intelligent people living in the present era."[31] Hartley's primary Dada principles, however, are liberation and humor. He closes "The Importance of Being 'Dada' " with: "We shall learn through dada-ism that art is a witty and entertaining pastime, and not to be accepted as our ever present and stultifying affliction."[32]

Adventures in the Arts, which Hartley subtitled "Informal Chapters on Painters, Vaudeville and Poets," contains essays written over an extended

period of time, many of which had previously been published in *Art and Archaeology, The Seven Arts, The Dial, The Nation, The New Republic,* and *Touchstone.* Scattered throughout the book are statements that illustrate Hartley's propensity to educate and enlighten the American public. It is clear that for Hartley, even Dada could serve such an end.

Waldo Frank, in his introduction to *Adventures in the Arts,* describes the anthology as an American book and Hartley as "the artist of a cultural epoch," a man who has "mastered the plastic messages of modern Europe," and who, at the same time, "has gone deep in the classical forms of the ancient [American] Indian Dance."[33] As Frank's introduction suggests, Hartley's book is replete with statements advocating the integration of international modernist aesthetics with a local, indigenous American art. However, in his afterword, which was most probably written not long before the publication of the anthology, Hartley does not attempt to maintain such a position, but refers to America only once when he writes: "Art is at present a species of vice in America, and it sorely and conspicuously needs prohibition or interference."[34]

Complaining that America had nothing further to offer him as a painter and a poet, Hartley left for Europe soon after *Adventures in the Arts* appeared in print and was not to return until 1930.[35] Although we can infer that Hartley may well have been disillusioned with the state of modern art in America when he wrote "The Importance of Being 'Dada,' " it is significant that in 1921 Hartley did not reject modernism per se; quite the contrary, he rejoiced in his familiarity with what for him was its newest manifestation.

Katherine Dreier, in *Western Art and the New Era* (1923) explains that modern art, or the art of the new era, "sprang into existence everywhere at once."[36] For Dreier, modernism was a recent development in the unbroken "chain of western art"[37] that stretched back beyond the sixth century and forward into the new era. In "Modern Art Continued," the penultimate chapter of her book, she identifies the Simultaneists, the Futurists, the Blaue Reiter group, Expressionismus, the English Vortex movement, and the American Moderns. In addition, she notes that "another group has made its appearance which should be mentioned. These are the Dadaists!"[38] Just as Dada was presented as an afterword, albeit an important one, to Hartley's text, it also appears, almost like an afterthought, appended to Dreier's inventory of international modernist tendencies. She later adds: "They [the Dadaists] must be considered as an influence in the modern Western art of Europe." Despite her belief that Dada's message "belongs more to the art of literature than painting,"[40] Dada remains the last modern movement that Dreier discusses in her 1923 anthology.

In a chapter of her book entitled "What is Modern Art," Dreier states:

> In France and Spain the men with the new vision called it Cubism, in Germany and Russia Expressionismus, in Italy Futurism, while in England it was called the Vortex Movement.

> We gave it the rather vague term of Modern Art in America, as all these various move-
> ments came over to us at once.[41]

Modern art, or more specifically European modernism, "came over" to
America, en masse, for the Sixty-ninth Regiment Armory Exhibition. As we
have seen, for Hartley and for Dreier, in 1921 and 1923 respectively, Dada
unquestionably remained a new link on the modernist evolutionary chain. In
order to understand the complex context within which Dada was later to func-
tion in New York, it is essential to provide a brief synopsis of the climate into
which European modernism, in general, was introduced to America, and of the
social imperatives that subsequently caused the shift in American perspective
that was evident by the 1920s.

The pioneering role that the 291 gallery played in the history of early twentieth-
century American modernism is well documented. Alfred Stieglitz's Little
Galleries of the Photoseccession opened in 1905 and was soon to become
known as 291. The gallery provided a center where the newest European and
American works were exhibited until it was closed in 1917.

Through his schedule of exhibitions, Stieglitz attempted to establish a
didactic environment for his fellow American artists. His decision to exhibit
modern European drawings and paintings at 291 was based on his belief that he
could thereby teach his fellow Americans how to truly see.[42] His commitment
to the growth of a modern, indigenous American art was unshakable, as was
his faith in modernism per se. The activities of most of the members of the 291
group were, in fact, enveloped in an "evangelical" idealism, fundamentally
American in character, which was based on these two reciprocal principles and
on a general belief in the communicative, educational power of art.[43]

The 291 group, of which Hartley was an active member, was composed of
the most advanced modern American painters and poets. Most of them were
fully aware of current developments in Europe, and occasionally their ranks
included visitors from overseas. Francis Picabia, for example, who was later to
serves as the link between Tzara's Dada and New York, and his wife, Gabrielle
Buffet, became visibly involved with the 291 group during their visits to New
York. It is to the spirit of 291 that scholars generally look when searching for
American precursors to Dada.[44] Furthermore, it is clear that publications
initiated by members of the group, like the periodical *291*, were later to be
formally sanctioned by Dada, although the American idealism that fostered
these publications was neither understood nor included in this act of appro-
priation. .

Despite Stieglitz's early didactic activities, the general American public
was not to be introduced to modernism until 1913. Originally intended to serve
as a major exhibition of contemporary American art, the 1913 Armory
Exhibition, due to its subsequent inclusion of an extensive collection of
European painting and sculpture, came instead to present European modern-

ism as a powerful model for the United States.[45] The scope and eclectic nature of the 1913 exhibition introduced the American public to what appeared to them to be a "boundless modernity."[46] It has been suggested that most of the 300,000 astonished visitors who viewed the 1913 exhibition in New York, Boston, and Chicago were presented with a concept of modernity as a quality in itself,[47] and that the issues at stake were not simply aesthetic questions, for "to accept the new art meant to further the outlook of modern culture as a whole."[48] In "What is Modern Art," Katherine Dreier describes the Armory Exhibition as a "deluge" which proved conclusively that America had been "left behind in the art world."[49]

The Armory Show took place just prior to the outbreak of World War I. Although Europe was soon to be seriously affected by the war, its influence was not to be felt in America, in a similar fashion, for some time. In August 1914, Wall Street was booming, and fortunes were being made. Man Ray, settled into an idyllic rural life in Ridgefield, New Jersey, describes the early days of the war as "a great holiday, all the profits of war with none of its miseries."[50]

Walter Pach, who was personally involved in the selection of many of the Armory Show's European entries, explains in his book *Queer Thing, Painting* (1938), that faith in modernism was intensified at that time due to the return of many advanced American artists who, until the onset of hostilities, had been living in Europe and, to the migration of European artists who settled in New York seeking "the quiet of America."[51] The American Independents opened its first exhibition in the spring of 1917, just three days after America finally entered the war.[52] One direct result of the 1917 Independents exhibition was the publication of *The Blind Man*, yet another American magazine later to be appropriated by Tzara into Dada. Once again, however, it is clear that neither the little magazine, nor the impetus for its publication, had any concrete relationship to the European movement until some time after their retroactive inclusion into the history of Dada.[53]

The Blind Man was published during the last stages of an extended period of American history that presented the arts with a relatively unrestricted environment for experimentation. By the 1920s, the New York galleries and little magazines that supported international modernism earlier in the century began to dissipate. It was through the activities of the Société Anonyme (established in the spring of 1920 by Dreier, Marcel Duchamp, and Man Ray) that modernist tendencies continued to be defended in America.[54] It is generally maintained that the Société Anonyme concurrently provided Dada with its most active American forum.[55] Even during America's postwar period, Dreier maintained a faith in the power inherent within modernism to effect the well-being of the world,[56] as well as a longstanding belief in the need to educate the American public.

During the years that elapsed between the Armory Show and the establishment of the Société Anonyme, a great change had taken place in the United States. The Armory Exhibition opened in America during a period of general social idealism and idealistic individualism,[57] whereas the 1920s marked a period of isolationism and nationalistic retrenchment — reactions to the pervasive internationalism of the prewar period.[58] Even as late as the spring of 1917, both the American moderns and the expatriated European artists who were visiting New York functioned within a climate best characterized as being dominated by freedom of thought as well as of action. Soon after the United States entered the war, however, this tolerant environment was to dissipate, as the American general public was overcome by a feeling of "deadly seriousness."[59] In 1921, when Tzara published his mock authorization of *New York Dada,*[60] America was entrenched in an isolationist reaction to the liberal internationalism by which it had been dominated during its own prewar period. Within this context, the defense of international modernism can easily be understood as a valid response to prevailing social imperatives for both Hartley and Dreier, although it stands in direct opposition to European Dada.

Just as New York became a haven for expatriated European artists, so Zurich became a haven for members of the Cabaret Voltaire who settled in Zurich, seeking the quiet of neutral Switzerland. It is also clear that the early phases of Zurich Dada were eclectically modernist in nature, although even Dada in Zurich, once established, had no choice but to present a public face that stood in opposition to all idealistic responses to modern culture. In 1920, Dada's early modernist inclinations were used by Richard Huelsenbeck in his attempt to discredit many of his Zurich-based colleagues. A decade later, Georges Hugnet stated that even in overtly political Berlin, modernist theories could be used as a means by which to distinguish between true and false Dadaists.

The French Dadaist, Georges Ribemont-Dessaignes, in his "History of Dada" (1931), writes that "Dada in its early stages only half suspected its own road."[61] For Ribemont-Dessaignes, mature Dada was "a permanent revolt against art, against morality, against society." He explains that because members of the movement were poets, writers, and painters, it was "the media of art that bore the brunt of their attack."[62]

As I have already pointed out, Hugnet states that, at its birth in Zurich, Dada had a difficult time distinguishing itself from art, its "hereditary enemy," and began its evolution based on Futurist and Cubist principles. Ribemont-Dessaignes corroborates this position when he claims that in replacing that which had nourished them, the Dadaists "smashed the forms of cubist, futurist and simultaneous thought with means closely resembling the objects destroyed." He adds: "The real question was the destruction of values."[63]

Hartley and Dreier on the other hand attempted to defend international modernist principles in America. For both Dada, as a new manifestation of

modernism, was included in their didactic activities. It is particularly interesting to note that for Ribemont-Dessaignes, the final demise of Paris Dada resulted from André Breton's insistence that his planned (although never realized) "Congress of Paris" be committed to the distillation and unification of the essential principle of modernism. Breton's plans were based on a concept that both Stieglitz and Dreier would have applauded, but which was, as Ribemont-Dessaignes reminds us, undeniably "grotesque ... from the Dadaist point of view."[64]

That Hartley and Dreier did not define Dada as a reaction against modernism does not present sufficient cause to discredit New York as a functional Dada center. In the early 1920s, Dadaists in Paris were responding to a postwar public, hungry for aesthetic rejuvenation, willing to accept anything, "no matter what, as long as it was art"[65] (particularly modern art); as a result, Paris Dada reverted to "attacks on reasons for living."[66] In America, on the other hand, the public's response to modernism, by the early 1920s, had shifted from its earlier and relatively tolerant pro-internationalist position to one characterized by nationalistic conservatism.[67] Although it is difficult, if not impossible, to align 1921 European Dada with overtly didactic aesthetics and cultural idealism, it could be argued that, just as Paris Dada reacted to the cultural implications of postwar France, New York Dada, in its own fashion, responded to the social realities of America and thus retained its modernist inclinations. The evidence necessary to support such a position is not provided by either Hartley or Dreier, however, for both perceived Dada as being fundamentally a European movement.

Hartley dedicated *Adventures in the Arts* to Alfred Stieglitz, his friend and patron, but mentions neither Stieglitz nor other American members of the 291 group in "The Importance of Being 'Dada.' " Hartley insists that it is to Tristan Tzara and his followers that we are indebted for the existence of Dada. Picabia, "who was until the war conspicuous among the cubists," and who had since risen to prominence as "one of the most notable dada-ists of the day," remains the only other individual identified by name in Hartley's afterword.[68] Dreier, who in "Modern Art Continued" had almost begrudgingly stated that Dada must be considered an influence in the modern art of Europe, makes no mention of New York in her synopsis of the movement:

> This movement was started in Switzerland, in 1917, by Tzara, a Roumanian. In 1919 it reached Paris and was taken up by Picabia. A great following gathered and they appeared in literature and the applied arts, as well as painting, on the stage and in political life. Tzara appears to remain the leader of the entire group with many able men under him as leaders of their special section or country. We saw Picabia as leader in Paris, Max Ernst and Baargeld as leaders in South Germany, whereas George Grosz and John Heartfield are leaders in Berlin.[69]

From our present perspective, it is generally maintained that the principal players in the story of New York Dada were the Spaniard Francis Picabia, the

Frenchman Marcel Duchamp, and American-born Man Ray.[70] Although attempts to delineate American Dada have often presented somewhat contradictory information, there is no question that April 1921 marked the publication of the periodical *New York Dada*, the magazine that provided a concrete link between the activities of Man Ray and Duchamp in America and Tzara and his colleagues in Paris. Furthermore, although unable to provide a definitive date for the beginning of New York Dada, most contemporary scholars tend to agree that the migration of Man Ray to Paris, soon after the appearance of *New York Dada,* marked the end of the American stage of the movement.[71] One would expect that Dreier and Hartley, aware of recent activities that we currently associate with an historically significant phase of New York Dada, and personally familiar with the members of the American Dada triad, would have included information to that effect in their explanatory statements. However, an examination of their respective writings further confirms that perceptions in the early 1920s differed greatly from our currently held beliefs.

Hartley was fully aware of Picabia's pivotal role in Dada, but there is no reference in his essay to Picabia's earlier affiliations with the 291 group nor, for that matter, to any connections between Picabia and America. Dreier, on the other hand, is entirely specific when she states that Picabia took up Dada once it was transported to Paris and subsequently became a leader of the movement's French contingent.

Although Hartley makes no reference whatsoever to Duchamp in "The Importance of Being 'Dada,' " Dreier provides us with several observations. In "What is Modern Art," Dreier describes Duchamp's decorative panel *Tu'm* and writes: "In this picture he renders a higher expression of the theories the Dadaists bring forth, than any expression which was brought to my attention by a Dadaist."[72] This statement indicates that, although she was aware of the existence of a number of conceptual and stylistic affinities between Duchamp and the European movement, she did not think of her friend as a Dadaist. Dreier further clarifies her position when, in "Modern Art Continued," she explains: "Only one painter besides Duchamp has expressed Dadaism through the art of painting, Kurt Schwitters ... and strangely enough, he rejects the appellation whereas Duchamp is counted a Cubist."[73]

It is clear that in the early 1920s, Dreier was unable to identify Duchamp as a card-carrying Dadaist. Five decades later, retrospective perceptions about Duchamp's role as an active member of the movement changed drastically. Despite the fact that the summer of 1915 predated the historical birth of Dada by almost a year, Arturo Schwarz, in his "Interview with Man Ray," felt free to suggest that New York Dada may have begun when Duchamp and Man Ray first met in Ridgefield, New Jersey.[74] Ignoring this obvious anachronism, Man Ray responded by reminding Schwarz that the Dada spirit had been part of his

own character long before his involvement with Duchamp.[75] It is important to note, however, that he distinguished between the Dada state of mind and historical New York Dada. In the interview's closing statement, Man Ray firmly maintained that a formal Dada center never existed in New York.[76]

What then of Man Ray's prominent contribution to the single issue of *New York Dada,* and what of the very existence of the magazine to begin with? In his *Self Portrait*, published in 1963, Man Ray explains:

> Duchamp was in correspondence with the young group of poets and painters in Paris: the Dadaists, who asked for contributions to their publications. Why not get out a New York edition of a Dada magazine? We went to work. Aside from the cover which he designed, he left the rest of the make-up to me, as well as the choice of the contents. Tristan Tzara, one of the founders of Dadaism, sent us a mock authorization from Paris, which we translated. I picked material at random — a poem by the painter Marsden Hartley, a caricature by a newspaper cartoonist, Goldberg, some banal slogans, Stieglitz gave us a photograph of a woman's leg in a too-tight shoe; I added a few equivocal photographs from my own files. Most of the material was unsigned to express our contempt for credits and merits. The distribution was just as haphazard and the paper attracted very little attention. There was only one issue. The effort was as futile as trying to grow lilies in a desert.[77]

Man Ray's statements suggest that the publication of "a New York edition of a Dada magazine" did not, at least as far as he was concerned, necessarily coincide with the existence of an active American Dada group. Furthermore, while being interviewed by Schwarz, he insisted that the magazine was an entirely in-house affair, that it was neither distributed nor sold, and that like its precursor, *TNT,* "it reached just a few people who did not need to be converted."[78]

Man Ray's affiliation with Dada was mentioned by neither Hartley nor Dreier. The fact that each of these fairly knowledgeable Americans omitted their New York–based colleague from their early 1920 statements on Dada coincides with Man Ray's own repeated insistence that his direct involvement with the movement did not begin in earnest until his arrival in Paris in the summer of 1921, at which time Duchamp introduced him to the French Dadaists.[79]

In the teens and early 1920s, during what seems to have been an active stage of New York Dada, Man Ray's sights were directed, not toward the American Moderns, but to the French avant-garde. On 14 July 1921, he finally arrived in Paris, settled into a furnished room that Tzara had recently vacated, and was taken by Duchamp to a cafe, where he had his first encounter with the Dadaists. Of that meeting he writes: "It was rather summary, yet I felt at ease with these strangers who seemed to accept me as one of themselves, due, no doubt to my reputed sympathies and the knowledge they already had of my activities in New York."[80]

In the 1960s, in response to Pierre Cabanne's suggestion that some of his own early New York activities — in this case, the periodicals *The Blind Man* and *Rongwrong* — may have been influenced by Dada, or may at least have been undertaken in the "Dada Spirit," Duchamp stated: "It was parallel if you

Frenchman Marcel Duchamp, and American-born Man Ray.[70] Although attempts to delineate American Dada have often presented somewhat contradictory information, there is no question that April 1921 marked the publication of the periodical *New York Dada*, the magazine that provided a concrete link between the activities of Man Ray and Duchamp in America and Tzara and his colleagues in Paris. Furthermore, although unable to provide a definitive date for the beginning of New York Dada, most contemporary scholars tend to agree that the migration of Man Ray to Paris, soon after the appearance of *New York Dada*, marked the end of the American stage of the movement.[71] One would expect that Dreier and Hartley, aware of recent activities that we currently associate with an historically significant phase of New York Dada, and personally familiar with the members of the American Dada triad, would have included information to that effect in their explanatory statements. However, an examination of their respective writings further confirms that perceptions in the early 1920s differed greatly from our currently held beliefs.

Hartley was fully aware of Picabia's pivotal role in Dada, but there is no reference in his essay to Picabia's earlier affiliations with the 291 group nor, for that matter, to any connections between Picabia and America. Dreier, on the other hand, is entirely specific when she states that Picabia took up Dada once it was transported to Paris and subsequently became a leader of the movement's French contingent.

Although Hartley makes no reference whatsoever to Duchamp in "The Importance of Being 'Dada,' " Dreier provides us with several observations. In "What is Modern Art," Dreier describes Duchamp's decorative panel *Tu'm* and writes: "In this picture he renders a higher expression of the theories the Dadaists bring forth, than any expression which was brought to my attention by a Dadaist."[72] This statement indicates that, although she was aware of the existence of a number of conceptual and stylistic affinities between Duchamp and the European movement, she did not think of her friend as a Dadaist. Dreier further clarifies her position when, in "Modern Art Continued," she explains: "Only one painter besides Duchamp has expressed Dadaism through the art of painting, Kurt Schwitters ... and strangely enough, he rejects the appellation whereas Duchamp is counted a Cubist."[73]

It is clear that in the early 1920s, Dreier was unable to identify Duchamp as a card-carrying Dadaist. Five decades later, retrospective perceptions about Duchamp's role as an active member of the movement changed drastically. Despite the fact that the summer of 1915 predated the historical birth of Dada by almost a year, Arturo Schwarz, in his "Interview with Man Ray," felt free to suggest that New York Dada may have begun when Duchamp and Man Ray first met in Ridgefield, New Jersey.[74] Ignoring this obvious anachronism, Man Ray responded by reminding Schwarz that the Dada spirit had been part of his

own character long before his involvement with Duchamp.[75] It is important to note, however, that he distinguished between the Dada state of mind and historical New York Dada. In the interview's closing statement, Man Ray firmly maintained that a formal Dada center never existed in New York.[76]

What then of Man Ray's prominent contribution to the single issue of *New York Dada,* and what of the very existence of the magazine to begin with? In his *Self Portrait*, published in 1963, Man Ray explains:

> Duchamp was in correspondence with the young group of poets and painters in Paris: the Dadaists, who asked for contributions to their publications. Why not get out a New York edition of a Dada magazine? We went to work. Aside from the cover which he designed, he left the rest of the make-up to me, as well as the choice of the contents. Tristan Tzara, one of the founders of Dadaism, sent us a mock authorization from Paris, which we translated. I picked material at random — a poem by the painter Marsden Hartley, a caricature by a newspaper cartoonist, Goldberg, some banal slogans, Stieglitz gave us a photograph of a woman's leg in a too-tight shoe; I added a few equivocal photographs from my own files. Most of the material was unsigned to express our contempt for credits and merits. The distribution was just as haphazard and the paper attracted very little attention. There was only one issue. The effort was as futile as trying to grow lilies in a desert.[77]

Man Ray's statements suggest that the publication of "a New York edition of a Dada magazine" did not, at least as far as he was concerned, necessarily coincide with the existence of an active American Dada group. Furthermore, while being interviewed by Schwarz, he insisted that the magazine was an entirely in-house affair, that it was neither distributed nor sold, and that like its precursor, *TNT*, "it reached just a few people who did not need to be converted."[78]

Man Ray's affiliation with Dada was mentioned by neither Hartley nor Dreier. The fact that each of these fairly knowledgeable Americans omitted their New York–based colleague from their early 1920 statements on Dada coincides with Man Ray's own repeated insistence that his direct involvement with the movement did not begin in earnest until his arrival in Paris in the summer of 1921, at which time Duchamp introduced him to the French Dadaists.[79]

In the teens and early 1920s, during what seems to have been an active stage of New York Dada, Man Ray's sights were directed, not toward the American Moderns, but to the French avant-garde. On 14 July 1921, he finally arrived in Paris, settled into a furnished room that Tzara had recently vacated, and was taken by Duchamp to a cafe, where he had his first encounter with the Dadaists. Of that meeting he writes: "It was rather summary, yet I felt at ease with these strangers who seemed to accept me as one of themselves, due, no doubt to my reputed sympathies and the knowledge they already had of my activities in New York."[80]

In the 1960s, in response to Pierre Cabanne's suggestion that some of his own early New York activities — in this case, the periodicals *The Blind Man* and *Rongwrong* — may have been influenced by Dada, or may at least have been undertaken in the "Dada Spirit," Duchamp stated: "It was parallel if you

wish, but not directly influenced. It wasn't Dada, but it was in the same spirit, without however being in the Zurich spirit."[81] Earlier in the interview, when asked when he had first heard of Dada, Duchamp answered:

> In Tzara's book, *The First Celestial Adventure of Mr. Fire Extinguisher.* I think he sent it to us, to me or to Picabia, rather early, in 1917, I think, or at the end of 1916. It interested us but I didn't know what Dada was, or even that the word existed. When Picabia went to France, I learned what it was through his letters, but that was the sole exchange at that time. Then, Tzara showed things by Picabia in Zurich, and Picabia went there before coming back to the United States. Picabia's story is very complicated from the point of view of his travels. He arrived in the United States at the end of 1915, but didn't stay more than three or four months before leaving again for Spain, for Barcelona, where he founded the magazine *391*. It was in Lausanne, in 1918, that he made contact with the Zurich Dadaist group.[82]

Duchamp dates Picabia's formal contact with Dada to 1918. Although anxious to clarify that *The Blind Man* and *Rongwrong* (and, for that matter, Man Ray's *TNT*) were published not only without any concrete association with historical European Dada, but were also undertaken in a spirit "parallel" to, yet distinct from, the "Zurich spirit," Duchamp was entirely willing to accept Cabanne's statement that the first manifestations of the Dada spirit in America were embodied in the 1917 publication of the New York issues of *391*, Picabia's Barcelona/New York/Zurich/Paris-based periodical.[83]

In 1951, Gabrielle Buffet-Picabia attempted to reconstruct her husband's initial meeting with the Dadaists. She recollected that, in 1918, soon after Picabia's *Poèmes et Dessins de la Fille née sans Mère* appeared in Lausanne, he received a letter from Tzara which included an invitation to join the Dada group. "Very amused by the name 'Dada' *which we had never heard* [emphasis mine] and by the enthusiastic tone of the letter, he replied to the invitation and we went to Zurich in early 1919."[84]

Hans Richter, in *Dada: Art and Anti-Art* (1964), remembered the first encounter between the Zurich Dadaists and Picabia in the following fashion:

> The exhibition at the Galerie Wolfsberg in September 1918 marked the end of this period of 'balance' within Dada.[85] ... In a dark room on the other side of the gallery from our brightly-lit exhibition hung a series of pictorially almost disembodied 'machine pictures,' mainly, as I recall, in gold and black. They were by a Spaniard then unknown to me, Francis Picabia. ... Shortly afterwards, Picabia himself arrived in Zurich with his talented wife Gabrielle Buffet. Viewed in retrospect, Picabia's arrival marks the end of an era in the history of Zurich Dada. As an incidental consequence, it gave an enormous boost to Tristan Tzara's rise to fame.[86]

It is fair to assume that it is, in part, to Tzara's relocation in Paris that Richter refers when he writes of the "incidental consequence" of Picabia's arrival in Zurich. Ribemont-Dessaignes, from a French 1930s perspective, was more specific when he suggested that it was not unitl after Picabia became

involved with Dada that the Paris avant-garde consented to contribute to Dada publications,[87] and furthermore, that Dada did not begin to discover its "own road" until after Zurich, Picabia, and Paris were integrated with one another.[88] Hugnet confirmed this School of Paris position when he wrote, in 1932-1934:

> The arrival in Zurich of Picabia, who brought with him the Duchamp-Picabia spirit, is a noteworthy date in the history of Dada; on this date the useless begins to drop away and the essential narrows down to that human force, unconscious and willful, destructive and clean, that truly constitutes what Breton was to call "l'état d'esprit Dada" (the Dada state of mind), then expressed by a handful of individuals.[89]

Three decades later, Richter postulated that Picabia's primary contribution to the movement had been his periodical *391,* which he described as a French version of *Dada* with tangential Spanish origins.[90] It is clear from our current perspective that the origins of *391* were at least as much American as they were French or Spanish. Even Hugnet believed that Picabia named his Barcelona-initiated periodical "in memory" of the New York–based *291.*[91]

Picabia's involvement with Stieglitz and the 291 group began when he visited New York in 1915 and continued long after he undertook his formal affiliation with Dada. His regular contributions to Stieglitz's periodical, *291,* which ceased publication in 1916 (at approximately the same time that the word "Dada" was first coined in Zurich), were extensive. Picabia was influenced by America, and American artists were influenced by Picabia.

Until the publication of *391,* no. 8 (Zurich, February 1919), there is little contained in the periodical that can be described as being specifically Dada in design. The cover of the Zurich issue illustrates that when Picabia first became familiar with Tzara and the Zurich group, he was aware that certain stylistic affinities existed between activities in Zurich, Paris, and New York and was anxious to illustrate these international coincidences. In *Construction Moléculaire,* the drawing that is reproduced on the cover of the February 1919 issue, Stieglitz, Marius de Zayas, and Duchamp are noted, as are Tzara, Ribemont-Dessaignes, Walter Conrad Arensberg, and Guillaume Apollinaire. In fact, Apollinaire's pre-Dada periodical *Soirées de Paris* shares equal billing with Tzara's *Dada;* Picabia's *391* sits alongside Stieglitz's *Camera Work* and *291* (fig. 8-1).

Curiously enough, despite Picabia's 1919 attempt to juxtapose the various elements of what he perceived as concurrent international tendencies, little more than a decade later both Hugnet and Ribemont-Dessaignes were ignorant of the full extent of Picabia's early twentieth-century affiliation with the American Moderns. When Hugnet refers to Picabia's debt to *291,* he seems completely unaware that Stieglitz was the periodical's editor or that Paul Haviland, Marius de Zayas, and Agnes Meyer were primarily responsible for the magazine's publication. It is clear that Hugnet perceived of the New York precursor to *391* as being Picabia's personal accomplishment, for he wrote: "In

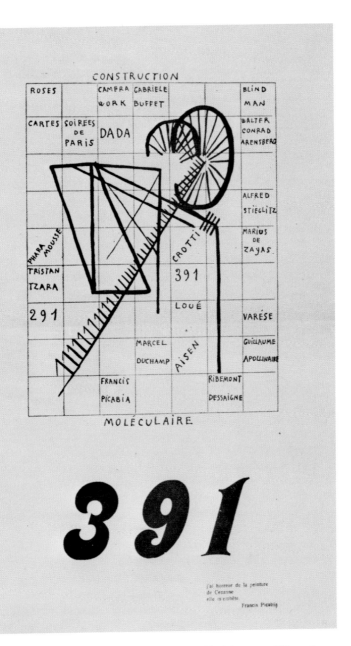

Figure 8-1. Francis Picabia, *Construction Moléculaire,* cover, *391,* no. 8,
 ed. Francis Picabia, 1919, Zurich.
 (*Collection: Jean Brown; photo: Estera Milman*)

1917, Picabia, who was then in Barcelona, brought out several numbers of a magazine called *391* in memory of *his* [emphasis mine] New York venture, *291*."[92] This statement cannot be explained away as a mere slip of the pen, for earlier, in his "History of the Dada Spirit in Painting," Hugnet had written: "Francis Picabia, though about to leave New York, *where he had brought out 291* and contributed to *Camera Work*, tingeing both of these publications with a brand of humor full of destructiveness, submitted work to two magazines founded by Marcel Duchamp."[93] Furthermore, Ribemont-Dessaignes maintained a similar misconception when he recalled that despite the propitiousness of certain postwar Paris publications, they would not have successfully ensured the "flowering" of the Dadaist revolution were it not for "the support of Francis Picabia *with his reviews 291 and 391* [emphasis mine], and of Marcel Duchamp, with his two magazines *Wrong-Wrong* [sic] and *The Blind Man*, of which only two issues appeared."[94]

I am not suggesting that Ribemont-Dessaignes and Hugnet believed that *The Blind Man, Rongwrong,* and *291* were Dada publications. Hugnet was clearly aware that certain activities in America were realized without intimate knowledge of affinitive activities in Zurich.[95] For example, he wrote, "Picabia discovered Dada, and let Dada discover him. He brought with him a past, akin to Dada, over which hovered the spirit of Marcel Duchamp."[96] It is almost as if Breton's "Dada state of mind" and Tzara's "Dada spirit" were coined specifically to allow for the inclusion of sympathetic, parallel spirits, like those of Duchamp/Picabia, into a consciously reconstructed history of Dada. On the other hand, sometime between March 1915 (when Stieglitz published the first issue of *291*) and the early 1930s (when Hugnet and Ribemont-Dessaignes published their respective histories of Dada), contributions by the American Moderns were temporarily written out of this particular chapter in the history of the twentieth-century avant-garde.

Nor am I suggesting that Tzara intentionally obscured the historical relevance of certain aspects of New York modernism. It is unlikely that he contemplated the fact that they had not been initiated in response to the aftermath of the First World War, but had instead been realized during a particularly affirmative and idealistic period of American history. As Dada's "most ardent spirit,"[97] his primary concern in the early part of the century was the propagation of the movement, and I believe that it was in order to extend the scope of Dada that Tzara first applied the concept of "the Dada spirit." By 1951, long after Surrealism succeeded Dada in Paris, Tzara's retrospective awareness of the strength of this universal and inclusive concept allowed him to state: "From the point of view of poetry, or of art in general, the influence of Dada on the modern sensibility consisted in the formulation of a human constant which it distilled and brought to light." For Tzara in the 1950s, the historical importance of Dada depended upon its definition of an "existing STATE OF MIND."[98]

As we have seen, Katherine Dreier was primarily concerned with Dada as an historically specific entity. Yet, she seemed aware of the existence of this "human constant" when she wrote of affinities between Dada and Duchamp, without extending this concept to include aspects of American modernism. When she offered her prognosis that the movement could not, in all probability, secure a foothold in the United States, she credited her fellow Americans, not with the ability to provide "theories" that ran parallel to Dada (as she had with Duchamp), but rather with something that she described as a form of "natural Dadaism":

> One is constantly being asked in America, what is Dadaism? One might say in response that almost any form of our modern advertisements, which are essentially American and original, is some form of natural Dadaism in our country. As an illustration the advertisement of a young woman with attached hands, made out of paper, supposedly ironing with a real iron, is pure Dadaism. Where the Jazz band in our country has almost obliterated music, one gets an expression of Dadaism. Charlie Chaplin, through his feet, is a pure expression on the stage. We in America often appear natural-born Dadaists as regards art, without possessing the constructive side. Therefore it seems doubtful whether an intellectual Dadaism would ever secure a foothold in America, with its intellectual constructive side as an undercurrent.[99]

In the early 1920s, "natural-born American Dadaism" referred to aspects of American popular culture. In using the term, Dreier did not intend to suggest that any direct affiliation existed between New York and Dada; on the contrary, she could not even conceive of conceptual affinities between her fellow Americans and the European movement.

"Natural Dadaism" has not weathered well as a concept and has slipped into historical obscurity. The "Dada state of mind," on the other hand, has proven to be far more influential. Six decades after its formulation, this "human constant" has established what might best be described as an historiographic quagmire. These preliminary inquiries suggest that historical "New York Dada" is, in part, an a posteriori construct, dependent to a large extent on the prevalence of the ahistorical concept, "the Dada spirit." Continuing the investigation of how features of American modernism were retroactively synthesized into the history of Dada will help us to comprehend one aspect of the mechanics of the early twentieth-century avant-garde. Perhaps even more important, we shall better understand the process by which realities are reconstructed into historiographic illusions.

Notes for Chapter 8

1. Tristan Tzara, "Zurich Chronicle 1915-1919," trans. Ralph Manheim, in Hans Richter, *Dada: Art and Anti-Art* (New York and Toronto: Oxford Univ., 1965), p. 228.

2. By early February 1916, many of the individuals who were to participate in Zurich Dada had gathered at the cabaret. This date, however, precedes the selection of the magical transmu-

tation "Dada." In his Dada chronology, Richard Sheppard writes: "March/April 1916: Invention of the word "Dada," probably by Ball." Richard Sheppard, "Dada: A Chronology," in *Dada Artifacts* (Iowa City: Univ. of Iowa Museum of Art, 1978), p. 29. Tzara's mention of the birth of the word "Dada" is listed under his entry for June 1916. His entry for 14 July 1916 begins: "For the first time anywhere, at the Waag Hall: First Dada Evening." Tzara, "Zurich Chronicle 1915-1919," in Richter, p. 224.

3. Ibid.

4. Richard Huelsenbeck states: "Tristan Tzara had been one of the first to grasp the suggestive power of the word Dada. From here on he worked indefatigably as prophet of the word, which was only later to be filled with a concept. He wrapped, pasted, addressed, he bombarded the French and the Italians with letters: slowly he made himself the 'focal point.' " Richard Huelsenbeck, *En avant Dada: A History of Dadaism,* trans. Ralph Manheim, in Robert Motherwell, ed., *The Dada Painters and Poets: An Anthology* (New York: Wittenborn, 1951), p. 26.

5. Huelsenbeck, clearly demanding his own piece of the historical Dada pie, mockingly refers to Tzara as the "fondateur du Dadaism" (ibid., p. 26) and continually reminds us that Dada, as it proceeded upon its "triumphant march throughout the world," was a word empty of any specific content until it became firmly established in Berlin. He goes so far as to say: "Dada, as a mere word, actually conquered a large part of the world even without association with any personality. This was an almost magical event. The true meaning of Dadaism was recognized only later in Germany by the people who were zealously propagating it, and these people, succumbing to the suggestive power and propagandistic force of the word, then became Dadaists." Ibid., p. 33.

6. Georges Ribemont-Dessaignes, "History of Dada," trans. Ralph Manheim, in Motherwell, p. 105.

7. Tristan Tzara, "New York Dada," *New York Dada*, April 1921, p. 20.

8. Tzara, "Zurich Chronicle 1915-1919," in Richter, pp. 226-28.

9. Huelsenbeck, *En avant Dada*, in Motherwell, p. 28.

10. Ibid., p. 33.

11. Huelsenbeck writes: "If Tristan Tzara had barely suspected the meaning of this famous existence we drag along between apes and bedbugs, he would have seen the fraud of all art and all artistic movements and he would have become a Dadaist." (Ibid., p. 33). His opinion of Johannes Baader is made clear in his description of the Dada tour that Huelsenbeck, Dadasoph Hausmann, and Oberdada Baader undertook in February 1920 (ibid., pp. 44-47). Huelsenbeck's relationship with Kurt Schwitters was also problematic and was partially responsible for the exclusion of Schwitters from the Berlin Dada circle.

12. Ibid., p. 28.

13. In a paper entitled "Duchamp: Three Avant-Garde Stoppages," presented during the conference "Perspectives on the Avant-Garde" (Univ. of Iowa, Iowa City, April 1971), Stephen C. Foster.

14. Katherine Dreier, *Western Art in the New Era* (New York: Brentano, 1923), p. 119.

15. During the early 1930s, Georges Hugnet is to explain that "eager to spread, to gain ground, intent above all on action rather than selection, Dada utilized any people or methods available, feeling free to spew them out later." Georges Hugnet, "The Dada Spirit in Painting," trans. Ralph Manheim, in Motherwell, p. 134.

16. Huelsenbeck, *En avant Dada,* in Motherwell, p. 24.

17. Ibid., p. 26.

18. "*February 1916* in the most obscure of streets in the shadow of architectural ribs, where you will find discrete detectives amid red street lamps — birth — birth of the Cabaret Voltaire — poster by Slodky, wood, woman and Co., heart muscles Cabaret Voltaire and pains. Red lamps, overture piano Ball read Tipperary piano 'under the bridges of Paris' Tzara quickly translates a few poems aloud, Mme. Hennings — silence, music — declaration — that's all. On the walls: van Rees and Arp, Picasso and Eggeling, Segal and Janco, Slodky, Nadelman, coloured papers, ascendancy of the New Arts, abstract art and geographic futurist map-poems: Marinetti, Cangiullo, Buzzi; Cabaret Voltaire, music, singing, recitation every night — the people — the new art the greatest art for the people — van Hoddis, Benn, Tress, — balalaika — Russian night, French night — personages in one edition appear, recite or commit suicide, bustle and stir, the boy of the people, cries, the cosmopolitan mixture of god and brothel, the crystal and the fattest woman in the world." "Under the Bridges of Paris." Tzara, "Zurich Chronicle 1915-1919," in Richter, p. 223.

19. Hugnet, "The Dada Spirit in Painting," p. 126.

20. Tzara states that it was not until 14 April 1917, during the second event at the Galerie Dada, that Zurich Dada's intentions began to be clarified. Tzara, "Zurich Chronicle 1915-1919," p. 225.

21. Huelsenbeck, *En avant Dada,* in Motherwell, p. 33.

22. Hugnet, "The Dada Spirit," in Motherwell, p. 144.

23. Ibid.

24. Huelsenbeck, *En avant Dada,* in Motherwell, p. 24.

25. Ibid., p. 27.

26. Paul Schmelzer, Priscilla Siegel, and William Rasmussen, "The Rise of the Avant-Garde in America: Issues and Aesthetics," in *Avant-Garde Painting and Sculpture in America,* Delaware Art Museum (Philadelphia: Falcon, 1975), p. 9.

27. Meyer Schapiro states that during these years, the world of art was imbued with an unprecedented "appetite for action, a kind of militancy that gave to cultural life a quality of a revolutionary movement, of the beginnings of a new religion." Schapiro's article provides a compelling analysis of the relationship between modernism and social idealism in America. Meyer Schapiro, "Rebellion in Art," in Daniel Aaron, ed., *America in Crisis* (New York: Alfred A. Knopf, 1952), p. 206.

28. For an in-depth account of the Société Anonyme, Inc., see Ruth Bohan, *The Société Anonyme's Brooklyn Exhibition, Katherine Dreier and Modernism in America* (Ann Arbor: UMI Research Press, 1982).

29. Tzara, "New York Dada," p. 2. Contributors from Calcutta, Chile, and Mantoue were also listed.

30. Marsden Hartley, *Adventures in the Arts* (New York: Boni and Liveright, 1921), p. 247.

31. Ibid., p. 250.

32. Ibid., p. 254.

33. Ibid., pp. xv, xvi.

34. Ibid., p. 249.

35. Patrick Stewart, "Marsden Hartley (1877-1943)," in *Avant-Garde Painting and Sculpture in America,* p. 80.

36. Dreier, *Western Art in the New Era,* pp. 71, 72. This anthology of didactic essays that had originally been presented as part of the Société Anonyme's lecture series was published a decade after the Armory Show, and postdated the 1921 migration of New York Dada to Paris by approximately two years.

37. Ibid., p. 19. The third chapter in Dreier's anthology bears the title "The Chain of Western Art, from the Byzantine to Post Impressionism."

38. Ibid., p. 118.

39. Ibid., p. 120.

40. Ibid.

41. Ibid., p. 74.

42. Bram Dijkstra, *The Hieroglyphics of a New Speech* (Princeton: Princeton Univ., 1969), p. 145.

43. Ibid., p. 112.

44. Although more valuable as a record of the "Dada Spirit" in New York than as an investigation of historical Dada in America, Ileana Leavens's recently published book *From "291" to Zurich, The Birth of Dada* (Ann Arbor: UMI Research Press, 1983), is a carefully worked study of early twentieth-century American modernism.

45. Shapiro, "Rebellion in Art," in Aaron, p. 204.

46. Ibid., p. 207.

47. Ibid.

48. Ibid., p. 223.

49. Dreier, *Western Art in the New Era,* p. 76.

50. Man Ray, *Self Portrait* (Boston, Toronto: Atlantic Monthly, 1963), p. 50.

51. Walter Pach, *Queer Thing, Painting* (New York and London: Harper & Brothers, 1938), p. 231.

52. Ibid., p. 232. Pach also recounts that by abolishing hanging committees, the American society went a step further than its French predecessor. He then adds that the suggestion to hang entries alphabetically was proposed by Marcel Duchamp. Pach goes on to say that for Duchamp "it was doubtless an advance toward the nihilism of 'Dada,' the movement negating all things (including itself) which he took an interest in some years later." Ibid., p. 234.

53. Pierre Cabanne, *Dialogues with Marcel Duchamp,* trans. Ron Padgett (New York: Viking, 1960), p. 56.

54. Bohan, *The Société Anonyme's Brooklyn Exhibition,* p. 29. In "Modern Art in America," published as part of his anthology *Adventures in the Arts* (p. 60), Marsden Hartley wrote: "There is no reason to feel that prevailing organizations like the Society of Independent Artists, Inc., and the Société Anonyme, Inc., will not bear a great influence and power upon the public, as there is every reason to believe that at one time or another the public will real-

ize what is being done for them by the societies, as well as what was done for them by the so famous '291' gallery.''

55. Bohan, *The Société Anonyme's Brooklyn Exhibition*, p. 32.

56. Ibid., p. xxiii.

57. Shapiro, "Rebellion in Art," in Aaron, p. 240.

58. Bohan, *The Société Anonyme's Brooklyn Exhibition*, p. 39.

59. Dijkstra, *The Hieroglyphics of a New Speech*, p. 41.

60. Tzara, *New York Dada*, p. 2.

61. Ribemont-Dessaignes, "History of Dada," in Motherwell, p. 104.

62. Ibid., p. 102.

63. Ibid.

64. Ibid., p. 119.

65. Ibid., p. 109.

66. Ibid., p. 110.

67. In *Adventures in the Arts* (p. 60), Marsden Hartley wrote: "Art in America is like a patent medicine, or a vacuum cleaner. It can hope for no success until ninety million people know what it is. The spread of art as 'culture' in America is from all appearances having little or no success because stupidity in such matters is so national."

68. Ibid., p. 250.

69. Dreier, *Western Art in the New Era*, p. 120.

70. Arturo Schwarz, *New York Dada, Duchamp, Man Ray, Picabia* (Munich: Prestel Verlag, 1973), p. 126.

71. Richard Sheppard includes the following entry under his list of Dada events that took place in July 1921: "Man Ray leaves New York for Paris — This marks the end of New York Dada." Sheppard, "Dada: A Chronology," p. 37.

72. Dreier, *Western Art in the New Era*, p. 92.

73. Ibid., p. 120. This statement further implies that Dreier may not have classified the Société Anonyme's 1920 show of Schwitters' collages as a legitimate Dada exhibition.

74. Schwarz, *New York Dada*, p. 117.

75. Ibid.

76. Ibid., p. 126.

77. Ray, *Self Portrait*, pp. 100-101.

78. Schwarz, *New York Dada*, p. 121.

79. Ibid., p. 120.

80. Ray, *Self Portrait*, p. 108.

81. Cabanne, *Dialogues with Marcel Duchamp*, p. 56.

82. Ibid., p. 55.

83. Ibid., p. 56.

84. Gabrielle Buffet-Picabia, cited in Elmer Peterson, *Tristan Tzara* (New Brunswick, N.J.: Rutgers Univ., 1971), p. 56.

85. Richter is referring to Arp, Janco, Bauman, McCouch, Hennings, Morach, and himself.

86. Richter, *Dada: Art and Anti-Art,* p. 71.

87. Ribemont-Dessaignes, "History of Dada," in Motherwell, p. 108.

88. Ibid., p. 104.

89. Hugnet, "The Dada Spirit," in Motherwell, p. 134.

90. Richter, *Dada: Art and Anti-Art,* p. 71.

91. Hugnet, "The Dada Spirit," in Motherwell, p. 140.

92. Ibid., p. 140.

93. Ibid., p. 39.

94. Ribemont-Dessaignes, "History of Dada," in Motherwell, p. 10. Both Hugnet and Ribemont-Dessaignes misspell the periodical's title in their respective histories of Dada.

95. Hugnet, "The Dada Spirit," in Motherwell, p. 140.

96. Ibid., p. 136.

97. Ribemont-Dessaignes, "History of Dada," in Motherwell, p. 105.

98. Tristan Tzara, "An Introduction to Dada" (New York: Wittenborn, Schultz, 1951), n.p.

99. Dreier, *Western Art in the New Era,* pp. 118-20. Particular note should be made of Dreier's understanding, in 1923, of Dada's constructive intentions. Although for many years Dada's primary characteristic was thought to have been its nihilism, scholars in the field have recently begun to reevaluate the movement's constructive component. For an interesting example of this new research, see Stephen C. Foster, "Constructivist Recipes for Dada Breakfasts," *The Nelson-Atkins Museum of Art Bulletin* 5, 7 (1982): 72-82.

Joseph Stella's *Man in Elevated (Train)*

Ruth L. Bohan

The years following the Armory Show were years of great strides forward toward fuller and freer self-expression in the arts in the United States. Straight photography, primitive art, children's art, and the new directions in European art held out vast new possibilities for the American artist. So, too, did the influx of European artists, writers, and intellectuals, who provided essential nourishment and inspiration to the fledgling avant-garde community then centered in New York. Marcel Duchamp, Francis Picabia, Jean Crotti, Henri-Pierre Roché, Albert Gleizes, Henri-Martin Barzun, Edgar Varèse, and the redoubtable Baroness Elsa von Freytag-Loringhoven joined forces with Man Ray, Walter Arensberg, Alfred Stieglitz, John Covert, Joseph Stella, William Carlos Williams, John Marin, Charles Sheeler, Walter Pach, and others to create an artistic community pregnant with the possibilities of significant new achievement. Within this loosely organized, multinational coterie, Marcel Duchamp offered the greatest challenges for the American artist. Less volatile than Picabia, more personable, and a resident of the States for a longer period of time,[1] Duchamp galvanized the attention of artists as diverse as Man Ray, John Covert, Morton Schamberg, Charles Sheeler, and Charles Demuth.

Less well known but no less significant was Duchamp's influence on Joseph Stella. Stella was a mature artist, nearly forty years old, and ten years Duchamp's senior when the two met, probably at the home of Louise and Walter Arensberg shortly after Duchamp's arrival in this country in June 1915. Stella had already produced one masterpiece — *Battle of Lights, Coney Island, Mardi Gras* (1913) — and established himself as one of the foremost progressive artists in the country at the time of their first meeting. But like others of his generation, Stella found fresh stimuli in Duchamp's engaging wit and willfully unorthodox ways. Not long after they met, Stella commenced work on a series of reverse paintings on glass that pays homage to his French friend. One of the most interesting of these is the little known *Man in Elevated (Train)* (ca. 1918-

1922) (fig. 9-1).[2] Like other works in the series, it is among Stella's most experimental paintings. At the core of its significance is the way it merges Duchamp's ironic detachment, his experiments with nontraditional materials, his sexual preoccupations, his concerns with the fourth dimension, and his fascination for the machine with Stella's own longstanding commitment to urban-technological themes. The result is, at once, a creative and independent work of art by one of the country's most gifted early modernists and a moving testimonial to the personal and professional commitment he felt toward Duchamp.

Stella's friendship with Duchamp grew out of their joint participation in the avant-garde soirées held nightly at Arensberg's New York apartment. Their collaboration on the ill-fated first exhibition of the Society of Independent Artists in 1917 strengthened their relationship, as did their frequent visits to Man Ray's Greenwich Village studio.[3] Their friendship persisted following Duchamp's return from Argentine and his collaboration with Katherine Dreier and Man Ray, on the founding of the Société Anonyme, Inc. in the spring of 1920.[4] Dreier, like Duchamp, was an avid supporter of Stella's art, and Stella reciprocated by becoming actively involved in Société Anonyme affairs.[5] During the organization's ambitious first year, Stella served under Duchamp on the exhibition committee and participated regularly in its active lecture program, giving one himself in 1921.[6] It was during this time that Stella also executed the exceedingly beautiful, silverpoint portrait of Duchamp, which Dreier later bequeathed to the Museum of Modern Art.

As the title suggests, Stella's *Man in Elevated (Train)* portrays a lone individual, a man, visible from the shoulders up, viewed through the window of an urban commuter train. The man faces inward toward the center of the painting, wearing a navy blue suit with a starched white collar. A distinctive broad-brimmed, black hat shields his downturned head. A triangular section of brown hair at the nape of his neck and a portion of his well-defined jaw provide the only clues to his physiognomy. The remainder of his face is obscured from view by a series of distortions animating the intervening window pane. An open book, partly visible in the lower left corner of the work, attracts the man's momentary attention. Behind and to the right of his head, a series of vertical bands suggests the vertical steel posts common to commuter car construction, while the series of rectangular planes overlapping his face suggests the shape and reflective quality of the train's many exterior windows.

Two well-known works by Duchamp influenced Stella, both in the conception of the work and in its unusual method of construction. The first, and in many ways the more obvious of these, is *The Bride Stripped Bare By Her Bachelors, Even* (1915-1923) (fig. 9-2), the large painting on glass to which Duchamp devoted the major part of his artistic energy during the years he and Stella were friends. In contrast to the secrecy that surrounded the construction of *Given: 1. The Waterfall, 2. The Illuminating Gas* (1946-1966), begun after the close of the Second World War, Duchamp's struggles with the *Large Glass* were public

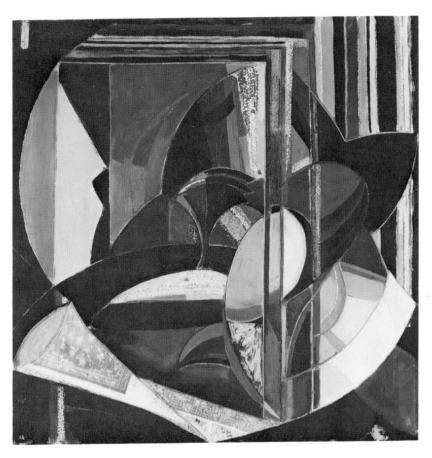

Figure 9-1. Joseph Stella, *Man in Elevated* (*Train*), 1918
Oil, wire, and collage on glass, 36.2 x 37.5 cm.
(*Washington University Gallery of Art, St. Louis*)

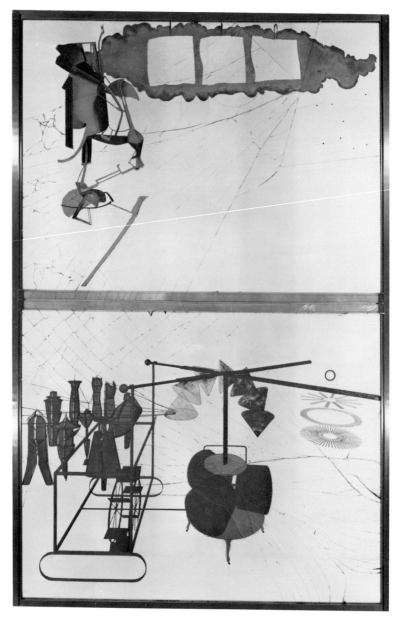

Figure 9-2. Marcel Duchamp, *The Bride Stripped Bare By Her Bachelors, Even,* 1915-1923
Oil and lead wire on glass, 227.1 x 175.8 cm.
(*Philadelphia Museum of Art, bequest of Katherine S. Dreier*)

knowledge among members of the New York avant-garde. Artists and intellectuals alike visited him regularly in his studio to monitor progress on what all knew to be a work of considerable consequence.

Work commenced on the *Large Glass* in a studio in the Lincoln Arcade Building, 1947 Broadway, where Duchamp set up shop shortly after his arrival in New York in the summer of 1915. Work continued in a second studio, above Arensberg's apartment at 33 West 67th Street, where Duchamp moved in the fall of 1916 and where he continued to work until his departure for Argentina in August 1918. Two subsequent studios, at 246 West 73rd Street and in the Lincoln Arcade Building, provided the setting for the final phases of the work, tackled during two subsequent visits to New York in the early 1920s.[7]

As a member of the Arensberg circle and a close friend of Duchamp, Stella would have had frequent access to Duchamp's studio, where the *Large Glass* was always on view. Stella's interest in the work is further supported by the fact that he owned three of the preliminary studies, which Duchamp had brought with him from Paris. All three depict elements of the bachelor machine. Two show early stages of the *Chocolate Grinder* (figs. 9-3, 9-4); the third is the well-known *Network of Stoppages* (1914) (fig. 9-5), in which the nine capillary tubes are superimposed over an enlarged version of *Young Man and Girl in Spring*. That Stella retained two of the three until his death in 1946 testifies both to the high regard in which he held the *Large Glass* and to his fondness for Duchamp.[8]

Under the powerful stimulus of Duchamp's *Large Glass*, Stella initiated his own series of reverse paintings on glass. He had not used glass as a support prior to this time and would abandon it shortly after Duchamp ceased work on the *Large Glass* in 1923. But, during the years Duchamp labored over the work, Stella produced more than a dozen reverse paintings on glass, including *China-town* (ca. 1917) (fig. 9-6) and *Landscape* (ca. 1920-1924) (fig. 9-7). Land-scapes, urban and industrial scenes, flowers, and the human figure, all themes Stella had explored earlier using more conventional techniques, provided the subjects for his glass paintings.[9] Like *Man in Elevated (Train)*, the composi-tions were generally small. Known examples measure no more than 30 x 35 inches, with one as small as 11 x 7.[10] Stella's decision to work on such a small scale must have been a conscious one, for he was no stranger to the larger scale chosen by Duchamp for the *Large Glass*. *Battle of Lights, Coney Island, Mardi Gras* measures more than 8 x 9 feet; *Spring* (1914) is also over eight feet high; and *Brooklyn Bridge* (1919-1920) and *Tree of My Life* (1919) are both over nine feet high. The consistently more intimate scale of the glass paintings suggests that Stella considered them largely experimental. This would seem to be borne out by the fact that the works were rarely exhibited during Stella's lifetime.[11]

Stella's debt to the *Large Glass* goes considerably beyond his choice of glass as the principal support for the works, however. In *Man in Elevated*

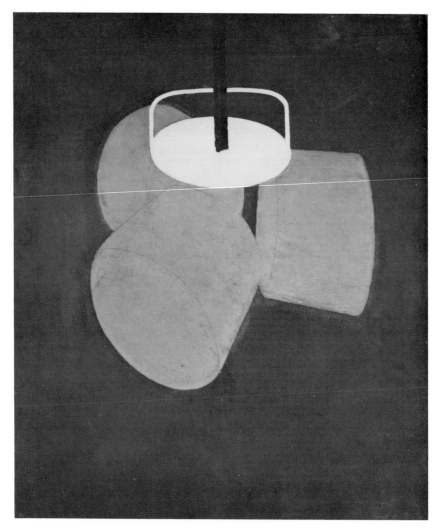

Figure 9-3. Marcel Duchamp, *Chocolate Grinder,* 1914
 Oil and pencil on canvas, 73 x 60 cm.
 (Kunstsammlung Nordrhein-Westfalen, Düsseldorf; photo: Walter Klein)

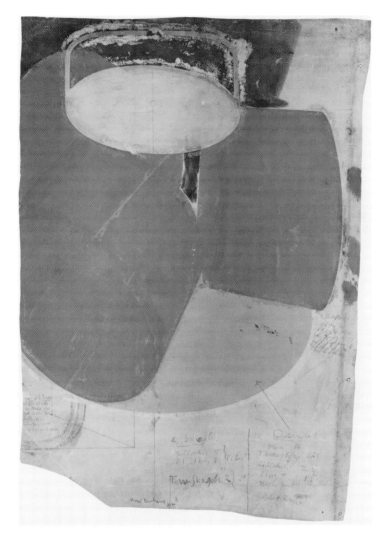

Figure 9-4. Marcel Duchamp, *Study for Chocolate Grinder, No. 2*, 1914
Oil, colored pencil, and ink on canvas, 57.3 x 40.5 cm.
(*Staatsgalerie Stuttgart*)

Figure 9-5. Marcel Duchamp, *Network of Stoppages*, 1914
Oil and pencil on canvas, 148.9 x 197.7 cm.
(*Museum of Modern Art, New York, Abby Aldrich Rockefeller Fund
and gift of Mrs. William Sisler*)

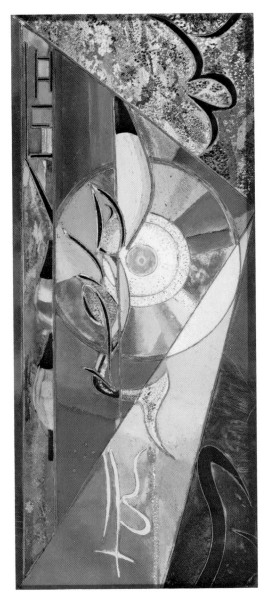

Figure 9-6. Joseph Stella, *Chinatown,* ca. 1917
 Oil on glass, 48.1 x 21 cm.
 (*Philadelphia Museum of Art,*
 The Louise and Walter Aresnberg Collection;
 photo: A.J. Wyatt)

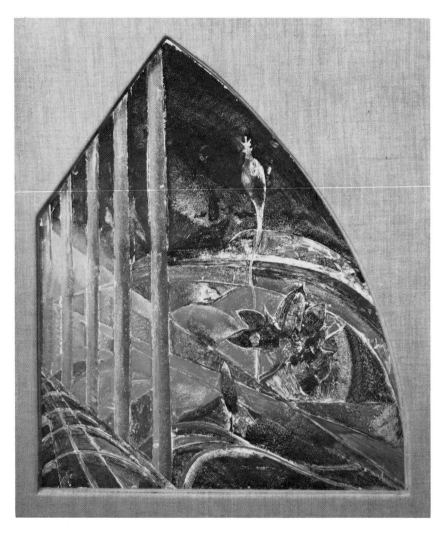

Figure 9-7. Joseph Stella, *Landscape,* 1920-1924
 Oil on glass, 75 x 62.5 cm.
 (*Hirshhorn Museum and Sculpture Garden, Smithsonian Institution*)

(*Train*) and in at least three of his other paintings on glass — *Chinatown* and two untitled works in the collections of the Whitney Museum of American Art and the New Jersey State Museum, Trenton — Stella also appropriated Duchamp's novel technique of outlining the principal forms on the reverse of the glass with lead wire.[12] The cloisonné-like effect produced by the wire is demonstrated to advantage in photographs of the reverse of the two men's work (figs. 9-8 and 9-9). In both, the wire reads like a line when seen from the front of the glass. It accents the contours of the forms, while its silver patina provides additional color to the composition. As an accomplished draftsman, Stella was familiar with the subtle intricacies possible through the expressive manipulation of line. His early drawings of Pittsburgh miners demonstrate his practice of outlining portions of his figures with delicate linear accents to stress the subtle irregularities of their individual physiognomies and to set them off more emphatically from their surroundings (fig. 9-10). A similar tendency prevails in *Battle of Lights, Coney Island, Mardi Gras,* where a weblike system of narrow gray lines fans out from the center of the composition to contain the many smaller color wedges within. Duchamp's technique of edging forms with a thin, supple wire may, conceivably, have struck Stella as a natural extension of his own earlier practices.

But the two artists had decidedly different ideas about how much emphasis to accord the wire accents. Where Duchamp encased every form with the same wire outline, Stella enclosed only certain forms. The wire he used was also of a coarser gauge and was supplemented, at times, by the use of heavy string. As a result, the finished piece lacks both the precision and the consistency of the younger man's work. Yet, Stella was clearly not an indifferent craftsman, as the bulk of his oeuvre confirms. His inconsistent handling of the wire in this, and other of his paintings on glass, seems rather to mirror the permissiveness inherent in his affiliations of that time.[13]

Different working methods may also have played a role in the varying amounts and placement of the wire. Duchamp knew from the beginning exactly what forms were to be outlined and where they were to be placed on the two glass panels. Few, if any, alterations were made once he began attaching the wire to the glass. Stella, on the other hand, worked in a more intuitive, less methodical manner. He rarely made the kind of detailed preliminary studies that guided Duchamp, preferring instead to invent and expand his designs as he went along. Once the principal shapes were outlined and colored in, it would have been difficult, if not impossible, to add more wire as new shapes were added. Stella may also have had difficulty manipulating the relatively coarse gauge of wire he chose to apply to smaller forms in his composition. In the finished work, only the larger shapes, and not even all of these, are edged with the wire's distinctive silver color.

Stella's handling of the wire may also reflect his knowledge of Jean Crotti's slightly earlier adaptations of Duchamp's technique. Later to be

Figure 9-8. Man Ray, *Dust Breeding*, 1920
Photograph.
Reproduced from Marcel Duchamp's *Green Box* (Paris, 1934).
(*Special Collections Department, The University of Iowa Libraries, Iowa City*)

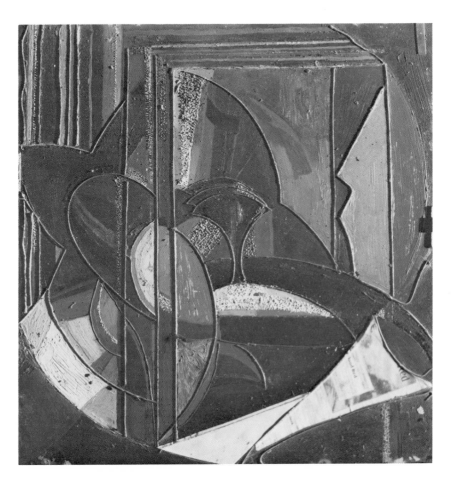

Figure 9-9. Joseph Stella, *Man in Elevated* (*Train*) [verso], 1918
Oil, wire, and collage on glass, 36.2 x 37.5 cm.
(*Washington University Gallery of Art, St. Louis*)

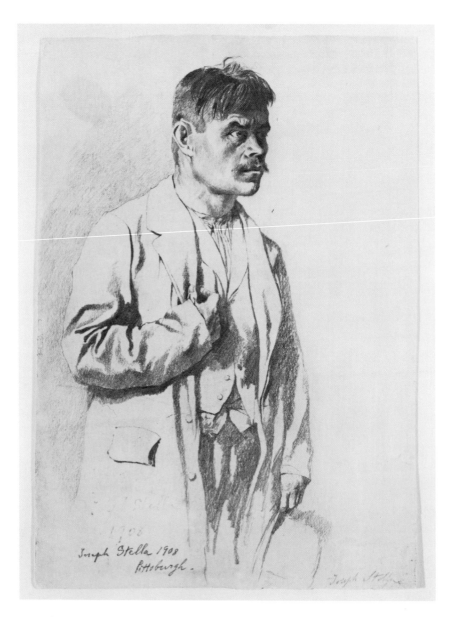

Figure 9-10. Joseph Stella, *Croatian,* 1908
 Pencil on paper, 20 x 14.4 cm.
 (*Hirshhorn Museum and Sculpture Garden, Smithsonian Institution*)

Duchamp's brother-in-law, Crotti shared Duchamp's studio during the fall and winter of 1915.[14] Crotti's art underwent a profound change as a result of his friendships with Duchamp and Francis Picabia, who was then developing his highly influential mecanomorphic style. Before the year was out, Crotti began studies for several reverse paintings on glass in which wire and other materials were adhered to the reverse of clear glass sheets. *The Mechanical Forces of Love in Movement* (1916) (fig. 9-11) is one such work.[15] In it, as in *Man in Elevated (Train)*, wires outline only some of the forms and the gauge used is relatively coarse. Additional similarities can be found in the fact that, as in Stella's work, virtually the entire surface of Crotti's painting, and not just the areas bounded by the wires, is filled in with oil paint.[16] Duchamp also colored in his forms with oil paint, but used it much more sparingly. Large sections of the *Large Glass* were left purposely transparent to allow the painted forms to interact more directly with the constantly shifting forms in the surrounding environment. Crotti, too, left large areas of glass unpainted in his other glass paintings,[17] but followed a more orthodox path in *The Mechanical Forces of Love in Movement.*

Stella never rejected the image of himself as a painter and, in each of his reverse paintings on glass, exercised the full potential of the oil medium. In *Man in Elevated (Train)*, brushstrokes remain visible and variations in the thickness of the paint produce subtle color modulations across the smooth surface of the glass. Further surface texture is achieved by the use of small, irregular daubs of color overlapping the man's hat in the center of the composition. Together, these pointillist dots capture a sense of the flickering of natural sunlight as it filters through the window of the moving train. Stella employed similar color dots in *Battle of Lights, Coney Island, Mardi Gras, Spring,* and other earlier works to simulate the effects of natural and artificial illumination. Their reappearance in *Man in Elevated (Train)* and in other of his works on glass (fig. 9-6) demonstrates the extent to which past practices continued to nourish Stella, even as the iconoclastic tendencies of Marcel Duchamp inspired him with new and more radical goals.[18]

Stella's painting is, however, neither exclusively nor even primarily painterly in nature. Like the *Large Glass*, and particularly like the two versions of the *Chocolate Grinder* that Stella owned, *Man in Elevated (Train)* projects a highly mechanistic sensibility, which is most fully realized in the handling of the lone individual. The man's jaw, lower hairline, and starched white collar seem machine-tooled. The dark brown shadow paralleling his diagonal hairline is as crisply articulated and as geometrically precise as the hairline itself. So, too, are the gray trapezoidal shadows on his arching white collar and the dark gray and green shadows under his rigidly positioned chin. The figure looks forward to the smoothly contoured automatons of Fernand Léger's best work of the 1920s; at the same time, it acknowledges, albeit in more realistic terms, the mechanical emphasis of the *Large Glass.*

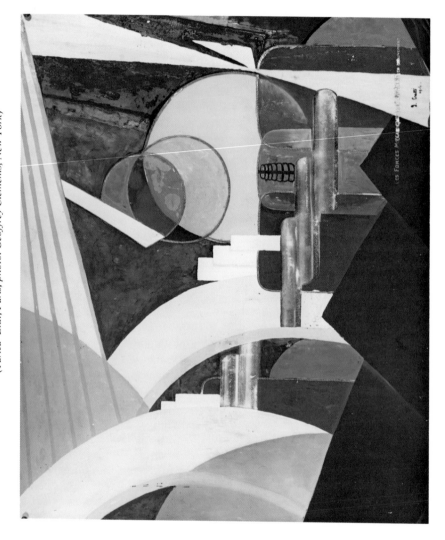

Figure 9-11. Jean Crotti, *The Mechanical Forces of Love in Movement*, 1916
Assemblage and oil on glass. 60 x 74 cm.
(*Tarica Ltd., Paris; photo: Geoffrey Clements, New York*)

Two areas in the lower left quadrant of the work diverge from the practices just described. There Stella filled in the areas bounded by the wire with elements of collage. The larger of the two areas, a pie-shaped segment placed diagonally to the corner, derives from a page cut from a contemporary journal. The second collaged fragment, also triangular, but smaller and located at the bottom center of the work, consists of a piece of wallpaper, printed with a delicate yellow and blue design. Together, they suggest the open page and decorated cover of the reading material that occupies the man's downturned gaze. Duchamp's habit of sealing his painted areas with sheets of lead foil, and his plans for incorporating varnished dust particles into a section of the bachelor panel, no doubt inspired Stella to enliven his surface with elements of collage. Although far less radical than Duchamp's practices, and less poetic than the smudged and crumpled paper fragments of his own better known collages, the collaged sections of *Man in Elevated (Train)* suggest that it was Duchamp, and not Kurt Schwitters, who first turned Stella toward collage.

If *The Bride Stripped Bare By Her Bachelors, Even* encouraged Stella to experiment with glass and with new methods of construction, a second work by Duchamp, the older and smaller *Sad Young Man on a Train* (fig. 9-12), gave him the immediate theme and subject of his work. Executed in 1911, *Sad Young Man on a Train* was first exhibited in this country at the Armory Show. From there it was purchased by Manierre Dawson, a Chicago-based modernist and friend of Walter Pach.[19] Pach always admired the painting and acquired it from Dawson between January and April 1922.[20] Pach was also a close friend of Duchamp and a regular at Arensberg's gatherings. His fondness for the work would have assured it a place in the group's discussions, even before it physically entered their circle. Thus, although Stella's only direct contact with the work prior to commencing *Man in Elevated (Train)* was probably limited to his viewing of it at the Armory Show, the work would have remained fresh in his memory as a result of these verbal summaries and analyses. This fact would seem to account, in large measure, for the lack of close visual accord between the two paintings; the similarities are far more conceptual and thematic than formal in nature.

Like Duchamp's, Stella's painting shows a man alone in a train, and it, too, would seem to be autobiographical. Duchamp acknowledged the autobiographical content of his painting in a conversation with Pierre Cabanne many years later. He explained that it was he, standing in the aisle on a train returning from Rouen to Paris, who was the subject of the work. "My pipe was there to identify me,"[21] he averred. In place of a standing figure, centered on an upright rectangular canvas, Stella's figure is seen in profile, visible only from the shoulders up, against the right margin. In each painting, however, the parameters of the train's physical construction determine the work's dimensions and orientation. The verticality of *Sad Young Man on a Train* suggests the verticality of the train's interior corridor where Duchamp stands, smoking his

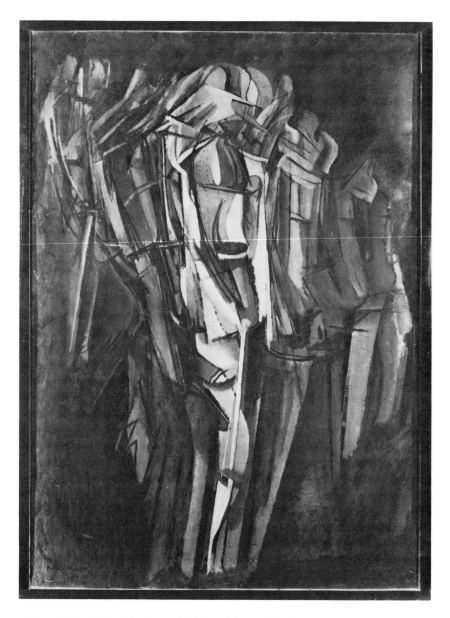

Figure 9-12. Marcel Duchamp, *Sad Young Man on a Train,* 1911
Oil on canvas on board, 100 x 73 cm.
(*The Peggy Guggenheim Collection, Venice [The Solomon R. Guggenheim
Foundation]; photo: Mirko Lion, Venice*)

pipe; the more squarish proportions of Stella's work suggest the dimensions of the exterior window through which we observe the behatted figure within. Also evident in both works is a sense of the train's gentle motion, but again each artist expresses it differently. Duchamp suggests the train's constant jostling by the faceted disintegration of the principal forms, a phenomenon that he termed "elementary parallelism," and that he employed again the following year in *Nude Descending A Staircase.*[22] Stella, on the other hand, suggests motion through the diagonal thrust of the man's head and the gently arching lines of his hat, jaw, and collar, all of which are reinforced by the repeating verticals in the background, the parallel right angles in the foreground, and the swirling cluster of curvilinear shapes located in the center of the composition.

The autobiographical content of Stella's work derives from a combination of factors, not least of which concerns the figure's implied physical girth. Stella's large physical size was legendary among members of the American avant-garde.[23] Reflections in the train window obscure much of the painted figure's physiognomy, but the tremendous size of his neck and encircling white collar suggest a person of substantial physical size. The broad-brimmed hat and profile pose link the figure even more strongly to Stella. In at least three other self-portraits, Stella wears a similar broad-brimmed hat and, in all three, shows himself in profile like the man in the train (fig. 9-13).[24] Although men frequently wore hats in Stella's day, it was rare for an artist to don one for a self-portrait. Even rarer are profile self-portraits.[25] That Stella presented himself in this manner on more than one occasion suggests that he considered it something of a signature, much as Duchamp did his pipe.[26]

By redoing Duchamp's painting in his own manner, and with himself substituted for the figure of Duchamp, Stella was openly affirming the kinship he felt for the younger artist. The change of venue from an intercity to an intracity commuter train strengthens the personal and autobiographical significance of the work and reinforces the connection with Duchamp. Stella was intimately familiar with the ubiquitous commuter lines that crisscrossed Manhattan, connecting the central city with his home in Brooklyn; his knowledge of intercity American trains was far more limited. During much of the time Duchamp and Stella were friends, Stella must have made the trip between Brooklyn and Manhattan almost daily.[27] The lengthy ride took him through some of the most colorful sections of the city, a large part of it on a system of elevated tracks like those referenced in *Man in Elevated (Train).* By changing the setting from an intercity to an intracity train, Stella was both affirming his familiarity with the city's principal public transportation system and underscoring a major theme that figured prominently in his friendship with Duchamp — their fascination with the American city and with the city of New York in particular.

In an interview, published in *Arts & Decoration* shortly after his arrival in this country, Duchamp unhesitatingly termed the city of New York "a

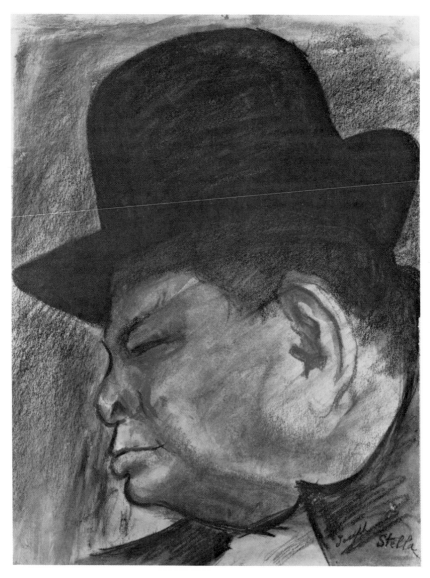

Figure 9-13. Joseph Stella, *Self Portrait,* ca. 1928
Charcoal, pastel, ink, and pencil on paper, 35 x 27 cm.
(*Hirshhorn Museum and Sculpture Garden, Smithsonian Institution*)

complete work of art."[28] In contrast to the findings of Alexis de Tocqueville, his nineteenth-century countryman and author of the popular *Democracy in America* (1835), Duchamp praised the "cold and scientific" side of the American character.[29] It was this, he stressed, that contributed to the country's magnificent scattering of skyscrapers, and it was this that set America refreshingly apart from "old" Europe. "If only America would realize that the art of Europe is finished — dead —," he lamented, "... that America is the country of the art of the future."[30]

Stella and his contemporaries had been trying to forge an indigenous American art out of the "stuff" of the American urban environment since long before Duchamp made his prophetic pronouncement. When Stella immigrated to this country in 1896, Walt Whitman's praises of the American city were ringing in his ears.[31] Almost immediately, he began sketching members of New York's ever-expanding immigrant community, many of whom, like himself, inhabited the city's bustling Lower East Side. In 1907, while on assignment for *The Survey,* he completed his first studies of industrial America, a series of very sensitive drawings of the victims of a mining disaster in Monongah, West Virginia. This was followed the next year by over a hundred charcoal sketches of the industrial city of Pittsburgh and, in 1913, by the monumental *Battle of Lights, Coney Island, Mardi Gras.* The people, the buildings, the technology, and the razzle-dazzle of city life were equally attractive to Stella, who would continue to draw sustenance from such characteristically urban phenomena for the remainder of his life. Duchamp's enthusiasm for a similar spectrum of urban phenomena effectively reinforced Stella's own longstanding commitment and helped strengthen the bond between them.

Another point of similarity between the two men concerns their bachelorlike lives. Duchamp was, in fact, a bachelor and Stella, although married, was living a bachelor existence.[32] Man Ray recalled that Stella "was very vain, considered himself a Don Juan and acted as if he was always involved in some escapade."[33] In *Man in Elevated* (*Train*), Stella alludes both to his own bachelor existence and to the bride-bachelor relationship of the *Large Glass.* Just as Duchamp's bachelor thinks about his elusive bride, isolated from him in the upper panel of the *Large Glass,* so Stella, the bachelor, contemplates the bride (some female friend, perhaps) while traversing the city alone in a train. His thoughts appear before him on the reflective surface of the train window. One of the most prominent forms, shown in triplicate in the exact center of the composition, bears an unmistakable resemblance to the fan-like shape contained in the upper portion of the *pendu femelle.* Just as the illusive form of Duchamp's bride achieves concrete reality on the surface of the *Large Glass,* so the bride in Stella's mind assumes concrete form on the reflective surface of the train's rectangular window.

Stella's intention was obviously to restate the bride-bachelor relationship of the *Large Glass* in more realistic terms, and with himself substituted for

Duchamp's anonymous bachelor machine. As in the *Large Glass*, a deftly shielded eroticism underlies the seemingly neutral character of the centered red and black fanlike image. Stella was no stranger to sexual themes, but never before had he presented them with such ironic detachment.[34] Not only does the image of the bride bear no relationship to the human body, but neither is it the least bit sensuous. In its rigid geometry and unyielding symmetry, it presents as cold and unfeeling an image as the machine-tooled male who contemplates it. Only its partial red coloring suggests any sense of passion, but that, too, is neutralized by the deadly black patina of its right half.

Allusions to the fourth dimension strengthen the connection with the *Large Glass*. Stella was clearly aware of Duchamp's detailed thinking about the fourth dimension and thoroughly familiar with his cryptic notes on the subject, later published in *The 1914 Box, The Green Box* and *A l'infinitif*.[35] A close analysis of *Man in Elevated (Train)* suggests that, like Duchamp, Stella conceived of his bride as a three-dimensional reflection of a four-dimensional object. "*The shadow* cast by a 4-dim'l figure on our space is a *3-dim'l* shadow," Duchamp wrote in *A l'infinitif*.[36] Further on, he likened the representation of the fourth dimension to the reflection in a mirror. Any depiction of a four-dimensional object would be a virtual representation of its volume, "not the Reality in its sensorial appearance."[37] Such is clearly the case in *Man in Elevated (Train)*, where the bride is only the reflection of an unseen object, not the object itself, and, by being painted on the reverse side of a sheet of glass, is denied a sensorial reality.

Additional references to the four-dimensional status of Stella's bride can be gleaned from the ambiguous handling of the space and forms surrounding it. In both *The Green Box* and *A l'infinitif*, Duchamp stressed that the forms comprising the bride would occupy a nonmensurable space where neither their size nor their relationship to one another would be clearly defined. The "principal forms [of the bride] are *more or less large or* small," wrote Duchamp in *The Green Box*. "Similarly and better in the Pendu femelle and the [wasp], parabolas and hyperbolas (or volumes deriving from them) will lose all character of mensurable position."[38] By contrast, the elements of the bachelor machine were designed according to the demands of conventional single point perspective, which assured a stable relationship among the individual parts, and with whatever environment interacted with them on the far side of the glass.

A similar dichotomy exists in *Man in Elevated (Train)*, where the bachelor's neck, chin, hat, and shoulder establish a comprehensible relationship with each other and with the vertical studs in the background. Not so with the bride's reflection on the window. Here full mensurability is thwarted. Although the crown of the man's hat forms a readily distinguishable anchor in the background, the fanlike element from the *pendu femelle* and the curving parabolic forms surrounding it establish a relationship with the hat, and with each other, that is ambiguous at best. The prominence accorded the parabolic forms in

Stella's work contrasts sharply with the more discrete realization of such forms in the bride's section of the *Large Glass*. This suggests that the strongest impetus for inclusion of the parabolas in Stella's work came not from the *Large Glass* itself, but from the accompanying notes, where Duchamp makes explicit reference to parabolas and hyperbolas in his discussion of the *pendu femelle.* Duchamp was well aware of the phallic suggestiveness of such forms, and in one note he explained that their inclusion in the *pendu femelle* would serve as an additional reminder of the thwarted nature of the bride-bachelor relationship. Such forms, Duchamp wrote, would "lose all connotation of mensurated position."[39] Not only would they float in an indefinite, undefined space, but, in being physically separated from the bachelors below, they would also lack the potency of an attached male phallus.

Stella's reliance on the notes is also apparent in his handling of the fanlike portion of the *pendu femelle*, whose triple showing in the exact center of the glass represents a literal transcription of the phenomenon of "elemental parallelism" outlined in the notes. In "The Continuum" section of *A l'infinitif,* Duchamp defined "elemental parallelism" as "parallel multiplication of the n-dim'l continuum, to form the n + 1 dim'l continuum." Further on, in the same note, he stated that "the passage from volume to 4-dim'l figure [would] be produced through parallelism." Put another way: "A representation of the 4-dim'l continuum will be realized by a multiplication of closed volumes evolving by elemental parallelism along the 4th dimension."[40] The pivotal statement for Stella, however, would seem to have been the one accompanying a rough sketch of the *pendu femelle,* later published in *The Green Box.* There Duchamp observed that the upper part of the *pendu femelle,* the part Stella included in *Man in Elevated (Train)*, would move "in a plane parallll [sic] to its plane."[41]

In her pioneering analysis of the impact of the fourth dimension and non-Euclidean geometry on twentieth-century art, Linda Henderson judged Duchamp's concept of "elemental parallelism ... the key to his visualization of the four-dimensional continuum."[42] Duchamp based his ideas largely on the writings of noted French mathematician Jules Henri Poincaré and his countryman, Esprit Pascale Jouffret.[43] At the theoretical level, at least, Duchamp was willing to accept a purely geometrical solution for realizing the fourth dimension. It was only as his ideas matured, Henderson avers, that he "put away his geometry texts in favor of personal geometrical reasoning by the process of analogy."[44] The correspondence that he sensed between the four-dimensional continuum and a virtual mirror image soon came to dominate his thinking and to provide the most direct clues for his own realization of the nature of a four-dimensional object in space.[45] Perhaps because the concept of "elemental parallelism" conjured up such vivid visual imagery, however, a geometrical solution remained tenable for Stella. In *Man in Elevated (Train),* the receding parallel repetitions of the *pendu femelle*'s distinctive fanlike head

constitute an exacting transcription of that concept onto the two-dimensional surface of the glass.

The complex meanings contained in Stella's handling of the fourth dimension own much of their potency to the conceptual complexities inherent in the glass itself. Some of these derive directly from Duchamp; others are of Stella's own creation. In the first place, and on the most basic level, the glass on which the work is painted represents the glass train window through which we observe the lone passenger within. Its rectangular proportions correspond roughly with the rectangular proportions of a real train window, while its silver frame reads like the metallic outer surface of a commuter train. The man and the vertical supports behind him first appear to occupy an extension of our own space, separated from us only by the intervening glass window. It is only on closer observation that we realize that both the windowlike qualities of the glass and the "reality" of the man beyond are illusions. What at first appears transparent is, in fact, opaque.

Additional references to windows can be found in the center of the composition, where a row of vertically positioned rectangles reads like the reflections of still other train windows on the surface of the principal window. But because each pane lacks a clearly defined boundary, the reality of these panes is even more difficult to assess than is that of the man whose face they partially obscure. Complicating matters is the fact that the reality reflected on these panes is not the three-dimensional reality of the physical world, but the unseen reality of the fourth dimension.

By completely covering the surface of his glass with paint and other materials, Stella denied his work the transparency that constitutes such a crucial component of Duchamp's *Large Glass*. On the other hand, because the work was designed to hang against the wall, it afforded Stella the opportunity to approximate Duchamp's practice of hermetically sealing his painted surface from the vicissitudes of time and change. Duchamp accomplished this by pressing a layer of lead foil against the painted areas of his glass; Stella did so by sandwiching his painted surface between the outer surface of the glass and a simple cardboard backing. The means differed, but the effect is much the same.

Man in Elevated (Train), then, is a highly complex and thoroughly unique integration of two major Duchamp paintings, which demonstrates the thoroughness with which Stella assimilated both the technical challenges and the intellectual and philosophical underpinnings of his oeuvre. For Stella, as for others of his generation, Duchamp functioned primarily as a catalyst. Without imposing himself on Stella or his art, Duchamp was able to elicit from him a level of creativity that, although, heavily indebted to Duchamp's thinking, was a far cry from the blind copying of his work. That Stella did not continue to work in this highly experimental and thoroughly Duchampian vein for long does not mean that the lessons of the glass paintings in general, and of *Man in*

Elevated (Train) specifically, were soon forgotten. Rather, the experience of working on glass, of visualizing the invisible, and of exploring themes of transparency and opacity continued to feed his creative imagination for years to come.

Brooklyn Bridge (1919-1920) (fig. 9-14) constitutes a prime example of the successful transference of these ideas to a non-Dada context.[46] Although painted on canvas, *Brooklyn Bridge* has the look and feel of a stained glass window. A web of black lines outline the principal forms and color areas, which retain a strong sense of transparency. Together, these lines read like the lead armature encasing the individual glass panes in a traditional stained glass window and derive, in part, from the experience of manipulating actual lead wires in *Man in Elevated (Train)* and other of the reverse paintings on glass. The colors, moreover, have the rich sonorities and subtle irregularities of handmade glass, while the radical shifts from dark to light give the illusion of the constantly shifting tonalities of natural sunlight filtering through the window from behind. The unseen properties of the fourth dimension have been supplanted by an overt mysticism. In contemplating the bridge, Stella "felt deeply moved, as if on the threshold of a new religion or in the presence of a new DIVINITY."[47] A short time before commencing the work, he had taken a position teaching Italian to students in a Baptist seminary in the Williamsburg section of Brooklyn, not far from the bridge.[48] This, coupled with his own earlier religious training, a growing nostalgia for his native Italy, and his wildly romantic nature, inspired him to treat the bridge like a religious icon. Seen frontally, in the exact center of the composition, and shrouded in the navy blue mystery of night, the bridge's awesome Gothic piers dominate the composition and rise above the New York skyline, which unfolds in the distance. To the bridge's two piers Stella added a third and placed the three one above the other to suggest a soaring Gothic spire. The arched openings call to mind the stained glass windows traditionally found in Gothic churches, and Stella himself likened the steely gray cables to "divine messages from above."[49]

Two years later, Stella completed *New York Interpreted* (1922), his five-panel, 22-foot-long tribute to the city, which combines nighttime views of *The Bridge* (fig. 9-15), the skyscrapers, and the port with wildly colorful impressions of the taudry commercialism and blaring lights of Broadway. Once again, the weblike profusion of lines and the soft, translucent coloring of the nighttime scenes are strongly evocative of the mystery and majesty of stained glass windows in a dimly lit church interior. The more brightly colored panels of *The White Way,* too, are suggestive of stained glass's mosaiclike patterning. That Stella was aware of the windowlike qualities of the work, and of their implicit religious connotations, is evident in his observation that "from the arcs and ovals [in the narrow bands at the base of each panel] darts the stained glass fulgency of a cathedral."[50]

Although Henry McBride made no mention of the windowlike qualities of

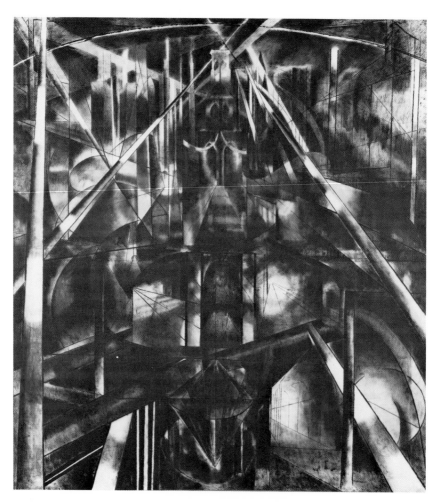

Figure 9-14. Joseph Stella, *Brooklyn Bridge,* 1919-1920
Oil on canvas, 219.5 x 194 cm.
(*Yale University Art Gallery, Collection Société Anonyme;
photo: Joseph Szaszfai*)

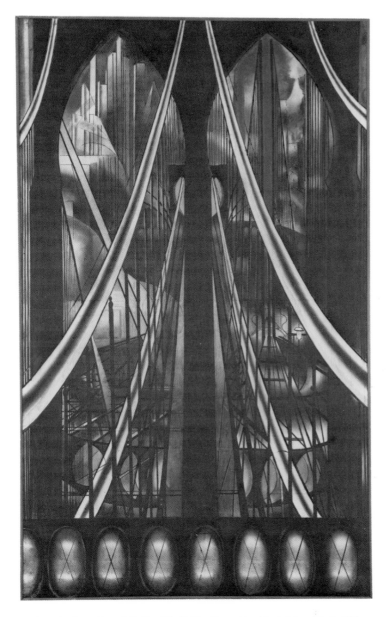

Figure 9-15. Joseph Stella, *The Bridge* (from *New York Interpreted*), 1922
Oil on canvas, 135 x 220.6 cm.
(*Collection of the Newark Museum*)

the polyptych in his review in *The Dial,* written shortly after its first showing at the Société Anonyme's Stella exhibition in the spring of 1923, he did comment on what he judged to be its insistent linearity. "The tall towers appearing behind each other are razor-edged. I get the effect that Stella's New York is all strung upon wires." McBride was not entirely satisfied with the results, which he thought made New York seem "ineffectual and thin." "If [Stella] intended his New York to be so very wiry, then why not have done it in wires *à la* Marcel Duchamp?"[51]

McBride's comments underscore the prominence accorded Duchamp's *Large Glass* among members of New York's avant-garde. That Stella chose not to apply Duchamp's technique to either *Brooklyn Bridge* or *New York Interpreted,* however, supports the view, posited earlier, that for him, the glass and wire paintings were largely experimental and probably never conceived of as steppingstones toward major glass paintings. The fact that McBride makes no mention of Stella's own wire experiments would seem only to confirm the low profile such works had in Stella's oeuvre.

Man in Elevated (Train), like the remainder of the glass paintings, records a specific and highly significant phase in Stella's continually evolving artistic development. Not one to perpetuate past triumphs, Stella was continually seeking new challenges and opportunities. *Man in Elevated (Train)* acknowledges the influence of both Duchamp and New York Dada, but on Stella's own terms and with echoes of both previous commitments and future directions in full view. Although never a central figure in New York Dada, Stella embraced many of its central challenges and, through his friendship with Duchamp, maintained steady contact with its principal proponents. The effects of this liaison form the backdrop of *Man in Elevated (Train)* and underscore an aspect of Stella's career that has previously been all but overlooked.

Notes for Chapter 9

1. Duchamp lived in the United States for a total of 57 months between 1915 and 1923. His residency was broken down into the following periods: June 1915 through August 1918, January 1920 through June 1921, and January 1922 through February 1923. Picabia, on the other hand, was continually crossing and recrossing the Atlantic. Between his first visit in 1913 and his final visit in 1917, he was never in the States for more than about six or seven months at a time, and he never learned English as Duchamp did. See William A. Camfield, *Francis Picabia: His Art, Life and Times* (Princeton: Princeton Univ., 1979), pp. 106-9.

2. *Man in Elevated (Train)* has been owned by Washington University Gallery of Art, St. Louis, since 1946, when it was purchased from the Charles Egan Gallery, New York, in the year of Stella's death. In 1935, the work was exhibited as *Man in the Elevator* and dated 1922 in the Whitney Museum of American Art's exhibition, "Abstract Painting in America." Eleven years later, in the Whitney's 1946 showing, "Pioneers of Modern Art in America," the work was exhibited as *Man in Elevated* with a date of 1918. That same year, in notes written for the Whitney Museum of American Art and later published in *Art News,*

Stella referred to it as *Man in the Elevated.* Joseph Stella, "Discovery of America: Auto-biographical Notes," *Art News* 59 (November 1960): 66. The parenthetical word "Train" seems to have been added to the title by the Charles Egan Gallery just prior to its purchase by Washington University, perhaps to clear up the confusion generated by the 1935 title. The collaged fragments, located in the lower left quadrant of the work, might be thought to hold the key to a more precise date. On the reverse of one of these (fig. 9-9) is an advertise-ment for the novel *Overland Red,* written by Henry Herbert Knibbs, with illustrations by Anton Fischer, and published anonymously by Houghton Mifflin Co. in 1914 and by Gros-set & Dunlap in June 1915. The periodical from which this fragment was clipped has not been located, but presumably it dates from 1914 or 1915, shortly after the novel's first ap-pearance. For reasons that will become clear in the course of this paper, such a date is clearly too early for the Stella collage, making the ca. 1918-1922 date the only acceptable one at this time.

3. Stella and Duchamp were both on the board of directors of the newly formed Society of Independent Artists, and *Battle of Lights, Coney Island, Mardi Gras* was illustrated in *Blind Man* 2 (May 1917): 9. Stella was also featured, along with Marsden Hartley, in the humor-ous article, "Pug Debs Make Society," *New York Dada* 1 (April 1921): n.p. See also, Man Ray, *Self Portrait* (Boston: Little, Brown, 1963), p. 73.

4. Duchamp left for Argentina in August 1918 and returned to New York via France in Janu-ary 1920.

5. Dreier and Stella probably met in 1916 or 1917 when allied with the Society of Independent Artists.

6. Stella's lecture was given at the Société Anonyme Gallery on 27 January 1921 and was later published as "On Painting," *Broom* 2 (December 1921): 119-23. He also assisted Dreier and Duchamp by being available to answer questions following three lectures given by Dreier at the People's School of Philosophy that same month. See *Report 1920-1921* (New York: Société Anonyme, Inc., Museum of Modern Art, 1921), pp. 19-21, repr. in *Selected Publi-cations Société Anonyme: (The First Museum of Modern Art: 1920-1944),* vol. 1 (New York, Arno, 1972). Stella's work was included in the Société Anonyme's inaugural exhibi-tion and in numerous subsequent exhibitions, including a one-man show in 1923. The Soci-été Anonyme also owned more than a dozen of his works, including *Battle of Lights, Coney Island, Mardi Gras* and *Brooklyn Bridge.*

7. See note 1 above for the dates Duchamp was in New York in the early 1920s.

8. The two *Chocolate Grinders* were part of Stella's estate at the time of his death in 1946. See Anne d'Harnoncourt and Kynaston McShine, eds., *Marcel Duchamp* (New York: Museum of Modern Art; Philadelphia: Philadelphia Museum of Art, 1973), pp. 271-72.

9. Stella was working on glass as early as April 1916. He appears to have continued to work in the medium intermittently until 1926 when eight glass works were included in the exhibition "Joseph Stella, Encaustic Paintings," held at The New Gallery Art Club in New York (16 April through 1 May 1926). Five of these employed stained glass executed by Mary F. Wes-selhoeft. See "Exhibition Now On," *American Art News* 14 (18 April 1916), 3; and Irma B. Jaffe, *Joseph Stella* (Cambridge: Harvard Univ., 1970), pp. 88, 185. Jaffe's statement (p. 88) that "Stella's paintings on glass are Dada only in the marginal sense that the tech-nique implied an attack on the sacredness of traditional material" is naive and misleading. While some of the glass paintings, including the Hirshhorn's *Landscape,* employ conven-tional subjects and, save for the glass support, are handled in a fairly straightforward and conventional manner, others, including *Man in Elevated (Train)* are clearly Dada in the full sense of that word. Not until more of Stella's glass paintings are located can a full appraisal

of their significance within Stella's oeuvre or within the phenomenon of American Dada be attempted. See note 11 below.

10. *Man in Elevated (Train)* measures 14-1/4 x 14-3/4 inches.

11. In addition to the 1926 exhibition referenced in note 9 above, glass paintings are known to have been included in only five exhibitions of Stella's work during his lifetime: two group exhibitions at the Bourgeois Gallery, New York (25 March through 20 April 1918 and 3–24 May 1919); a one-man show at the Bourgeois Gallery (27 March through 24 April 1920); and two group shows at the Whitney Museum of American Art ("Abstract Painting in America," 1935, and "Pioneers of Modern Art in America," 1946). In addition to the works previously noted, other glass paintings include: *Untitled,* ca. 1919 (Whitney Museum of American Art, New York); *Untitled,* ca. 1922 (New Jersey State Museum, Trenton); *Lotus Flower,* ca. 1920 (formerly, Collection Bernard Rabin, Cranbury, N.J.); *La Fusée,* ca. 1918 (location unknown); *Abstract with Vertical Bars,* ca. 1918 (location unknown); *Pittsburgh,* ca. 1919 (location unknown); *Aria (Canto Paesano),* ca. 1920 (location unknown); and three works entitled *Water Lily* (locations unknown).

12. Duchamp first used lead wire to outline the forms of *Glider,* 1913-1915 (Philadelphia Museum of Art), his first painting on glass. He turned to wire after his original plan of outlining the forms with a line etched by hydroflouric acid produced unsatisfactory results. Two additional works on glass, *9 Malic Molds,* 1914-1915, (Collection Mme. Marcel Duchamp, Villiers-sous-Grez) and *To Be Looked at (From the Other Side of the Glass) with One Eye, Close to, for Almost an Hour,* 1918, (Museum of Modern Art, New York), also have forms outlined in lead wire. See Richard Hamilton, "The Large Glass," in *Marcel Duchamp,* pp. 61-62.

13. In both *Chinatown* and the two untitled glass paintings, the same inconsistent handling of the wire prevails.

14. Crotti arrived in New York around September 1915.

15. Crotti produced at least five reverse paintings on glass before his return to Paris in the fall of 1916: *The Mechanical Forces of Love in Movement,* 1916; *Clown,* 1919 (Musée d'Art Moderne de la Ville de Paris); *Solution de continuité,* ca. 1916 (private collection); *Composition à l'équerre,* 1916 (private collection); and *Dans deux sens,* 1916. *Clown* and *The Mechanical Forces of Love in Movement* were well known to members of the New York avant-garde. *Clown* was exhibited twice within less than a year's time, first at the Montross Galley (4–22 April 1916) and then at the Bourgeois Gallery (10 February through 10 March 1917), which also showed *The Mechanical Forces of Love in Movement.* The latter was also the focus of an important interview with Crotti and Duchamp by Nixola Greely-Smith, "Cubist Depicts Love in Brass and Glass, 'More Art in Rubbers than in Pretty Girl,' " New York *Evening World,* 4 April 1916, p. 3. Significantly, Crotti ceased to produce reverse paintings on glass following his return to Paris and his separation from Duchamp and the *Large Glass.* It was only in the late 1930s and 1940s that he returned to the medium in works that utilized pieces of colored glass bound by a translucent material. See Walter Pach, "The Gemmeaux of Jean Crotti: A Pioneer Art Form," *Magazine of Art* 40 (February 1947): 68-69.

16. A major difference between *The Mechanical Forces of Love in Movement* and *Man in Elevated (Train)* is the fact that Crotti's work is constructed like a shadowbox. The space separating the glass and the backing contains hollow metal tubes attached to the reverse of the glass. One peers into the tubes from strategically placed unpainted areas on the glass itself. Two other of Crotti's glass paintings, *Clown* and *Solution de continuité,* are constructed in similar shadowbox fashion. For a recent discussion of Crotti's glass paintings,

see William A. Camfield, "Jean Crotti & Suzanne Duchamp," in *Tabu Dada: Jean Crotti & Suzanne Duchamp, 1915-1922,* eds., William A. Camfield and Jean-Hubert Martin (Bern: Kunsthalle Bern, 1983), pp. 14-15.

17. Both *Clown* and *Solution de continuité* incorporate large areas of clear, unpainted glass, but unlike the *Large Glass,* both are backed with a solid material (painted glass in the case of *Clown*), thereby limiting the interaction between the work and the surrounding environment. Duchamp also inspired Man Ray to work on glass and, in 1920, Man Ray produced *Dancer/Danger* (Collection Morton G. Neumann, Chicago), an airbrush painting on glass. Marsden Hartley also produced a number of reverse paintings on glass in 1917, but his inspiration came not from Duchamp, but from a combination of non-Dada factors, principally Bavarian glass painting, the glass paintings of the Blaue Reiter artists, and early American glass painting. See Barbara Haskell, *Marsden Hartley* (New York: Whitney Museum of American Art in Association with New York Univ., 1980), pp. 56-57; and Gail Levin, "Marsden Hartley and the European Avant-Garde," *Arts Magazine* 54 (September 1979): 161-63.

18. In *Untitled* (Whitney Museum of American Art, New York), pointillist dots simulate the effect of light pouring forth from two conical lamp shades; in *Chinatown* they function more abstractly as simple surface enhancement.

19. Manierre Dawson bought *Sad Young Man on a Train*, exhibited as *Nu* at the Armory Show, for $162 on 7 April 1913. Milton Brown, *The Story of the Armory Show* (New York: The Joseph H. Hirshhorn Foundation, 1963), p. 240.

20. In February 1919, Pach wrote Dawson that if he would ever consider divesting himself of the painting, "I wish you would write me of it ... I think of Duchamp's work as something very important, more so even than I did in 1913 and I should hate to see any examples of it in the hands of people who would bury it in a dead place where no one got any pleasure or benefit from it." In April 1922, after having taken possession of the painting, Pach wrote Dawson that he was showing it to Duchamp, who had not seen the painting in nearly ten years. He reported that Duchamp "studied it with great attention and seemingly with satisfaction and wrote its proper name: 'Jeune Homme triste dans un Train,'" on the back." Walter Pach to Manierre Dawson, 4 February 1919 and 30 April 1922, Manierre Dawson Papers, Archives of American Art, Smithsonian Institution, Washington, D.C., roll 64, frames 892-93 and 896-98.

21. Marcel Duchamp in Pierre Cabanne, *Dialogues with Marcel Duchamp,* trans. Ron Padgett (New York: Viking, 1971), p. 33.

22. Ibid., p. 29.

23. In later years, Stella's close friend, August Mosca, described Stella as "of medium height and rather full amidship ... in a vague way, he reminds one of Winston Churchill." Draft of letter, August Mosca to Theodore Sizer, [ca. February 1942,] August Mosca Papers, Archives of American Art, roll N70-7, frame 129.

24. Additional self-portraits showing Stella in profile wearing a hat include: *Self-Portrait,* ca. 1929 (Collection Mr. and Mrs. Herbert A. Goldstone, New York; illus. Jaffe, *Joseph Stella,* no. 94) and *Figures, including Self-Portrait,* ca. 1944 (illus. Jaffe, *Joseph Stella,* no. 108).

25. Stella was extremely fond of profile portraits, which he did not reserve for himself alone. He also used the profile pose for portraits of Marcel Duchamp, Edgar Varèse, Eva Gauthier, Helen Walser, and Louis Eilshemius, among others.

26. This would seem to be borne out by the fact that in *Figures, including Self-Portrait* (see note 24 above), Stella is the only figure wearing a hat.

27. Stella moved to Brooklyn in 1916 or 1917. He returned to New York in 1920. John I.H. Baur, *Joseph Stella* (New York: Praeger, 1971), p. 142.

28. "A Complete Reversal of Art Opinions by Marcel Duchamp, Iconoclast," *Arts & Decoration* 5 (September 1915): 428.

29. Ibid.

30. Duchamp, quoted in "The Iconoclastic Opinions of M. Marcel Duchamps [sic] Concerning Art and America," *Current Opinion* 59 (November 1915): 346.

31. Stella, "Discovery of America," p. 41.

32. Little is known about Stella's marriage, which he kept secret from even some of his closest friends. His wife, Mary Geraldine Walter French, was a native of Barbados. They seem to have married sometime before 1920, but were estranged for many years. They reconciled in 1935 and, in 1937, Stella accompanied his ailing wife back to Barbados, where she died on 29 November 1939. Mrs. H.W. Nice, Barbados Museum and Historical Society, to John I.H. Baur, 22 April 1963, Whitney Museum Papers, Archives of American Art, roll N689, frames 8-12; Jaffe, *Joseph Stella*, p. 96.

33. Man Ray, *Self Portrait*, p. 93.

34. In *Battle of Lights, Coney Island, Mardi Gras*, e.g., the bejeweled electric tower that dominates the central portion of the composition connotes unmistakable phallic power. Further sexual analogies are present in the orgiastic swirl of the brightly colored bodies that spiral upward from the baseline and in the park's exotic dancers, who gyrate in hedonistic abandon to the cacophonous sounds wafting through the park's magical corridors.

35. The greatest number of notes date from the years 1912 through 1914, before Duchamp's arrival in America, but he continued to add to the notes until 1921 or 1922. All of the notes have been published in Michel Sanouillet and Elmer Peterson, eds., *Salt Seller: The Writings of Marcel Duchamp (Marchand du Sel)* (New York: Oxford Univ., 1973), pp. 22-101.

36. Duchamp, "A l'infinitif," in *Salt Seller*, p. 89.

37. Ibid., p. 99.

38. Duchamp, "The Green Box," in *Salt Seller*, pp. 44-45. See also Duchamp, "A l'infinitif," in *Salt Seller*, p. 83.

39. Duchamp, "A l'infinitif," in *Salt Seller*, p. 83.

40. Ibid., p. 92.

41. Duchamp, "The Green Box," in *Salt Seller*, p. 48.

42. Linda Dalrymple Henderson, *The Fourth Dimension and Non-Euclidean Geometry in Modern Art* (Princeton: Princeton Univ., 1983), p. 148.

43. Ibid., pp. 61, 72, 120-27, 138-50.

44. Ibid., p. 150.

45. Ibid., pp. 150-57.

46. The chronological relationship between *Man in Elevated (Train)* and *Brooklyn Bridge* is not fully clear. *Man in Elevated (Train* may have been completed as early as 1918, in which case it would predate *Brooklyn Bridge* by more than a year; or it may date as late as 1922, in which case it would postdate the painting by roughly two years. (See note 2 above.) It is also possible that Stella worked on the two pieces simultaneously. Regardless of the exact

sequence of events, however, Stella's use of glass as an artistic medium clearly precedes his work on *Brooklyn Bridge.*

47. Stella, "The Brooklyn Bridge (A Page of My Life)," (n.p.: n.d.), n.p.

48. Jaffe, *Joseph Stella,* p. 49.

49. Stella, "The Brooklyn Bridge," n.p.

50. Stella, "Discovery of America," p. 66.

51. Henry McBride, "Modern Art," *The Dial* 74 (April 1923): 423-24.

10

H2SO4: Dada in Russia

John E. Bowlt

Francis Picabia once remarked that the "Dada spirit existed only between 1913 and 1918."[1] When he uttered that statement, Picabia evidently had in mind the Swiss, German, and American Dadaists and was not aware of the fact that a number of Russian avant-garde artists and writers of the period also qualified for inclusion. Although neither Dada nor Surrealism became influential, titled movements in Russia, there were many gestures, events, and phenomena in Moscow, St. Petersburg, and other Russian, Ukrainian, and Georgian cities during the 1910s that paralleled, or even preceded, the Dada and Surrealist developments in the West.

The formula H2SO4 in the title of this chapter is a reference to a group and journal of that name active in Tiflis (now Tbilisi), Georgia, in the early 1920s (fig. 10-1). This was the home of Georgian Dada, led by the poet Ilia Zdanevich, and connected directly to another eccentric group by the name of 41°. Actually, H2SO4 itself is of limited interest and was only one symptom of a general Dadaist tendency evident in Russian literature and art just after the Revolution. Although H2SO4 receives some treatment towards the end of this chapter, it does not constitute the focus of attention here. Rather, the general sentiment that it denoted — illogicality, absurdity — is central to a related discussion here of specific aspects of Russian Cubo-Futurism of the 1910s.

A distinctive aspect of modern Russian, and also of East European art, is its frequent juxtaposition of irrationality and rationality, intuition and reason, the individualistic and the collective. This interaction is apparent on many levels, not least in the literature and art of the Symbolists, who endeavored to use art as a "source of intuitive cognition"[2] on the one hand, and to discover its "mathematical regulators"[3] on the other. During the avant-garde period, this counterpoint of ideas was identifiable in particular with the pioneers of abstraction — Vasili Kandinsky, Kazimir Malevich, and Olga Rozanova — and, as their essays and lectures demonstrate, they aspired to resolve this ostensible

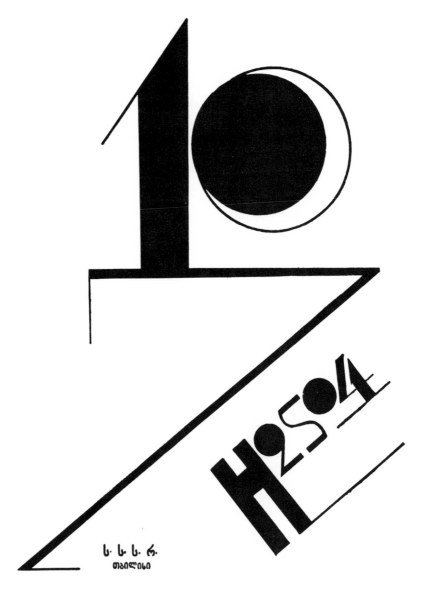

Figure 10-1. Front cover of *H2SO4*, ed. Simon Chikovani, 1924, Tbilisi.
 (*Collection: The Institute of Modern Russian Culture at Blue Lagoon, Texas*)

disharmony of themes. For example, the poet and occasional painter Sergei Bobrov, speaking in December 1911 on the new works of the Russian "Purists" (Natalia Goncharova, Mikhail Larionov, et al.), referred simultaneously to the "metaphysical" and to the "painterly" essence of their art.[4] A few years later, Malevich formulated his concept of the new art as an experience dictated by "intuitive reason,"[5] and Rozanova envisaged the intuitive sense as the gateway to the "era of purely artistic achievement."[6]

This contradiction of values was illuminated in a provocative essay by the Lithuanian artist and critic Vladimir Markov (Waldemar Matvejs), *The Principles of the New Art,* which he published in 1912. In his text, Markov elaborated these ideas, identifying them as the two fundamental, but opposing principles germane to the forms of art, i.e., "nonconstructiveness" (the application of intuition and fortuity) and "constructiveness" (the application of rationality and formal discipline).[7] While indicating his preference for the nonconstructive element, which he saw as the aesthetic basis of Eastern and primitive art, Markov was, nevertheless, profoundly interested in the structural organization and arrangement of the work itself, something that prompted him to make detailed examinations of the intrinsic qualities of art such as color, weight, and texture. It is of interest to note that several years later, in very different contexts, both the artist Henryk Berlewi and the Formalist critic Nikolai Punin made positive references to Markov's interpretation of texture as the "noise" emitted from the surface of the painting.[8] But what we find in Markov, ultimately, is not necessarily an exclusive predilection for the nonconstructive or the constructive element, but rather a desire to integrate them. On a practical level, this integration certainly did occur, whether in the improvisations and compositions of Kandinsky or in the aerial Suprematism of Malevich. In wider terms, the equal validity of the two principles of nonconstructiveness and constructiveness was proven simply by the coexistence of Dada/Surrealism and Constructivism in Russia and East Europe throughout the 1910s and 1920s.

While there can be no doubt as to the higher aesthetic appeal of Constructivism in relation to its more subjective counterparts, the one cannot be understood without the other, especially in the context of Russia and East Europe. In any case, it is incumbent upon us to reexamine those conventional national categories imposed on certain trends (e.g., "French" Cubism, "German" Expressionism, "Italian" Futurism, "Russian" Constructivism) and to present a more synthetic picture of the European tradition. This would justify, for example, a long discussion of the Cubist school in Prague; of the Dada and Constructivist movements in Warsaw and Budapest; and of the Dada, Expressionist, and Surrealist trends in Russia.

Reference to what Markov described as the nonconstructive value in art provides an approach to the question of Dada in Russia and East Europe. It should not come as a surprise that such a tendency existed east of Berlin, since

the names of Berlewi, Lajos Kassák, Karel Teige, Marcel Janco and, of course, Tristan Tzara himself, all born in East Europe, are now recognized as important members of international Dada. However, the presence of Dada and Surrealism vis-à-vis Constructivism does form an unusual, ill-explored area of research. Dadaism, that is, the outgrowth of the Dada group founded in Zurich by Tzara and Hans Arp in 1916, became known very quickly in Budapest, Warsaw, and Prague. It did not reach Russia or, at least, Georgia until 1920, if we can believe the reminiscences of Ilia Zdanevich fifty years later.[9]

In Zurich, Dadaism arose as a protest against all social and political fronts, and "as a manifestation of almost lunatic despair,"[10] a point of view that might have appealed to the nineteenth-century Russian and Polish intelligentsia. Some artists from Hungary, Poland, and Czechoslovakia played a key role in the Dada movement. Berlewi, Kassák, Moholy-Nagy, and Teige, for example, were soon applying the principles of displacement, absurd juxtaposition, and superobjectivity to photomontage and typographical design with exciting results. The journal *MA* (Budapest/Vienna, 1915-1926) carried some of the movement's most arresting examples of Dada verbal and visual language. On the other hand, Russian artists and intellectuals played no role in the Dadaist endeavor, as such, even though Zurich in 1916 was full of temporary and permanent émigrés (including Lenin). Nevertheless, the Russian Cubo-Futurists at home, in the persons of David Burliuk, Malevich, Vladimir Maiakovsky, Vasilii Kamensky, Ivan Puni (Jean Pougny), and others, anticipated Dada's antics by also disregarding artistic and social conventions, by shocking the bourgeoisie, by creating "illogical" artifacts such as a painting with a glued-on wooden spoon (Malevich's *Englishman in Moscow* of 1913), or a painting carrying a plate or a hammer (Puni). Still, these exaggerated gestures were stimulated by the sense to create rather than to destroy, to affirm a new code rather than to destroy all norms. Indeed, the charge of destruction leveled often at the Russian Cubo-Futurists should be qualified substantially. Despite such loud proclamations as "Throw Pushkin, Dostoevsky, Tolstoi, etc. overboard from the Ship of Modernity,"[11] the Russians were at heart too mystical, too inspired to embrace a philosophy of persistent and mechanical destruction.

Of course, this attitude to Western Dada as a destructive, nihilistic movement is conditional and inaccurate, and some scholars now regard Dada as creative and affirmative, as contributing directly to the evolution of German Constructivism in the 1920s. Actually, Dada and Constructivism (Raoul Hausmann and Carl Buchheister, Rudolf Jahns and El Lissitzky) are perhaps not so very different. For example, Kurt Schwitters' careful systems of collages and the subtle organization of his Merz Constructions, including his *Merzbau,* bring his art close to the sober principles of Constructivism; on the other hand, Lissitzky's constant use of ellipse, displacement, and denial of gravity (expressed in his Prouns) bring him close to Dada and even to Surrealism. In fact, Schwitters and Lissitzky almost read as metaphors for each other. These

formal parallels point to the danger of stylistic categorization, especially with regard to modern European art, and they also emphasize the frequency of artistic coincidence. For instance, Schwitters' collages of ca. 1920 share exactly the same principles as those done by Olga Rozanova for her Cubo-Futurist books of 1916, and Friedrich Vordemeberge-Gildewart's *Composition No. 35* (1927) bears an uncanny resemblance to the painting *White Ball* done by Puni twelve years before in Petrograd.

These artistic coincidences between Germany and Russia are intriguing because the two countries were at war between 1914 and 1917, and Soviet Russia experienced an economic and cultural blockade from 1918 until 1921. In any case, the respective avant-gardes in Germany and Russia between ca. 1914 and ca. 1921, i.e., Expressionism and Cubo-Futurism/Suprematism, were rather different. That is why Hans Richter, Buchheister, Jahns, and others, were surprised to see nonfigurative and Constructivist works at the 1922 Soviet art exhibition at the Galerie Van Diemen in Berlin. Conversely, the influence of German Expressionism, especially that of Otto Dix, George Grosz, Otto Nagel, and Max Pechstein, was appreciable on young Soviet artists. But the opposition of Expressionism and Suprematism does not disprove the fact that there were artistic programs common to both Germany and Russia before 1921. One of these was, in fact, Dada.

Although an effective and cohesive Dada movement did not exist in Russia, certain of the Dada and Surrealist features were peculiar to Russian culture. In a broad historical context, reference might be made to the role of "infantilism" in Russian literature, to the importance of the *yurödivyi* (Holy Fool) in popular Russian culture, to the irrationalities in the writings of Nikolai Gogol. But what, specifically, of the twentieth century? Evidence of the irrational, but still constructive impulse of the Russian avant-garde is provided by an examination of the concept known as *zaum* (transrationality or alogicality), practiced by poets and painters just before and after World War I. The inventor of *zaum* was the poet and painter Alexei Kruchenykh who, in a miscellany of January 1913, published his first *zaum* poem:

<div align="center">

dyr bul shchyl
ubeshshchur
skum
vy so bu
r l ez.[12]

</div>

Then, in April 1913, together with the poet Velimir Khlebnikov, he published the first *zaum* manifesto called "The Declaration of the Word as Such:"

4. Thought and speech cannot catch up with the emotional experience of someone inspired, the artist is free to express himself not only in a common language (concept), but also in a private one (a creator is individual), as well as in a language that does not have a

definite meaning (is not frozen), that is *transrational*. A common language is binding; a free one allows more complete expression....

2. Consonants create a national everyday atmosphere; vowels, on the contrary, a universal language....[13]

For Kruchenykh, *zaum* was a new linguistic system that, he felt, would be more sensitive and more expressive than conventional language. Essentially, Kruchenykh and Khlebnikov wished to purify language of its orthodox associations and to bring the *word* closer to its *meaning,* i.e., to rediscover the primal, authentic *sound* of the noun or adjective. The most famous example of this is by Kruchenykh who, tired of the Russian word for "lily" (*liliia*), offered his own word, *eyu*, which, in his opinion, communicated more clearly the essence of the concept of lily. Khlebnikov, too, hoped that by reducing language to its "molecules," he would perceive its incantational force, its magic. Consequently, much in the same way as the Surrealists later regarded the liberation of the dream, Khlebnikov felt that such a verbal power could constitute a *universal language.* Needless to say, Khlebnikov regarded himself as the king of this universe — just as Johannes Baader regarded himself as the axis of the terrestrial globe later on. Khlebnikov's and Kruchenykh's wish to return the word to its original state, to reunite the Word and the Flesh, was voiced at least a decade earlier by the Russian Symbolists, especially by the poet and philosopher Andrei Bely. Bely had also tried to reanimate language by resorting to neologisms, to catachresis, and to pure sound effects; as he wrote in his article "The Magic of Words" in 1909: "The usual prosaic word, i.e., the word that has lost its phonic and pictorial image and has not yet become an ideal term — is a stinking, decomposing corpse."[14]

In passing, we should note that many painters of the Russian avant-garde — Pavel Filonov, Malevich, Rozanova, Varvara Stepanova — also tried their hand at *zaum* poetry; although, except for Filonov's magnificent *zaum* poem "Propoven o prorosli mirovoi" ("Chant of Universal Flowering"), their verbal experiments were slight. Even so, it is possible to speak of an entire *zaum* school in Russian poetry, one that attracted many primary and secondary talents in the 1910s and 1920s. Led by Kruchenykh, *zaum* culminated in the foundation of the 41° group in Tiflis in 1918 under Ilia Zdanevich. With branches in Moscow, Peking, and Paris, 41° published *zaum* poems, staged *zaum* dramas, and sponsored *zaum* exhibitions (fig. 10-2). A direct outgrowth of 40° was H2SO4, a Georgian Dada group.

Kruchenykh, Khlebnikov, and the painters Ivan Kliun, Malevich, and Alexei Morgunov developed *zaum* as both a destructive and a constructive system — and in two different ways. The poets, especially Kruchenykh, concerned themselves with the liberation of sounds (not to be confused with Marinetti's "words at liberty") and used language as raw material much in the way a painter such as Malevich might use pure color in an abstract composition (fig.

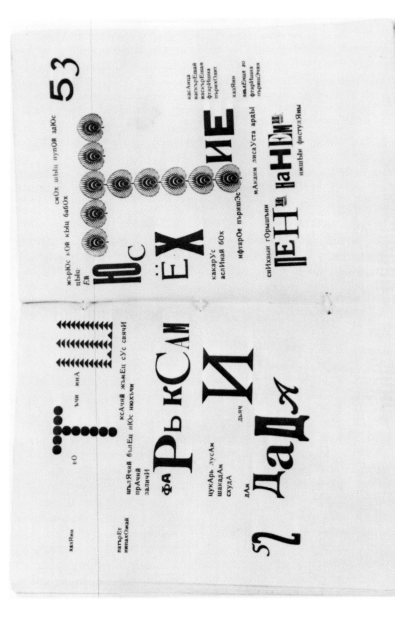

Figure 10-2. Ilia Zdanevich, *Le-Dantiu as a Beacon*, page design, *41°*, 1923, Paris. (*Private collection, Texas*)

10-3). This distinctive quality of *zaum*, as opposed to the Italian Futurists' "words at liberty," was emphasized in a conversation between the Russian poet Benedikt Livshits and Marinetti, who visited Russia in 1914:

> M.: No, word-creation is not the be-all and end-all.... We have destroyed syntax! ... We use verbs only in the infinitive mood, we have abolished adjectives, we have annihilated punctuation....
>
> L.: Your militancy is superficial. You do battle with individual parts of speech and don't even attempt to go beyond the level of etymological categories.... Despite the innovations which you have made, the connection between the logical subject and its predicate has remained unshakeable.
>
> M.: All psychology must be expelled from literature and must be replaced by the lyrical possession of substance....
>
> L.: ... Mere possession of substance is not enough. In order to transform it into a work of art a feeling for material is needed first and foremost.... But it is precisely this that the West does not have. The West does not feel material as the organic substance of art....[15]

Perhaps the most convincing example of this Russian prerogative — the possession of substance — is provided by Kruchenykh's 1913 poem "Heights," which is composed entirely of vowels:

$$
\begin{array}{c}
e\,u\,yu \\
i\,a\,o \\
o\,a \\
o\,a\,e\,e\,i\,e\,ya \\
o\,a \\
e\,u\,i\,e\,i \\
i\,e\,e \\
i\,i\,y\,i\,e\,i\,i\,y^{16}
\end{array}
$$

Incidentally, Kruchenykh's poem serves as a prototype to Louis Aragon's poem, called "Suicide," which consists only of letters of the alphabet.[17]

Kruchenykh's minimalist literature was reduced ever further by another Russian Cubo-Futurist poet, Vasilisk Gnedov, in the same year. Gnedov wrote a poem called "The Poem of the End" in which the last section was simply a blank page — an expression of nothingness that anticipated similar manifestations in the Russian avant-garde, such as Malevich's series of *White on White* paintings, the Moscow Dada group called The Nothingists, and the Constructivist slogans issued by Alexei Gan in 1922: "Death to Art! It arose naturally, developed naturally and disappeared naturally." Actually, Kruchenykh himself expressed a similar mood in the early 1920s, as, for example, in his call to "create conditions whereby everything that evokes [the sense of] art, religion and beauty in man be atrophied."[18]

Contemporaries recall how Gnedov would actually recite his "Poem of the End." He put on a formal suit, adjusted his spectacles, opened a book on the

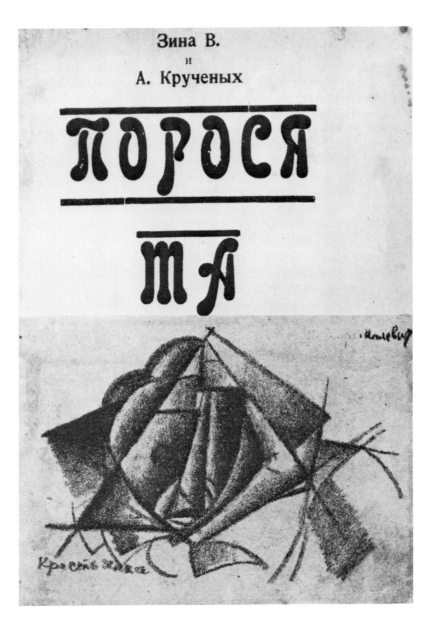

Figure 10-3. Kazimir Malevich, front cover, *Piglets,*
ed. Zina V. and A. Kruchenykh, 1913, St. Petersburg.
(*Dallas Museum of Fine Arts*)

lectern, brushed an imaginary speck of dust from his lapel, took out his pocketwatch and placed it in front of himself, raised his right arm slightly, adopted an inspired facial expression, his eyes lifted heavenward — and then remained silent, until the audience's forebearance gave way to fidgeting and then to hissing and booing. Audience reaction was vital to the practice of the Russian Cubo-Futurists, since, like their colleagues at the Cabaret Voltaire, they relied substantially on public response. However, the Russian audience, particularly the publics in Moscow and the provincial towns, raised on a long tradition of mummers and buffoons, regarded individuals such as Kruchenykh and Gnedov as clowns, rather than as the desecrators of hallowed ritual. Of course, there were limits to the tolerance even of the Russian audience. When Kruchenykh threw hot tea into the first rows of the audience, the local gentry were highly displeased; when David Burliuk and his friends sold auditorium tickets twice over for one of their performances, the audience began to participate in no uncertain terms; and when the liberated Goncharova walked around downtown Moscow bare-breasted except for abstract cosmetic treatment, the custodians of decency were, indeed, appalled.[19]

Naturally, dressing up — or dressing down — was as much a shock tactic with the Russian avant-garde as it was with the Zurich Dadaists. David Burliuk often wore an earring, a top hat, and a tuxedo in his Futurist escapades; Vladimir Maiakovsky wore a yellow vest and a wooden spoon. During their Futurist tour of 1913-1914, when David Burliuk, Kamensky, and Maiakovsky traveled through Kharkov, Odessa, Kazan, and other cities, they sometimes suspended a grand piano upside down above the stage; sometimes they recited poetry in cacophonic unison. In Tiflis, the curtain went up to reveal "Maiakovsky in the middle in a yellow vest, Kamensky on one side in a black coat covered in brilliant stars, Burliuk on the other side in a dirty-pink jacket...."[20] Such theatrical gestures, such flagrant anti-aestheticism was expressed just as clearly in the visual art of the Russian Cubo-Futurists. The painter Aristarkh Lentulov later described an avant-garde exhibition of 1915:

> [At the exhibition] were relief combinations hastily thrown together by Larionov and Goncharova; the Burliuks hung up a pair of torn trousers and stuck a bottle in the middle; the artist V.V. Maiakovsky took part by exhibiting a top hat cut into two halves with gloves either side; Tatlin exhibited his counter-reliefs. The poet V.V. Kamensky divined what he thought was the mood of the exhibition and asked the jury rather convincingly to allow him to exhibit a live mouse in a mouse-trap, but the jury rejected his proposal severely, finding that it would lower the conception of the exhibition and would disrupt the conventions of artistic taste....[21] (fig. 10-4).

Similarly, the Russian Cubo-Futurists destroyed tradition — and created a new one — in their interpretation of the book. Poets and painters combined forces to produce artifacts that departed radically from the graceful, elegant editions of the *fin de siècle*. They used wallpaper, even toilet paper, for covers;

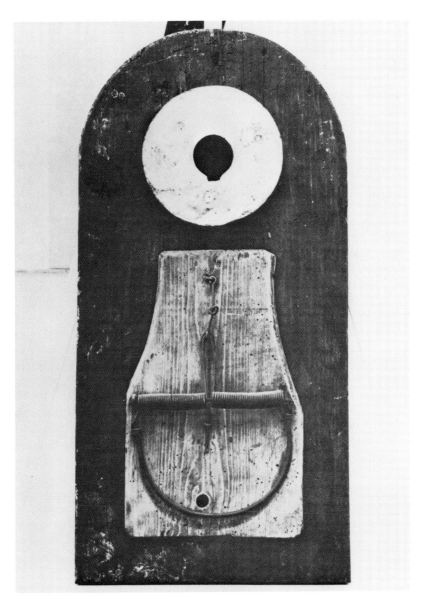

Figure 10-4. Vasilii Kamensky, *Mouse Trap*, 1915
Wood relief, 60 x 30 cm.
(*Gmurzynska Gallery, Cologne*)

they combined papers of various grades and various inks; they produced books of unusual sizes — in miniature form, in scroll form, flat albums, single sheets — and used collage and montage in their graphic designs. The titles they chose were often completely unbookish: *Milk of Mares, Roaring Parnassus, Croaked Moon, A Slap in the Face of Public Taste.* Instead of being an object of respect and discernment, the Cubo-Futurist book now became a joke. Instead of being a symbol of permanence and of truth, it was a throwaway object, a piece of ephemera. Instead of being a source of solace and of reassurance, it was now a provocative, uncomfortable artifact that demanded the reader's active, creative response.

A key concept that Kruchenykh identified with his theory of *zaum* was "shift" or "displacement": the impetus of the work of art should be to destroy traditional sequences, to undermine accepted responses to a poem or painting, and thus to sharpen sensibility, to force the audience to contemplate the work. Malevich and Morgunov, close to Kruchenykh in 1912-1914, gave particular attention to this method in their paintings such as *Englishman in Moscow, Woman at an Advertisement Column* (1914), and *Study for an Aviator* (Morgunov, 1914). For example, in his *Englishman in Moscow*, Malevich brought together disparate objects — a fish, bayonets, a church, a man in a top hat, a wooden spoon, etc. — and created an artistic totality, if not a semantic one. Actually, it is not easy to conceive of a complex of images that are unrelated, because our consciousness operates according to sequences and series. We should not be surprised to recognize images here that derive from a common source, namely, from the Cubo-Futurist opera *Victory Over the Sun,* which Malevich, Kruchenykh, and the painter-composer Mikhail Matiushin produced in St. Petersburg in December 1913. The bayonets, the saber, the scissors, all symbols of severance and disruption, come from the libretto of *Victory Over the Sun.*

The notion of shift is expressed very clearly in Malevich's transrational painting *Woman at an Advertisement Column,* where even objects recognizable in isolation are now eclipsed and about to be replaced by a new visuality — the geometric abstraction of colored planes. Shift is used on many levels in this picture, from the disappearing dancing couple to the divided line of lace, from the parted head of hair lying on its side to the sign of infinity, from the fragments of words scattered over the picture's surface to the clash of two media, painting and photography. The latter contrast between painting and photography is also evident in Malevich's *Composition with Mona Lisa* (1914), a parody that brings to mind similar, contemporary gestures both in Russia and in the West (fig. 10-5).[22] The photographic aspect of *Woman at an Advertisement Column* and *Composition with Mona Lisa* did, of course, find parallels in Dada practice in the West, particularly in the application of photocollage and photomontage, for ironic and satirical effect, by John Heartfield, Hannah Höch, Raoul Hausmann, and others. Still, the possibilities that Male-

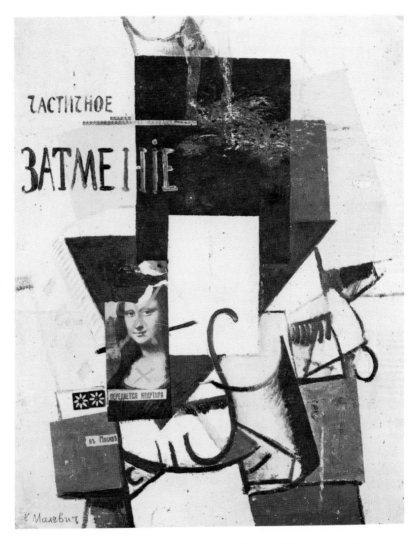

Figure 10-5. Kazimir Malevich, *Composition with Mona Lisa,* 1914
Oil on canvas, 62 x 49.5 cm.
(*Private collection, Leningrad*)

vich alluded to remained unexplored until after the Revolution, when Alexandr Rodchenko and others began to use photographs in collages in 1918 for a series of Dada compositions incorporating cigarette packs, tickets, colored paper, and photographic details. Actually, there was one precedent both to Rodchenko and to Malevich, namely the amateur artist Georgii Leonov, who, in the 1880s, assembled a series of still lifes using the same kind of materials as Rodchenko — and generating the same artistic effect as Malevich.[23]

It might be tempting at this point to interpret Malevich's subsequent development — his painting of the *Black Square* of 1915 — as a Dada gesture of nothingness. But there is a substantial difference between the world view of Malevich and that of the Dada members: with his *Black Square*, Malevich established a positive and prescient artistic system. Far from representing "aesthetic sadism,"[24] as some critics contended, Malevich, with his Suprematism, restored the very essence of painting, just as Kruchenykh and Khlebnikov did with language. In this respect, the Russian avant-garde behaved rather differently from their Dada colleagues. Still, as they were for the Dadaists, the concepts of spontaneity, automatism, and intuition were of vital importance to the Russian Cubo-Futurists, contributing to the formation of *zaum* on the one hand, and to the "Expressionism" of Pavel Filonov and Vasili Kandinsky on the other. But in both cases, this development can be traced to the Russian Symbolists' interest in what Rudolf Steiner called "consciousness through intuition,"[25] a doctrine that drew wide intellectual support in Russia and East Europe in the 1900s and 1910s, and upon which various artists — from Archipenko to Kandinsky, from Kupka to Malevich — depended in greater or lesser degree. Even in the case of such a down-to-earth individual as Mikhail Larionov, the depiction of an artistic vision, unrestrained by convention and dependent upon the intuitive impetus, encouraged him to speak of a "super-real" or "sur-real" art as early as 1914 — which anticipated Apollinaire's use of the term by three years.[26]

At home and abroad, Russians were aware of the Dada movement from 1916 onwards. Zurich was full of temporary and permanent Russian émigrés enjoying Swiss neutrality. The Dadaists were also aware of the Russian avant-garde, if not in 1916, then very soon thereafter, as Hausmann, Heartfield, and George Grosz demonstrated by their homage to Tatlin in 1920 (fig. 10-6).[27] Mention might be made of contributions by the Ukrainian artists Jeffim Golyscheff and Mark Slodki to Dada exhibitions in the early days and, on a facetious level, to Lenin's frequent visits to the Cabaret Voltaire. But, by and large, Russians were not active in Western Dada. However, the sheer force of Dada could not fail to reach Russia, and although it never attracted a large following, it left its mark on the development of Russian art and literature. In 1919-1920, a small group of writers and painters, led by the poet Simon Chikovani, came together in Tiflis, capital of the still independent Georgia and a Bohemian center for many Russian intellectuals fleeing from the Bolshevik

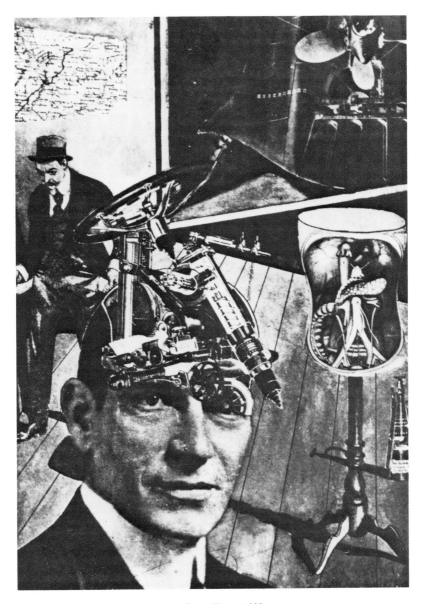

Figure 10-6. Raoul Hausmann, *Tatlin at Home,* 1920
Collage, 41 x 28 cm.
(*Hausmann's photograph from the original; Prévot collection, Limoges*)

forces in the north. This group, much indebted to the researches of Kruch-enykh and Khlebnikov, called themselves Dadaists and, in 1924, issued a journal under the editorship of Chikovani called *H2SO4* (fig. 10-1), in which *zaum* was treated as a central literary medium, although the language used was Georgian, not Russian. The H2SO4 group looked upon themselves as the newest stage in the progression from Western Dada through the 41° group. As their title would imply, they were especially interested in the formal makeup of art, or the "molecules" as Khlebnikov would have said. Who invented the title, and why the formula for sulphuric acid was chosen, has not been documented, although the H2SO4 members, obviously, wished to symbolize their intended decomposition of cultural and social values.

The most curious manifestation of Dada in Russia was a group called the Nichevoki (Nothingists), founded in Moscow at the end of 1919. This group admitted their debt to Western Dada, but refused to take the title "Dada" because of its positive meaning in Russian (i.e., *da, da* means "yes, yes"). As the Nothingists wrote in their manifesto: "There is nothing in poetry, only Nothingists.... Write nothing! Read nothing! Say nothing! Print nothing!"[28] This is reminiscent of Tzara's earlier declaration: "No More Looks! No More Words! No More manifestoes. Stop looking! Stop talking!"[29] On a different level, it is also reminiscent of Lissitzky's opening caption in his book *Pro dva kvadrata* (*About Two Squares*) of 1922: "DON'T READ." The Nothingists — the poets Sergei Sadikov, Suzanna Mar, Elena Nikolaeva, Alexandr Ranov, Riurik Rok, Denis Umansky, and Oleg Erberg and the artist Boris Zemenkov — operated out of the so-called Creative Bureau of the Nothingists in Moscow, and they ran a publishing house called The Hobo. Their first decree or manifes-to, issued in August 1920 in Rostov-on-Don, under the title "On the Nothing-ists of Poetry," declared that it was

> time to cleanse poetry of the traditional amateurish, poetical dung of life in the name of the collectivization of the volume of creation of the world principle [sic] and the Visage of Nothing. For materialists and stereotype idealists this principle does not exist: for them it is nothing. We are the first to raise the bricks of insurrection on behalf of Nothing.[30]

Zemenkov, who joined the poets of the group in April 1921, also compiled a separate decree for painting, in which he stipulated that, as part of the strug-gle against the decay in sensitivity toward the environment, entry to all mu-seums, exhibitions, or storerooms with works of art would be disallowed by the Rev[olutionary] Tribunal of the Nothingists, except with special passes. On April Fools' Day 1922, Zemenkov and his colleagues published a collection of their decrees, commentary, and historical data called *Sobachii yashchik* (*Dog Box*) — called so "because we liked the combination of the words" (fig. 10-7).[31] This document established a formal link between the Moscow Nothingists and the European Dadaists since it included two declarations entitled "An Appeal to the Dadaists" and "The Nothingists of Russia [and] the Dada of the

НИЧЕВОКИ.

—

СОБАЧИЙ ЯЩИК

или

ТРУДЫ ТВОРЧЕСКОГО БЮРО НИЧЕВОКОВ

втечсние 1920-1921 г.г.

Под редакцией Главного Секретаря Творничбюро

С. В. Садикова.

—

ВЫПУСК ПЕРВЫИ.

МОСКВА. „ХОБО".

1921.

West." Zemenkov — artist, writer, and memoirist, *vedun expressionizma* (knower of Expressionism), as he called himself — has become the most familiar member of the group owing to his romanticized reminiscences of Moscow, published in the Soviet Union a few years ago. As a Nothingist however, Zemenkov had a limited audience since what he wrote and painted was often incomprehensible. For example, his illustrations to Alexei Chicherin's 1927 nonsense poem, "Zvonok k dvorniku" ("A Call to the Yardman"), merited him the title Dadaist or, rather, Surrealist (fig. 10-8).

Moscow Dada, in the form of Nothingism, was exported to the West through two poets and painters who were associated with it: Ilia Zdanevich (Iliadze) of 41 ° ³² and Sergei Sharshun (Charchoune). Both men collaborated with the Dadaists and Surrealists in Paris during the 1920s and 1930s, particularly as typographical artists (fig. 10-9). Charchoune, in fact, published a book called *Dadaizm. Kompiliatsiia* (*Dadaism. A Compilation*) in Berlin in 1922, for which he translated various statements by Dadaists into Russian — the first and only Russian language publication of its kind and intended, of course, for the émigré reader. Quotations from Tzara, Picabia, and Breton, as well as from Symbolist poets and Cubist painters, provided an aggregate impression of European Dada, although Charchoune made no reference to Kruchenykh, Khlebnikov, or any other Russians.

The Nothingists were not an influential force; their publishing house was responsible for only three books and, like many experimental groups in the Soviet Union in the early 1920s, they disbanded very quickly. Still, their alignment with Dada was symptomatic of a continued strong interest in a lyrical, internal art, one that paralleled and opposed the contrasting interest in Constructivism and design. The current popularity of Soviet Constructivism among scholars and collectors has eclipsed the significance of this alternative tradition in early Soviet art, but it certainly deserves our attention inasmuch as it touches on the entire question of Surrealism in Soviet Russia.

Although Constructivism, especially as it was applied to design, retained its position as the most innovative, most exciting trend throughout the 1920s in Soviet Russia, it never gained wide popularity. In any case, as general dissatisfaction with the rationality and severity of Constructivist forms increased, there was a corresponding renewal of interest in more traditional, figurative tendencies — prompting the development of Heroic Realism on the one hand, and a "neo-Romanticism" on the other, of which Expressionism and Surrealism were immediate extensions. It is important to remember that this demand for a more introspective perception of art in Soviet Russia was part of an international trend and that, in October 1924, André Breton published his Surrealist manifesto in Paris.

Surrealism, as a term, was not commonly applied in Soviet Russia, and no written equivalent of Breton's declaration appeared in Russian. But by about 1924, many Soviet artists and writers were also disheartened by the positivist,

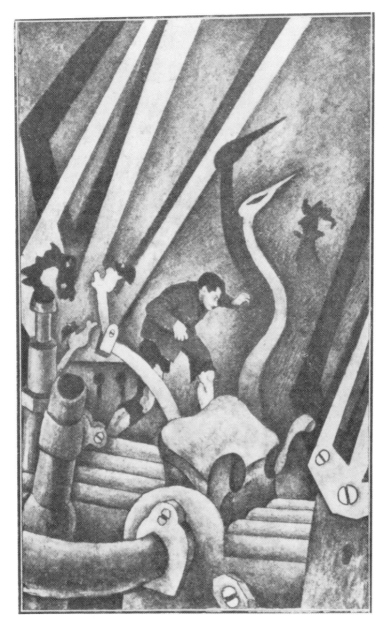

Figure 10-8. Boris Zemenkov, illustration to the poem "A Call to the Yardman"
("Zvonok k dvorniku"), by Alexei Chicherin, 1927
Reproduced in *Novye Stikhi* (Moscow: All-Union Club of Poets, 1927).
(*Collection: The Institute of Modern Russian Culture at Blue Lagoon, Texas*)

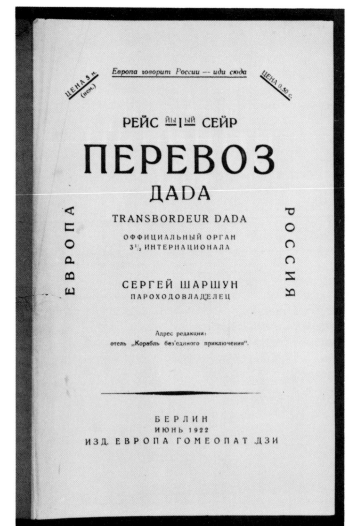

Figure 10-9. Serge Charchoune, *Transbordeur Dada,* 1922, Paris.
Front cover of a printed announcement.
(*Private collection, New York*)

scientific world and aspired toward a more intuitive or romantic world view. In the words of the writer and artist Boris Zemenkov, the artist should endeavor to reach the "transverse point between the physical and the astral."[33] Actually, the sentiments expressed by Breton were not especially novel to the Russian consciousness. Breton's contention that "childhood is nearest to the 'true' life" and that the "world must be replaced by the world of apparition"[34] echoed what the Russian Symbolists and neo-Primitivists had already asserted. Breton's paraphrase of Freud, that our reason "revolves in a cage from which it becomes more and more difficult to release it,"[35] is reminiscent of Matiushin's reference, made a decade before, to the "annoying bars of a cage in which the human spirit is imprisoned."[36] Breton's remark that "this summer the roses are blue"[37] brings to mind the Moscow Blue Rose group of artists of 1907.[38]

As in Western Europe, the ideas of Freud were attracting particular attention in the Soviet Union in the mid-1920s, and his name was involved in critical appraisals of the new art.[39] Moreover, this new concern coincided with a renewed interest in children's art, contributing to a series of publications on this subject and to the organization of an international exhibition of children's art in Moscow in 1934. In the late 1920s, there was still a flourishing literary and artistic Bohemia in Moscow and Leningrad — a "wandering and nomadic tribe" of Soviet students and intellectuals, as one critic observed.[40] Even Party members began to voice their dissatisfaction with the science of Communism.[41] In other words, Soviet conditions were appropriate and conducive to the formation and practices of a Surrealist style.

These cultural parallels between Soviet Russia and Western Europe in the mid-1920s are apparent not only in the respective moods and theoretical pronouncements, but also in artistic production. In particular, the release of the subconscious pursued by Surrealists such as Louis Aragon, Breton, Dali, and Tanguy was also identifiable within the aspirations of a number of Soviet painters, especially with members of the Society of Easel Artists (OST). This group, supported by Alexandr Drevin, Solomon Nikritin, Kliment Redko, David Shterenberg, Alexandr Tyshler, and many others, served as an important dispenser of Expressionist and Surrealist ideas in Soviet painting during the second half of the 1920s.[42] Its leading members, who, in addition to the above, included Alexandr Labas, Sergei Luchishkin, and Yurii Pimenov, had all experienced a long period of war and revolution, and the disturbing calm of their paintings seemed to communicate a wish for serenity after the long nightmare of violence. For example, in much the same way that Dali uses real objects in an unreal context, so Tyshler, in paintings such as *Waiting* (ca. 1927), *Woman and an Airplane* (1927), and *Director of the Weather* (1927), breaks conventional temporal and spatial sequences and produces immediate disorientation. Luchishkin, Tyshler, and Petr Vilyams, in particular, emphasize the neutral, "infinite" mood of their dislocations by applying a monochrome scale of brown, grey, and green and by avoiding bright, dynamic colors. Shterenberg

also tries to divide the objects in his paintings from their normal contexts, often removing references to background, distance, and ancillary images. Not surprisingly, during the 1930s, the OST artists came under fire for their rejection of "reality, of the causal and sequential interdependence of phenomena... and of social motivation."[43]

Of course, the OST members were not the first Russian artists to use the idea of displacement as a creative device. This particular method had been used extensively by the Russian Cubo-Futurists, especially by Kruchenykh. Some writers in the 1920s and early 1930s also developed the aesthetic of "shift," producing "absurd" literature that was often published in the form of children's stories — sophisticated and complex exercises in "nonsense." Led by Daniil Kharms and Alexandr Vvedensky, the Absurdist writers, who formed the group Oberiu (Association for Real Art) in Leningrad in 1927, continued to write their stories, plays, and poems throughout the 1930s. One such piece by Kharms, in its suspension of logic, brings to mind certain paintings by the OST artists:

> There was once a red-haired man who had no eyes and no ears. He also had no hair so he was called red-haired only in a manner of speaking.
>
> He wasn't able to talk, because he didn't have a mouth. He had no nose, either.
>
> He didn't even have any arms or legs. He also didn't have a stomach, and he didn't have a back, and he didn't have a spine, and he also didn't have any other insides. He didn't have anything. So it's hard to understand whom we're talking about.
>
> So we'd better not talk about him any more.[44]

The close, but uneven relationship between the European Surrealists and the Soviet Union reached its culmination in late 1930, when Aragon and Georges Sadoul were invited as consultants to the Second International Conference of Revolutionary Writers in Kharkov. In his presentation there, Aragon criticized observers for relegating Surrealism to literature; in fact, he maintained Breton's original conviction that Surrealism was outside art and occupied the same relative position as did, for example, chemistry. But despite Aragon's positive report on the conference and his notorious pro-Communist poem "Front Rouge," published in January 1932,[45] a certain disillusionment in Soviet Communism became apparent in the Surrealist ranks during the early 1930s. As early as 1926, Breton stated that "it is ... necessary ... for the experience of the inner life to continue ... without exterior control, even Marxist."[46] By 1933, the Surrealists, while still haunted by thoughts of universal revolution, were parodying their own political beliefs, at least vis-à-vis Soviet Russia (Dali's *Six Apparitions of Lenin on a Piano* of 1933 seems to reflect this). In 1935, Breton left the Communist Party while still remaining a Marxist, although Aragon maintained his membership throughout the harsh years of the Stalin administration.

By establishing the existence of a tentative Dada and Surrealist tendency in Russia, one might challenge the conventional view of modern Russian art as a simple progression from Futurism to Suprematism, Constructivism, and Realism. Just as the recent reexamination of French Symbolist painting has demonstrated the presence of a tradition alternative to that of Impressionism in the second half of the nineteenth century, so, similarly, in the context of Russian art, a new chronology of Futurism, "neo-Romanticism" (for want of a better word), and Realism might be established. In other words, one might question the ostensible and exclusive significance of nonobjective art by pointing to the existence of a highly original and individual aesthetic, understood outside names such as Lissitzky, Rodchenko, and Tatlin.

This argument enables us, in turn, to attempt an unexpected evaluation of Socialist Realism. According to the advocation of 1934, "Socialist Realism ... demands of the artist a true, historically concrete depiction of reality in its revolutionary development. In this respect truth and historical concreteness of reality must be combined with the task of ideologically transforming and educating the workers in the spirit of Socialism."[47] This call to reprocess reality according to an ideological perspective (and, therefore, to create an alternative reality) was echoed by Andrei Zhdanov in his concurrent statement that "the whole life of the working-class and its struggle consist of combining the most severe and sober practical work with grand heroism and great prospects ... (and so) Romanticism, a new type of Romanticism, a revolutionary Romanticism, cannot be alien to Soviet literature...."[48] This simultaneous advocation of Realism and Romanticism maintained, as it were, the ambiguity of Russian art evident in the modernist period and especially in the 1920s.

On the one hand, therefore, one might now regard the emergence of Socialist Realism not simply as the result of a political imposition, but rather as the logical outcome of a lyrical principle that was never concealed, even during the heyday of the avant-garde. On the other hand, one might venture to equate the terms Surrealism and Socialist Realism. Surrealist painting sought to replace a mundane world of convention and logic with a dream world full of objects that "could be." If this was the essence of Surrealism, then Socialist Realism was not so very distant — indicated by a comparison of two images ideologically very different and yet visually very close: Magritte's painting *L'Invention collective* (1935) and M. Alpert's propaganda photograph illustrating Stalin's maxim: "Life is improved, comrades, life has become more joyous." (figs. 10-10, 10-11).[49] The point is that the smiling faces of Soviet shipbuilders, the sunburnt girls gathering corn, or the venerable professor posing at his desk were artistic images totally illogical and "surreal" in a world punctured by oppression, famine, and imprisonment. It is a curious paradox, one that would have appealed to the Dada humor and sensibility, that the wildest dreams, the most luxurious visions, were experienced and described precisely under Stalin's hegemony. Well, at this stage, as Kharms said, it's hard

Figure 10-10. Max Alpert, illustration of Stalin's statement, "Life is improved, comrades, life has become more joyous." Reproduced in USSR in *Construction*, no. 3 (1937). (*Collection: The Institute of Modern Russian Culture at Blue Lagoon, Texas*)

"LIFE IS IMPROVED, COMRADES, LIFE HAS BECOME MORE JOYOUS," SAID STALIN, AND JOY IS TO BE FOUND EVERYWHERE—FROM THE WHEAT FIELDS, WHERE THE TRACTOR IS THE SERVANT OF THE COLLECTIVE FARMER, TO THE FISHERIES OF THE CASPIAN, WHERE THE ABDUOUS TOIL OF THE FISHERS HAS BEEN RE-PLACED BY MECHANICAL EQUIPMENT AND THE TEEMING DEPTHS OF THE SEA ARE FISHED BY MOTOR TRAWLERS.

Figure 10-11. René Magritte, *L'Invention collective*, 1935
Oil on canvas, 72.2 x 114.1 cm.
(*Private collection, Brussels*)

to understand what we're talking about. So we'd better not talk about it any more.

Notes for Chapter 10

1. Robert Motherwell, ed., *The Dada Painters and Poets: An Anthology* (New York: Wittenborn, 1951), p. 183.

2. V. Ivanov, *Borozdy i mezhi* (Moscow: Ory, 1916), p. 132.

3. *Turkestan. 11 seriia risunkov P. Kuznetsova* (Moscow-Petrograd: State Publishing House, 1923), n.p.

4. S. Bobrov, "Osnovy novoi russkoi zhivopisi," in *Trudy Vserossiiskogo sezda khudozhnikov i Petrograde dek. 1911–yanv. 1912,* vol. 1 (Petrograd: Golike and Vilborg, 1914), p. 42.

5. K. Malevich, *Ot kubizma i futurizma k suprematizmu. Novyi zhivopisnyi realizm* (Moscow: n.p., 1916), p. 22.

6. O. Rozanova, "Osnovy novogo tvorchestva i prichiny ego neponimaniia," in *Soiuz molodezhi* 3 (St. Petersburg, 1913): 20.

7. V. Markov, "Printsipy novogo iskusstva," *Soiuz molodezhi* 1 (1912): 5-14; 2: 5-18.

8. Markov wrote on texture in his booklet *Printsipy tvorchestva v plastike. Faktura* (St. Petersburg, 1914). Punin referred to it in his *Tsikl lektsii* (Petrograd: 17th State Printing House, 1920), p. 18. Berlewi also referred to it in his booklet *Mechano-Faktura* (Warsaw, 1924; repr. in ex. cat. *Constructivism in Poland 1923-1936 BLOK Praesens a.r.* [Museum Folkwange; Essen: Rijksmuseum Kröller-Müller; Otterlo, 1973; Lodz, 1973], pp. 72-74; the reference to Markov appears there on p. 72.

9. V. Markov, *Russian Futurism* (Berkeley: Univ. of California, 1968), p. 417, note 136. For a recent discussion of Russian Dada, see Marzio Marzaduri, *Dada Russo* (Bologna: Cavaliere Azzurro, 1984).

10. D. Gascoyne, *A Short History of Surrealism* (England: Cobden-Sandersen, 1935), p. 24.

11. D. Burliuk, et al., *Poshchechina obshchestvennomu vkusu* (Moscow: Kuzmin, 1912), p. 3.

12. Markov, *Russian Futurism,* p. 44.

13. Ibid., p. 345.

14. A. Bely, "Magiia slov," in his *Simvolizm* (Moscow: Musaget, 1910), p. 436.

15. John E. Bowlt, ed. and trans., *Benedikt Livshits: The One and a Half Eyed Archer* (Newtonville: Oriental Research Partners, 1977), p. 191.

16. Markov, *Russian Futurism,* p. 121.

17. A. Gan, *Konstruktivizm* (Tver, 1922). Trans. in John E. Bowlt, ed., *Russian Art of the Avant-Garde: Theory and Criticism 1902-34* (New York: Viking, 1976), p. 221.

18. A. Kruchenykh, *Oktiabr v kube* (Moscow, 1922[?]), p. 11

19. One of Goncharova's designs for a lady's bosom was reproduced in *Argus* (St. Petersburg, December 1913), p. 115.

20. S. Gints, *Vasilii Kamensky* (Perm: Permskoe knizhnoe izdatelstvo, 1974), p. 105.

21. Lentulov was describing the "Exhibition of Painting" held in Moscow in the spring of 1915. Maiakovsky and Tatlin showed ex. cat. A. Lentulov. "Avtobiografiia," in *Sovetskie khudozhniki* (Moscow, 1937), vol. 1, p. 160.

22. Of particular interest is the caricature of Leonardo's *Mona Lisa* by Nikolai Remizov. It was reproduced in *Sokrovishcha iskusstv v sharzhakh khudozhnikov A. Radakova, Re-mi, A. Yunger, A. Yakovleva* (St. Petersburg: Kornfeld, 1912), n.p.

23. For information on Leonov, see Yu. Gerchuk, *Zhivye veshchi* (Moscow: Sovetskii khudozhnik, 1977), pp. 66-68.

24. N. Radlov, *O futurizme* (Petersburg: State Publishing House, 1923), p. 30.

25. R. Steiner, *Philosophy of Spiritual Activity* (trans. of his *Philosophie der Freiheit)* (London, 1922), p. 148.

26. M. Larionov, "Le Rayonisme pictural," in *Montjoie!* no. 4-5-6 (Paris, 1914), p. 15. Apollinaire used the word "sur-réalisme" for the first time in the program for the ballet *Parade* performed on 18 May 1917 in Paris.

27. Grosz and Heartfield make a poster proclaiming "Die Kunst ist tot. Es lebe die neue Maschinenkunst Tatlins" for the Dada exhibition in Berlin in 1920. Hausmann created the collage *Tatlin at Home* in 1920 also.

28. "Dekret o Nichevokakh Poezii," in *Sobachii yashchik ili Trudy tvorcheskogo biuro nichevokov v tech. 1920–1921 gg.* (Moscow: Khobo, 1921), p. 8.

29. T. Tzara, "Seven Dada Manifestoes," in Motherwell, p. 84.

30. "Dekret," p. 8.

31. *Sobachii yashchik,* p. 3.

32. For information on I. Zdanevich, see ex. cat. *Iliazd* (Paris: Centre Georges Pompidou, 1978). Also see B. Goriély, "Dada en Russie," in *Cahiers Dada Surréalisme* 1 (Paris, 1966): 31-42.

33. B. Zemenkov, *Koryto umozakluchenii* (Moscow, 1920), p. 5.

34. André Breton, "Premier manifeste du surréalisme," in *Les Manifestes du Surréalisme* (Paris, 1946), p. 66.

35. Ibid., p. 22.

36. M. Matiushin, Preface to the miscellany *Troe* (St. Petersburg, 1913). See Markov, *Russian Futurism,* p. 125.

37. Breton, "Premier manifeste," p. 75.

38. For information on the Symbolist Blue Rose group, see John E. Bowlt, "The Blue Rose: Russian Symbolism in Art," in *The Burlington Magazine* (London, August 1976): 566-74.

39. See, e.g., Ya. Tugendkhold: "4-ia vystavka OST," in *Pravda* (Moscow, 16 May 1928). Quoted in V. Kostin, *OST* (Leningrad: Khudozhnik RSFSR, 1976), pp. 119-20. For other references to Freud and art in this context, see A. Voronsky, "Freidizm i iskusstvo," in his *Literaturnye zapiski* (Moscow, 1926), pp. 7-34.

40. M. Reisner, "Bogema i kulturnaia revoliutsiia," in *Pechat i revolutsiia* 5 (Moscow, 1928): 92.

41. Voronsky, p. 32.

42. The best source of information in Kostin's book on OST. Nikritin and Redko were not formal members, but they were close to the movement.

43. O. Beskin, *Formalizm v zhivopisi* (Moscow: Vsekokhudozhnik, 1933), p. 32.

44. George Gibian, ed. and trans., *Russia's Lost Literature of the Absurd* (Ithaca: Cornell Univ., 1971), p. 53.

45. Louis Aragon, "Le Surréalisme et le devenir révolutionnaire," in *Le Surréalisme au service de la révolution* 3 (Paris, 1932): 6. The transactions of the Kharkov Conference were published as *Vtoraia Mezhdunarodnaia konferentsiia revoliutsionnykh pisatelei. Doklady, rezoliutsii, preniia* (Moscow, 1931).

46. Andre Breton, "Légitime défense," in *La Révolution surréaliste* 8 (Paris, 1926), quoted in Ferdinand Alquie, *The Philosophy of Surrealism* (Ann Arbor: Univ. of Michigan, 1965), p. 60.

47. From the Charter of the Union of Soviet Writers of the USSR in I. Luppol, et al., eds., *Pervyi Vsesoiuznyi sezd sovetskikh pisatelei 1934. Stenograficheskii otchet* (Moscow, 1934), p. 716. Trans. in Bowlt, *Russian Art of the Avant-Garde,* p. 297.

48. From A. Zhdanov's speech, ibid., p. 4. Trans. in Bowlt, *Russian Art of the Avant-Garde,* p.293.

49. Reproduced in *USSR in Construction* 3 (Moscow, 1937): n.p. This particular issue was designed by S. and El Lissitzky.

[A small part of this essay was published in modified form under the title "Die Kunst der Konstruktion/The Art of Construction" in the exhibition catalog *Die 20er Jahre in Osteuropa/ The 1920s in Eastern Europe* (Cologne: Galerie Gmurzynska, 1975), pp. 5-18.]

Johannes Baader: The Complete Dada

Stephen C. Foster

It is tempting to discuss very specific aspects of Baader's career because of the extent to which it anticipates aspects of post-modernism. I have decided otherwise, however, in view of the simple, but surprising fact that no more than a few substantial discussions of the artist currently exist. A more general review of the artist's activities spanning the most important years of his career, but concentrating especially on the Dada years (1917–1921), seemed to be a more useful endeavor. The very fact that Baader has been so neglected requires at least a brief discussion.

Raoul Hausmann, perhaps the best known of the Berlin Dadaists, and sometime collaborator with Baader, has stated that "Baader was the right man for Dada."[1] Most serious retrospective accounts of the period by the Dadaists themselves suggest that Baader, more than any single individual of the group, typified their work and goals. For a variety of reasons, however, Baader stories have rarely been founded on fact. What we have so far are Baader legends. Yet, there is significant agreement among many of these accounts, especially in the more reliable records, that Baader was crucial to the development of language works, the "manifestation," photomontage, and other dimensions of the arts in Berlin Dada. Even a brief exposition of Baader's career will, therefore, prove useful in dispelling certain misunderstandings about the Berlin Dada movement in general, and Baader's case in particular.

Baader's obscurity can be attributed to two factors; first, his virtual disappearance after the breakup of Berlin Dada in 1920, and second, the particular historiographic development of the movement following its demise. Relative to the first, suffice it to say that following 1921, Baader was no longer practicing art in the public eye. His contact with former colleagues lapsed totally; to what extent is indicated by occasional passages by former friends in search of him. Information on his activities was scarce. Under these circumstances, consigning him to a minor role in history was inevitable. Baader, at least to a

significant extent, was Dada's forgotten man.

On the other hand, Baader was subjected to a certain amount of historical censorship. Although a small number of praiseful, but guarded discussions of Baader exist in the literature, an equal number make a clear point of writing Baader out of the movement. A brief mention of these accounts is valuable both in indicating the volatility of Baader's reputation among his comrades and in establishing a secondary literature for the artist.

From among the German Dadaists themselves, opinion on Baader varies tremendously. Hausmann, who has written at length on the artist, is probably the most reliable and, in view of his many collaborations with Baader, perhaps the most detailed and informative. Yet his approach, basically honorific, sometimes betrays impatience.

> The quasi-astronomic constellation of his eccentric constitution made Ober-Dada a mixture of ordered and at the same time intransigent existence, for he paid attention to nothing but the unwinding of his cellular clock and nothing or nobody could do anything to make him abandon his "tricks," forever fraught with lack of constraint.[2]

Franz Jung views Baader as a nuisance and an imposter, the "punching bag" of Raoul Hausmann, one who was simply used by Dada to do its dirty work.[3] Walter Mehring offers a comparatively warm account of Baader and, although fully aware of his reputation as a madman, represents Baader, aside from his Dada activities, as a more or less normal, reasonable, and functional individual.[4] Hannah Höch, in her few statements about Baader, counts him among the most talented of the artists (his actual role in Berlin Dada, it should be noted here, far exceeded that of just artist).[5] George Grosz is typically anecdotal and slightly condescending in his stories,[6] while Richter, one of the most ambitious Dada chroniclers, takes a fairly straightforward, narrative, and largely appreciative look at Baader.[7] Yet, with the possible exception of Richter, these accounts of Baader are relatively unknown and unread by all but specialists.

In the better-known accounts of Baader (especially those translated into English), Baader does not fare so well. Georges Hugnet's later account, written out of a Surrealist milieu, stressed the anarchic, deranged, and uncontrolled Baader and gave, in the process, what appeared to be substance to the myth of Baader as a madman.

> Johannes Baader, who was not a painter, exhibited among other manuscripts and objects, his visiting-card, "the luggage of Superdada (a nickname he had adopted) at the time of his first escape from the insane asylum, 18 September, 1899. A Dada relic. "Historic"; "Why Andrew Carnegie rolls his eyes"; "A project for an animals' paradise in the Paris zoo, containing compartments for all the French and German Dadaists in the Hagenbeck style without bars." ... Baader represents still another aspect of German Dadaism. He represents folly without restraint, an anarchic force that describes a trajectory and then vanishes. The events of his life, and his life itself, denote an unbalanced mind, and above

all, a lack of control in his approach to the task defined by his friends; but at the same time they are characteristic of man's striving for power through will.[8]

Hugnet is typical in stressing such questionable facts as Baader's exhibition of the luggage used during his first escape from an insane asylum on 17 September 1899. His characterization of Baader as an embodiment of "unrestrained folly" is hopelessly misleading, even in specific reference to the exhibition of his works in the 1920 International Dada Fair, to which he refers above. Indeed, exactly the opposite interpretation would be considerably closer to the truth.[9] Most writing on Baader has been a reiteration of the same myths and irrelevancies, and Hugnet, unfortunately, has been widely quoted as a source in this literature.

While Hugnet was writing largely out of hearsay, lack of evidence, and a strong taste for the sensational, Richard Huelsenbeck, author of the widely read *Memoirs of a Dada Drummer,* had radically different motives. Perhaps the most prolific memoirist of the Berlin group, Huelsenbeck is highly pejorative in his outlook and makes every effort to "prevent a Baader myth from forming."

> Today, after fifty years, it is obvious that Baader's activities were quite detrimental to us. His self-appointment as "Oberdada" (Supreme Dada), his carryings-on in the Berlin Cathedral and in the Weimar Popular Assembly (he threw hundreds of dada propaganda leaflets on the heads of the deadly earnest delegates) made dada look like a metaphysical gag, a kind of universal joke, far removed from all art. It is important to repeat: although originally dada was an emotional reaction that could express itself in any form, it operated on a level from which art could easily be reached. Our position on art was dictated by hate and love, we were artists overwhelmed by the coyness of our mistresses. Baader, however, had absolutely nothing to do with art.[10]

The above passage typically reflects later attempts by the Berlin Dadaists to establish their own priority in the movement, to settle old scores, and to write their own histories. Baader suffered tremendously at the hands of these retrospective accounts, not the least by virtue of Motherwell's republication of them (or many of them) in his seminal, but in Baader's case, neglectful, *Dada Painters and Poets.*[11]

Motherwell's neglect was not ignored by Baader who, just before his death in 1955, came to notice, that is not to say prominence, in a Munich newspaper article of 8 May 1952.[12] The reason: Baader was threatening to file suit against Wittenborn (Motherwell's publisher), Bernard Karpel, and Charles Hulbeck (formerly Richard Huelsenbeck) for neglecting to report adequately his role in Berlin Dada. It seems odd that so sensational and so vehemently disputed a personality as Baader should have been overlooked. It is, nonetheless, true that only in the past ten years has an interest in this complex and engaging man (I shall maintain important, as well) quickened to the point of producing something like a history for him. The point of mentioning the notice is the clarity

with which he speaks to his concrete involvement in the movement, the vehicle, as even he perceived it in 1952, through which his name would enter history.

Baader's position in Berlin Dada is worth briefly sketching. His main ally was Hausmann, with whom he founded what is generally considered the most radical wing of the movement. Referred to by Giroud as "cultural criticism," their activities stood opposed to the more orthodox politicizing of George Grosz, Wieland Herzfelde, and John Heartfield.[13] Along with Hausmann, Baader discounted the work of the latter group because it failed to seek reform of culture at its roots. Grosz, for example, impugned German society with biting irony and satire, but from Baader's and Hausmann's point of view, failed to come to grips with important, indeed, crucial concepts of culture, per se. That is, Grosz and the Herzfelde brothers tried to reform culture from the inside and, consequently, for the most part adopted the very facts of culture they were opposing as inevitable and given (Grosz was later to become much more radical in this respect). It was from within the culture they were criticizing that their criticism was generated. It was through their radicalizing, but not fundamentally changing, the accepted roles of art and literature that reform was sought.

By 1918, Hausmann had described an alternative to these established conventions and had moved well beyond a Heartfield/Huelsenbeck/Futurist-oriented concept of Dada as mere uproar. His polemics already held a considerable analytical edge and must have offered an altogether instructive means to approaching aspects of art for Baader as well, especially his concepts of Dada art as "a plane with the appearance of conflicts, as the insolence of the creator who protests."[14]

Baader's rejection of the opposition was perhaps even more complete than Hausmann's; this goes far to explain the extreme character of Baader's role as it was formulated to exist outside and above conventional society and culture. Many of his best-known gestures, for example, his proclamation of himself as the new Christ or his adoption of the title "Oberdada," are best understood in this light. Although partly explained as Baader's escalation of his self-proclaimed personal role in guiding the universe, and partly as Club Dada's attempts to formulate a mock jurisdiction over Germany of the time, the role is, more significantly, Baader's answer to finding an extracultural position from which to speak.

Such actions are consistent with the other Berlin Dadaists' perceptions and utilizations of Baader. The 1919 document "Dadaisten gegen Weimar" indicates both the general tenor of Berlin Dada and its creation of a remarkable role for Baader that surpasses all others, "Oberdada als Präsident des Erdballs." (fig. 11-1).[15] This mock role, designed to be filled by a fool, provided Baader with a perfect platform. His surprisingly skillful execution of the role (he clearly recognized the value of playing the part of a fool), made easier by the legal immunity he had won by the 1917 certification of his insanity,

Figure 11-1. "Dadaisten gegen Weimar,"
broadside manifesto, 1919, Berlin.
(*Collection: Jean Brown; photo: Estera Milman*)

provided him with a power base (often used, to the consternation of his fellow Dadaists, in the most preemptive ways imaginable) and capability for sensation (the press followed his activities closely) that justified, at least to an extent, the alarm over his activities expressed by such individuals as Jung and Huelsenbeck. How aware Baader was of the potential of his role is well indicated in a postcard to Tzara, dated 1920, in which he observed that "we have in German a beautiful word for genius: 'fool,' " and suggested that Tzara might have cause to use it in the course of his own activities.[16]

It was out of such a context that Baader offered some of Berlin Dada's most sensational and, at the time, best-known activities. They represent the very cutting edge of Berlin's social radicalism and consequently enjoyed wide press coverage. In chronological order, some of the most notable of these include:

1) Baader's presentation of himself as a candidate for the Reichstag (Saarbrücken).
2) Street readings of Gottfried Keller's poetry upon the occasion of the poet's birthday.
3) Baader's (and Club Dada's) presentation of himself as candidate for the Nobel prize.
4) The Berlin Cathedral incident in which Baader asked the famous rhetorical question, "What is Christ to the common man?" He, himself, replied, "Christ is a sausage" ("Christus ist uns Wurscht"). Baader was freed, following his arrest, on grounds of his insanity and the nature of the whole text from which the event was framed — the formulations of a long correspondence with a theologian.
5) The announcement of Baader's (Oberdada's) death.
6) The announcement of Baader's (Oberdada's) resurrection.
7) Baader's donation to the German National Assembly of a large picture of Schiller inscribed with the prophecy that the Weimar Republic will be destroyed for despising the spirit.
8) Baader's interruption of proceedings at the constituent assembly (Weimar National Assembly) to lecture on his philosophy. He was arrested, but not before he showered the press boxes with a pamphlet declaring himself "Präsident des Weltballs." Once again he was exonerated on grounds of his insanity and the nature of his preparations for the event (e.g., soliciting "pro forma" interest from the constituents).[17]

While enumerating some of these actions serves to indicate the nature of Baader's role, development of them is here impossible for lack of space. I do wish to stress the importance of Baader's death and resurrection, however, because they provide the best fulcrum to his program taken as a whole. They are pivotal as markers between Baader's old and new worlds and, as such,

symbolize a constant refrain running throughout the work of Baader's entire career.

The nature of Baader's new world can be clarified by a brief discussion of key texts. On 19 July 1918, Baader (with the blessing of the Club Dada) wrote to poet Paul Ernst explaining why the Nobel prize should be conferred upon himself, that is, Baader (fig. 11-2). Challenging Ernst's contention that their generation had experienced outstanding accomplishments, especially in the sciences, he pointed out that having knowledge does not guarantee control of knowledge for the proper objectives. Baader then proceeded to present Ernst with quotes from his *Acht Weltsätze* (published in its complete form in 1919) as the kernel of Baader's new and all-inclusive world view of the future.[18] For Baader (and, indeed, for our current art world) such a positioning stands consistently and comfortably within his (and our) self-defined boundaries of art.

Eleven months later, Baader unveiled his *Buch des Weltgerichts (HADO)* (fig. 11-3), essentially a book of collages and photomontages that presents a sustained visual counterpart to his earlier, textually based programs such as the *Acht Weltsätze*. George Grosz left one of the most copious and entertaining accounts of the book and the effect it presumably had on its reader.

> He assembled a huge scrap-book that he called "Dada-con" and claimed it was greater than the Bible, including the New Testament. Yes, Baader was indeed a bit cracked — a megalomaniac. To him, his book was the greatest, the most powerful of all times. It consisted of newspaper clippings and photo-montages. He believed that in thumbing through the book as he had arranged it, one was bound to develop a dizzy headache, and that only after the mind was in a complete whirl could one comprehend the "Dadacon."[19]

More insightful comments isolate two characteristic aspects of Baader's work as a whole. Villegle rightly points out that Baader composed programs and manifestoes with his works;[20] Hausmann, who writes most sensitively about the book, is the first to identify Baader's work as "collage-literature" or "collage-poetry." "With these [materials] he created a sort of collage-literature or collage-poetry. It is regrettable that his manual was lost. The first HADO appeared 26 June 1919, the second 28 June 1920, as Baader had noted with his customary exactness in the catalog of the Dada Fair."[21]

It is precisely Baader's strength to have run, as he did in this work, with the implications of Dada's language, unburdened of the traditional workshop and stylistic values from which it, qua art, was evolved. It was precisely his outsideness from the art world that heightened his consciousness of Dada experiments as "artistic ways of thinking" — as artistic "means." Art was, for Baader, a basically unaesthetic affair; it was just as much a statement as conventional art, but much more a strategy. Richter has indicated something of the same when he claims that "Baader destroyed these poster collages which were designed purely for direct action; as soon as he had done with them."[22] The events and the works achieve perfect parity.

S o l u s

Glindow in der Mark, 1. August 1918.

Ein Brief an den Dichter Paul Ernst.

Lieber Doktor Paul Ernst! Sie schreiben im „Roten Tag" vom 16. Juli 1918: „Wir haben in den letzten Menschenaltern nicht bloß äußerlich, sondern auch innerlich ungeheuer viel geleistet. Es ist das möglich geworden durch die wissenschaftliche Arbeitsteilung. In allen Wissenschaften sind wir in kurzer Zeit so weit gekommen, daß ein ganz neues Weltbild möglich wäre. Aber es ist bloß möglich, denn niemand faßt die Einzelleistungen zu einem solchen zusammen: Wir haben das Wissen, aber nicht die Beherrschung des Wissens für einen höheren Zweck. Ein solches Beherrschen des Wissens ist nur durch eine Tätigkeit zu gewinnen, die man heute als dilettantisch bezeichnen würde. Zu einer solchen Tätigkeit aber hat niemand die Zeit . . . Vielleicht erforderte das neue Weltbild, welches möglich wäre, einen sehr großen Mut, um ertragen werden zu können, oder eine sehr große seelische Kraft; vielleicht fürchten sich die Menschen unbewußt davor . . ." — — Ich habe es mir geschaffen. Ein Weltbild, in das sich alles restlos einfügt. Es sollte Ihnen nicht mehr ganz unbekannt sein. Aber ich will es noch einmal umreißen:

Die Menschen sind Engel und leben im Himmel. Sie selbst und alle Körper, die sie umgeben, sind Weltallakkumulationen gewaltigster Ordnung. Ihre chemischen und physikalischen Veränderungen sind zauberhafte Vorgänge, geheimnisvoller und größer als jeder Weltuntergang oder jede Weltschöpfung im Bereich der sogenannten Sterne. Jede geistige und seelische Aeußerung oder Wahrnehmung ist eine wunderbarere Sache als das unglaublichste Begebnis, das die Geschichten von Tausendundeine Nacht schildern. Alles Tun und Lassen der Menschen und aller Körper geschieht zur Unterhaltung der himmlischen Kurzweil als ein Spiel höchster Art, das so vielfach verschieden geschaut und erlebt wird als Bewußtseinseinheiten seinem Geschehen gegenüberstehen. Eine Bewußtseinseinheit ist nicht nur der Mensch, sondern auch alle die Ordnungen von Weltgestalt, aus denen er besteht, und inmitten deren er lebt als Engel. Der Tod ist ein Märchen für Kinder und der Glaube an Gott war eine Spielregel für das Menschenbewußtsein während der Zeit, da man nicht wußte, daß die Erde ein Stück des Himmels ist, wie alles andere. Das Weltbewußtsein hat keinen Gott nötig.

Das sind Sätze, für deren Gestaltung mir von rechtswegen ein Nobelpreis zuerteilt werden müßte. Nach den Satzungen der Stiftung ist das möglich. Wenn es trotzdem nicht geschieht, so wird dadurch der Beweis geliefert, daß meine Mitbürger den Schöpfer des Weltbildes der Zukunft nicht für wert halten, in den Kreis der Nobelpreisträger aufgenommen zu werden.

Ihnen und Ihrer Frau recht schöne Grüße

Im Kirschgarten am 19. Juli 1918. Baader.

Figure 11-2. Johannes Baader, ''Ein Brief an den Dichter Paul Ernst,'' typeset letter, 1918, Berlin.
(*Collection: Jean Brown; photo: Estera Milman*)

28. Juni 1.

Heute nachmittag 3 Uhr wurde in Berlin das

Buch des Weltgerichts

veröffentlicht. Dieses Buch ist weder Koran, noch Bibel, noch Tipitakam, sondern

HADO

(Depesche in alle Welt; abgegangen an den amerikanischen Berichterstatter Hecht (Chikago) z. Z. Berlin. Hotel Adlon, Zimmer 355.)

Der Verfasser: d a d a

Empfänger: Dr. S. Friedländer (Mynona).

Figure 11-3. Johannes Baader, *HADO*, announcement, 1919, Berlin. (Collection: Jean Brown; photo: Estera Milman.)

Thus, Baader recognized that one of the chief values of his written work was its concrete incorporation into his visual images. At the same time, Baader persisted in treating his visual creations as though they were language works. The *Club der blauen Milchstrasse* poster (1919-1920), a superbly balanced achievement in the collage medium, is composed both of recycled language and visual works, mostly of Baader's own authorship (fig. 11-4). Besides functioning on a purely formal basis, they also present a prospectus, of sorts, for the "new world," parts of which are detailed in fragments from "Reclame für Mich," a textual piece accompanying the photograph of a visual work (lower left of the work here under discussion) originally published in *Der Dada 2*. Both the recycled text and the recycled pictorial piece served as visionary/biographical accounts of events leading to the war and its upshots. Also included in the *Milchstrasse* poster are the open letter to Paul Ernst (referred to above) in which Baader nominates himself for the Nobel prize, a text that rationalizes his action at the Berlin Cathedral, and much more. A collaborative photomontage picturing both Baader and Hausmann (the latter in profile) is also reproduced for inclusion in this piece (and was also a work that appeared originally in *Der Dada 2*).[23] Below this section appears what, by this time, had already become something of a signature for Baader — a personal notation for reckoning new time from the date of his death and resurrection (April 1919).[24] With the inscription that "Dada had forecast all these things," the work is dated 28 May 1919 but is more likely from much later, the date more an indication of the inception of his new era than the work's date of execution.

An earlier work, *Das ist die Erscheinung des Oberdada* (referred to above as another component of the *Milchstrasse* poster), illustrates a further situation (fig. 11-4). Here, the language (written) parts superficially function in a totally concrete and pictorial way, but are actually highly specific in their reference to events both from contemporary political life and from the life (real or imagined) of Baader himself. Throughout the collage and the text, "Reclame für Mich," which accompanied the work in its original context of *Der Dada 2*, Baader's life and world events are as freely mixed as are his verbal and visual idioms. It is particularly worth noting, especially in the *Milchstrasse* poster, that the format closely follows that of the media, that is, the newspapers.[25] Even a casual comparison of the visual works with *Die freie Strasse*, no. 10 (December 1918), a special number edited by Baader, makes this clear.[26] The media format, a "collage of events," as it were, is interesting not only as a source for Baader's organization, but also as a basis of Baader's conviction that all social realities were, to a degree, determined by their perception through the media (fig. 11-6). This goes far to explain Baader's use of the publications media as the structural basis of much of his own work, his employment of their persuasive social powers, and his persistent and remarkably successful attempts to acquire more or less conventional media coverage of his activities.[27]

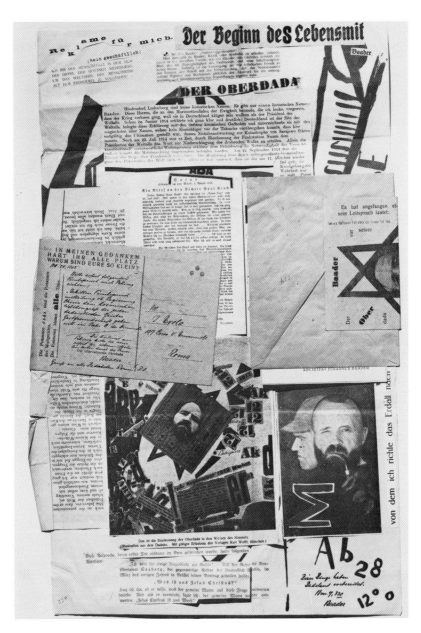

Figure 11-4. Johannes Baader, *Club der blauen Milchstrasse*, 1919
 Collage, 50 x 32.5 cm.
 (*Collection: Arturo Schwarz, Milan*)

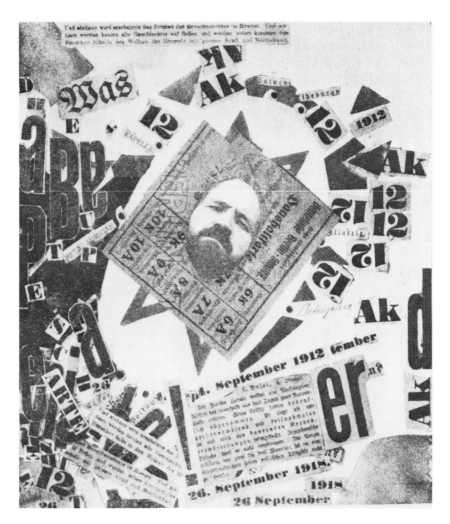

Figure 11-5. Johannes Baader, *Das ist die Erscheinung des Oberdada in den Wolken des Himmels, Der Dada 2,* ed. Raoul Hausmann, 1919, Berlin. (*Private collection, New York: photo: Estera Milman*)

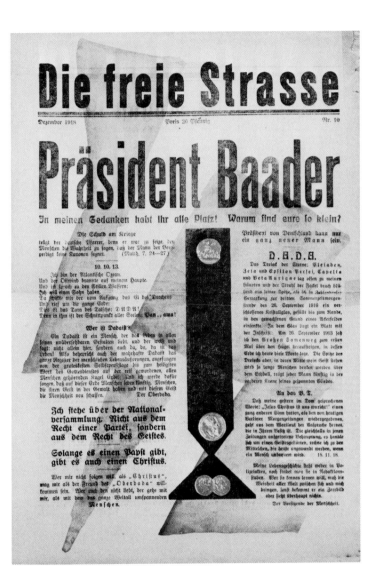

Figure 11-6. Johannes Baader, guest ed., *Die freie Strasse,* no. 10, 1918, Berlin.
(*Collection: Jean Brown; photo: Estera Milman*)

While the syntax of his picture making was to assume the structure of language, the language elements themselves were transposed into a visual arts idiom. The visual/language components of the work were not, however, prevented from carrying content, often highly critical of the society of World War I Germany, within the work. Such manipulation of his pieces permitted Baader to avoid convention and normality on the levels of both organization and content, a highly difficult task for artists working in either one or the other as single enterprises. His collages and photomontages offer an unparalleled case within which to study the fusion of language and the visual arts and their application, as such an entity, to the task of social criticism. Baader solved the vexing problem of how to convey revolutionary content without the use of conventional language and how to utilize revolutionary syntax without enjoining conventional content. Reversals in the functions of visual and verbal idioms, until then approached from only one of the two sides, were, in Baader's pieces, forged into a consummate marriage.

Such is the nature of Baader's problems and the artistic strategies through which he executed them. What yet requires discussion is his overarching role as "Architekt Baader." Any such discussion must begin with what appears to be his equation of the roles of architect, artist, and God. The collage entitled *The Author in His Home* (1920) is, at once, an expression of all of these (fig. 11-7). Baader, the artist, is pictured in his studio after the manner of Hausmann's *Tatlin at Home.* But instead of being the prophet of scientific art (the Dadaists exhibited a placard at the 1920 International Dada Fair bearing the inscription: "Down with art, long live the machine art of Tatlin,")[28] Baader is the prophet of his own program, the program that is reflected with such clarity in each of the two works discussed above.

Referring to a series of pacifist letters composed by Baader in 1914, the title, by reference to his role as the new Christ and advocate of monism, makes it clear that this creation of a new era succeeds the biblical creation. Collage becomes a sweeping metaphor for the act of such creation, and the artist (architect) a metaphor for God. The very content of the work is "creation" itself, the process of collaging the materials, pictured in the background, from which the artistic work is to be composed. Among other things, these materials include Hausmann's optophonetic poetry, picture sections from the newspapers, and his own special number of *Die freie Strasse,* referred to above. The dummy, representing Baader himself, recurs in his monumental assemblage exhibited at the 1920 International Dada Fair, a work Baader himself referred to as a "monumental work of Dada architecture."

Architect by training and early trade,[29] Johannes Baader was no longer active in the profession at the time of his involvement with Dada. Nevertheless, he persisted in referring to himself in that capacity and frequently included allusions to his earlier architectural work in his later pieces. Actual traces, textual and photographic, of his early architectural career are often incorpo-

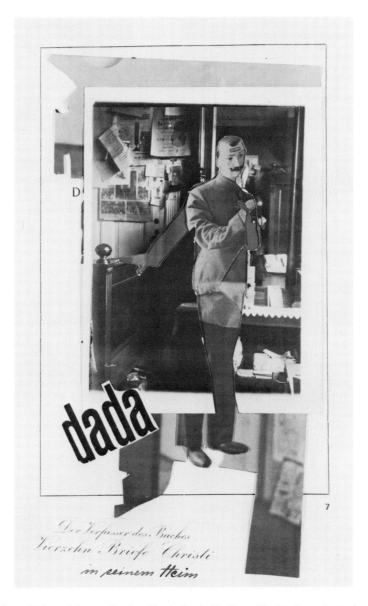

Figure 11-7. Johannes Baader, *The Author in His Home* (Der Verfasser des Buches
 vierzehn Briefe Christi in seinem Heim), 1920
 Collage, 21.3 x 14.4 cm.
 (*Museum of Modern Art, New York, purchase*)

rated into his later collages and assemblages, for example, the monumental *Grosse Dio-Dada-Drama: Deutschlands Groesse und Untergang* (1920). It is not entirely surprising that even his later proclamations and correspondences addressing questions of politics, theology, and philosophy should be signed as "Architekt Baader." Unlike many artists to whom we apply the word "architect" in an essentially analogical way, Baader is an individual to whom we apply the word "architect" in the most persistent and literal way. Baader, no matter what the topic or medium of his thought, clearly exemplifies the notion of an "architect of new worlds." Like Kurt Schwitters, El Lissitsky, or Theo van Doesburg, Baader, in taking an art position, was total and utopian in his outlook. Unlike them, Baader exercised almost no restraints, aesthetic or otherwise, and consequently achieved a position of such extremes as to find almost no counterpart in the history of modern art.

What exactly "architect" meant to Baader clearly included a notion of "role" in the world, as well as monuments or works produced. The scope of his task was boundless and, rather immodestly, indicated nothing short of structuring a new era of humanity. For Baader, the perfect artist was Christ, an individual Baader first assumed spokesmanship for and, by 1914, had in his own mind, historically succeeded. The role of architect, then, was an office to fill on the most mundane or grandest and most divine level. "Architect," for Baader, was synonymous with Christ, dilettante, and synthesizer, all major dimensions by which Baader at various times characterized his own role and his own purpose.

Such a concept of "architect" is certainly not unprecedented, and of turn-of-the-century German architects, Fidus, among others, leaps to mind as the kind of cosmic frame of reference that set the stage. Indeed, his works probably provided at least some of Baader's direct prototypes, if not the particular stylistic basis, of Baader's projected, but never realized, *Welttemple* of 1905-1906 (fig. 11-8). Although not especially characteristic of Baader's "built" works, and there are many, *The Welttemple* is, in every respect, a work of latent characteristics in both its style and the role of architect it projects. It is one of a rather long series of such monuments in the early history of Expressionist architecture. The monument itself, in the form of a pyramid, is described by Bergius as the aesthetic culmination of the social-utopian Lebensreformbewegnung. Offered by and financed through a project entitled the "International and Inter-religious League of Humanity," of which Baader was the director, this building program was to span 1,000 years, at a cost of over 500 million marks, and measure 1,000 meters square at the base by 1,500 meters high.[30]

It was from such a background that Baader came to represent a unique case of the convergence between architecture, Dada, and social utopianism. Baader, who was subsequently to become the very embodiment of Berlin Dada between the years 1918-1920, maintained, throughout his activities as a social critic, his identity as "Architekt Baader." Although silent as a builder from

Architekt Baader

Figure 11-8. Johannes Baader, *Welttempel*, 1906
Drawing reproduced on postcard.
(Collection: Jean Brown; photo: Estera Milman)

1906, Baader well recognized the pivotal role of architecture as an axis in the reformulation of urban culture and accepted it as the conceptual prerequisite for virtually any dimension of cultural activities (theology, philosophy, science, etc.). Likening himself to Christ, the architect of the universe, Baader thus developed from his highly visionary *Welttemple* to the *Grosse Dio-Dada-Drama (The Rise and Fall of Germany in Five Stories),* exhibited in the International Dada Fair of 1920 (fig. 11-9).

It was a small jump for Baader from works like the *Milchstrasse* poster to works like the *Grosse Dio-Dada-Drama.* Hausmann has argued that Baader's work, an assemblage of, until then, unparalleled proportions, dates "before Schwitters" (although the latter had shown work, including *Die Kultpumpe* and *Der Lustgalgen,* in Berlin in late 1919 at Herwarth Walden's Der Sturm Gallery). One could argue that the idea for Baader's work was already present in Schwitters, although the dimensions of the latter's work, to say nothing of its ambition, were obviously more modest. It was not until 1923 that Schwitters made something, as a discrete object, that rivals Baader's work.[31]

The *Grosse Dio-Dada-Drama* seems to conform to what, by that time, had been a general tendency to environmentalize Berlin Dada work. Hausmann, in a letter to Bernard Karpel dated 7 September 1964, provides a general picture of the situation:

> I shall give here some of my observations about the origins of assemblage-art, and the Great Dada-Show of 1920 in Berlin.... The ready-mades of Duchamp and Man Ray have never been assemblages. It is of the highest importance, that the real first assemblages, that means: combines of heteroclite materials, have been executed for the first time by the Berlin Dadaists and exhibited at the Great "Dada-Messe" from 1920. As the photographs of this exhibition, several times reproduced in books and reviews, prove, I exhibited there the first great picture-assemblage, the first photomontages and too a relief composed with different planks of wood, in parts painted in black, on which I had nailed parts of an umbrella-stand, a blue plate of earthenware and a dozen of shaving-blades.
>
> Hannah Höch showed photomontages, the team Grosz-Heartfield "collages" and a "dummy"-assemblage decorated with electric bulbs, an electric bell, a knife-blade and a set of artifical teeth.
>
> Schlichter exhibited the dummy of a German soldier with the mask of a pork instead of the head. Baader was represented with a great pyramidal construction made with cartoon, paper, bottles, wood, metal, etc., that he called: The Great Plasto-Dio-Dada-Drama A great part of these works was already made in the years 1918 and 1919.[32]

The comparison of the *Grosse Dio-Dada-Drama* and the exhibition space itself suggests how the context of the earlier posters is literalized into three dimensions. The programming is simply taken out of a presentational picture format and resituated within the realm of the spectators' transactional, as opposed to pictorial, space. Just as the movement is given an environmental context in the exhibition, so Baader's two-dimensional programs are given an environmental context (already present in the events that the pictorial work served) in his assemblage.

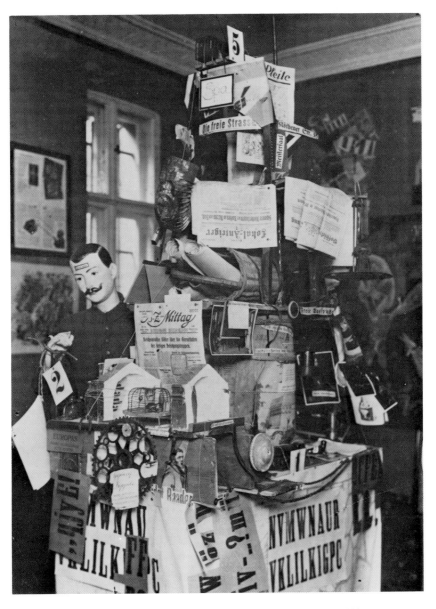

Figure 11-9. Johannes Baader, *Grosse Dio-Dada-Drama,* 1920
Assemblage. Nonextant.
(*Photo: Nakov Archives, Paris*)

Since culture and architecture were, according to Baader, typically experienced and perverted through the media, it was only through the reorganization of the media and the media's apparatus that they could be significantly reperceived. The collage nature of the 1920 assemblage, reflecting, among other things, the format of the newspaper, is nothing short of an architectural "gestalt" of cultural mechanics. It reflects Baader's initial position as an architect (the form is basically that of the 1906 *Welttemple*), his perception of the organizing factors of culture as press-oriented, and his architectural projection, through a confabulation of media events, of a new world order.

Throughout his career, Baader's concern for architecture moved decidedly from architecture as "building" to architecture as a conceptual basis for formulating cultural positions in general. Baader's projects, from early to late, were most importantly visualizations of an architectural frame of mind, required and cultivated in the context of a "monistic" synthesis worked out in reaction to the impoverishment of totalistic social schemes being offered in Germany at the time. Baader thus offers a highly instructive encapsulation of the architect's radical response to the crisis of early twentieth-century Germany and (the eclectic formal aspects of his work aside) achieves a compelling and extreme point of view that, from our perspective, looks distinctly post-modern.

Politics, in some wide sense of the word, obviously had much to do with Baader's art. Hanne Bergius writes of Baader's tendency to aestheticize politics.[33] Her remarks are perceptive and pertinent to Baader's work but can be developed further (and from a somewhat different point of view) in the purely art context that Hausmann suggests. Bergius' remarks are best applied, since she is thinking from his programs to his art, to Baader's published statements, the articles of his faith, if you will, from before his affiliation with the Dadaists. The aestheticizing of politics, however, when accomplished by *artists* like Hausmann and subsequently Baader, becomes more than just an altered perception of its conventional disguises; politics, *as a kind of activity and a way of thinking,* becomes the subject of art and its creative basis. It is not only political content, programs, or ideologies, but also how politics works and operates as a social mechanism, its procedural and structural features, which are crystallized in the work of art. Baader's work becomes both a reification and parody of the social mechanisms he means to address. But there is no loss of content in the process.

Finally, it is worth taking special note that there is little reason to think that Baader, upon entering the Dada circle, had been the least familiar with recent developments in the visual arts, in Berlin or anywhere else. This is an interesting situation for a number of reasons: (1) that he did not require an uneducation from the aesthetics of a Hausmann, Höch, or Grosz, all of whom came to their trade with routine art training, (2) that he probably accepted the potential of some of Dada's experiments at more or less face value (I am thinking of collage and photomontage especially) and, less than the others, as

antitraditional gestures, (3) that he consequently had fewer a priori artistic values to dispel that, as such, would inhibit his use of the medium, and (4) that his understanding of these techniques was more strategical or transactional than formal. This is important in precisely defining how art provided Baader with a means (unaesthetic, although not in the least unartistic) for presenting his thought. His particular situation permitted the content, much to the frustration of some of his colleagues, to remain consistent with his pre-Dada activity, at the same time that it gave what up to then had been mere Dada gestures and publications an active and revolutionary strategy of their own.

Baader's historiographical resurrection has been more difficult than his 1919 resurrection. Material has come to light slowly and its interpretation, due partly to the complexity of the man and the works, is rather difficult. It is now becoming clear, however, that Baader was a major factor in Berlin Dada and in the Dada movement in general. He is, by force of that, a major early twentieth-century artist. The technical and conceptual reach of his art rivals that of any artist of his period. Baader's art, along with that of Duchamp and a few others, puts us disconcertingly close to the present.

As late as the sixties, Richter was still able to maintain the following. "The first-magnitude star, the Oberdada, was extinguished as suddenly as he had appeared."[34] From our perspective now, it seems that Baader may have been more correct when he claimed that "not one of the Dadaists knows what Dada is, only the Oberdada, and he tells no one."[35]

Notes for Chapter 11

1. Raoul Hausmann, *Am Anfang War Dada,* ed. Karl Riha (Giessen: Anabas Verlag, 1980), p. 55.

2. Raoul Hausmann, "Dada Riots, Moves and Dies in Berlin," in *The Twenties in Berlin* (ex. cat., London: Anneley Juda Fine Art, 1978), p. 26.

3. The relevant passages from Jung's *Der Weg nach unten* (1961) are translated in Paul Raabe, *The Era of German Expressionism* (Woodstock: Overlook, 1974), pp. 354-55.

4. Walter Mehring, *Berlin Dada* (Zurich: Arche, 1958), pp. 53-59.

5. Hannah Höch, "Interview with Hannah Höch by Edouard Roditi," in Lucy Lippard, ed., *Dadas on Art* (Englewood Cliffs, N.J.: Prentice-Hall, 1971), p. 74.

6. George Grosz, *A Little Yes and a Big No* (New York: Dial, 1946), pp. 183-84.

7. Hans Richter, *Dada: Art and Anti-Art* (New York: Oxford Univ., 1978), pp. 123-28.

8. Georges Hugnet, "The Dada Spirit in Painting," in Robert Motherwell, ed., *The Dada Painters and Poets: An Anthology* (New York: Wittenborn, 1951, repr. 1963, 1981), p. 149.

9. Baader's moves are very calculated and cannot be interpreted at face value. Dr. Hans J. Kleinschmidt, longtime friend of Richard Huelsenbeck, has suggested in conversation that Baader might have suffered from an acute, but not uncommon, schizophrenia not at all incompatible with self-awareness or even strategical brilliance.

10. Richard Huelsenbeck, *Memoirs of a Dada Drummer,* ed. Hans Kleinschmidt (New York: Viking, 1974), p. 67.

11. Motherwell, p. 149.

12. "Der Oberdada klagt," *Neue Zeitung,* Munich, 8 May 1952.

13. Michel Giroud, "Dadasophe," in *The Twenties in Berlin,* p. 22.

14. Raoul Hausmann, *Courrier Dada* (Le Terrain Vague, 1958), p. 38: "Qui le veut soutienne les conventions imposées. Auparavant la vie nous apparaît comme un vacarme immense, complet; comme une tension dans les écroulements d'expressions jamais dirigées unilateralment, un (quand même aussi) gonflement important des inconsiderations profondes vers la forme, sans saut éthique, sur base étroite: l'art dada est le plan à apparence de conflits, d'une insolence de créateur qui proteste..."

15. "Dadaisten gegen Weimar," Berlin, 1919. An English translation is included in Richter, p. 126.

16. The work is illustrated as document 55 in Hanne Bergius, Norbert Miller, and Karl Riha, eds., *Johannes Baader, Oberdada* (Giessen: Anabas Verlag, 1977), p. 72.

17. I have relied, for convenience, on Richard Sheppard's "Dada: A Chronology," in *Dada Artifacts,* ed. Stephen C. Foster (Iowa City: Univ. of Iowa Museum of Art, 1978), pp. 27-39.

18. Johannes Baader, "Ein Brief an den Dichter Paul Ernst," 1918. *Die Acht Weltsätze* (*The Eight World Theses*) has been translated into a typographical facsimile by The Center Press (Fine Arts Dada Archive), Univ. of Iowa.

19. Grosz, pp. 183-84.

20. Villegle, "Aspetti del dada tedesco: Baader," *alpha-beta* 2 (1975): 61: "Ha inoltre preparato un *Manuale del Super-Dada,* (Hado). Sopra un fondo constituito da un centinaio di quotidiani ha incollato gionalmente nuovi documenti, macche colorate, lettere, cifre, rappresentazioni figurative dei suoi numerosi manifesti. Con questo materiale ha creato una spece di collages-letteratura o collages-poesia."

21. Hausmann, *Courrier Dada,* p. 79: "En 1919 Baader commença à faire des photomontages. Ses montages dépassaient toute mésure par leur quantité formidable et leurs formats. Dans ce domaine il était comparable à Schwitters. Partout, où il le pouvait, il arrachait des pancartes entères des murs et des colonnes d'affiches et les rapportait chez lui, où il les classait soigneusement. Entre autre il a fait un *Manuel du Super-Dada* (HADO): sur un fond fait de centaines de quotidiens, il collait journellement des documents nouveaux, des taches colorées, des chiffres et même des représentations figuratives de sa moisson d'affiches. Avec cela il créa une sorte de collage-littérature ou collage-poésie. Il serait regrettable, quo son Manual soit perdu. Le premier HADO fut terminé le 26 juin 1919, le second le 28 juin 1920, comme Baader, avec son exactitude coutumière l'avait noté dans le catalogue de la Foire-Dada."

22. Richter, p. 127.

23. Baader worked closely with Hausmann on editing the first two issues of *Der Dada.* For a discussion of the magazine, see Stephen C. Foster, "*Der Dada,*" in *International Art Periodicals* (Westport, Conn.: Greenwood, 1985).

24. The key to this code is provided by Baader on the above-mentioned card to Tzara (see note 16 above).

25. Baader's work in this realm had been anticipated by two large-format issues of *Neue Jugend,* nos. 1-2, May, June 1917, edited by Wieland Herzfelde. The later plans for *Dadaco,* projected as a 1920 publication but never printed, would have followed much the same format.

26. Significantly enough, Hausmann's special issue of *Die freie Strasse,* no. 9, is composed within a very different format, a fact that lends weight to the Baader comparison above.

27. Numerous newspaper clippings are housed in the Fine Arts Archive, Dada Archive and Research Center, Univ. of Iowa, Iowa City.

28. El Lissitzky's very similar work, *Tatlin at Work on the Monument for the Third International,* 1920, presents a perfectly equivalent Russian image of the artist as "social engineer." George Grosz brilliantly parodied such pretensions in his *The Engineer Heartfield,* 1920.

29. Baader had abandoned building by 1906. He enjoyed a considerable reputation as a "visionary" architect and earned an entry in the Thieme-Becker Künstler-Lexikon (1908), vol. 2.

30. Hanne Bergius, "Zur phantastischen Politik der Anti-Politik: Johannes Baader oder Die unbefleckte Empfängis der Welt," in *Johannes Baader: Oberdada,* p. 184.

31. Schwitters' *Merzsäule im Merzbau,* 1923, is reproduced in *Tendenzen der Zwanziger Jahre* (Berlin: Dietrich Reimer Verlag, 1977).

32. Raoul Hausmann, excerpt from a letter to Bernard Karpel dated 7 September 1964.

33. Hanne Bergius, "Baader," *alpha-beta* 5-6 (1976): 25-40.

34. Richter, p. 134.

35. Johannes Baader, "Der Oberdada," *Johannes Baader: Oberdada,* p. 75.

[Brief passages of this essay are revised from my essay, "Johannes Baader: Kunst und Kulturkritik," *Sinn aus Unsinn: Dada International,* ed. W. Paulsen (Bern/Munich: Franke Verlag, 1982).]

Notes on Research in Dada and Expressionism

Peter W. Guenther

It is well known that historical studies frequently show a kind of nostalgia for the period under study. The sense of purpose, the verve, the conviction, the daring observed in earlier periods can lead to the recognition of a lack of these qualities in the student's own period. It does not therefore come as a surprise that many, if not most, of the studies of artistic developments in the first quarter of our century deal primarily with the exciting and engaging beginnings of each of the many trends, styles, modes, and isms. This is particularly true when such beginnings take place as group (or semigroup) activities, a phenomenon shared by Expressionism and Dada. The often utopian enthusiasm, the idealism, and the daring that were always recognized in both of these developments have made it possible to apply their spiritual/intellectual/revolutionary roots to many later formations and directions and to make out of this approach a kind of fetishism. Terms like "breakthrough," "innovative," and "totally new" have become value statements. A contemporary exhibit that would elicit from the critics statements like "under the influence of...," "remindful of...," and "in succession to..." could sound the death knell for a gallery as well as for the artist(s). This tendency to look primarily at the beginnings of any new trend, or yet unfamiliar appearance, has also brought about a constantly proliferating vocabulary, so that modern criticism sometimes becomes an esoteric exercise in linguistics. Probably the worst condemnation under these circumstances would be the statement that an artist in a later exhibit "showed only minor variations of his earlier works."

It seems to be partially due to this tendency that studies of the two movements under discussion concentrate mainly on the earlier periods, while the middle periods (greatest spread) and, even more so, the end of the movements (demise, death) are either conveniently not included or relegated to a very short

summary. This chapter intends to suggest a slightly different accentuation of the chronologies and thereby attempts to further our understanding of Dada as well as of Expressionism. A few specific years are chosen as examples, since they were critical for Dada and for Expressionism. They may yield a greater comprehension of these two developments if used as supplements to the studies already available.

The first of these dates is the year 1916. It was the birth year of Dada and one of the critical years for Expressionism. Even a cursory look through the literary and artistic journals of the period shows clearly that something had changed in comparison with the year 1914. The nearly ecstatic chauvinism that engulfed all of Europe at the outbreak of World War I had subsided. The horrors of the war had become apparent. An example of this kind of change can be found in the works of the greatest Expressionist sculptor, Ernst Barlach. Paul Cassirer, whose importance for Expressionism can hardly be overstated, began to publish, in August of 1914, a new magazine called *Kriegszeit* (*Wartimes*).[1] Printed on rather cheap paper and sold for just 15 Pfennige (later 20), it was to bring modern artists' interpretations of the war to the public. The magazine's profit was designated to assist needy artists and their families. The first issue reproduced a lithograph by Max Liebermann that showed the crowds before the imperial palace in Berlin and used, as a caption, Kaiser Wilhelm II's statement: "I no longer know parties, I only know Germans." The journal was edited by Alfred Gold, carried the subtitle *Künstlerflugblätter* (*Artists' Broadsides*), and reproduced works by Gaul, Grossman, Trübner, Baluschek, Meid, and others. In the issues of December 16 and of December 20, two lithographs were reproduced, both by Ernst Barlach: *Der Heilige Krieg*[2] (*The Holy War*) and *Erst Sieg — Dann Frieden* (*First Victory — Then Peace*).[3] They were — like nine later ones — rather typical in sentiment of other works published in the journal. In 1916, Cassirer made two important changes: he replaced the editor with Leo Kestenberg, well-known music critic, pianist, and pacifist; and he gave the publication the more neutral title *Der Bildermann* (*The Picture Man*), *Steinzeichnungen für das deutsche Volk* (*Lithographs for the German People*). In the October and December issues of this new publication, two very different lithographs by Barlach appeared, both deeply moving and clearly indicative of the changed atmosphere and the artist's changed concepts that two years of war had brought about. The first of these prints was entitled *Anno Domini 1916 post Christum natum*[4] and showed the devil presenting to Christ a landscape filled to the horizon with grave crosses of dead soldiers. The other lithograph was simply called *Dona Nobis Pacem* (*Give Us Peace*).[5] One could hardly find a clearer demonstration that the year 1916 was indeed a turning point for Barlach and for many other artists.

The same changes can be demonstrated in the political atmosphere of this year. Younger artists began to form small groups to discuss the tasks awaiting the arts after the end of the war. As far as the "founder-generation" of Expres-

sionism was concerned, it had abandoned the once common roots. The Brücke had dissolved in 1913, and its ties of friendship, as well as its common style, had come to an end; E.L. Kirchner stayed in a sanatorium in Königstein, Erich Heckel was in the famous Red Cross unit of Dr. Kaesbach, Karl Schmidt-Rottluff was on the eastern front. A similar fate befell the Blaue Reiter group: August Macke and Franz Marc had died in the war; Kandinsky was in Russia; Jawlensky and the Werefkina were in Switzerland; Paul Klee was in the army; and Kubin, after a renewed nervous crisis, in Zwickelstedt. The founder generation had lost its coherence and what remained were independent, individual Expressionist artists. A study of the impact of the year 1916 on Expressionism — or more correctly on the individual Expressionist artists — is still a *lacuna* in the history of the movement.

Nineteen hundred sixteen was the birth year of Dada and should therefore fall into the category of the studies mentioned above: the birth of a new development. But the year 1916 was a much more complex period for Dada than can be summarized simply as "the birth of Dada."[6] The first performances at the Cabaret Voltaire were much more closely related to the romantic concept of *Gesamtkunstwerk* (complete work of art) than to what Dada later became. The diaries of Hugo Ball make it quite clear that the need to survive the emigration was one of the main springs for the Cabaret venture; that he left it and the group of artists who had already formed around him in May of 1917 indicates clearly that conditions, atmosphere, and concepts had changed. These changes were of even greater importance than the personal conflicts and tensions among the artists could explain. Although this first year of Dada has been well researched, there are still *lacunae* that need to be filled before all the aspects of the development can be understood. For instance, a precise and descriptive list of all works of art exhibited at the Cabaret and in the later Dada gallery is still missing. Equally important is a clarification of how the various works were obtained, how the artists were approached, their motivations for participation (and the names of those who refused to exhibit), and finally, a list of works that were sold and the names of the buyers. Another aspect is the relative influence of each of the artists in Zürich on the change from the entertainment aspect to the double feature of the resounding "NO" to the war and to the society that had permitted its outbreak and continuation, as well as the *épater-le-bourgeois* trend. In short, the transference from the Cabaret concept to the Dada performance still requires more minute documentation.[7]

It has now been recognized that there was no such thing as *the* Dada. The transformation of the Zürich group has been mentioned. Berlin Dada can be traced back to the appearance of Richard Huelsenbeck in Berlin (and his first contacts with the later Oberdada, Johannes Baader, and with George Grosz, Raoul Hausmann, Franz Jung, John Heartfield, and Walter Mehring), which led to the formation of the Club Dada. It is evident in most studies that Berlin Dada was, from its beginnings, much more political than the original

Zürich group, but that it, too, underwent changes. Even for Cologne
Dada, a few unanswered questions remain. The friendship of Max Ernst with
Johannes Theodor Baargeld (Alfred Grünwald), the publication of *Der Vent-
ilator,* and the visit of Hans Arp have been documented. But the difference
between Cologne Dada and the group that established itself at the same time and
chose the name Stupid (Heinrich and Angelika Hoerle, Franz Wilhelm Seiwert,
Anton and Marta Räderscheidt, and others) still lacks clarification.[8] Kurt
Schwitters, whose ambivalence to Dada is well known, has gained greater
attention lately; yet, the periodic visits and artistic cooperation with Arp,
Hausmann, and others, while mentioned in the various studies, have not
gained the attention they deserve. Schwitters is rightly considered a "one-man
movement," but these cooperations could explain, on a more precise and less
mystical level, what the visitors contributed and to what extent they influenced
Schwitters (or vice versa?). Intentionally, neither the questions connected with
New York Dada nor those connected with Paris Dada and proto-Dada groups
and trends are included in this list of suggestions. Not only would they require a
much larger framework than can be offered here, but they would also demand
an explanation of why so many semi-Dada activities today lack all the Dada
background and concepts.

At the end of the war, Expressionism underwent a third state of develop-
ment. While Die Brücke and Der Blaue Reiter were clearly prewar phenomena,
1916 brought about a transformation, which manifested itself also in a change
of subject matter and in a greater stridency, especially in the proliferating
graphic works. The second generation of Expressionist artists became the
dominant artistic force immediately after the war — even if judged by number
only. At first, it looked as if the prewar artistic centers would retain their
position of dominance. The Arbeitsrat für Kunst[9] in Berlin was somehow more
influential than the short-lived Aktionsausschuss revolutionärer Künstler
Münchens[10] (and similar groups in other cities). The most important organiza-
tion, however, was the Novembergruppe[11] in Berlin, to which all Expressionists
belonged at one time or another. The history of this organization is now well
known. What remains to be done, however, is to chronicle, research, and
evaluate the stunning spread of Expressionism all over Germany. After 1918,
neither Berlin nor Munich regained its monopoly as an avant-garde art city,
since a phenomenon occurred that must be called the Expressionist movement.
Just to indicate the dimensions this new movement attained, a few of the new
Expressionist groups of artists that suddenly sprang to life across the country
shall be mentioned: Der Wurf, Bielefeld; Gruppe Progressiver Künstler,
Cologne; Dresden Sezession: Gruppe 1919; Das Junge Rheinland, Düsseldorf;
Künstlergruppe Jung Erfurth; Hallische Künstlergruppe; Expressionistische
Arbeitsgemeinschaft Kiel; Die Kugel, Magdeburg; Die Schanze, Münster;
Uecht-Gruppe, Stuttgart; Die Wupper, Wuppertal; Rih, Karlsruhe (named
after the white horse owned by Kara Ben Nemsi of Karl May fame!). Parallel to

this expansion into the smaller cities was a proliferation of new journals and art magazines, the bulk of which also was located in smaller cities. Again, a few examples may suffice: Düsseldorf: *Feuer;* Dresden: *Menschen;* Darmstadt: *Das Tribunal;* Hamburg: *Die Rote Erde* and *Kündung;* Hannover: *Das Hohe Ufer;* Kiel: *Die Schöne Rarität* and *Der Schwarze Turm;* Mönchen-Gladbach: *Das Neue Rheinland;* Regensberg: *Die Sichel.*[12] This phenomenal spread of Expressionistic activities into the smaller cities of Germany separates Expressionism clearly from Dada, whose main activities remained concentrated in Berlin. The history of many of the various Expressionistic groups has yet to be researched. The greatest challenge remains to answer the questions: Why did this "new" Expressionism (and for that matter why did Dada) come to an end in the middle of the 1920s? What brought about their demise after the movements had just reached their greatest expansion?

Among the frequently offered explanations, economic reasons seem to dominate.[13] Shortly after the Weimar Republic was established, the deterioration of the economy continued. Widespread hunger, political instability, the lack of raw material (partially due to the Versailles treaties), and other factors contributed to a growing inflation, the dimensions of which are not always recognized.[14] To use just one example: an ordinary inland letter required a postage stamp worth 15 Pfennige in January 1918; by January 1922, it already cost 1.00 Mark in postage and, by December 15, 25.00 Marks; 1923 began with the price of 50.00 Marks and, by August 1, the postage required was 1,000.00 Marks; between October and November 20, the postage increased from 2 million Marks to 80 billion Marks before the new currency established the postage as 10 Pfennige. This dizzying avalanche destroyed most peoples' savings and, understandably, devastated the art trade — at least for a while. The economic argument for the demise of Expressionism would, however, be more valid were it not known that, at the same time, enormous wealth was gained by a considerable number of entrepreneurs and speculators who did (and some of them for the first time) buy works of art (although it is questionable that these were mostly Expressionist works). It also must be kept in mind that, from 1919 on, there was a surge in the publication of graphic works, which appeared usually in two editions, one on handmade paper and the other in a handmade portfolio as a deluxe edition, which sold well in spite of the much higher price.[15] Also, the very large number of contemporary exhibitions held by the various galleries, whose number had increased parallel to the proliferation of artist groups, provided sales which outpaced prewar times. The economic reasons for the end of Expressionism and/or Dada must therefore be much better substantiated before its actual importance can be evaluated (sales records of the provincial galleries are lacking; individual income accounts of famous, as well as the lesser known, artists in various parts of Germany need to be compiled; sales records of the publishers of the deluxe graphic portfolios have not yet been published.

Another of the frequently given reasons for the end of Expressionism is based on the famous exhibit in the summer of 1925 entitled Neue Sachlichkeit, Deutsche Malerei seit dem Expressionismus[16] (New Objectivity, German Painting since Expressionism), which Dr. G.F. Hartlaub organized for the Mannheim Kunsthalle. (It had been preceded by an inquiry in 1922 by Paul Westheim in his publicaton, *Kunstblatt,* asking artists, writers, and critics if a *Neuer Realismus* (New Realism) had been noticeable in German painting. The result was a variety of predictions.)[17] This exhibit traveled successfully to Dresden, Chemnitz, Dessau, etc. In the same year appeared the influential book by Frank Roh, *Nach-Expressionismus. Magischer Realismus. Probleme der neuesten europäischen Malerei (Post-Expressionism. Magic Realism. Problems of the Newest European Painting.)*[18] (Exhibition and book were closely related since Roh provided Hartlaub with his list of names for the preparation of the exhibit.) But one exhibit and one book cannot change the stylistic direction of the visual arts. The two could only serve as examples that, parallel to the spread of Expressionism, other styles had also shown enough strength to merit their recognition. These are therefore only signs indicating that the coherence of the Expressionist movement had begun to dissipate — as Dada had done even earlier. In January 1922, it was announced that George Grosz, Otto Dix, Raoul Hausmann, Thomas Ring, and Rudolf Schlichter had left the Novembergruppe and had founded a Gemeinschaft der Werktätigen (Community of Workers), convinced that the propaganda value of the arts required other forms and could not be achieved by Expressionism.[19]

By 1924, the dissipation of Expressionism had become obvious. Three examples, among many, may suffice. The Blue Four was founded, an exhibition and sales association for Feininger, Jawlensky, Kandinsky, and Klee, with Galka Scheyer as primary propagandist in the USA.[20] The founder generation required new propaganda means. In the same year, the Rote Gruppe, Vereinigung kommunistischer Künstler (Red Group, Association of Communist Artists) established itself with George Grosz, John Heartfield, Rudolf Schlichter, and others.[21] And even in the center of the Expressionist activities around the journal *Der Sturm* (*The Storm,* editor Herwarth Walden), this dissolution was observed with alarm. William Wauer tried to hold the artists together by forming the Internationale Vereinigung der Expressionisten, Futuristen, Kubisten und Konstruktivisten e.V. (International Union of Expressionists, Futurists, Cubists and Constructivists), which later was called Die Abstrakten (The Abstract).[22] Many more examples could be cited that would show a slackening of coherence in the Expresssionist movement. However, it is established that the New Objectivity was not the next step after Expressionism, since most of the Expressionist artists did not adopt this new style.

Therefore, if neither the economic argument (at least by itself), nor the Mannheim exhibit (and the Roh book), nor the turn toward the Communist

Party by some artists can be taken as reasons for the end of Expressionism, where could these reasons be found? A short analysis like this can only attempt to indicate the directions in which answers to this question may be found. Among them would be a very careful (re-)reading of the materials left by the artists, especially their diaries and letters. The Archiv der Akademie der Künste (Berlin), the Archiv für Bildende Kunst am Germanischen Nationalmuseum (Nürnberg), and the Deutsches Literaturarchiv im Schiller-Nationalmuseum (Marbach) are currently the richest deposits of this material, while other institutions (especially city and state archives, private archives, etc.) are trying to prevent the further loss of important contemporary materials.[23] However, as long as these collections have not become widely published, the frequently short-sighted generalizations are likely to prevail. While waiting for these detailed source publications, a few provisional summaries can be attempted. The coherence of the Expressionist movement (and that means also the coherence of the many different groups) lost its strength once individual conflicts between members of the groups developed, once life circumstances of individual artists changed, or once convictions were lost and/or replaced by others. That the tensions in these groups could be very strong can be illustrated by any number of examples. The strain between E.L. Kirchner and Max Pechstein, for instance, is as well known as the angry reasons for C. Felix-müller's and P.A. Boeckstiegel's resignation from the Dresden Sezession: Gruppe 1919. While, in the first instance, artistic jealousy played the larger part, in the second, political convictions clashed. In general, similar difficulties can be found among the Dadaists. But regardless of the willingness, and even eagerness, of the main Dadaists to place their memories at our disposal, these accounts have to be read with the greatest of care, since many of them are subjective clarifications of the importance of their individual roles within the development.

One other aspect that must be kept in mind was the shift that occurred from the primarily aesthetic goals of Expressionism (founder-generation) to the much more political and social goals of the later Expressionists. The similarity to the Dada patterns is obvious. Most of the groups started out with a program, frequently in the form of a manifesto summarizing their goals. The arts were to change man and society in order to build a new and better world. As the Weimar Republic became more unable to fulfill these utopian dreams, some artists began to denounce the original manifestoes, only to be declared traitors to the cause by others. To prove this contention will require patient evaluation of especially the private papers of those who, while playing, at the time, impor-tant roles in their respective communities, are today frequently forgotten. Parallel developments to that of the Novembergruppe (from an "association of radical artists" to a tolerant exhibition association) may very well be found in many cases.

There is still another aspect that may be helpful in explaining the

disappearance of the enthusiasm and revolutionary spirit in Dada and in the Expressionist movement, namely, the subject matter of the Expressionists and the Dadaists. A study of the iconography of Expressionism (and if this were possible, of Dada) is still lacking. The dominance of Christian iconographical themes, ranging in forms from apocalyptic visions to resurrection images, is easily recognized. The soldiers — alive as well as dead — the poor, the martyrs of the various political upheavals were represented in images that clearly recall their Christian origin. Misery, hunger, poverty, war cripples, mourning widows, and orphans were dominant subject matters for many of the Expressionists. Parallel to it was an accentuation of the theme of love, ranging from the brotherhood of men to strongly erotic images. The typical deformation patterns used by the Expressionists on the human form gave rise to a trend toward the caricature, which was, however, reserved for the wealthy, generals, politicians, judges — in short, for representatives of the State, who had disappointed so many of the artists. That such subject matter would lose its appeal once a certain political quietude had returned, and once the reestablishment of the middle class had begun in earnest, is more than understandable. Again, a study of the growing rejection of this subject matter, which Expressionists embraced after 1916 and proliferated after 1918, and a careful rereading of anti-Expressionist criticism of the period are tasks yet to be done.

While the suggestions made in this analysis are primarily concerned with required research in the visual arts, it should not be overlooked that this is only one aspect of many. Although the study of the literature of Expressionism and of Dada has made great progress (and the availability of the many reprints of books as well as of journals and magazines has accompanied these achievements), other fields still require more work. Detailed studies concerning Expressionistic plays and the whole aspect of the Expressionistic theater — with special emphasis on the intertwining importance of play, director (this was the period of the "star" director!), and stage designer — are very much needed. The history of their reception by the public should be relatively simple to assemble, and the documents are certainly available that would assist in the evaluation of the Volksbühnen movement (trade union subscription programs) and its impact on Expressionistic plays. While a number of studies of Expressionistic dance have appeared, they frequently are generalized biographies of the most famous dancers, dance troupes, and choreographers. In this field, too, the history of the reception of the new dance is still lacking, and hardly any serious work has been done concerning the cross-influence of dancers on the visual artists (e.g., E.L. Kirchner, Kandinsky, and Nolde) and that of the visual artists on the dancers. No catalog exists that would permit the tracing of the pieces of music the dancers used for specific performances, although the history of music of the period is well researched. Only the movies, which also went through a very significant phase of Expressionism, have received greater attention. Those studies have concentrated on the most famous of the films of

this period, but have usually skipped over the fact that the Expressionistic films were in the minority; the larger public watched rather different types of movies. Here a reception study is a necessity, especially if it could be based on attendance statistics. And nowhere is there a study of the "use" of Expressionistic or Dada art in public institutions, governmental offices, and especially in schools. What was hanging in the classrooms after the pictures of William II were taken off the walls, before the visage of Hitler took their place? The exhibition by the Institut für Volkskunde, University of Frankfurt, together with the Historical Museum of Frankfurt: *Die Bilderfabrik* (The Picture Factory) of 1973, were important contributions to an understanding of bourgeois preferences.[24]

This list of *lacunae* is frightfully long; and yet, it could still be expanded. It will take a long time to document and verify the various steps in the development, and primarily the demise, of Expressionism and of Dada to which this paper intended to call attention. Only one more aspect must be added. One of the requirements of all future studies of Dada and/or Expressionism is the necessary widening of their base. Without knowledge of the economics, the political history, the philosophy and psychology, and especially the sociology during the period between 1916 and 1925, our studies will be one-sided and based on generalizations inherited from earlier publications. The task is large, but it certainly will be worth the effort: the two movements belong to the forming powers of the arts within the first quarter of our century.

Notes for Chapter 12

1. Orrel P. Reed, Jr., *German Expressionist Art. The Robert Gore Rifkind Collection* (ex. cat., Los Angeles: F.S. Wight Gallery, Unv. of California, 1977), no. 231, pp. 222-26; no. 265, pp. 209-10; Victor H. Miesel, "Paul Cassirer's *Kriegszeit* and *Bildermann* and Some German Expressionist Reactions to World War I," in *Michigan Germanic Studies,* 2 (1976): 149-68; and Leo Kestenberg, *Bewegte Zeiten, Musisch-musikantische Lebenserinnerungen* (Munich/Zürich, 1961), pp. 35-39.

2. *Kriegszeit* 17 (16 December 1914), schult 65.

3. *Kriegszeit* 20 (30 December 1914), schult 66.

4. *Bildermann* 14 (October 1916), schult 80.

5. *Bildermann* 18 (20 December 1916), schult 92.

6. Stephen C. Foster, "Dada: Back to the Drawing Board," in *Dada Artifacts* (ex. cat., Iowa City: Univ. of Iowa Museum of Art, 1978), pp. 7-25. See also Richard Sheppard, "Dada: A Chronology," pp. 27-39 in the same catalog. Important bibliographies are by Bernard Karpel in Robert Motherwell, ed., *The Dada Painters and Poets: An Anthology* (New York: Wittenborn, 1951; repr. 1981), and by Hans Bolliger and Willy Verkauf in Willy Verkauf, ed., *Dada, Monograph of a Movement* (New York: St. Martin's, 1975), pp. 80-83.

7. See the ex. cat. mentioned in note 6 above. Other examples of such documentary catalogs are *Dada* (Zürich: Kunsthaus; and Paris: Musée National d'Art Moderne, 1966) and the

1958 catalog *Dada, Dokumente einer Bewegung* (Düsseldorf: Kunstverein für die Rhein-lande und Westfalen, Kunsthalle, and others).

8. *Vom Dadamax zum Grüngürtel. Köln in den 20er Jahren* (ex. cat., Cologne: Kunstverein, 1975 [with repr. of *Katalog Stupid I*, 1920, p. 97ff]).

9. *Arbeitsrat für Kunst: Berlin 1918–1921* (ex. cat., Berlin: Akademie der Künste, 1980), with complete repr. of the brochure *Ja! Stimmen des Arbeitsrats* and the other publications. The last meeting of the Arbeitsrat took place on 30 May 1921.

10. Justin Hoffmann, "Der Aktionsausschuss revolutionärer Künstler Munchens," in ex. cat., *Bildende Kunst/Fotografie der Revolution und Rätezeit* (Munich: Seminarbericht der Akademie der Bildenden Künste, 1979), pp. 21-75.

11. Helga Kliemann, *Die Novembergruppe*. Bildende Kunst in Berlin no. 3, Berlin, 1969. See also the special issue of *Kunst der Zeit, Zeitschrift für Kunst und Literatur* 3, 1-3 (1923), with an introduction by Will Grohmann.

12. For a more complete list, see Paul Raabe, *Die Zeitschriften und Sammlungen des literari-schen Expressionismus: Repertorium der Zeitschriften, Jahrbücher, Anthologien, Sammel-werke, Schriftenreihen und Almanache, 1910-1921* (Stuttgart, 1964).

13. Alfred Weber, *Die Not der geistigen Arbeiter* (Munich/Leipzig, 1923), esp. pp. 13ff and 30ff. Also, Ernst Francke and Walter Lotz, *Die Geistigen Arbeiter,* Part 2, *Journalismus und bildende Künstler* (Munich/Leipzig, 1922); Konrad Haenisch, *Die Not der geistigen Ar-beiter, Ein Alarmruf* (Leipzig, 1920), as well as the journal *Kunst und Wirtschaft,* 1920-1931, Berlin.

14. Gerald D. Feldmann, et al., eds., *The German Inflation Reconsidered, A Preliminary Bal-ance* (Berlin/New York, 1982), and many others.

15. Gerhard Pommeranz-Liedtke, *Der Graphische Zyklus von Max Klinger bis zur Gegenwart* (Berlin, 1956). Waltraut Neuerburg, "Der graphische Zyklus im deutschen Expressionismus und seine Typen" (dissertation, Rheinische Friedrich-Wilhelms-Universität Bonn, 1976).

16. Ex. cat., text by Gustav Friedrich Hartlaub. The exhibition was shown from 14 June to 13 September 1925; 125 paintings by 32 artists.

17. Paul Westheim, ed., *Das Kunstblatt,* vol. 9 (Potsdam/Berlin, September 1922), periodical published by Gustav Kiepenheuer.

18. Franz Roh, *Nach-Expressionismus. Magischer Realismus. Probleme der neuesten europä-ischen Malerei* (Leipzig, 1925). A critical evaluation was published by Wieland Schmied, *Neue Sachlichkeit und Magischer Realismus in Deutschland, 1918-1933* (Hannover, 1969). See also the ex. cats. *Les Réalismes — entre Révolution et Réaction* (Paris: Centre National d'Art et de Cultur Georges Pompidou), and its German edition, *Realismus, zwischen Re-volution und Reaktion, 1919-1933* (Munich, 1981); and *Neue Sachlichkeit und Realismus, Kunst zwischen den Kriegen* (Vienna, 1977).

19. As announced in *Sozialistische Monatschefte. Internationale Revue des Sozialismus* (Berlin: 9 January 1922), p. 66.

20. Sara Campbell, ed., *The Blue Four Galka Scheyer Collection* (ex. cat., Pasadena: Norton Simon Museum of Art at Pasadena, 1976).

21. *Die Rote Fahne, Zentralorgan der Kommunistischen Partei Deutschlands* 8, 57 (1925) printed the program of the newly founded group.

22. Carl Laszlo, *William Wauer* (n.p.: Editions Panderma, 1979). Also Lothar Schreyer, *Erinnerungen an Sturm und Bauhaus* (Munich, 1956), pp. 111-12.

23. The Dada Archive and Research Center at The Univ. of Iowa, Iowa City, has become an important collection point for these various memoirs.

24. Wolfgang Brückner, *Die Bilderfabrik, Dokumentation zur Kunst- und Sozialgeschichte der industriellen Wandschmuckherstellung zwischen 1845 und 1973 am Beispiel einer Grossunternehmens* (ex. cat., Frankfurt am Main: Institut für Volkskunde der Universität Frankfurt am Main and Historisches Museum, 1973), and the publication *Resonanz einer Ausstellung* of the same year.

[This is a slightly reworked paper delivered at the 10th Annual Meeting of the Mid-West Art History Society, Iowa City, 31 March 1983. I wish to express my gratitude to the Robert Gore Rifkind Foundation and the Center for the Advanced Studies in the History of Art for the resident scholarships that provided me with much of the material used in this chapter.]

Bibliographical Note

In view of extensive bibliographical work currently being produced for the Dada movement, I have here elected to list only a few of the more recent anthologies and collections of essays, exhibition catalogs, reprint companies, facsimile publishers, and periodical issues. In their bibliographies, the reader will discover virtually all the important older literature, much of which remains crucial to the study of the subject today. These citations should give ready access to both the general and the highly specific, detailed treatments of Dada, including substantial reproduction of the visual works of art. The following, then, is meant to introduce the reader to the serious literature of the field and does not constitute anything like a complete bibliography in its own right. Classic and unsurpassed works by Michel Sanouillet, Friedhelm Lach, Henri Béhar, and others, as well as standard works by Wulf Herzogenrath, Werner Schmalenbach, Michael Erlhoff, Arturo Schwarz, and a host of other scholars can easily be found in the bibliographies and notes of the works listed below. This is true, as well, of the writings by the Dadaists themselves.

Anthologies and Collections of Essays

Foster, Stephen C., and Kuenzli, Rudolf E., eds. *Dada Spectrum: The Dialectics of Revolt*. Madison, Wisc.: Coda Press; Iowa City: Univ. of Iowa, 1979.
Motherwell, Robert, and Flamm, Jack, eds. *The Dada Painters and Poets: An Anthology*. New York: Wittenborn, 1981 (repr. 1951, 1963).
Paulsen, Wolfgang, and Hermann, Helmut G., eds. *Sinn aus Unsinn: Dada International*. Bern/Munich: Franke Verlag, 1980.
Riha, Karl, *Da Da war ist Dada da*. Munich/Vienna: Hanser Verlag, 1980.
Schwarz, Arturo, *Almanacco Dada*. Milan: Feltrinelli, 1976.
Sheppard, Richard, ed. *Dada: Studies of a Movement*. Buckinghamshire: Alpha-Academic, 1980.
———, ed. *New Studies in Dada*. Driffield: Hutton Press, 1981.

Exhibition Catalogs

Dada Artifacts (Stephen C. Foster, guest curator). Iowa City: Univ. of Iowa Museum of Art, 1978.
Dada and Surrealism Reviewed (Dawn Ades, curator). London: The Arts Council of Great Britain, 1978.
Tendenzen der Zwanziger Jahre. Berlin: Dietrich Reimer Verlag, 1977.

Facsimiles and Reprints

Archivi d'arte del XX Secolo (Documenti e Periodica Dada), Milan
Krauss Reprint, Nendeln, Lichtenstein
ABC Periodicals, The Art Book Company, London
Editions Place, Paris
The Centre du XXe Siècle, Nice
Thomas Press, Ann Arbor, Mich.

For recent periodical literature, see Rudolf Kuenzli, "Dada Bibliography: 1973-1978," *Dada/Surrealism* 10-11 (1982): 161-201; also, "Bibliography on Dada, 1978-1983," *Dada/Surrealism* 13 (1984): 129-64. The full run of the periodical *Dada/Surrealism* (ed. Mary Ann Caws, Rudolf Kuenzli) should be consulted, as should the more specialized *Kurt Schwitters Almanach* (ed. Michael Erlhoff) and *Hugo Ball Almanach,* issuing from Hannover and Pirmasens, respectively. The monographic literature, lately grown very large, has been significantly enriched by the publications of UMI Research Press (Studies in the Fine Arts: The Avant-Garde, ed. Stephen C. Foster), Ann Arbor, Mich. Finally, attention should be called to the founding of the Dada Archive and Research Center in 1979 at The University of Iowa. Composed of a Fine Arts Archive and a Literary Archive, the center has become one of the largest repositories of Dada materials in the world. It is open to use by the public and invites inquiries.

Contributors

Roy F. Allen is Assistant Professor of German and Spanish at Wartburg College, Waverly, Iowa. His past publications include *German Expressionist Poetry* (1979) and *Literary Life in German Expressionism and the Berlin Circles* (1983). Alongside his ongoing research in this area, Professor Allen maintains an active involvement in contemporary American studies.

Timothy O. Benson is a doctoral candidate in the Department of Art and Art History at the University of Iowa in Iowa City. He is completing a dissertation on Raoul Hausmann and conducted his research in Europe under the auspices of the DAAD and the Kress Foundation. Benson has lectured extensively on Hausmann, concentrating on the artist's involvement with automatism, Expressionism, and Dada, and is currently working on an exhibition of the artist's works.

Ruth L. Bohan is Assistant Professor of Art at the University of Missouri, St. Louis, Missouri. Her recent publications include *The Société Anonyme's Brooklyn Exhibition: Katherine Dreier and Modernism in America* (1982). She also served as consulting editor for *The Société Anonyme Collection and the Dreier Bequest at Yale University: A Catalogue Raisonné* (ed. Robert L. Herbert, Eleanor S. Apter, and Elise K. Kenney; 1984).

John E. Bowlt is Professor of Slavic Languages at the University of Texas at Austin and Director of the Institute of Modern Russian Culture at Blue Lagoon, Texas. Among his recent books are *Scenic Innovation, Russian Stage Design 1900-1930* (1982) and, with Nicoletta Misler, *Pavel Filonov, A Hero and his Fate* (1984). He has also organized or co-organized many exhibitions of Russian art for both public museums and private galleries.

Stephen C. Foster is Associate Professor of Art History at The University of Iowa in Iowa City and serves as Director of the Fine Arts Archive. Working in both Dada and the contemporary arts, his publications include *The Critics of Abstract Expressionism* (1980), *Dada Spectrum* (co-edited with Rudolf E. Kuenzli) (1979), and *Dada Artifacts* (1978). Professor Foster is currently completing a monograph on Johannes Baader.

Allan C. Greenberg is Associate Professor of Politics and History at Curry College in Milton, Massachusetts. Concentrating on the role of artists and intellectuals in European society, he has published *Artists and Revolution: Dada and the Bauhaus, 1917-1925* (1979) and has since been involved in research on the cabaret in various European countries.

Peter W. Guenther is Professor of Art at the University of Houston in Texas. His past publications include *Edvard Munch, an Exhibition* (1976) and *German Expressionism, Toward a New*

Humanism (1977). Beyond his research in the area of early twentieth-century German art, Professor Guenther works actively in other fields, including Symbolism and the Renaissance, and has lectured extensively in these areas.

Jane H. Hancock is Supervisor of the Media Production and Resources at The Minneapolis Institute of Arts. Her previous publications include "Jean Arp's *The Eggboard Interpreted*" (1983) and "The Modern Movement (at The Minneapolis Institute of Arts)" (1983). She is currently preparing a monograph on Arp's Dada and Surrealist periods.

Friedhelm Lach is Professor of Ancient and Modern Studies at the University of Montreal. His five-volume critical survey entitled *Kurt Schwitters, Complete Works* was published between 1973 and 1982. His interests range from Dada studies to semiotics and the avant-garde. Alongside his scholarly pursuits, he also works as both an artist and an editor.

Estera Milman is Project and Collections Coordinator for The University of Iowa's Fine Arts Archive in Iowa City and serves as Adjunct Assistant Professor of Photography at the University's School of Art and Art History. She has conducted research on the relationship between Dada and the contemporary arts and is currently organizing a workshop series and exhibition devoted to "Fluxus."

Charlotte Stokes is Associate Professor of Art History at Oakland University, Rochester, Michigan. Her articles on Max Ernst have appeared in *Art Bulletin, Arts Magazine, Leonardo,* and *Simiolus.* Current projects include research into Surrealism in the 1940s, with special emphasis on Ernst's prints and sculpture of the period.

Harriett Watts is Assistant Professor of German at Boston University. Her past publications include *Three Painter-Poets: Arp/Schwitters/Klee* (1974) and *Chance: A Perspective on Dada* (1980). Professor Watts also served as Translator in Residence, National Translation Center, and has published numerous translations from French, German, and Portuguese.

Index

Wandervogel, 116–17
Wilcynski, Karl, 34
Williams, William Carlos, 187

Zdanevich, Ilia, 221
Zurich
 beginnings of Dada, 1, 2–3, 9, 26, 165,
 166, 167, 224, 274
 Cabaret Voltaire, 2, 3, 4–5, 26, 167–68,
 173
Zurich Group, 5

conceptualizing Dada's aims, 8, 15
defines "Dada," 9–10, 131
dissolution of, 15, 16
foundation of Berlin/Paris Dada Group, 15
Jean Arp's chance collages, 47, 55, 63
manifestos of, 8, 12, 14, 15
program, 7, 14

291 Group, 171, 178

391, 178–80